9.16.98

THE CULTURE OF SPONTANEITY

The Culture of

Daniel Belgrad

Spontaneity

Improvisation

and the Arts

in Postwar America

The University of Chicago Press
Chicago and London

Daniel Belgrad teaches American Studies at the University
of South Florida.

The University of Chicago Press, Chicago 60637
The University of Chicago Press, Ltd., London
© 1998 by The University of Chicago
All rights reserved. Published 1998
Printed in the United States of America
07 06 05 04 03 02 01 00 99 98 1 2 3 4 5

ISBN: 0-226-04188-3 (cloth)

Library of Congress Cataloging-in-Publication Data

Belgrad, Daniel.
 The culture of spontaneity : improvisation and the arts
 in postwar America / Daniel Belgrad.
 p. cm.
 Includes bibliographical references and index.
 ISBN 0-226-04188-3 (alk. paper)
 1. Improvisation in art. 2. Arts, American. 3. Arts,
 Modern—20th century—United States. I. Title.
 NX165.B35 1998
 700′.1′030973—dc21 97-29793
 CIP

⊗The paper used in this publication meets the minimum
requirements of the American National Standard for
Information Sciences—Permanence of Paper for Printed
Library Materials, ANSI Z39.48–1992.

Contents

Highbrow, Middlebrow, and Other
The "Beat Generation"

Conclusion
Into the Sixties

Formalism and Irony
Sixties Countercultures

Illustrations

Acknowledgments

Sometimes, as I worked on this book, words in my mind would take on a weighty and three-dimensional quality, like huge boulders or strange sculptures that I would have to shape and move. I could not have wrestled with so many without considerable help.

The successful completion of this project has been largely dependent on the intelligence, generosity, and enthusiasm of my advisors among the American Studies faculty at Yale, where I completed my Ph.D. in 1994. Jean-Christophe Agnew, the chair of my advisory committee, supported me through a difficult period during which I changed my dissertation topic. Michael Denning was my ideal reader during long days spent in front of the word processor; he grasped my arguments through reams of turgid prose and helped me to identify them. Ann Fabian went beyond the call of duty, as she always does with her students, in reading hundreds of pages of this manuscript in its early versions. Bryan Wolf taught me how to read paintings as cultural texts; without the confidence he instilled, I could not have undertaken this project. James Fisher first inspired me to look into this material when I was a teaching assistant in his American Studies lecture course seven years ago. Ann Gibson generously shared the contacts, bibliographies, and hard-to-find little magazines she has collected throughout the years.

Many other friends and teachers also inspired and helped me along the way: Daniel Rodgers, Jerrold Siegel, Toshiko Takaezu, Ron Meyers, and Michael Simon; Vera Lendvay, Phil Deloria, David Stowe, and Kenneth Haltman; Laura Saltz, Rishona Zimring, Laura Katzman, Kellie Robertson, Sharon Joyce, Shawn Rosenheim, and Cassandra Cleghorn. Lisa Binhammer, John Wilson, and Elena García-Martín helped me with final revisions of this manuscript. Doug Mitchell proved the ideal editor with his combined enthusiasm and perspicacity. Carol Saller, my copy editor, greatly improved the manuscript by catching many small errors I had otherwise overlooked.

My parents, Richard and Carolyn Verdoorn Belgrad, deserve thanks for

all sorts of things, especially, in this context, their generous financial support in the last year of my graduate education. A project of this scope is made possible only by years of such material assistance. I am thankful for the grants and fellowships that enabled me to complete this work, including a Jacob Javits fellowship from the U.S. government, a dissertation fellowship from the Mrs. Giles Whiting Foundation, and a faculty research grant from the University of South Florida. I hope that some of those whose labor ultimately makes such grants possible will feel that they have gotten their money's worth.

> The whole point of modern poetry, dance . . . per-
> formance, prose even, music, was the element of
> improvisation and spontaneity and open
> form . . . The development of poetics, as well as
> jazz and painting, seems to be chronologically
> parallel.
>
> —Allen Ginsberg

A will to explore and record the spontaneous creative act char-
acterized the most significant developments in American art
and literature after World War II. "Gesture" painting and
"beat" writing are perhaps the best-known examples of this phenome-
non. But the impulse to valorize spontaneous improvisation runs like a
long thread through the cultural fabric of the period,
appearing also in bebop jazz music, in modern dance
and performance art, in ceramic sculpture, and in
philosophical, psychological, and critical writings. To
study each of these media in isolation is to miss the
general importance of the spontaneous gesture as a
sign of the times. Indeed, an accurate understanding of
American intellectual and cultural life in the postwar
decades depends on recognizing the existence of a
coherent aesthetic of spontaneity and its social signifi-
cance.

The social significance of spontaneity can be appreci-
ated only if this aesthetic practice is understood as a cru-
cial site of cultural work: that is, as a set of activities and
texts engaged in the struggle over meanings and values
within American society. The cultural stance embodied
in the art of spontaneity—and communicated through
it—constituted a distinct third alternative, opposed to
both the mass culture and the established high culture
of the postwar period.[1] Its influence on American soci-
ety would be most strongly felt in the "counterculture"
of the 1960s, but it was fully articulated in avant-garde

practices between 1940 and 1960, functioning as the basis of a distinct counterculture in this earlier era.

Between 1940 and 1960, the dominant voices in American popular culture fostered an image of American supremacy based on a combination of wartime and Cold War xenophobia (a fear of "un-Americanism") and pride in America's material prosperity ("The American Way of Life"). Both during and after the war, divisions within American society were submerged in favor of an ideology of national consensus.[2] Meanwhile, established voices in American high culture (for instance, the "New Criticism" and the literature it valorized, or the religious neo-orthodoxy of Reinhold Niebuhr) responded to the horrors of the war with a sense of disillusionment about the perfectibility of human society. The resulting mood of psychological inwardness and the "rediscovery of sin" fostered the internalization and privatization of cultural struggles that a decade before had seemed intensely social in nature.[3]

Distinct from these groups, those artists and writers who embraced spontaneity as a style, while sharing the orientation toward self-examination that characterized the high-culture establishment of the period, assumed a more actively confrontational stance toward the dominant ethnocentrism and continued to believe in the social role of art. Unlike the social realism of the 1930s or the guerrilla theater of the 1960s, the spontaneous aesthetic for the most part avoided politics in the topical sense. Yet it was rooted in philosophical concerns that did have political implications.[4]

The Historical Context

Musician Ann Farber has explained how spontaneity operates at once as an aesthetic and as a group dynamic: "Our aim is to play together with the greatest possible freedom—which, far from meaning without constraint, actually means to play together with sufficient skill and communication to be able to select proper constraints *in the course of the piece*, rather than being dependent upon precisely chosen ones."[5] In the most successful improvisational art, the give-and-take of conversation functions as a model of democratic interaction: "No single instrumentalist or structure establishes absolute dominance. Instead, voices and structures keep weaving in and out, modifying and reshaping one another."[6]

Such thinking formed the basis of a resurgence in avant-garde activities among American artists and writers in the 1940s and 1950s. This new avant-garde shared the belief that cultural conditioning functioned ideologically by encouraging the atrophy of certain perceptions and the exaggeration of others.[7] They took it upon themselves to articulate and arouse perceptions that were denied or truncated by the dominant culture. In the

recovery of such an alternative "reality," outside the mental disciplines of corporate liberalism and mass culture, they saw the only basis for constructively radical social change.

Corporate liberalism is a social and economic arrangement that has predominated in the United States since the 1920s, replete with a value system that has been called "the culture of abundance."[8] As an outgrowth of Progressivism, corporate liberalism preserves the ideology of efficient mass production central to Progressive thinking.[9] Corporate liberals instituted an "American Way of Life" defined by a complementary combination of scientifically managed work with mass leisure and consumption. High wages, vacation time, and installment buying maintained a consistently high demand for industrial products, reversing the economic slump that had followed the end of the First World War. The federal government actively facilitated this arrangement by devoting its resources to projects that would benefit the business community as a whole, and big business in particular. It provided highways and electric power, developed industry standards, collected data, funded research, and cultivated domestic and foreign markets.[10]

The Great Depression of the 1930s threw corporate liberalism into crisis. With one-third of the workforce looking for jobs, Americans were forced to question the socioeconomic arrangements of the twenties. Many joined the Communist Party in search of answers to the social situation; hundreds of thousands embraced other radicalisms, from Francis Townsend's to Huey Long's.[11] Franklin Roosevelt's New Deal preserved corporate liberalism only by introducing extreme modifications, which redefined the powers of government and organized labor in relation to big business.

But after the doubts and social experiments of the Depression, the war years ushered in a new era of corporate-liberal predominance. The advent of the Second World War brought the New Deal to an end. As Roosevelt proclaimed his change of title from "Dr. New Deal" to "Dr. Win-the-war," business leaders reasserted former power relations.[12] During and after the 1940s, corporate liberals relied on government deficit spending to maintain the mass consumption economy. Military cost-plus contracts hastened economic concentration, as one hundred of America's largest companies absorbed $117 billion of federal funds.[13]

Corporate liberalism left the democratic political machinery of the United States intact, while concentrating more and more real social power at the top of pyramidal institutional hierarchies.[14] As Richard Edwards has written in *Contested Terrain: The Transformation of the Workplace in the Twentieth Century*, "bureaucratic control" gradually became the foremost means of ensuring social cohesion in the mid-twentieth century, with its greatest rate of implementation occurring during and after World War II.

Unlike the earlier "technological control" of industrial capitalism (exemplified by Henry Ford's moving conveyor belt), the "bureaucratic control" associated with corporate liberalism entailed the rationalization of mental attitude rather than of physical space. Corporations instituted a system of homogenization that rewarded rule-following and attitude management as good in themselves, requiring these qualities in workers as the first step to promotion.[15]

Advertising and the mass media were instrumental as cultural proponents of the corporate-liberal system. Advertisements, mass-circulation magazines, Hollywood movies, and radio and television programs celebrated American technology and the suburban "standard of living." Throughout the 1940s and '50s, popular culture media used such celebrations to foster an attitude of ethnocentric expansionism. Henry Luce, who headed the *Time-Life* media empire, urged Americans in 1941 to welcome "The American Century": to grasp "our opportunity as the most powerful and vital nation in the world . . . to exert upon the world the full impact of our influence, for such purposes as we see fit and by such means as we see fit." "The world of the 20th century," Luce wrote, "if it is to come to life in any nobility of health and vigor, must be to a significant degree an American century . . . a sharing with all peoples of our . . . magnificent industrial products, our technical skills."[16]

The socioeconomic arrangements of corporate liberalism relied heavily on the dual cultural supports of mass culture and bureaucratic discipline. Therefore, challenges to the corporate-liberal order often surfaced in the form of cultural criticism. In the little magazine *Neurotica* in 1949, for instance, Marshall McLuhan condemned Henry Luce's publishing empire for its particular brand of mass culture. Suggesting that the ideology promulgated by Luce's publications was at the base of an escalating "social neurosis," McLuhan accused *Time* and *Life* of maintaining a pretense of objective neutrality while in reality "vigorously thrusting an emotionally-charged spectator role on their readers."[17] Implicit in their approaches, McLuhan accused, was an ideology that treated engineers and managers as gods, and the mass of readers as foolish children. Through this cultural gambit, Luce was "surely taking political initiative. . . . A total absence of social and political thought is itself the major political fact." To McLuhan, *Time* exemplified the reduction of American intellectual life to a corporate-bureaucratic ant farm in which independent thinking was replaced by a "knowledge" industry aimed at gauging and managing human behavior.

McLuhan concluded that in the face of this cultural onslaught, social renewal could "only take the form of reawakened critical faculties. The untrancing of millions of individuals by millions of individual acts of the will." This was the modus vivendi of artistic enclaves like Black Mountain

College in North Carolina and the bohemias of North Beach, San Francisco; and Greenwich Village, New York. At such locales, artists, writers, and musicians congregated to exchange news and views. At the San Remo bar in Greenwich Village in the early 1950s, a visitor would sooner or later run into scores of people engaged in some aspect of the postwar aesthetic of spontaneity: Paul Goodman, Julian Beck and Judith Malina, John Cage and Merce Cunningham, Miles Davis, Jackson Pollock, Allen Ginsberg, Gregory Corso, and Jack Kerouac—among many others. As Ronald Sukenick wrote in his memoir of Greenwich Village life: "We thought of ourselves as in the spirit of the true left."[18] In opposition to the imperatives of bureaucratic control, "spontaneity" was the strategy and the rallying cry of this avant-garde cultural project.[19]

Among those whose work defined the aesthetic of spontaneity were the "Black Mountain" and "beat" poets; most significantly, Charles Olson, Michael McClure, Allen Ginsberg, Jack Kerouac, and LeRoi Jones. In music, it was pioneered by the bebop musicians, including Charlie Parker, Lester Young, Miles Davis, and Max Roach. "Abstract expressionist" painters developed some of the movement's most important forms; foremost among these artists were Robert Motherwell, Adolph Gottlieb, Jackson Pollock, Willem de Kooning, James Brooks, Helen Frankenthaler, Jack Tworkov, and Lee Krasner. Katherine Litz, Merce Cunningham, Peter Voulkos, and Toshiko Takaezu extended the aesthetic of spontaneity into the media of modern dance and ceramic sculpture. Psychologist Paul Goodman proposed it as a way of life.

In identifying a common cultural project among so many, we immediately encounter the issue of generalization: for what we are dealing with here was not an organized cultural movement but a loose coherence of individually unique artists, writers, and musicians. Even the attitudes of individuals changed and developed over time, further complicating the story. But with this apology for the truncations inevitable in the cultural historian's approach, I would like to offer a paradigm that I think accounts for much of the continuing cultural significance of these artists.

The culture of spontaneity developed an oppositional version of humanism, rooted in an alternative metaphysics embodied in artistic forms.[20] The basic attributes of this alternative metaphysics can be summarized as intersubjectivity and body-mind holism. Corporate liberalism embraced an ontology and epistemology of objectivity, which was the basis of its advanced technological mastery of nature. Against this, spontaneity posed intersubjectivity, in which "reality" was understood to emerge through a conversational dynamic. Objectivity understood "rationality" to be defined exclusively by an intellect that separated objective truths from subjective perceptions; thus it posited a dichotomy of mind and body. By contrast, the avant-garde defined the "rational"

as a viewpoint determined by the interaction of body, emotions, and intellect.[21]

In response to the quantum leap that they experienced in the power and scope of corporate-liberal ideology, the avant-garde of the 1940s asserted with renewed force and vocabulary a romantic critique of Western civilization. The dominant "Western tradition," of which American corporate-liberal culture is an extension, has historically been Eurocentric, asserting the superiority of objective, intellectual, Western civilization over so-called primitive ways of being. Against this ideology, an antimodern "primitivism" or a postmodern multiculturalism has often been a component of romanticism in the arts.

Though spontaneity privileges the unpremeditated act, the aesthetic of spontaneity had many prior sources. As a cultural movement, spontaneity boasted a formidable intellectual heritage, including the works of John Dewey, Alfred North Whitehead, and Carl Jung, in addition to existentialism, surrealism, gestalt psychology, and Zen Buddhism. When situated within the marginalized intellectual discourses that formed the basis for their aesthetic, the artistic practices of the culture of spontaneity can be recognized as constituting an important chapter in American intellectual history.[22] The logic of the philosophies that informed this aesthetic implied that socially useful ideas would no longer be articulated in conventional intellectual forms, but would develop new means that did not privilege the abstract intellect. The culture of spontaneity embodied ideas in artistic forms, extending intellectual activity beyond the ken of conventional intellectual history. My study, by reconstituting this intellectual discourse, addresses a significant gap in our understanding of modern American intellectual life.

Understanding how ideas are disseminated through the arts requires the tools of art history and literary analysis as well as those of the intellectual historian. It also requires rethinking what the term "intellectual" denotes. When we understand some art as embodying ideas, however, intellectual history is at once complicated by issues concerning the sociology of knowledge. What ideas have been socially constituted as the domain of those whom we conventionally term intellectuals, and what ideas have historically found voice in apocryphal "discourses" in diverse nonacademic media?[23]

Russell Jacoby has argued in *The Last Intellectuals* that the postwar gravitation of intellectual life to the universities spelled the end, in the United States, of the "public intellectual."[24] But I believe that what actually occurred was a shift in the definition of the intellectual as a social type. Public intellectuals no longer defined themselves as "intellectuals," choosing instead the roles of artists, poets, and musicians. The postwar period saw not the end of public intellectuals, but a watershed event in

what Christopher Lasch once called "the social history of intellectuals": the rise of a new type of intellectual, with a different relation to American society.[25]

THE HISTORIOGRAPHICAL CONTEXT

To see spontaneity as embodying a cultural stance is to grasp that what is most significant about spontaneous art, music, and literature is the world-view (or *mentalité*) that it communicates.[26] This book is concerned with an explication of that *mentalité* and a recovery of its social implications and origins. In advancing this perspective, I find my nearest allies in the recent contextual analyses of abstract expressionist painting by Ann Gibson, David Craven, Stephen Polcari, and Michael Leja.[27] These scholars approach the material with an explicitly art-historical, rather than a more comprehensive cultural-historical, scope. But they are united in adopting a *mentalité* approach in order to step into the breach defined by the long-standing schism between formalist and social-historical analyses of abstract expressionist art.

The limited terms of this debate between formalists and Marxists over the meaning of modern art were encapsulated in an exchange between Michael Fried and T. J. Clark in 1982.[28] The Marxist reading has focused on the appropriation of abstract expressionist art by the hegemonic culture. For instance, T. J. Clark has written that the modes of individual freedom represented by Jackson Pollock's painting were useful to "capitalism" in its effort "to extend—perhaps to perfect—its colonization of everyday life."[29] Clark insists that abstract expressionist art is defined by an impulse to "negation," or the stripping down of experience, which identifies it with late capitalism's aggression against the human subject. As in Serge Guilbaut's *How New York Stole the Idea of Modern Art*, this argument is made with scant reference to the art itself; more significant, in the Marxist context, is the damning presence of the art market: as Clark accuses, "[The speculator] Dupuy invested in Georges Seurat."[30]

Michael Fried rejects Clark's categorical denunciation of modern art on these grounds. But Fried offers no alternative understanding of the relation of abstract expressionist painting to the late capitalist mode of production. Instead, he begs the social question in order to defend modern art as a wholly self-referential discourse, constituting meaning through the manipulation of representative conventions that cannot be reduced to Clark's vulgar Marxisms.[31] He supports this assertion with a formalist reading of a piece of contemporary sculpture.

This conflict over the meaning of abstract expressionist painting could continue indefinitely, achieving nothing beyond more elaborate restatements of the two positions. For these two stances, seemingly opposed

within the single discourse of art criticism, in fact represent two mutually incompatible discourses, each dedicated to a wholly different conception of the relevant "data" constituting the field of inquiry, the narrative into which this data fits, and the analytical tools by which the data and the narrative are fitted to one another.[32] Both the Marxist and the formalist discourses inherit fatal flaws as approaches to the social meanings of abstract expressionism: one detects collusion in the content of the art itself, while the other has no way of engaging the social experience in which the symbolic act is rooted.

I approach these texts neither as commodities nor as objects, but as artifacts of a cultural practice. Like all cultural practices, the production of works emphasizing the spontaneous creative process was simultaneously grounded both in the social world, where culture functions as "equipment for living,"[33] and in the intellectual discourses which inform the act of signification. Thus, in the history of the *mentalité* that these practices embody, formal and sociological readings are both comprehended.

While my approach, which focuses on the production and not the distribution or consumption of this art, relies substantially on recent Marxist theory, it provides an important complement to the extant Marxist critique. For artistic texts are polysemous, and do not always function in the service of the power elite. As Serge Guilbaut has argued in *How New York Stole the Idea of Modern Art*, the politics of cultural forms is always contextual; that is, the meaning of an artwork is dependent on the cultural milieu into which it is received. What Guilbaut has overestimated, however, is the monolithic nature of the American culture that abstract expressionism represents.[34]

It is this work of reconstituting the discursive context informing abstract expressionist painting that has been undertaken by Ann Gibson, David Craven, Stephen Polcari, and Michael Leja. But my work, focusing not on abstract expressionist painting per se, but on the larger cultural movement in which the painting was encompassed, substantially reconfigures much of the ground we seem to share.[35] Availing myself of the interdisciplinary approach of American Studies, I have traced the aesthetic of spontaneity through innovations in painting and ceramics, prose and poetry, jazz and dance performance—treating all of these media as diverse manifestations of a single event in the history of cultural forms.[36]

While I have worked to describe the connections among artistic practices that I believe belong together, I have also done my best to dissociate them from other phenomena with which they have been wrongly linked. Externally imposed schema often result in such false associations, as witnessed by Leja's persistent effort to explain abstract expressionism through references to film noir.[37] My study explores the social meanings of spontaneity in American arts and literature by identifying a vocabulary

used by the artists themselves, and by exploring the intellectual and social implications of this formal vocabulary. "Ideogram," "plastic automatism," "energy field" or "force field," "dialogue" or "counterpoint," and "spontaneous bop prosody": as the names of particular practices subsumed within the larger project of spontaneity, these terms point toward how forms linked the intellectual and social dimensions of this art.

My work makes the assumption that it is possible to approach artists as thinking subjects. Though their words may be only inarticulate or oblique expressions of what their art seeks to accomplish, the diligent cultural historian will do his or her best to make sense of them. I take artists' statements and other extant evidence of their practices as indicative of their cultural activities; remembering always that the philosophies and values they sought to articulate were embodied in forms, not in scholarly prose, and this for good reason. This book therefore seldom attempts to offer "interpretations" of individual works. It focuses instead on providing a social and intellectual history of the formal vocabulary that large numbers of these works shared.

The postwar avant-garde were engaged in a search for forms of communication adequate to their situation. In my efforts to avoid the reduction of their poetry and prose to an interpretive schema imposed from without, I have tried to fulfill Susan Sontag's directive in *Against Interpretation:*

> [E]very style embodies an epistemological decision, an interpretation of how and what we perceive . . . [selectively] focusing our attention. . . . [Therefore] the aim of all commentary on art now should be to make works of art—and, by analogy, our own experience—more, rather than less, real to us. The function of criticism should be to show *how it is what it is*, even *that it is what it is*, rather than to show *what it means*.[38]

This book seeks to recover the *mentalité* that led to the production of spontaneous works of art, not so as to supplant this art, but in order to direct the reader to it.[39] If the postwar avant-garde embodied their ideas in forms, those ideas can be assimilated only through an encounter with the art itself.

OUTLINE OF THE ARGUMENT

The practice of spontaneous improvisation rooted in "psychic automatism" was adopted by American artists and writers at the outset of World War II, as a technique for bringing ideologically inadmissible possibilities into awareness. The first chapter of this book describes how disillusionment with Stalinist Communism and European civilization, combined

with the triumph of a corporate-liberal advertising culture in the United States itself, led to the renewed vitality of an American avant-garde around the year 1940. It also explains why the aesthetic of spontaneity was so closely identified with the struggle of ethnic Americans to achieve cultural authority.

Chapter 2 describes how, drawing on the influences of surrealism and Jungian psychology, the avant-garde used spontaneity to pursue the formulation of "another" humanism, based on a revised relation between the ego and the unconscious that they called "participation mystique." These artists and poets followed their European predecessors in looking to the symbols and myths of "primitive" cultures for alternative sources of value. They believed that such cultures offered an improvement on modern Western civilization in their mechanisms for integrating the life of the unconscious into public decision-making processes, and in their sense of the moral relations binding humans to their environments. Self-consciously American, the avant-garde particularly sought to adapt cultural materials available from Native American sources. The New Deal programs of John Collier and René d'Harnoncourt fostered a cross-cultural dialogue between the avant-garde and American Indian artists.

By the mid-1940s, the artistic method of "plastic automatism" had directed the avant-garde's pursuit of "participation mystique" into a significant body of work concerned with the unique communicative potential of the "ideogram." The avant-garde came to understand the social ills they faced as rooted in the increasingly abstract character of human experience in the modern world. They believed that Western civilization, relying more and more on the artificial constructions of abstract rationality, had been led into systematic absurdities. As described in chapter 3, the ideogram or "glyph" represented the avant-garde's effort to develop a "plastic language" to counter this cultural tendency. Through sensitive engagement with their materials, the avant-garde hoped to revive in their contemporaries the atrophied forms of awareness.

Though the philosophy of existentialism had considerable impact on the American intellectual establishment in the postwar period, I argue that the aesthetic of spontaneity cannot be identified with existentialist alienation. The mainstream of postwar spontaneity eluded the shortcomings of existentialist philosophy, rejecting its vestiges of a mind/body dichotomy in favor of a more radical "field" theory of subjectivity. Consistent with the tenet of intersubjectivity, spontaneity embodied a strategy of entering into improvisational "dialogue" with one's materials. It was this sense of dialogue—of give-and-take never completely ended, and full understanding never completely accomplished—that accounted for the characteristic lack of closure in abstract expressionist works. Chapter 4 examines American existentialism in connection with the

practice of "plastic dialogue," developing a typology of abstract expressionist gesture painting on this basis.

Chapter 5 establishes the influence of Alfred North Whitehead's materialist cosmology in the avant-garde practices of gesture-field painting and collage. Whitehead made an alternative geometry, rooted in Einsteinian physics, the basis of his "process philosophy." His model of human experience defined the individual as an organized event in the flux of energy through space-time. Following this model, postwar spontaneous art and poetry dramatized the emergence of the self through the interaction of the human organism with its environment. Whitehead's "energy field" suggested a model of human society contrary to the liberal idea of civility as a function of reason alone.

Following similar field theories, Paul Goodman's "gestalt therapy" supplanted Jungianism as the psychological basis of avant-garde practices in the fifties. Chapter 6 explores the links between Goodman's social criticism, his psychological theory, and his celebration of spontaneous art. According to Goodman, the unconscious mind was not located only in inaccessible reaches of the brain, but was manifest in the "attitude" of the body's muscular structure. The body, as the site of cognition, linked the individual to the world beyond, both physically and psychologically. Thus it provided a focal point for artistic intervention in the social system.

"Kinesthetics," the idea that body motions constitute a repository of unconscious knowledge, ultimately led to experimental collaborations between poetry, painting, and other media. Boundaries were breached between painting and performance art in the work of Jim Dine and Robert Rauschenberg. Kinesthetics led to new forms of modern dance in the work of Katherine Litz and Merce Cunningham; and to the art of clay pottery as practiced by Peter Voulkos and Toshiko Takaezu. Chapter 7 describes these developments and discusses the influence of Zen Buddhism on the culture of spontaneity through these media.

Chapter 8 explores the evolution of bebop jazz as a reaction against the culture of big-band swing jazz. Swing epitomized the ethos of corporate-liberal culture, whereas bebop consisted of prosodic voices engaged in spontaneous conversation. "Prosody," in this sense, refers to the meanings of an utterance that are communicated not by the word-symbol but by its bodily production, including timbre, tempo, and inflection. Attenuated in the written word, these elements contribute much to the message communicated in face-to-face contact. Bebop jazz built on the African American "oral" idiom to encode intersubjectivity and body-mind holism in musical form.

Like the "spatiality" of the ideogram, prosody served avant-garde writers of the fifties as a means by which they attempted to correct the pathological "bias of attention" in their culture. Emphasizing prosody was one

way in which the beat writers insisted on the value of "presence": that is, on the importance, to a democratic society, of "authentic," face-to-face, human contact. The spontaneous "sketching" technique developed by Jack Kerouac aimed at a form of intersubjective communication that integrated conscious and unconscious experience. Chapter 9 describes the relationship of beat writing to earlier versions of the culture of spontaneity, particularly the "field" poetics of Charles Olson and the prosodic experiments of bebop jazz.

Chapter 10 explores the interactions of the culture of spontaneity with the dominant culture of the Cold War period. The beats engaged in a strategy of disclosing the "social neurosis" which linked their personal confessions to a general social critique. This made them the targets of critics in both academic and popular culture. "Highbrows" and "middlebrows," battling each other for cultural authority in the postwar period, seized on the culture of spontaneity as an example of what was wrong with American society. But the sense of the spontaneous aesthetic appealed to an increasing number of Americans, who constituted a "beat generation."

The final chapter of this book describes how the postwar culture of spontaneity was transformed during the 1960s. The sixties avant-garde turned away from the themes that had defined abstract expressionism and projective verse, embracing irony, neo-dada, and pop art. At the same time, the beat generation gave way to the New Left and the hippie counterculture. These movements embraced important aspects of the spontaneous legacy, but discarded most of its art forms in favor of their own.

More than half a century has passed since the Second World War reached America; since Adolph Gottlieb painted his first Pictograph and Charlie Parker played bebop at Minton's Playhouse. In the interim, it has become harder than ever to disagree with the criticisms that spontaneous art leveled against corporate liberalism back then. Today, bureaucratic control continues to invade new ground in American life. Our latest economic relations are characterized by "downsizing" and our latest social relations by "cybersex." The corporate-liberal order continues to encourage the forgetting of many kinds of useful knowledge; today we are almost all "specialists," but few of us are clever or wise. Still, looking at the story of the past that is compiled in these pages, I wonder if art can do anything about it.

The Collective Unconscious

The Emergence of an Avant-Garde

You had your searches, your uncertainties
And this is good to know—for us, I mean,
Who bear the brunt of our America
And try to wrench her impulse into art.

—Ezra Pound, "To Whistler, American"
(1912, 1949)

In the 1940s and 1950s, spontaneity had social meaning, both for the artists who used it and for the culture at large. The social meanings of spontaneity were several, and varied by degrees from artist to artist. Nonetheless, three interrelated social meanings motivated and defined the practice of spontaneity as a coherent cultural movement. Most broadly, spontaneity implied an alternative to the vaunted rational progress of Western civilization, which had succeeded in developing technologies and principles of organization that threatened human life and freedom on an unprecedented scale. In the specific historical context of wartime and postwar America, spontaneity did battle against the culture of corporate liberalism, which was the most recent and local manifestation of these principles. Finally, spontaneity was a means for challenging the cultural hegemony of privileged Anglo-American "insiders," giving voice to artists and writers from ethnic and social backgrounds remote from the traditional channels of cultural authority. In all these ways, the spontaneous aesthetic was rooted in a search for social influence outside political channels.

Spontaneity's challenge to the existing social order was founded on a belief in the value of the unconscious mind as the locus of possibilities denied legitimacy within the prevailing ideology. Writers, artists, and musicians hoped that the spontaneous work of art might serve as a communication from the "open" realm of the unconscious to the ideologically restricted world of

consciousness. Such ideas had their basis in theories articulated in the 1920s by an earlier generation of modernists.[1] But the postwar avant-garde gave unique shape to the intellectual and artistic traditions they inherited, reflecting the disillusionment that tempered their idealism.

The avant-garde's rejection of traditional politics resulted partly from disillusionment with the Communist Left and partly from disillusionment with the corporate-liberal center. As the New Deal ended and the Second World War began, corporate liberals consolidated their hegemony in American political life. In this process, it was advertising that acted as the cultural vanguard of bureaucratic capitalism. Mass media advertising techniques served the information management strategies of corporate and government bureaucracies. It was against such manipulative strategies that the wartime avant-garde defined its position, rejecting the propagandistic populist art forms of the 1930s and giving new impetus and direction to modernism's early-twentieth-century critique of mass culture.

The "open" or "heteroglossic" forms developed by the wartime avant-garde challenged the social power of America's dominant Anglo-American tradition. The aesthetic of spontaneity emphasized "honesty," "awareness," and "authenticity" over the mastery of traditional forms and techniques stressed by the established institutions of high culture. It therefore provided an alternative means to cultural authority more accessible to aspirants from immigrant, working-class, and minority backgrounds.

THE REJECTION OF "REALISM"

The historical problem posed by the aesthetic of spontaneity might be formulated this way: what happened to American mural painting during the Second World War? Before the culture of spontaneity developed, in 1931, a young man named Jackson Pollock quit his job as a lumberjack in rural California and came to New York City to study painting under the famous regionalist Thomas Hart Benton. Benton's mural *Steel*, completed in 1930, was used as a model for classroom emulation (fig. 1.1).[2] *Steel*'s working-class subject matter and the muscular classicism of its figures are exemplary of thirties realist art and its celebration of the "common man."

But between 1938 and 1941, Jackson Pollock's painting methods veered away from Benton's influence. Pollock's *Mural*, painted for Peggy Guggenheim in 1943, is an abstract palimpsest—an early example of the spontaneous virtuosity that Pollock would ultimately develop into a signature style (fig. 1.2).[3] After brooding for weeks over the empty canvas, Pollock completed the entire 160-square-foot work in an overnight burst of activity. Its content is more obviously psychological than social. The abstract expressionists specialized in similarly huge paintings with psy-

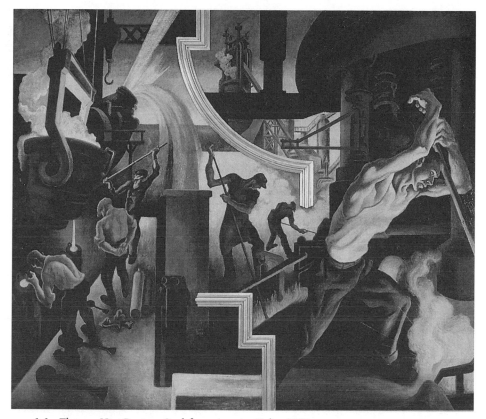

1.1. Thomas Hart Benton, *Steel,* from *America Today,* 1930

chological or metaphysical themes. How and why did this change in American murals occur?

Many writers have described the resurgence of American modernism in the 1940s as a flight from leftist political commitments.[4] During the 1930s, American artists and intellectuals had flocked to Communism in hopes of using their talents to solve the social crisis of the Depression.[5] By the end of the decade, disillusionment with the Left impelled them to gravitate toward abstraction in order to differentiate their art from Stalinist propaganda.

Specifically, in April 1940, the question of the role of art in relation to the Left's political program precipitated a schism within the American Artists' Congress, an organization strongly influenced by the American Communist Party's Popular Front.Against Fascism.[6] The AAC voted against condemning the Soviet invasion of Finland—a move that members understood as tantamount to an endorsement of the nonaggression

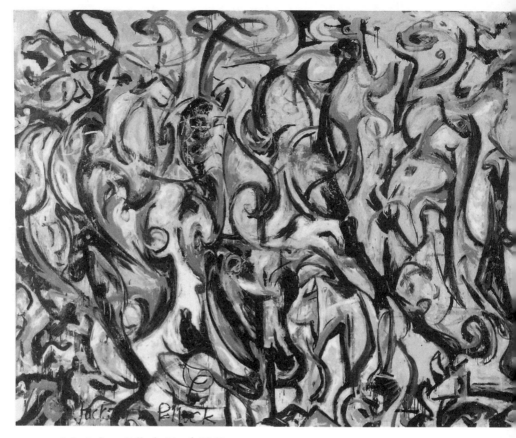

1.2. Jackson Pollock, *Mural*, 1943

pact between Hitler and Stalin. As a result, many influential members publicly broke with the organization. The dissidents were led by art critic Meyer Schapiro, and included Mark Rothko, Adolph Gottlieb, and many of the Congress's most prominent abstract painters. These artists were not only alienated by the sudden shift in Communist politics that the Hitler-Stalin pact represented, but, as abstract artists, could not reconcile their work to the increasingly narrow definitions of good art insisted upon by the Stalinists. As Meyer Schapiro wrote in an explanatory statement to the *New York Times*, the Communist Party had come to anathematize modern art and to promote "social realism" in the service of the state, much as the Nazis had done.[7]

The problem with this incomplete genealogy of the movement is that it tends to portray the culture of spontaneity as a flight from political com-

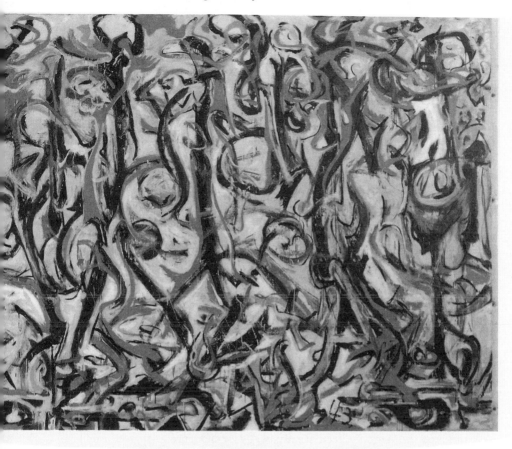

mitment into abstraction. It leaves the artists and writers in question vulnerable to charges that they consciously chose to pursue a safely apolitical form of art during the dangerous days of McCarthyism. What this story leaves out is that the political leanings of realist artists during the Depression spanned a wide spectrum, from the socially conservative pastoralism of regionalist painters like Grant Wood to the "social realism" encouraged by the Popular Front Against Fascism. In truth, the rejection of realism by the avant-garde was as much a rejection of the American political center as a flight from the Stalinist Left.

The Second World War, following as it did on the heels of an international economic depression, bred conjectures among many American artists and intellectuals that Western civilization, whether capitalist or state socialist, had normalized a way of life that threatened human survival. Nazism had, after all, developed in Germany in the context of an international economic system that the Allies had eagerly created upon the

conclusion of World War I. The little magazine *Iconograph*, linked to the abstract expressionist movement in painting, printed lengthy excerpts from Henry Miller's *Obscenity and the Law of Reflection* that did not discriminate between the Allies and the Axis in denouncing the "obscenity and insanity" of "the stupendous machine-like character of the war which the big nations are carrying on." The war among war machines boded ill for humanity, Miller warned, regardless of which side emerged as the victor: "Whatever the outcome, one senses that life will not be altered radically but to a degree which will only make it more like what it was before the conflict started. This war has all the masturbative qualities of a combat between hopeless recidivists."[8] The avant-garde therefore wanted to define a social role for art distinct from the "Artists for Victory" exhibitions and the editorial policies of most American art magazines, which hastened to put art at the service of the Allied war effort.[9]

The problem confronting the avant-garde was not how to distance themselves from the Left, but how to reformulate the Left along more productive lines. Many of the artists who had left the American Artists' Congress in 1940 eventually formed the Federation of Modern Painters and Sculptors (FMPS) in conjunction with a Trotskyite group founded by Dwight Macdonald called the League for Cultural Freedom and Socialism. Leon Trotsky, who was living as a political refugee in Coyoacán outside Mexico City, served as the focal public figure for those who challenged the power of Stalinism to define international Communism. In 1938, Dwight Macdonald had translated a manifesto written jointly by Trotsky and André Breton, the leader of the French surrealists, calling for artistic freedom.[10] The authors aligned themselves "against those who would regiment intellectual activity . . . for ends foreign to itself, and prescribe, in the guise of so-called 'reasons of State,' the themes of art."

The surrealists looked toward a social revolution to be achieved by converting people, through art, to a way of thinking outside the bounds of habit and social constraint. Although Breton had allied the surrealists for a time with the Communists, he had broken from them in 1929, asserting that social revolution depended not on a mere change in the political order, but on a change in "conscience and awareness."[11] In parallel with the ideas developed in the 1930s by the neo-Marxists of the Frankfurt school, the surrealists suggested that culture was not mere "superstructure," but constituted the ideological basis of the social order. In *Dyn* magazine, published in Coyoacán with the help of American painter Robert Motherwell, Dutch surrealist Wolfgang Paalen asserted: "Engels was in error when he wrote: 'Men must eat, drink, be clothed and sheltered before they are able to concern themselves with politics, art, science or religion . . .' But, in their very beginnings politics, art, science, and religion, were among the chief means of acquiring food and clothing."[12]

Emphasizing the cultural basis of the social order made it possible to argue for the political significance of abstract art. Since it was through artistic production that a culture was continually recreated, it might be possible to precipitate a change in the social structure through a change in consciousness, arrived at through experimental art. Paalen, writing in *Dyn*, condemned all "realistic" art as implicitly dictated by conservative ideologies: "The true value of the artistic image does not depend upon its capacity to *represent*, but upon its capacity to *prefigure*, ie., upon its capacity to express potentially a *new order* of things. . . . All realistic propaganda painting is reactionary . . . Everything that opens the way for new possibilities of experience is revolutionary—without the need of superimposed *finalities*."[13] Abstract expressionism developed among those American painters who were influenced by surrealism to explore spontaneous abstractions as the key to an art of greater social significance.

The avant-garde's rejection of realist subject matter thus did not connote an abandonment of socially engaged art.[14] But their work forsook the topical nature of realist art in favor of the more "abstract" project of transforming the viewer's awareness. That is why the dissidents from the American Artists' Congress aligned themselves with surrealism rather than with the existing abstract art community in New York (represented by a group called the American Abstract Artists). They felt that the latter had abandoned claims to social relevance in favor of purely formal preoccupations.[15] Trotsky and Breton had asserted: "In defending freedom of thought we have no intention of justifying political indifference, and . . . it is far from our wish to revive a so-called 'pure' art which generally serves the extremely impure ends of reaction." Writing in *Dyn* in 1944, Robert Motherwell likewise condemned the "desire for purity" implicit in much abstract art as "the rejection of contemporary social values for the aesthetic." Painting, Motherwell insisted, must not be seen as a merely formal challenge; formal considerations were themselves but the means for structuring a painting as a "medium of thought."[16]

THE TRIUMPH OF CORPORATE LIBERALISM: THE OFFICE OF WAR INFORMATION

During the Second World War, then, the culture of spontaneity developed to replace the organized Left of the thirties as a challenge to the American political center. Chastened by the easy appropriation of realist art for undemocratic political purposes, democratic idealists in American artistic and literary circles left behind the strategies of "proletarian art" in favor of new forms that addressed new challenges. During the 1930s, many writers and artists, including leftists with visions of social change, had participated in New Deal cultural programs.[17] In the final years of the New Deal,

however, the nature of these programs was changing. The experiences of writers and artists in government cultural programs during the war duplicated the dynamics of a broader transformation of the American workplace at midcentury. The aesthetic of spontaneity emerged in response to the wartime triumph of corporate liberalism and its techniques of "information management."

It was during the war that corporate liberalism again became, as it had been in the twenties, the unquestionable "center" of the American social system. Within the broad coalition that was Roosevelt's New Deal, the war shifted administrative power away from democratic idealists in the left wing of the Democratic Party, to business and military leaders and the hierarchical power structures they favored. Since the war effort depended on the cooperation of private industry, corporations assumed greater sway in government activities. In cooperation with the military, corporate executives working as "dollar-a-year men" instituted tighter bureaucratic control over government programs.[18] Once, the Roosevelt administration had encouraged innovative projects; now, stepping out of line could get you fired.

The experiences of painter Ben Shahn and poet Charles Olson in the Office of War Information exemplify how the wartime avant-garde emerged in opposition to the increasing social power of corporate liberalism. The Office of War Information (OWI) was established by executive order in June 1942, replacing the Office of Facts and Figures (OFF), which had been led by poet and dramatist Archibald MacLeish.[19] At the OFF, MacLeish and his staff had worked to supply Americans with information about the developing war. Insisting that "a full knowledge of what we are fighting for," was the best way to ensure "national unity," they had emphasized the ideals of increased democracy and social equality at home and abroad.[20] When the OFF was absorbed into the new OWI, MacLeish was named assistant director in charge of the Policy Development branch, implying that he would continue to shape OWI output according to this vision.[21] However, his idealism soon ran afoul of administrators with a different idea of the OWI's function.

MacLeish's allies were writers, artists, and intellectuals who had joined the OWI because they wanted both to fight fascism and to articulate a social vision for the postwar period. Among them were John Houseman, Robert Sherwood, Owen Lattimore, Malcolm Cowley, Ben Shahn, Ruth Benedict, Charles Olson, and Arthur Schlesinger, Jr. Some were associated with the Popular Front Against Fascism promoted by the American Communist Party; all wanted to use the OWI as a forum to address fundamental social issues relevant to the war effort. Their medium of choice was the independently produced pamphlet. Many had followed MacLeish from the OFF and were inducted en masse into the Bureau of Publications and Graphics in the Domestic Branch of the OWI.

Under the overall direction of radio announcer Elmer Davis, the OWI was originally organized into three branches. The Domestic Branch was placed under Gardiner Cowles, Jr., a liberal Republican from the Midwest. Cowles owned a group of newspapers, *Look* magazine, and a radio station,[22] and was thus predisposed to favor the attitudes and ways that prevailed in the worlds of corporate business and the mass media. Cowles believed that the OWI should focus specifically on developing advertising campaigns in the service of other government bureaus. His allies had their greatest presence in the Bureau of Campaigns, which was charged with arousing public enthusiasm for specific home-front drives such as rationing.[23]

It was not long before a split emerged within the ranks of the Domestic Branch between MacLeish's writers and researchers and the media and advertising executives brought in by Cowles. MacLeish was quickly ousted from power. In September 1942, his "branch" of the OWI was abolished, and in January 1943, he tendered his resignation, citing "policy differences." Later in life he confided to an interviewer, "I hated information work. . . . I suppose in times of peace, so-called, you could probably devote yourself to information, trying to help a self-governing people to govern themselves by seeing that they got the information they had to have. But in war you were always on the verge of propaganda and . . . I just detested it."[24]

Immediately upon MacLeish's resignation, Davis gave Cowles the go-ahead to reorganize the Domestic Branch. Cowles's restructuring plan promoted James Allen, a public relations professional for the Hollywood movie industry, and William Lewis, a former vice president of the CBS radio network, to posts as assistant managers of the branch. Allen was to be in charge of policy and subject matter; Lewis, in charge of program coordination and production. Furthermore, Cowles implemented a divide-and-conquer strategy against MacLeish's Bureau of Publications and Graphics, splitting it into a Bureau of Publications under Allen and a Bureau of Graphics and Printing under the direction of Price Gilbert, vice president of advertising for the Coca Cola Company. James Allen's plan for the Bureau of Publications was to phase out independently produced pamphlets in favor of increased liaisons with the mass media.[25] It was furthermore announced that "since the Bureau of Campaigns is concerned with the operations of all bureaus of the Domestic Branch, it has recently been made a division in the office of the Assistant Director in charge of plans and production."[26] That is, William Lewis had taken the advertisers under his wing and promoted them to the head of the office.

Within the restructured OWI, MacLeish's writers and researchers found that their work was subject to new restrictions. A confrontation soon developed over the publication of agricultural statistics. Data gathered by an OWI researcher implied the possibility of a food shortage and

conflicted with projections made by the Department of Agriculture. William Lewis intervened to kill the story. Henry Pringle, who had headed the erstwhile Bureau of Publications and Graphics, appealed to Elmer Davis on the issue, contending that a matter of principle was at stake. Davis coldly told Pringle to observe the proper channels of authority. Outraged, and sensing the futility of further efforts to provide the public with information antagonistic to the emerging public relations ideology, Pringle resigned on April 15, 1943, taking fourteen other writers and researchers with him. Bernard de Voto, one of those who resigned, wrote in an angry letter to Elmer Davis that the new OWI did "too God-damned little straight-talking over the table at an adult public."[27]

Within the new Bureau of Graphics and Printing, the poster work of social realist painter Ben Shahn came under fire from Price Gilbert. Gilbert accused Shahn of lowering public morale with his evocations of the grimness of war. He contrasted Shahn's work unfavorably to that of Norman Rockwell.[28] Gilbert's vision of the graphics program became clear when the new design for a poster to encourage gasoline conservation proved to be an attractive woman accompanied by the caption, "Walk and Be Beautiful."

In response, Shahn and Francis Brennan (the former art editor of *Fortune* magazine, where Archibald MacLeish had also served on the editorial board) collaborated in making a parodic poster that alluded to Gilbert's corporate identity. Taking a work of Shahn's that depicted soldiers carrying bayonets, they substituted cola bottles for the weapons and encaptioned it, "The War that Refreshes"—adding, "Try all 4 Delicious Freedoms."[29] Brennan, who later resigned along with Pringle, complained to Elmer Davis that "ad techniques have done more toward dimming perception, suspending critical values, and spreading the sticky syrup of complacency over the people than any other factor."[30]

Commenting on the episode in the *New Republic*, Malcolm Cowley editorialized that the OWI had succumbed to a "promotional technique that can be used to sell anything, good, bad, or indifferent—victory gardens, war bonds, dictatorship, polygamy . . . the one thing it cannot sell is democracy, which is based on trust in the ability and good will of the people at large."[31]

After this escapade, Ben Shahn was not officially fired, but was instead "lent," along with Charles Olson, to Nelson Rockefeller's Office of Inter-American Affairs. The OIAA had particular jurisdiction over propaganda efforts relating to Latin American themes. There Shahn and Olson collaborated in producing a bilingual pamphlet, *Spanish-Speaking Americans in the War*. This was one of several OWI pamphlets meant to counter Axis propaganda encouraging minorities to question their stake in an American victory.[32]

But once again, the veterans of MacLeish's OFF found that they had crossed an invisible political line. The ideas of racial equality asserted in their pamphlets fomented congressional opposition. The most controversial, Chandler Owen's *Negroes and the War*, alienated Southern Democrats in the House, compromising OWI appropriations in the fall of 1943.[33] Representative Joe Starnes of Alabama successfully introduced an amendment in the House to abolish the Domestic Branch entirely. Only Cowles's success in swaying Willkie Republicans in the Senate to his cause preserved his small domain. Under the terms of the compromise, though, Domestic Branch appropriations were slashed by 40 percent, and the new law explicitly stated that no funds were to be made available for the independent production of pamphlets.[34]

Cowles interpreted the new appropriations bill as a mandate to purge the remnants of MacLeish's faction under his jurisdiction. Without any money for the production of pamphlets, there was little these writers could accomplish in any event. Charles Olson and his immediate superior resigned in May 1944, charging that the activities of their division had been "hamstrung."[35] Shahn was laid off in July, with the cut in appropriations cited as cause. "I went back home, really sick and frustrated," he later confided.[36] Anticipating his later career as a poet, Olson's reaction waxed more eloquent, recalling 1930s democratic rhetoric of "the people" and "the common man": "If we, the people, shall save ourselves from our leaders' shame, if we, the people, shall survive our disgust, if we, the people, shall end our own confusion, we must see this big war for the lie it has become."[37]

Olson and Shahn worked together again that year, fighting one last round for democratic leftism in the government by supporting Henry Wallace's renomination as Roosevelt's vice president.[38] Truman's nomination sealed Wallace's marginalization, and confirmed for Olson what he had surmised from his years at the OWI: that the democratic possibilities of the New Deal had come to a close, and a corporate-advertising oligarchy was firmly in power. Echoing Brennan's parting complaint to Elmer Davis that ad techniques had spread "the sticky syrup of complacency" over the American people, Olson would write in his "Songs of Maximus" poem of 1951:

> colored pictures
> of all things to eat: dirty
> postcards
> And words, words, words
> all over everything
> No eyes or ears left
> to do their own doings (all
> invaded, appropriated, outraged, all senses

> including the mind, that worker on what is . . .
> (greased
> lulled . . .
> all
> wrong
> And I am asked—ask myself (I, too, covered
> with the gurry of it) where
> shall we go from here, what can we do . . .[39]

"THE ROOT IS MAN": THE POLITICS OF ANOTHER HUMANISM

For a sense of the logic by which these questions were answered, it is helpful to turn to Dwight Macdonald, whose translation of the joint manifesto by Leon Trotsky and André Breton had influenced dissatisfied American artists to experiment with the techniques of surrealism. In 1946, Macdonald published a two-part essay in *politics* magazine, entitled "The Root Is Man," suggesting a new vocabulary of political opposition. In his essay Macdonald observed that "the brutality and irrationality of Western social institutions have reached a pitch which would have seemed incredible a short generation ago."[40] For evidence he cited not only the Nazi Holocaust, but also the Soviet Gulag and the American atomic bombing of Nagasaki.

As Henry Miller and Charles Olson had, Macdonald decried the "fraudulent character of World War II," asserting that a fundamental similarity defined the social structures of all major antagonists. He identified this common socioeconomic system as "bureaucratic collectivism." Its distinguishing characteristic, he argued, was a fusion of monopoly capitalism and state authority. For such systems, war had become an end in itself, with much the same effects on the "victors" as on the "defeated"; for, he wrote, "the effects of the technical measures that must be taken to fight a modern war have become more important than any political effect of the war's outcome."[41]

Macdonald found it telling that the Nazis had planned to rid an occupied Britain not of labor leaders but of pacifists. He concluded that traditional class politics merely demanded from rulers that which, under bureaucratic collectivism, they were only too willing to grant. The governing elite guaranteed higher living standards to the working masses in exchange for their social docility and their participation in the military-industrial economy. The "health" of that economy in this way became ideologically identified with the "national interest" of the organic state.

Therefore, the problem facing oppositional politics was a conceptual one. We "have *no vocabulary* with which to ask for the things which are to-

day really in the interests of the oppressed—and which will not be granted from above," Macdonald asserted.[42] According to his thinking, the political vocabulary of "Left" and "Right" that had been inherited from the republicanism of the French Revolution had been made obsolete by the new organization of power. Bureaucratic collectivism incorporated some of the tenets of the old Right—such as an ideological defense of social privilege, and the idea that a smoothly functioning society mattered more than the personal development of individuals. At the same time, it was also marked by the antitraditionalism, futurism, and faith in scientific progress that characterized the old Left. Macdonald therefore suggested a new political distinction: that of "Radical" versus "Progressive."

For Macdonald, the Progressive orientation, which included the old Left, was ideologically aligned with bureaucratic collectivism. Its distinguishing feature was a worship of scientific technologies of mastery. "Marxism is the most profound expression of what has been the dominant theme in Western culture since the 18th century," he wrote: "the belief that the advance of science, with the resulting increase of man's mastery over nature, is the climax of a historical pattern of progress. Before we can find any new roads, . . . a break with a whole cultural tradition is involved."[43]

Macdonald opposed the Progressive's faith in social perfection through science to a "Radical" concern with revitalizing social interactions at the level of the individual. "'Radical' would apply to the as yet few individuals," he wrote, ". . . who reject the concept of Progress, who judge things by their present meaning and effect, who think the ability of science to guide us in human affairs has been overrated and who therefore redress the balance by emphasizing the ethical aspect of politics." By "ethical," Macdonald meant those principles that formulated ideals of interpersonal relations—"truth, justice, love, etc."[44] To combat bureaucratic collectivism, he urged, Radicals would have to learn to "think in human, not class terms."

In this political project, Macdonald conceded a new level of political significance to the arts. As he asserted: "This is the traditional sphere of art. . . . The Radical sees any movement like socialism which aspires toward an ethically superior kind of society as rooted in that sphere." Macdonald even acceded to the modernist imperative to forego mass appeal in favor of attempting a radical break with past cultural patterns. It was preferable, he asserted, "to be able to speak modest meaningful truths to a small audience than grandiose empty formulae to a big one. . . . For the present time at least, as in art and letters, communicability to a large audience is in inverse ratio to the excellence of political approach."[45] He hastened to assure his readers, "This is not a good thing . . . nor is it an eternal rule." But unfortunately "the very media by which one must com-

municate with a large audience—the radio, the popular press, the movies—are infected [with bureaucratic collectivism]; the language and symbols of mass communication are infected."

Macdonald's "The Root Is Man" articulated an analysis that was shared by many. Sociologist C. Wright Mills asserted much the same argument in his essay "The Powerless People: The Role of the Intellectual in Society," published in *politics* in April 1944. Mills criticized the undemocratic nature of corporate liberalism, accusing, "Never before have so few men made such fateful decisions for so many people who themselves are helpless."[46] Like Macdonald, he emphasized the need for personal and cultural modes of resistance against corporate liberalism's mass deceptions: "The independent artist and intellectual are among the few remaining personalities equipped to resist and to fight the stereotyping and consequent death of genuinely lively things. Fresh perception now involves the capacity continually to unmask and to smash the stereotypes of vision and intellect with which modern communications swamp us."

These essays in *politics* set forth tenets that the avant-garde was already acting upon. When Charles Olson left Democratic politics in 1944, he too was frustrated by the links between mass culture and the political hegemony of large corporations. His acquaintance with the mechanisms of political decision-making had left him discouraged about the possibility of meaningful change through political channels. Anticipating Macdonald's dream of a politics of "human scale," he had written in January 1945 of his decision to search for other avenues of influence. In a letter to anthropologist Ruth Benedict, he indicated that he was leaving politics and turning to literature: "I have left both politics and govt. again and gone back to writing. I have a feeling you will know what I mean when I regret we are not city states here in this wide land. Differentiation, yes. But also the chance for a person like yourself or myself to be central to social action at the same time and because of one's own creative work."[47]

Olson elucidated his thinking further in a poem entitled "Telegram," which he wrote that month in response to an imaginary offer of a new post in Roosevelt's bureaucracy.[48] The poem establishes that Olson's turn away from politics did not constitute an abandonment of his efforts to be socially relevant. "The affairs of men remain a chief concern," he wrote. But he compared the course of his life to a sea tide, pulled cyclically to the opposite shores of politics and art. In the coming phase of the cycle, he would turn his attention away from the problems of political organizing and resource management and toward the roots of political motivation and social behavior in the human psyche. As he wrote to Ruth Benedict, "I continually find myself reaching back and down in order to make sense out of now and to lead ahead."

The Spontaneous Writing of William Carlos Williams and Charles Olson

For the emerging avant-garde, spontaneous composition answered the question of how to engage in cultural politics in an era of mass culture and advertising. In 1950, in an essay entitled "Projective Verse," Olson presented his theoretical justifications for a new style of poetry rooted in spontaneity. Projective verse was, Olson wrote—using the unpaired, open parentheses that became his trademark—"(projectile (percussive (prospective." That is, the poem was a projectile: an object thrown by the poet like a ball or a rock in a transfer of energy to the reader-listener; it was percussive, oriented toward sound rather than sight; and it was prospective: exploratory, its fruits uncertain at the outset—with the added connotation of the poet as a prospector or archaeologist, digging through the sediments of a culture to find treasure that is buried.

Spontaneous composition was for Olson the key to poetry's social relevance. Having absorbed the writings of psychologist Carl Jung, he believed that the conscious mind was the gatekeeper of social proprieties; social alternatives were therefore available first only at the unconscious level. Spontaneous composition avoided the falsifications introduced by a conscious mind that internalized ideological standards. By offering unmediated access to unconscious thought processes, spontaneity provided a vantage point from which to question the culture's authority and created the potential for authentic communications exploring new forms of human relatedness.

Olson insisted on the poet's need to trust the unconscious leanings of the mind and ear in collaboration, letting the syllables flow automatically and accepting an unconscious sense of their fitness. To stop to search for a word was to let proprieties interfere, and so to fail to capture or communicate the meaning one intended to convey. "It is spontaneous, this way," he wrote. ". . . [A]t *all* points (even, I should say, of our management of daily reality as of the daily work) get on with it, keep moving, keep in speed, the nerves, their speed, the perceptions, theirs, the acts, the split second acts, the whole business, keep it moving as fast as you can, citizen."[49] By invoking "daily reality" and the "citizen," Olson implied that his poetic method was merely an extension of everyone's democratic responsibility to think independently.

Much of Olson's thinking about poetry in 1950 was based on the precepts of his mentor, William Carlos Williams. A poet of the first modernist generation, Williams shared the avant-garde notion of art as a social force. In *The Descent of Winter*, published in 1928, he had condemned "the fragmentary stupidity of modern life, its lacunae of sense, loops, perversions

of instinct, . . . amputations, fulsomeness of instruction and multiplica-
tions of inanity."[50] Against such "debased precedent," Williams wielded
the syntactical disjunctions of his poetry. As he explained in 1939, on the
eve of war, "A work of art is important only as evidence, in its structure, of
a new world which it has been created to affirm."[51] Williams had urged
poets to defy the social conventions lodged in syntax, to become "loose,
disassociated (linguistically), yawping speakers of a new language."[52] In
the same way, Olson declared in "Projective Verse" that the malleability of
poetic form was essential, since the significance of poetry lay exactly in its
ability to break open "the conventions which logic has forced on syn-
tax."[53]

If Olson's essay began with the simple reassertion of such modernist ar-
ticles of faith, it was nevertheless insurrectionary in the American literary
climate of the 1940s. The essay was consciously conceived as an attack on
the "New Criticism," which then dominated the way literature was taught
in American universities. The New Criticism valorized conscious crafts-
manship in pursuit of the *mot juste*.[54] The New Critics looked to T. S. Eliot
as the quintessential modernist poet; their formalist approach privileged
Eliot's careful style against the sprawling works of Williams. Eliot had
written that poetic forms constituted a lasting cultural heritage and that
the true test of a modern poet was the ability to bring new content to these
forms. The best poets, wrote Eliot, did not invent homemade philoso-
phies.[55] Olson hoped to create a poetry that would vindicate Williams
and refute Eliot's pessimistic conservatism.

Contrary to Eliot's respect for poetic form as the vessel of literary tradi-
tion, Williams and Olson conceived of poetic forms as ephemeral struc-
tures housing fleeting meanings. Because forms at once became obsolete,
they constantly had to be recreated in the new context of the present. In
Paterson, a long poem which is considered Williams's masterwork and
which was published in four books in 1946, 1948, 1949, and 1951 (with a
fifth book added in 1958), the poet described his encounter with truth as
"a dark flame . . . counter to all staleness . . . a defiance of authority." Po-
etry is the artifact of this encounter and is symbolized by a bottle that has
been warped by fire, emphasizing the fluidity of its form:

> a bottle: unbottled . . .
> the glass warped
> to a new distinction, reclaiming the
> undefined . . .
>
> Hottest
> lips lifted till no shape but a vast
> molt of the news flows. . . .[56]

Williams believed experimental forms communicated new visions of reality; and their best source was spontaneous writing unfettered by the rules structuring conscious perception.

Williams and Olson sought to develop an oppositional voice in a cultural climate defined by the academicism of Eliot on one hand and by the profusion of advertising and mass culture on the other. Their strategy was voluminous production, which the embrace of a spontaneous or improvisational style made possible. "That is our somewhat undistinguished burden," Williams wrote in 1948; "profusion, as, we must add in all fairness, against [Eliot's] distinction. His is a few poems beautifully phrased . . . We are in a different phase—a new language—we are making the mass in which some other later Eliot will dig."[57] Williams developed this idea most fully in book 3 of *Paterson*, which articulates this cultural strategy through the image of a flood. There the poet advises himself, "Speed against the inundation"; and tells himself:

> Only one answer: write carelessly so that nothing that is not green will survive . . .
>> Texts mount and complicate them-
> selves, lead to further texts and those
> to synopses, digests and emendations. So be it.
> Until the words break loose or—sadly
> hold unshaken.[58]

In their work, Williams and Olson sought to integrate unconscious possibility with empirical reality. They were convinced that spontaneity alone was not enough to ensure poetic truth, without the discipline of empiricism. Williams had experimented with spontaneous writing as early as the First World War, when he wrote *Kora in Hell: Improvisations* as an exercise in Ezra Pound's poetry of "imagism."[59] But he was immediately dissatisfied with the results. In his next book, *Spring and All* (1923), he offered this mixed evaluation: "The virtue of the improvisations is their placement in a world of new values—their fault is their dislocation of sense, often complete."[60] *Spring and All* reasserted the importance of a precise rendering of observed detail, obeying the "objectivist" poetics of Louis Zukofsky and Charles Reznikoff.[61] (Williams dedicated it to the American precisionist painter, Charles Demuth.)

It was in *Spring and All* that Williams's famous poem "The Red Wheelbarrow" first appeared, exemplifying his new technique of "the object as image."[62]

> So much depends
> upon
> a red wheel

> barrow
> glazed with rain
> water
> beside the white
> chickens

While still using spare language and a visual image to evoke an "emotional and intellectual complex," thus fulfilling Pound's definition of imagism, this poem is markedly different from Pound's "In a Station of the Metro" of 1913, the archetypal imagist poem:

The apparition of these faces in the crowd;
Petals on a wet, black bough.[63]

Whereas Pound's poem is built on a metaphorical association of faces with petals, Williams's technique here is synecdochic: the red wheel barrow is described literally in its physical context, and through its stark presence evokes the world of which it is part. The active word in Pound's poem is "apparition," which draws attention to the poet's imagination and to the ephemerality of perceptions. By contrast, Williams's is a materialist observation that "so much depends / upon" the red wheel barrow. Its presence evokes the whole worldview of an agrarian society.

In his "Projective Verse" essay of 1950, Olson made it clear that he hoped to see poetry returned to a position of influence in American society that recalled the cultural power of epic poetry and Elizabethan drama. Setting forth the principles of projective verse, he emphasized the poet's role as sayer and insisted on the capacity of poetry to deal with important social issues. "The moment the projective purpose of the act of verse is recognized, the content does—it will—change," Olson predicted; "It starts with the composer. The dimension of his line itself changes, not to speak of the change in his conceiving, of the matter he will turn to, of the scale in which he imagines that matter's use." By integrating unconscious possibilities with empirical observations, the poet could pioneer new structures of reality to challenge corporate liberalism's ideological assumptions. As Olson well knew, avant-garde painters harbored similar ambitions for the social role of spontaneous painting.

The Black Mountain Glyph Exchange

In 1951, the year Olson wrote his "Songs of Maximus" poem critical of "the gurry" of corporate-liberal culture, he was working as the rector of Black Mountain College in the hills of western North Carolina. That summer, he and Ben Shahn collaborated once more on a cultural project—not a propaganda pamphlet, this time, but an exchange of spontaneous art. Many members of the avant-garde would pass through Black Mountain in

the 1940s and '50s. It had been founded in 1933, as an experimental community modeled on the educational philosophy of John Dewey. During the war, it had metamorphosed into a center for experimentation in the arts and literature.[64]

Scrambling for funds to keep the college alive (it finally folded in 1956), Olson, with Shahn's encouragement, wrote to Wilbur Ferry, an associate of theirs from the war years. The three had worked together in 1944, mobilizing the ethnic working-class vote for President Roosevelt's final reelection campaign.[65] Now, Ferry was vice president of the Fund for the Republic, a grant-giving agency quietly created by the Ford Foundation to combat McCarthyism.[66] In his letter, Olson tried to convince Ferry that the cultural and educational work then going on at Black Mountain was of sufficient social relevance to merit the Fund's support. "What is happening here, students & faculty, is not at all local—is, in fact, answering a need of the whole society," he wrote.[67]

Olson's plea emphasized the uniqueness of Black Mountain's blend of artistic experiment, intellectual exploration, and democratic community structure. By way of example he told Ferry of a recent event at the college: an exchange of work on the theme of Maya glyphs. "Ben [Shahn] can tell you what a happy business happened amongst four of us guest faculty this summer—a GLYPH show, initiated by Ben as the consequence of his giving me a drawing as a trade-last for a poem, and now, because of these two acts, [Katherine] Litz the dancer has added a number to her repertory, a GLYPH, with set by Shahn, and my words set to music by [Lou] Harrison."[68] For Olson, this "glyph exchange" was the crowning success of Black Mountain's 1951 summer institute. Representing mutual inspiration among artists working in various media with a common core of innovative ideas, it illustrates the best of what Black Mountain became under Olson's leadership.[69]

In conjunction with the glyph exchange, Ben Shahn's painting style underwent a development of genuine significance (fig. 1.3). What Shahn came to call his "palimpsest" paintings were inspired by the improvisational work being done by students in Black Mountain's Light-Sound-Movement Workshop. Like many of his earlier, realist paintings, these palimpsests contain a central human figure. Yet they also evince a gestural component new to his work, resulting from his determination to preserve every discarded attempt to situate that figure on the canvas. This willingness to record trial and error, refusing to repudiate any stroke as insignificant to the final product, evokes in *Nicolas C.* a feeling of work-in-process. As Bernarda Shahn later described this moment in her husband's work:

> He had found in the markings and tracings that were left upon a picture, . . . as he might wash out and rework an image, an effective pictorial element. He called such an accumulation of traces a

1.3. Ben Shahn, *Nicholas C.,* 1951

"palimpsest"; he had, at an earlier time, expunged such marks, but now he studied their qualities, preserving the effect as part of the completed work. He commented, "The feeling about for form is a vital part of a picture; it has a dimension, almost a time dimension."[70]

Shahn's new strategy of painting, with its connotation of a temporal dimension on the canvas, shows the clear influence of abstract expressionist ideas. In its overworked treatment of a human figure, Shahn's work seems most akin to a style Willem de Kooning was simultaneously developing (see plate 2). De Kooning had taught at Black Mountain College in previous years and had left a strong impression on the community.[71] Other painters at Black Mountain during Shahn's tenure painted in abstract expressionist styles as well; among them, Joseph Fiore, Dan Rice, Robert Rauschenberg, Robert Motherwell, and Cy Twombly. Faculty and students also made frequent trips to Greenwich Village, to visit Franz Kline at the Cedar Tavern and to see exhibits of abstract expressionist work.[72]

THE NEW AMERICAN PAINTING: AUTOMATISM AND INTEGRATION

As previously recounted, abstract expressionism first emerged during the Second World War, as some American painters rejected both realism and the prevailing abstract styles in favor of the radical potential of surrealism. Abstract expressionists' interest in surrealism emphasized the technique of automatism, or the effort to paint spontaneously in order to allow the structures of the unconscious to manifest themselves as the subject of art.[73] Adapting the method of automatism to their needs, these American painters nonetheless maintained their distance from Breton. They preferred the more abstract and automatic paintings of Joán Miró and André Masson to the carefully rendered dreamscapes of Salvador Dali that Breton favored.[74] They acquainted themselves with automatism indirectly through exhibitions at the Museum of Modern Art, and learned it from emigré intellectuals on the edges of the surrealist circle, especially John Graham, Wolfgang Paalen, and the Chilean painter Matta Echaurren.[75]

In the early 1940s, Paalen and Matta, intent on creating a version of surrealism oriented toward the Americas and centered in automatism, challenged Breton's authority to define surrealism in America.[76] American painter Robert Motherwell visited Mexico with Matta in the summer of 1941. They met up with Paalen in Coyoacán, and Motherwell stayed there through the early winter to help in the editing of *Dyn* magazine. Motherwell later described how Matta organized a group including himself, William Baziotes, Jackson Pollock, Willem de Kooning, Hans Hof-

mann, Gerome Kamrowski, and Peter Busa to experiment with new directions for automatism:

> And if we could come up with something, Peggy Guggenheim, who liked us, said that she would put on a show of this new business. And so I went around explaining the theory of automatism to everybody . . . I was trying to lay the basis of a new aesthetic based on free association . . . It was a Surrealist technique but it had all kinds of possibilities that had really never been developed.[77]

To the surrealists' praise of the unconscious as the source of a superior reality, these American painters added a note of warning.[78] In a world characterized by repression and frustration, it seemed to them, the unconscious was likely to harbor unacknowledged needs and violent impulses. As such, its contents did not constitute a higher reality, as Breton's term "surrealism" suggested. Rather, they were "unthinkable" possibilities, some of which might yet prove fruitful in the construction of a new worldview.

The relatively somber sensibility of the American avant-garde painters is evident in many of their works, as well as in their writings. In *Dyn*, Edouard Renouf, an American painter living in Mexico, wrote:

> [M]odern artists . . . , acutely responsive to the social and moral realities of the day, [have] found that the more spontaneously, the more quasi-automatically they worked the more their work expressed the emotional disintegration and desperation that lurked concealed and inhibited behind the compulsive Optimism of industrial civilization.[79]

When Breton and Max Ernst inaugurated *VVV*, a magazine of American surrealism, in New York City in June 1942, Harold Rosenberg took the opportunity to chastise the Europeans for their excessive giddiness in an article entitled "Life and Death of the Amorous Umbrella." His title alluded to a favorite phrase of the French surrealists, culled from the French symbolist poet Lautreamont: "fair as the chance meeting on a dissecting table of a sewing-machine and an umbrella."[80] Rosenberg took the image to task in a metaphorical attack, writing:

> This ability to combine spontaneously has been taken as a sign of dermal alertness characteristic of those born of the spirit who, like the wind, blow where they list. The embrace of the umbrella and the sewing machine has thus become the device on the banner of absolute freedom.
>
> In our admiration for the free, pure, beautiful and revolutionary, we must take care not to overlook the pathos of the umbrella's quick-fire romance. Though his act is perfect in its moment, a distinct psycho-

logical malady is implied by his unpremeditated leap . . . Everything points to frantic impulses and the absence of critical spirit.

The anarchism of the amorous umbrella does not change the conditions of his existence. . . . He is still himself, the slave that society made of him, and the force and duration of his embrace are not really as unconditioned as they seem.[81]

The first issue of *VVV* was full of such warnings indicating the intellectual climate of the New York art scene. These statements emphasized the power of those suprapersonal forces (whether social, cultural, or natural) in which the individual artist was embedded.

To such skeptics as to the poets Charles Olson and William Carlos Williams, it seemed imperative to integrate the free play of the unconscious with an empirical "reality principle" in order to arrive at truth. Integrating the unconscious with the conscious, the possible with the necessary, would become a governing trope of abstract expressionist painting. Robert Motherwell wrote in 1944, "All my works [consist] of a dialectic between the conscious (straight lines, designed shapes, weighed color, abstract language) and the unconscious (soft lines, obscured shapes, automatism) resolved into a synthesis."[82] In *Dyn*, Edouard Renouf wrote: "As in painting, so cultural progress in general will be achieved through new syntheses: not through exclusion but through inclusion; not through anathematizing reason and science, but through the revitalization and fertilization of reason and science by fusion with the irrational and emotional."[83]

The emphasis on subjecting the possibilities latent in the unconscious to the discipline imposed by the conscious mind led American painters to strive to assimilate the automatist subject matter of surrealism to the flat picture plane of cubism.[84] They criticized the illusionistic perspective of much surrealist work, including Dali's and Matta's, on this basis.[85] They valorized the two-dimensional painting on a two-dimensional canvas, associating it with honesty, reality, and the materiality of the artwork itself. In statements, they often referred, with rhetorical significance, to the "integrity" of the picture plane. As Barnett Newman, Mark Rothko, and Adolph Gottlieb wrote in 1943: "We wish to re-assert the picture plane. We are for flat forms because they destroy illusion and reveal truth."[86] It was from this determination to integrate antiillusionism with psychic automatism that the unique qualities of abstract expressionism emerged.

Adolph Gottlieb's "Pictograph" paintings, which he painted throughout the 1940s, demonstrate an early solution to the problem of integrating automatism with the two-dimensional cubist plane. One of the earliest of the Pictographs was *Eyes of Oedipus* (fig. 1.4). Gottlieb divided the canvas into rectangular sections, and into each one he spontaneously painted a fragmentary figure.

1.4. Adolph Gottlieb, *Eyes of Oedipus*, 1941

Eyes of Oedipus is indebted to the intellectual milieu of surrealism for several elements in addition to the automatist technique. The eye was a common symbol among surrealists, who associated it with the social role of the artist as seer, as well as with the permeability of the boundary between internal and external reality.[87] The title and the images in the painting provoke meditation on the Oedipus myth, a favorite narrative of Freudians and surrealists alike. As the viewer's gaze travels from the blind eyes of Oedipus at the center of the canvas, around the other compartments and back again, the painting as a whole evokes a complex of associations suggested by the myth.

From cubism, Gottlieb had absorbed the idea of simultaneously representing multiple viewpoints. The cubist plane, in collapsing illusionistic perspective, presented several different perspectives or moments without priority or sequence. The uneven rectangular grid of Gottlieb's Pictograph similarly allows indefinite juxtapositions of the several sketchy figures, creating meaning through their shifting interrelations. The meaning of the whole is different from that of each image presented singly, or from that which would be created by a simple sequential arrangement suggestive of a linear narrative. The artist refused to define this meaning authoritatively, leaving an active role to the viewer. As Gottlieb later said: "I didn't want to control the imagery, and I set up a system on the canvas whereby I could let unrelated images appear next to each other."[88]

The son of Jewish immigrants, Gottlieb began painting the Pictographs in 1941, during a crisis of conscience over the relation of his painting to the war effort. He later confided: "There was some kind of sense of crisis so that you had to, at least I felt that I had to dig in to my self, find out what it was I wanted to express, what it was possible for me to express."[89] To me, the staring eyes in the painting suggest judgment or surveillance by the populace, or by the superego, or by the gods. Though they sit in judgment, these eyes are as blind as those of Oedipus—the blindness of justice? Or perhaps, of ignorance? At the same time, they are all the eyes of Oedipus, who has sat in judgment of himself, and whose insight is inextricable from his blindness. At the top of the painting, his blind crowned head symbolizes the limits as well as the powers of authority, whether social or internal. *Eyes of Oedipus* invokes the artist, the viewer, and political authority, and links them all through implications of guilt and responsibility.

SPONTANEOUS HETEROGLOSSIA AND ETHNIC DIVERSITY

The defining characteristic of avant-garde art of the 1940s and 1950s was spontaneous composition in conjunction with unfinished or "open" forms, as Gottlieb's Pictographs exemplify. We have seen how the aes-

thetic of spontaneity developed in response to World War II and in opposition to the corporate-liberal culture the war furthered. At the same time, however, spontaneity also opposed the established high culture, whether defined by the quiescent modernism of the New Critics and the American Abstract Artists or by vestiges of the Genteel Tradition in music, literature, and painting. Challenging the predominance of these Anglo-American traditions in the name of a more pluralistic and inclusive definition of American culture was an important social meaning of spontaneity. Historically, the development of spontaneous art was linked to the social issue of ethnic identity.

In his autobiography, *I Wanted to Write a Poem* (1958), William Carlos Williams explained why, in his prologue to *Kora in Hell*, he had called T. S. Eliot "a subtle conformist": "I had a violent feeling that Eliot had betrayed what I believed in. He was looking backward; I was looking forward. He was a conformist, with wit, learning which I did not possess."[90] Coupled with his condemnation of university English departments as the abettors of oppressive social relations (a charge that Charles Olson would repeat),[91] Williams's equation of Eliot's conformity with "learning which [Williams] did not possess" reveals a social dynamic (or, at times, a social fiction) that recurred persistently among the avant-garde of the 1940s and 1950s. The pattern is that of a creative artist seeking the means to cultural authority ("looking for a voice" or "coming to authorship"), who, because of class or ethnic background, begins this search from the disadvantaged position of a cultural outsider.[92] The collage structure of *Paterson* incorporates many voices in order to present an American idiom that cannot be equated with "English"—that is, of England. In his autobiography, Williams recalled how an "obvious Britisher," a college instructor, asked him, "This language of yours . . . where does it come from?" "From the mouths of Polish mothers," Williams answered.[93]

If authorship and by extension cultural authority could be achieved only through the mastery of traditional forms, as T. S. Eliot had insisted, such outsiders would face an almost insurmountable handicap. But an aesthetics of spontaneity, in which authority derives from the artist's ability to consult his or her own unconscious, democratizes access to cultural authority. According to Charles O. Hartman in his book *Jazz Text*:

> For the whole poetry that derives from Williams' modernism rather than Eliot's the logic of poetic authority runs almost this directly:
> improvisation →
> spontaneity →
> genuineness →
> authenticity →
> authority.[94]

Significantly, a great majority of the producers of spontaneous art in the 1940s and '50s were first- or second-generation Americans, or hailed from positions socially or geographically remote from the institutional centers of cultural authority.

Bebop jazz, one focus of Hartman's book, is a case in point. Bebop musicians understood their music as a distinctively African American form offering an alternative to the commercially successful, big-band swing jazz. Bebop was, from its inception, the music of a younger generation of urban blacks who demanded a wider recognition of their contributions to American society and refused to concede the superiority of the Anglo-American symphonic tradition.[95]

Charles Olson was intensely aware of his own ethnic identity and its relation to his authorial voice. "That is the price I paid for America—an immigrant father never quite sure of himself," he once meditated.[96] This was what led him to work, during the war years, first for Louis Adamic's Common Council for American Unity and then in the foreign-language division of the OWI.[97] The title of his first book, *Call Me Ishmael*, reflects his sense of himself as an outsider.[98] Olson dedicated the book to the memory of his father, a Swedish immigrant and postal worker; and he rendered the dedication poignantly in a pidgin dialect:

> O fahter, fahter
> gone amoong
>
> O eeys that loke
>
> Loke, fahter:
> your sone!

African American poet LeRoi Jones wrote in his autobiography of the crucially liberating effect that the spontaneous aesthetic had on his own struggle to authorship. As a young man, reading the poetry valorized by the New Critics, he had cried as he realized it was not a poetry that he could ever write. Later, he was overjoyed to discover the work of Williams and Olson, and a spontaneous aesthetic that he identified as his own. As he commented:

> In the US and the Western world generally, white supremacy can warp and muffle . . . especially an "intellectual" trained by a system of white supremacy. The dead bourgeois artifact I'd cringed before in *The New Yorker* was a material and spiritual product of a whole way of life and perception of reality that was hostile to me. I dug that even as a young boy weeping in San Juan. . . .[99]

At Columbia University on Manhattan's upper West Side in the early 1940s, beat poet Allen Ginsberg felt like a shabby, Russian-Jewish inter-

loper from Brooklyn. Like LeRoi Jones, Ginsberg felt that Williams offered a model that was open to him in a way that the tradition of T. S. Eliot and the New Critics was not. He identified with Williams, he said, in that the older poet "had this sort of guilty second generation . . . thing of trying—well that's the whole point about Williams, he was a foreigner trying to talk American. . . . It was his advantage, in a way."[100] Ginsberg's identification with Williams as a fellow "foreigner" contrasted with a dream about T. S. Eliot that he recorded in his journal, in which Eliot was an object of Ginsberg's desire, but was also greatly to be feared. In the dream, Eliot had written poems on sheets of what Ginsberg identified as lox—Jewish ethnic food—but Eliot insisted it was "Alaskan smoked salmon." "I love him—but I am afraid of him . . . I am searching the volume for more . . . that interests me—long line or Jazzline . . . I am nervous and jealous . . . thumbing his book and hadn't been able to find the poems I wanted to inquire about."[101]

Ginsberg's fellow beat writer Jack Kerouac, whose parents were French-Canadian, felt equally out of place at Columbia University and at Horace Mann prep school, where he attended on a football scholarship. Kerouac was raised speaking Quebecois French, and he learned English as his second language. The oral culture of French-Canadian immigrants is preserved in his novels, particularly in *Dr. Sax* and *Visions of Cody*. Later, Kerouac attributed his success with spontaneous composition to the fact that he had heard the sounds of the English language without knowing the meanings of words.[102]

Among abstract expressionist artists, the pattern is equally clear. Many abstract expressionist painters boasted working-class origins; several grew up in ethnic enclaves.[103] Jackson Pollock was a farm boy from rural Wyoming; he played cowboy on the streets of New York City. Theodoros Stamos was the son of Greek immigrants; his father owned a shoe-shine shop off St. Mark's Place. Peter Voulkos was also a second-generation Greek American, while Adolph Gottlieb and Lee Krasner were second-generation Jewish Americans. Jack Tworkov, an immigrant, alluded to his dilemma as a "shtetl Jew in cosmopolis." Toshiko Takaezu was the daughter of Japanese immigrants who labored in the Hawaiian sugar plantations.

The significance of marginal social identities in the making of spontaneous art points to more than the simple opportunism of artists hoping to play the underdog. The psychological conflicts that characterize such identities may be an essential basis for this art, and for the solution it presents to the problem of authority. In *Jazz Text*, Charles Hartman has pointed out that the "open" form of spontaneous art embodies Mikhael Bakhtin's concept of "heteroglossia." Heteroglossia describes a situation in which the poet or artist is not represented in the text as a unified self or

"subject," but as a multiplicity of voices or selves representing different orientations and worldviews.[104] Hartman observes that the language of heteroglossia "might include national languages and regional dialects, but it more tellingly embraces and distinguishes the characteristic speech of different classes, age groups, trades, literary traditions, and perhaps states of mind."

"Open" form, instead of claiming final authority for any single voice, recapitulates the process through which the artist's position has developed. The poet's own voice is the emergent sum of the heteroglossia. As Bakhtin put it, "One's own discourse is gradually and slowly wrought out of others' words that have been acknowledged and assimilated." In its provisional structure, as it reproduces the process of the artist's thinking, the palimpsest or "palimtext" refrains from replacing deposed authority with a new authority of its own creation.[105] The open structure, Hartman explains, works "to enact the process of internal persuasion: not to replace old authority, but to display an effort of assimilation. The poet refuses authority so as to insist that it be shared; it falls to us to revive the poem in our reading."[106] This deconstruction of authority is an implicitly political feature of spontaneous art. Like the recovery of human values neglected in the progress of Western civilization, and the struggle against corporate liberalism's growing social power, it is one of the social meanings of the aesthetic of spontaneity.

2

The Avant-Garde and the American Indian

It is because of this acute sensitivity to form that artists are so frequently involved in disagreements, for they deduce, from formal details and nuances of which others are barely aware, a whole logic of ramifications and connotations which amount to an entire metaphysical system.

—Maya Deren, *Divine Horsemen: The Living Gods of Haiti* (1953)

During World War II, the avant-garde's disillusionment with America's dominant culture led them to search for new artistic forms embodying different social values. In this search, they relied on art from societies outside the scope of "Western civilization" as a model and resource. The culture of spontaneity during the 1940s was characterized by forms and subject matter referring to the myths and arts of archaic or tribal civilizations— what were sometimes referred to as "primitive" societies, although then, as now, there was uneasiness about the derogatory implications of that term. Abstract expressionist painter Barnett Newman, for instance, wrote in 1944 about an exhibition of pre-Columbian sculpture at the Wakefield Gallery in New York: "A full appreciation of these works should force us to abandon our condescending attitude toward the 'primitive' label with all of its confusing implications of child-like perception. . . . Are they 'the best primitive man could do?' Are not these masterpieces the best any man can do?"[1]

Carl Jung's psychology of the "collective unconscious" provided an influential theory linking the method of spontaneous association to the subject matter of primitive myths and symbols. Writing in the period between the wars, Jung had theorized the existence of suprapersonal patterns of thought and experience, called "archetypes," which were manifested in moments of personal or social crisis as visual images. These archetypes arose in the unconscious mind and, ac-

cording to Jung, were particularly prevalent in the arts of primitive cultures. Jungian psychology invested the avant-garde program with new authority by giving painters and writers a way of thinking about the links between their spontaneous unconscious associations and the social situation.

Among American poets and painters influenced by Jung, it was Native American cultures that most often inspired interest and emulation.[2] American Indian art made sense for an avant-garde that was declaring its independence from the Old World; in the words of painter Richard Pousette-Dart, "I felt close to the spirit of Indian art. My work came from some spirit or force in America, not Europe."[3] Particularly, the stylized figures in Northwest Coast, Anasazi, and Navajo art suggested the synthesis of surrealist imagery and cubist "integrity" that the avant-garde were seeking. As Jackson Pollock told Robert Motherwell in a February 1944 interview, "The Indians have the true painter's approach in their capacity to get hold of appropriate images, and in their understanding of what constitutes painterly subject-matter . . . their vision has the universality of all real art."[4]

In pursuit of the social alternative that he referred to as "another humanism," Charles Olson wrote to his fellow poet, Robert Creeley, that the Maya civilization into which he was delving on the Yucatán peninsula of Mexico seemed "precisely the contrary" of modern America. In this connection, he referred to William Blake's "careful discrimination" between the contrary and the opposite—the contrary offered a positive alternative to social and spiritual imbalance, while the opposite was merely a negative reflection, equally unbalanced in itself. If corporate liberalism was the danger America faced, "the collective or communist deal" of state socialism, wrote Olson, was only its opposite.[5] The social alternative that was its true contrary lay outside the logic of action and reaction, perhaps in pre-Columbian cultures like the Maya.

In discussing the avant-garde's interest in American Indian cultures, I have found the concept of "cross-cultural dialogue" a useful one, for dialogue suggests a complex and dynamic model of interaction.[6] The term "cultural appropriation," a clumsy Marxist metaphor on the capitalist appropriation of surplus value, is useful for emphasizing the context of unequal social power in which cultural exchanges often take place. The disadvantage of this term is that it reduces all acts of cross-cultural inquiry to the single dimension of theft or dispossession, denying the variety of motives, opportunities, and effects that characterize different modes and moments of cultural exchange. In fact, mutually beneficial exchanges (and hybridizations) of cultural forms can and do take place; Michael Taussig has indeed recently suggested that such cultural mimesis is the basis of all cross-cultural understanding.[7] A conversational model of cul-

tural interaction recognizes the dynamics of social power, but in a way that invites further investigation instead of precluding it. Dialogue connotes give-and-take from both sides, and a potential for mutually beneficial communication; but like most dialogue, cross-cultural dialogue is characterized by ellipses, misapprehensions, intimidations, misrepresentations, and silences conditioned by the context of social power. As a case in point, the dialogue between avant-garde and American Indian artists during the 1940s was conditioned by the intersection of Jungian primitivism with the vicissitudes of federal Indian policy.

John Collier, René d'Harnoncourt, and "Indian Art of the United States"

I began chapter 1 by posing the question of what happened to American mural painting during World War II. I answered that question by describing how artists rejected realism in order to develop a new social role for art, a role that became identified with the spontaneous presentation of unconscious associations. Yet it is also clear that, in rejecting the realism that they associated with "bureaucratic collectivism" and the death dance of Western civilization, abstract expressionists turned away from the mural styles of the New Deal era to a more ancient wall-painting tradition. Jackson Pollock's *Magic Mirror*, of 1941, looks like the cave paintings of California's Chumash Indians; and Richard Pousette-Dart's *Desert*, of 1940, resembles a prehistoric Anasazi mural from Awatovi in Arizona (figs. 2.1 through 2.4). How and why did this affinity for pre-Columbian Indian murals develop?

For New York artists, museum exhibits prompted by New Deal politics were a major source of exposure to American Indian art. Nelson Rockefeller, president of the Museum of Modern Art, was also Franklin Roosevelt's coordinator of inter-American affairs beginning in 1940. In that year, as part of Roosevelt's Good Neighbor Policy, the Museum of Modern Art hosted an exhibit of "Twenty Centuries of Mexican Art," in which pre-Columbian art received significant attention. To American painters, Maya and Aztec art already had an attractive aura of social relevance because of their prominence in the works of the great Mexican muralists Diego Rivera, José Orozco, and David Siqueiros.[8] Pollock had even worked with Siqueiros on a mural project in the mid-1930s; and after studying the traditional mural-painting techniques used by Thomas Hart Benton, Pollock was impressed by Siqueiros's experiments with Duco paint, photographic enlargement, and direct painting (all of which were later associated with abstract expressionist work).[9] "Twenty Centuries of Mexican Art" included paintings by the muralists and by other contemporary Mexican artists using variations on Amerindian motifs. The exhibition

2.1. Jackson Pollock, *The Magic Mirror,* 1941

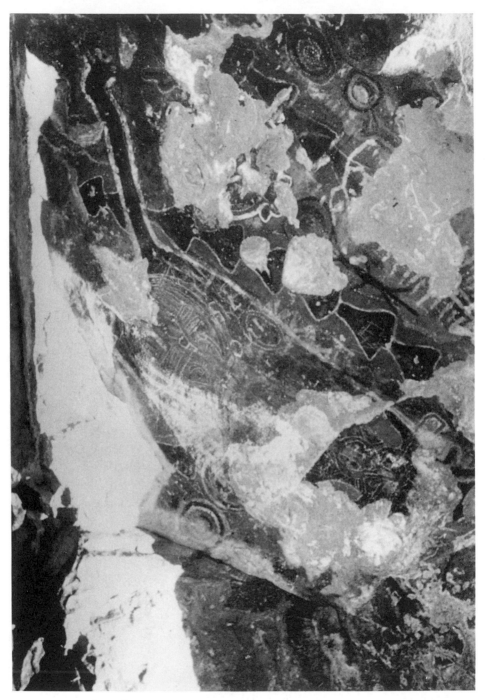

2.2. Chumash cave paintings

catalogue even furnished a brief history of the muralists' roles in the recent Mexican revolution, including Siqueiros's 1921 manifesto calling for a revolutionary art emphasizing Native American forms and values.[10]

"Twenty Centuries of Mexican Art" was followed almost immediately at the Museum of Modern Art by the influential "Indian Art of the United States" exhibit of 1941. "Indian Art of the United States" was visited by Adolph Gottlieb, Richard Pousette-Dart, Jackson Pollock, John Graham, Wolfgang Paalen, and Barnett Newman, among others. The most imposing artifact in the entire exhibit was a huge mural executed by the WPA, which reproduced, in full scale, Indian pictographs from the cliff walls of Barrier Canyon, Utah (fig. 2.5). On the walls of Barrier Canyon, pictographs from different prehistoric eras were superimposed. In its size, its imagery, and its structure as a palimpsest evoking a time dimension, this mural anticipated the most distinctive characteristics of early abstract expressionist painting.

The "Indian Art of the United States" exhibit of 1941 represented one of the last high-water marks in the receding tide of New Deal Indian policy. It had resulted from John Collier's work as Roosevelt's commissioner of Indian affairs, and from René d'Harnoncourt's management of one of Collier's pet projects, the Indian Arts and Crafts Board.[11] Collier's tenure as commissioner, from 1934 to 1945, defined a period in federal Indian policy radically different from what preceded and followed it. Collier's programs were more akin to the model of tribal sovereignty that regained favor in the late 1960s than they were to the policy of assimilationism that had held sway since the Dawes Act of 1887, and that was resumed after Collier's resignation.

Federal Indian policy as defined by the Dawes Allotment Act of 1887 was grounded in the ideological assumptions of "social Darwinism." Social Darwinists understood society as an aggregate of individuals engaged in a competition over scarce resources; progress and ultimate good were assured by the "survival of the fittest." The Dawes Act aimed to assimilate Native Americans into America's dominant culture by making them into competitive individualists. This was to be accomplished by disbanding their tribes and distributing all tribal lands to individual members (who were then conveniently free to sell their lands to white settlers).

In his years as commissioner, John Collier tried to undo this policy. Envisioning the ideal society as a "cooperative commonwealth," he worked to restore Indian tribal communities and the landholdings that were their material base.[12] The Indian Reorganization Act of 1934 ended land allotment and encouraged tribal self-government.[13] Ultimately, Collier's political fortunes would fall victim to the conservative Congress of 1942, which demanded a resumption of assimilationist policies.[14]

Collier's plan to resuscitate Native American cultures led to the creation

2.3. Richard Pousette-Dart, *Desert*, 1940

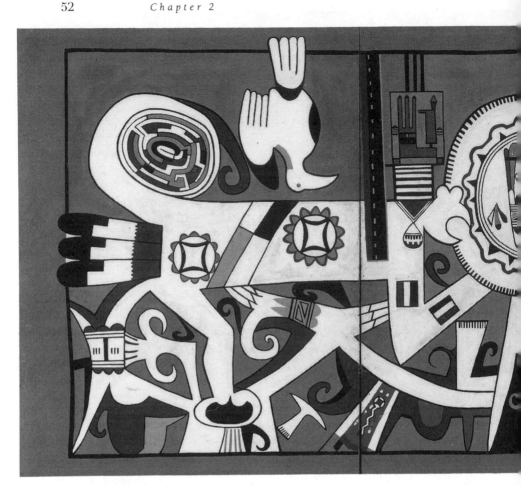

2.4. Reproduction of the Anasazi mural at Awatovi

of the Indian Arts and Crafts Board to protect authentic Indian artistry. The board worked to raise the quality and market value of American Indian crafts and to prevent sweatshop manufacturers from producing inferior imitations for the tourist trade. It coordinated the establishment of crafts cooperatives among several tribes, including the Paiute, Washoe, Shoshone, Choctaw, Pueblo, and Seminole. Fulfilling Collier's hopes, with the revival of traditional quality in craft production came a revival of traditional uses and the creation of a stable local market among tribal members for goods that had previously been reduced to mere curios for tourists.[15]

René d'Harnoncourt served as general manager of the Indian Arts and Crafts Board beginning in 1937. In 1926, d'Harnoncourt had emigrated to

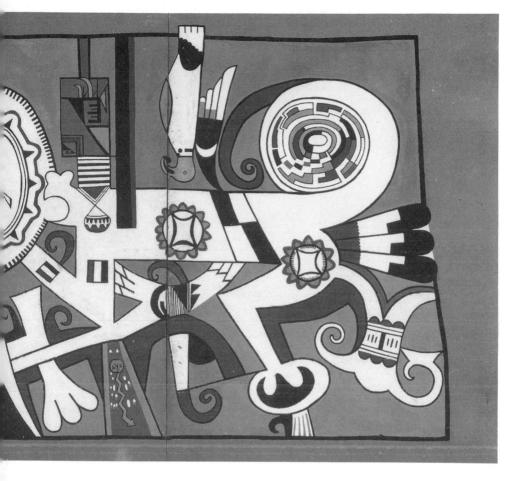

Mexico City from Vienna, where he had been a collector of modern art and had sponsored exhibits of work by Matisse and Picasso. In Mexico, he effected the revival of wooden lacquer work in Olinalá—first prodding the memories of elder craftsmen with superior examples of the work from collections in Mexico City, and then furnishing them with raw materials. In 1930, Dwight Morrow, the U.S. ambassador to Mexico, enlisted d'Harnoncourt to organize a traveling art exhibit to improve Mexico's image in the United States. A little over a decade later, d'Harnoncourt was the art director at Nelson Rockefeller's Office of Inter-American Affairs, making him Ben Shahn's superior when Shahn and Olson collaborated on the OIAA pamphlet *Spanish-Speaking Americans in the War*.[16]

It was d'Harnoncourt who organized the "Indian Art of the United States" exhibit at the Museum of Modern Art in 1941. The idea for an ex-

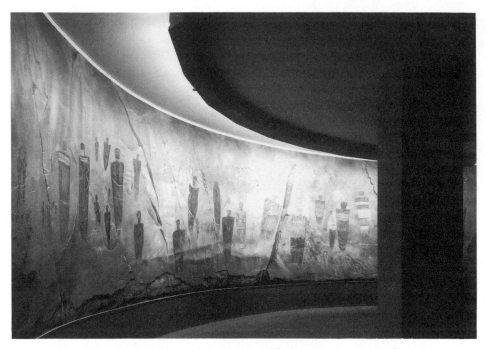

2.5. Reproduction of the basketmaker mural from Barrier Canyon, Utah

hibit began at the Golden Gate International Exposition in San Francisco in 1939. Tribal crafts cooperatives sponsored by the Indian Arts and Crafts Board had organized an installation there designed to show that American Indians were an important presence in the American cultural landscape and not just figures from the distant past. This show was so successful that six of the largest museums in the East agreed to sponsor a traveling exhibit of similar art beginning at the Museum of Modern Art in 1941.

With war breaking out in Europe and the Depression not yet ended, the time was ripe for reimagining the American Indian as a positive symbol of survival in the face of oppressive hardships.[17] D'Harnoncourt wrote on the San Francisco exhibit in the *Magazine of Art:*

> The American Indian has in the past shown an admirable ability to cope with his physical surroundings, to build a well-ordered society and a highly specialized culture even in the most unfavorable environments, and . . . his achievements are of such value that were they more generally known they would become a real contribution to our contemporary life and would thus give the Indian his deserved place in the contemporary world.

The point was not lost in its translation from a popular to a high art venue. Oliver La Farge, reviewing the Museum of Modern Art show for the *New York Times*, wrote that the vitality of Indian art centuries after the European conquest proved that the Indians remained "a people whom disaster has failed to break." D'Harnoncourt's framing of the exhibition encouraged the public to ask the troubling question: did Native Americans possess some quality of stability that the dominant culture lacked?[18]

La Farge's *New York Times* piece emphasized that American Indian art represented a worldview and a way of life distinct from Western civilization. Indian culture, La Farge insisted, was "the first American experiment," disrupted by European colonization. This language evoked the dream of American exceptionalism: the belief that America as the "New World" had a chance to avoid Europe's mistakes. But La Farge's curious revision of this myth projected the colonists' ideal "city upon a hill" back in time to encompass the very Indians they had fought to displace, while vilifying the colonists themselves as destructive European influences. American Indian art, he wrote, represented "the only art original to this land," with "abstract forms . . . the equal of any abstract art from abroad." He concluded, "There is certainly something here for us to welcome and use."

In keeping with the organizers' progressive New Deal orientation, the catalogue of the "Indian Art of the United States" exhibition encouraged readers to regard American Indian art as a cultural resource helping to point the way toward a better future. The foreword, written by d'Harnoncourt and signed by Eleanor Roosevelt, stated:

> At this time, when America is reviewing its cultural resources, this book and the exhibit . . . open up to us age-old sources of ideas and forms that have never been fully appreciated. In appraising the Indian's past and present achievements, we realize not only that his heritage constitutes part of the artistic and spiritual wealth of this country, but also that the Indian people of today have a contribution to make toward the America of the future.

In places, however, d'Harnoncourt's introduction implied a more radical rejection of the myth of Western progress. He added a note dismissing the word "primitive" as a description of American Indian art, condemning its connotation of an "early stage" of cultural development. Instead he turned the tables, accusing Western civilization of a "childish fascination with our own mechanical advancement [which] has made us scorn the cultural achievements of all people . . . unwilling to follow . . . in the direction of what we believe to be the only worthwhile form of progress."[19]

D'Harnoncourt's theme, the adaptation of American Indian "ideas and forms" to contemporary uses, found favor among abstract expressionist

artists. The rhetoric of the exhibition catalogue was that of the New Deal and the Good Neighbor Policy. But other discourses influential among the avant-garde, including surrealism and Jungian psychology, similarly suggested that the cultural orientation presented in "primitive" art offered a potential cure for modern social ills. Upon seeing the "Indian Art of the United States" exhibit, abstract artist Max Weber wrote excitedly to the museum's director: "We have the *real* sur-realists right here in America."[20]

JUNGIAN PSYCHOLOGY AND PARTICIPATION MYSTIQUE

Wolfgang Paalen's *Dyn* magazine, published in Coyoacán, Mexico, linked surrealist theories to Amerindian art of the United States and Mexico. A special issue of *Dyn* was dedicated wholly to the subject in December 1943. Paalen was probably foremost among the surrealists in championing American Indian art, although John Graham and Max Ernst also collected it.[21] Paalen visited Northwest Coast Indian settlements in May 1939, and was profoundly affected by the towering Haida totem poles, which, he wrote, "rank among the greatest sculptural achievements of all time."[22] He envisioned a modern art that would create a "world consciousness" embracing the different sensibilities of Asia, Africa, Oceania, and pre-Columbian America. Eventually, he parted company with the French surrealists because he felt that they did not value American Indian art highly enough.

Among the American avant-garde, Carl Jung's analytical psychology supplemented surrealist theories about the psychological and social roles of art. A disciple of Freud who became interested in mysticism, Jung believed that the ideal artist created images through a process much like surrealist automatism: regression into a state of mind that allowed the retrieval of previously unassimilated psychological contents.[23] But the Jungian paradigm explicitly anticipated that the images that emerged would be like those found in the arts and myths of "primitive" societies. As Jung stated in 1937, "The images themselves are sometimes of such a primitive character that we might suppose them derived from ancient, esoteric teaching. Mythological themes clothed in modern dress also frequently appear." Adolph Gottlieb and Mark Rothko echoed this idea in a public letter defending the Federation of Modern Painters and Sculptors' annual exhibit of 1943. "*The Syrian Bull* [is] a new interpretation of an archaic image," they wrote; "We profess spiritual kinship with primitive and archaic art."[24] Jungian theory enabled avant-garde artists to conceive of their work as simultaneously both modern and mythic.

Any effort to create a socially relevant art requires at least an implicit theory of psychology; efforts to influence people's minds must incorpo-

rate some idea of how people's minds work. One attraction of Jungian psychology for painters was its insistence that primary thought processes are visual rather than verbal: that people think in images before reducing their thoughts to language. The surrealists under André Breton had embraced Freudian psychology; the verbal emphasis of Freudian psychology appealed to Breton, who leaned toward poetry. But it was problematic for abstract painters, who felt that their visions could not be put into words.[25]

Other aspects of Jung's psychology also made it popular among artists. Jung disputed Freud's interpretation of art's social function. Because Freud believed that psychic energy (libido) was exclusively sexual in origin, he interpreted all other human activities as sublimations of the sex drive. As one such sublimation, art served a compensatory function, offering illusory satisfactions that reconciled people to the repression demanded by their struggle for survival. In Freud's view, to use painting as Robert Motherwell intended, as a "medium of thought," could only "open the paths which lead to psychosis . . . [and] withdraw valuable amounts of energy from endeavors which are directed towards reality."[26]

By contrast, Jung believed that the libido had multiple origins, of which the sex drive was but one, and the source of art another.[27] In his view, artistic images had the capacity to refer to an immediate psychological reality. True, art did not necessarily uphold the established social order embodied in Freud's "reality principle." But it indicated the deficiencies of that social order and could point the way to its improvement.

It was Jung's idea of the "collective unconscious" that diverged most radically from orthodox Freudianism. Freud understood the contents of the unconscious to consist entirely of private memories repressed by individuals in the course of their personal histories. Jung hypothesized the existence of a "collective" or suprapersonal unconscious, housed in the biological structure of the brain and giving rise to psychic contents outside personal experience. "This unconscious, buried in the structure of the brain and disclosing its living presence only through the medium of creative fantasy, is the *suprapersonal unconscious*. It comes alive in the creative man, it reveals itself in the vision of the artist."[28] The idea of the collective unconscious defied the implicit intellectual elitism of Freudian psychology. "The true history of the mind is not preserved in learned volumes," Jung wrote, "but in the living mental organism of everyone."[29] It also challenged the Freudian dictum that the principal psychological saga was that of the individual within the nuclear family; for the collective unconscious connected all of the human race in a single, long case history.

Jung's theory of the collective unconscious had profound implications for the relationship of the individual to the society or tribe. For Freud, conscious and unconscious contents developed simultaneously during the construction of identity, as repressed material was "split off" from the

ego. But for Jung, the collective unconscious pre-existed the individual. Each person forged an unstable *persona* by gathering some of these unconscious contents into consciousness, while leaving the greater part unarticulated and unassimilated. Individual identity was like a wave on the surface of the sea of the collective unconscious; and like a wave it was prone to breaking. This process, repeated several times during the life span of the individual, Jung called "individuation."[30]

Individuation was a cycle of regression and progress, entailing the destruction of the persona (or ego) and its rebirth. Such cycles occurred in the life of an individual when the psychic resources of the persona as currently constituted proved inadequate to life's situations. It was during this process that the collective unconscious would assert its presence by generating archetypal images.

Jung called the patterns of the libido in the collective unconscious "archetypes" and argued that they would appear throughout the history of art and literature as symbols with recognizable formal similarities but specific historical contents. Archetypal symbols were to a great degree "natural symbols," relying for their meaning not on local conventions but on the structuring principles of the mind, and so enjoying a certain universality. Yet their precise meaning remained opaque to the inquiring consciousness. As Jung wrote in *Essays on a Science of Mythology:* "Contents of an archetypal character are manifestations of processes in the collective unconscious. Hence they do not refer to anything that is or has been conscious, but to something essentially unconscious. In the last analysis, therefore, it is impossible to say what they refer to."[31]

Archetypal symbols, Jung believed, emerged spontaneously to correct the course of the individual and also of the society. "[Their unconscious] contents issue from a psyche more complete than consciousness. They often contain a superior analysis or insight or knowledge which consciousness has not been able to produce."[32] Surfacing archetypes indicated the source of a psychological imbalance in the individual and, inferentially, in the culture as a whole:

> These primordial images are numerous, but do not appear in the dreams of individuals or in works of art until they are called into being by the waywardness of the general outlook. When conscious life is characterized by one-sidedness and by a false attitude, then they are activated—one might say, "instinctively,"—and come to light in the dreams of individuals and the visions of artists and seers, thus restoring the psychic equilibrium of the epoch.[33]

In order to effect this social cure, the culture had to have institutions to accommodate such visions constructively. Otherwise, the libido that energized the archetype could erupt in violence and destruction. This was

one aspect, Jung suggested, in which modern European civilization, to its own great detriment, proved inferior to other, "primitive" cultures. Jung believed that different cultures varied in the extent to which individuals created identities differentiated from the collectivity. The greater the investment in a stable persona, the less often the cycle of individuation occurred. "Primitive" societies relied on a lesser degree of individualization than was the norm in contemporary Western civilization. Therefore they returned more often to the collective unconscious for the structuring of experience. Consequently, the arts of such peoples abounded in archetypal imagery. In Western civilization, individuals regressed less often, and always more catastrophically.

Jung believed Europe's social ills resulted from the lack of any cultural means to organize and assimilate archetypal impulses. In lectures he delivered at Yale University in 1937, he blamed the eruption and manipulation of libidinal energy for the rise of Nazism and the imminence of war. He complained that, with the Reformation and the advent of the modern age, European society had "lost the sacred images expressive of important unconscious factors together with the ritual which, since time immemorial, has been a *safe* way of dealing with the unaccountable forces of the un conscious mind."[34] As a result, power and technology had increased, but at the expense of psychological and social health:

> A great amount of energy thus became liberated and went instantly into the old channels of curiosity and acquisitiveness, by which Europe became the mother of dragons that devoured the greater part of the earth. Since those days Protestantism has become a hotbed of schisms and, at the same time, of a rapid increase of science and technics which attracted human consciousness to such an extent that it forgot the unaccountable forces of the unconscious mind.

The outcome was war of unprecedented magnitude. Jung feared that the "habitual misuse of reason and intellect for an egotistical power purpose"[35] had caused unconscious forces to be unleashed which were now likely to seek redress only in the destruction of much that reason and intellect had created:

> The catastrophe of the Great War and the subsequent extraordinary manifestations of a profound mental disturbance were needed to arouse a doubt that everything was well with the white man's mind. . . . [Yet once again we find ourselves in a similar situation:] This state of affairs is the demonstration of our psychological problem on a gigantic scale.[36]

Jung contrasted the European condition to the "participation mystique" that defined tribal cultures. Participation mystique, the experience

of a lesser degree of individualization, entailed a different awareness of the physical world than that which prevailed in European civilization. Specifically, wrote Jung, the European "since the 18th century" had tried to separate humans from nature, by formulating principles of physical causality that enabled the manipulation of an "objective" world. But, Jung continued, nature ultimately resisted human control; the component neglected by Western science, the element of "psychic causality," continued to assert itself. In the worldview characterized by "participation mystique," natural and psychic causes were perceived in an undifferentiated amalgam:

> Identifications, brought about by the projection of psychic happenings, create a world in which man is contained not only physically, but psychically as well. To a certain extent he coalesces with it. In no way is he master of this world, but rather its component. Primitive man, in Africa for instance, is still far from the glorification of human powers. He does not dream of regarding himself as the lord of creation. His zoological classification does not culminate in *homo sapiens*, but in the elephant. Next comes the lion, then the python or the crocodile, then man and the lesser beings. It never occurs to him that he might be able to rule nature; it is civilized man who strives to dominate nature and therefore devotes his greatest efforts to the discovery of natural causes which will give him the key to nature's secret laboratory.[37]

So completely had the culture of the West invested in individualism and objectivity that it had lost the ability to constructively use the archetypes of the collective unconscious. It was therefore helpless in moments when the boundaries between the conscious and unconscious self were transgressed from below. In such crises, however, the totems and symbols of "archaic man" could still provide guideposts for the restructuring of consciousness. The psychological health of the future human race, Jung believed, depended on a synthesis of the "modern" and "archaic" worldviews, in which "objective" causality and "psychic" causality would both be comprehended.

Writing in *Dyn*, Wolfgang Paalen expressed the same ideas. He praised the Haida totem poles as representative of a worldview different from the rational ideal of Western science, with its "pretended Zero-point of observation . . . like a chaste sword tip inserted between perception and interpretation." American Indian art in general, he felt, embodied participation mystique as a usable principle for modern art: "Thus all pre-individualistic mentality in whatever race, not distinguishing clearly between the subjective and the objective, identifies itself emotionally with its environing world."[38]

Paalen suggested that participation mystique promised an end to the

alienation that Karl Marx had identified in his earliest criticisms of industrial capitalism: the alienation of the individual (whether worker or capitalist) from the "truly human."[39] Paalen expected that the "world consciousness" for which modern art was to be the vanguard would, by overcoming this alienation, simultaneously unite nations and heal individuals. As he wrote:

> This is the moment to integrate the enormous treasure of Amerindian forms into the consciousness of modern art. . . . Such an effort at integration prefigures nothing less than a vision that today only the most audacious dare to entertain: the abolition of the barriers that separate man from his own best faculties, the abolition of the interior frontiers without which no exterior frontier can be definitively abolished.[40]

Jung and Paalen envisioned the artist as a mythic hero. They conceived of art not as an exercise in reproducing the appearances of nature, but as a social act. Integrating the unconscious archetype with a consciousness of the present, the artist created symbols relevant to the social moment.

Some American artists read Jung's works as they became available in English; others learned about his ideas from friends who had read his works, or from analytical psychologists to whom they turned for therapeutic treatment.[41] The Bollingen Foundation, through its publishing ventures and fellowship awards, did much to further Jungian thought after 1943. Named after the town in Switzerland where Jung made his home, Bollingen was the pet project of the wealthy Mary Mellon, who was a Jungian disciple. Her husband, Paul Mellon, continued to bankroll the foundation after her untimely death in 1946. The Bollingen Press published books on Jungian psychology, mythology, and art that would have had scant chance of commercial publication.[42] Through its fellowship program, the foundation also financed studies on the art and religions of Asia, Maya archeology and culture, indigenous religions in Mexico and Cuba, and American Indian culture. By 1943, the first Bollingen fellow, Maud Oakes, was exhibiting her renditions of Navajo sandpaintings at the National Gallery in conjunction with the publication of her book on the subject.[43]

But even before Bollingen began its immense cultural project, an affinity for Jungian psychology existed among artists. According to one contemporary, "Jung was in the air, the absolute texts were not necessary, there was general talk among painters."[44] Mary Mellon had herself become interested in Jung through contacts within the New York art world in 1934, when she worked as an assistant at the John Becker gallery on Madison Avenue.[45] At that time, Jung's collection of essays entitled *Modern Man in Search of a Soul* was receiving considerable attention in intellectual circles, having been published the previous year. Jung came to

America himself in October 1937, to deliver the Terry Lectures on Religion and Society at Yale (which were published the next year as *Psychology and Religion*) and to lecture at the Analytical Psychology Club in New York.

Many painters absorbed Jung's ideas through the writings and conversation of Russian emigré John Graham. In his influential *System and Dialectics of Art*, published in 1937, Graham synthesized ideas from Jungian psychology and surrealism into his own theory of abstract art. Like Jung, Graham called for an art that would integrate the unconscious and conscious mind; the collectivity and the individual; the human universal and the historically particular. Graham wrote: "The purpose of art . . . is to re-establish a lost contact with the unconscious . . . with the primordial racial past and to keep and develop this contact in order to bring to the conscious mind . . . lost inherent associations." In "Primitive Art and Picasso," an essay published in the *Magazine of Art* in 1937, Graham praised Pablo Picasso's painting *Guernica*, which he felt demonstrated the presence of both components necessary to modern art: "the same ease of access to the unconscious as have primitive artists—plus a conscious intelligence."[46] American painters who aspired to surpass Picasso's achievement took serious note.

THE INFLUENCE OF AMERICAN INDIAN ART ON ABSTRACT EXPRESSIONIST PAINTING

Given that the imagery of primitive myth is what the American avant-garde expected to find in the unconscious, it is not surprising that painters' automatic scribbling in the early 1940s often resolved itself into such figures. Abstract expressionist painters found in such symbols a subject matter that satisfied their quest for an art of more than topical social relevance. Yet the urgency of their quest was directly related to the present context of the war. Adolph Gottlieb made this clear in a radio broadcast that he prepared with Mark Rothko in October 1943, which stated,

> All primitive expression reveals the constant awareness of powerful forces, the immediate presence of terror and fear, a recognition of the brutality of the natural world as well as the eternal insecurities of life. That these feelings are being experienced by many people throughout the world today is an unfortunate fact and to us an art that glosses over or evades these feelings is superficial and meaningless.[47]

Unlike earlier generations of American painters who took the world of the American Indian as their subject matter, the abstract expressionists did not try to *depict* Native American life, but to use the forms of Native American art as a "medium of thought" and apply them to their own situa-

tion. They sought to enter into the American Indian worldview through the adoption of Native American representational conventions.

Richard Pousette-Dart, who resisted conscription into the U.S. armed forces, explaining, "I cannot further cooperate with those . . . [whom] I believe to be corrupt (consciously or unconsciously) and who, I believe, are further and further leading humanity toward degradation, immorality, catastrophe, and total chaos," identified American Indian art with a "primal" experience of the world and with "whole thinking" as opposed to the fractured reasoning of the modern West.[48] His painting *Desert*, of 1940, makes use of the flattened designs and modified symmetries of the Anasazi murals represented in the "Indian Art of the United States" exhibit (see figs. 2.3 and 2.4).

The development of Adolph Gottlieb's radically new "Pictograph" style of 1941 also closely coincided with the "Indian Art of the United States" exhibit; and it referred in both its formal organization and its invocation of petroglyphs to the art that was on exhibit there. The most often reproduced object in the exhibit, a Chilkat ceremonial blanket that illustrated d'Harnoncourt's preview in the *Magazine of Art*, could easily have served as a model for the structure of Gottlieb's Pictographs (figs. 2.6 and 2.7). In fact, Gottlieb added a Chilkat blanket to his personal art collection in the mid-1940s.[49]

Gottlieb had begun collecting primitive art in 1935, prompted, as he later said, by the cubists' interest in African art and by the collection of his friend, John Graham.[50] His interest in using such forms in his painting was explicitly related to Jungian theories. As he told an interviewer: "I think it was more the Jungian notion of a sort of collective unconscious that permitted me to feel free and to discover that there are shapes . . . which are interesting . . . without attributing any specific meaning to them."[51]

Gottlieb's early automatist work, *Eyes of Oedipus* (fig. 1.4), was unusual in its allusion to Freudian mythology. Most Pictographs referred instead to "primitive" signs midway between archetypal image and abstract symbol and, by implication, between the unconscious and the conscious mind (fig. 2.7). As he explained: "[E]ventually . . . I just dropped the whole idea of classical mythology as subject matter and decided that the proper subject matter for me was subjective, free association of images and symbols which I couldn't explain. . . . I then dropped the classical allusions which were more in the verbal reference than in the painting."[52]

The fragmentary images in Gottlieb's work point simultaneously toward both Native American art and surrealism; the formal structure of his rectangular grid suggests a Chilkat blanket, but can equally well be said to have evolved through the wish to organize his automatic imagery within the disciplined plane of cubism. These are not contradictory explana-

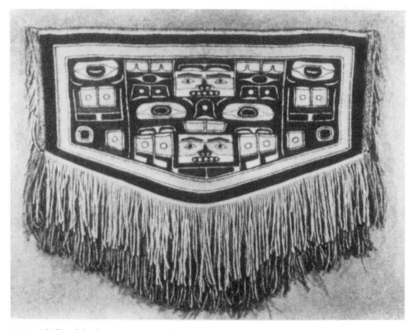

2.6. Chilkat blanket

tions, but only serve to confirm that the abstract expressionists valued American Indian art precisely because it offered solutions to the aesthetic problems they confronted—and, by extension, to the cultural problems that they had encoded in aesthetic form. Noting this convergence of aesthetic and cultural concerns, Stephen Polcari has written of Jackson Pollock's *The Magic Mirror* from 1941 (fig. 2.1) that it

> both announces Pollock's concern with . . . interiority and connects it to Native American thought. He has rendered the image in hard-to-decipher fragments that evoke Native American signs. . . . And the entire surface of sand, while perhaps an allusion to Native American sand and rock painting, deliberately evokes the buried strata we have seen, for example, in Rothko and Gottlieb. Within the psyche lies the buried past.[53]

Sensitive to comparisons that might impugn the creativity or the high-art status of his painting, Gottlieb tended to downplay the influence of American Indian art on his work, preferring instead to cite Jungian notions of the collective unconscious. In contrast, Jackson Pollock, who is probably still considered the most significant abstract expressionist painter, openly acknowledged his indebtedness to American Indian art.[54]

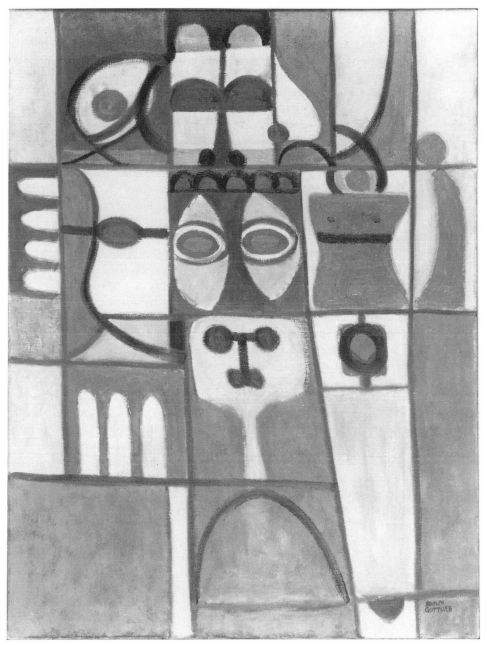

2.7. Adolph Gottlieb, *Pictograph*, 1942

Sometime during the 1930s, Pollock and his older brother Charles (who had preceded Jackson to New York and to Benton's classes at the Art Students League) bought several volumes of the *Annual Report* of the Bureau of Ethnology. These reports contained reproductions of American Indian designs, as well as accounts of Amerindian languages, myths, and ways of life.[55] Pollock also visited the Museum of Natural History to see the Franz Boas collection of Northwest Coast Indian art there. And he kept the special issue of *Dyn* devoted to Amerindian art.

The Jungian paradigm structured Pollock's exploration of Navajo and Northwest Coast Indian (Tlingit, Tsimshian, and Haida) imagery. Janet Wolfe has traced the central figure of Pollock's *Moon Woman Cuts the Circle*, of 1943, to an illustration of Haida myth reproduced in Jung's writings.[56] In an interview with Selden Rodman in 1956, Pollock stated unambiguously: "I've been a Jungian for a long time."[57]

A decade ago, scholars argued lengthily about the exact extent of Jungian influence in Pollock's painting.[58] By now, it is generally accepted that Pollock grasped the generalities of Jungian theory as I have explained them above, but did not adopt Jung's elaborate interpretations of specific archetypal symbols. According to Gerome Kamrowski, who with Pollock participated in Matta's automatist experiments of the early 1940s, Pollock used Jungian imagery "as a device" of self-expression. Pollock's most recent biographers conclude that "What Jackson Pollock derived from Jungian analysis—in addition to a few specific motifs, as opposed to elaborated myths—was permission to engage in his own myth-making."[59]

In addition to his friendship with John Graham, Pollock's sources for Jungian theory included Joseph Henderson, an analytical psychologist to whom he was referred in 1939 for treatment of his alcoholism. At that time Pollock was already slightly familiar both with Jungian thought and with automatism.[60] Henderson encouraged Pollock to employ American Indian imagery in his paintings. Henderson himself had directed his own scholarly research toward searching American Indian cultures for archetypes of the collective unconscious. He studied the corn dance of the Zuni and the snake dance of the Hopi, and lectured on these topics to Jungian psychologists in London. During his sessions with Pollock, Henderson would interpret the automatic drawings Pollock brought to him. These discussions about Jungian symbology furnished Pollock with a vocabulary of images with which to represent his inarticulate yearnings and conflicts.[61]

Pollock's work of the early 1940s abounds with totemic symbols of transformation. The central motif of *Birth* (1938–41), for instance, is an Inuit mask that John Graham had reproduced in his article "Primitive Art and Picasso"; such masks were supposed to effect the transformation of a dancer into a spirit.[62] Pollock was particularly fond of images that merged

different animals, or animals and humans. Such figures were featured in *She-Wolf* and *Guardians of the Secret*, both from 1943. These two paintings confirmed Pollock's reputation when they were purchased by the Museum of Modern Art and the San Francisco Museum of Art, respectively, in the mid-1940s.[63]

Pollock's symbols of transformation allude to Jung's ideas about the socially transformative power of art. They also suggest Pollock's personal social climb from day laborer to fine artist. The fashionability of American Indian art provided Pollock with a way of transforming his background in the rural American West from a cultural embarrassment to a cultural asset. His assumed affiliation with American Indians allowed him to assert a status at once outside and transcendent of the Beaux Arts tradition.

Pollock was extremely interested in the Navajo sandpainting demonstrated at the Museum of Modern Art in conjunction with the "Indian Art of the United States" exhibit in 1941.[64] He compared his famous later works, which he painted while moving around and even onto a large canvas lying on the floor of his studio, to this sandpainting technique.[65] A documentary film that Pollock made with Hans Namuth in 1952 shows him pouring sand from his hand onto the plate glass that substitutes for a canvas, and using paint to make it adhere. Other shots in the same film show him guiding paint in long arcs onto the canvas as he steps rhythmically along its periphery. This dancelike activity may have been inspired by a description of totemic rituals in the special Amerindian issue of *Dyn;* these rituals, Paalen wrote, combine

> an active part: assimilation through a sort of somatic mimetism (dance movements similar to the movements of animals, all kinds of mimicry of emotions), with a passive part: mimetism of camouflage (masks, disguises). These two kinds of mimetism, active and passive, are the two poles which release the great current of rhythm which, going as far as trance, in traversing the individual, effaces his personal memory in order to conjoin it emotionally with the great reservoir of generic memory.[66]

Pollock would have found such an idea congenial. As the decade progressed, his work gravitated from a "passive" to a "somatic" mimesis of Native American forms.

The Influence of Abstract Expressionism on American Indian Art: Cultural Dialogue through Hybrid Forms

Early abstract expressionist art might easily be dismissed as a primitivist "appropriation" of American Indian culture. But this reductive reading of

its social meaning elides its role in a larger cultural dialogue between Native and European Americans. American Indians would mobilize the ideas and forms of abstract expressionism in their own political struggles of the early 1970s.[67]

To an observer comparing abstract expressionism to contemporaneous Native American art, it may at first appear that American Indians found nothing useful in abstract expressionism or the discourse surrounding it. The dominant style in American Indian painting throughout the 1950s remained what it had been for the past thirty years: the "Studio" style, taught to successive generations at the Indian School in Santa Fe since the 1920s (fig. 2.8).[68] The hegemony of the Studio style represented a tacit agreement between Indian artists and white patrons over what constituted "authentic" Indian art. Although the Studio style misrepresented American Indian life as a romantic pastoral, most Indian painters of the 1950s were not interested in challenging this definition.

Why was this? The answer lies in the social dynamics of cultural distribution, and in the social uses of painting among American Indians. Although abstract expressionist painting was well-known in Europe by 1959, it was still virtually unknown on the reservations. More generally, there existed in American Indian cultures almost no precedent for thinking of painting as a subjective expression of cultural identity. Some tribes, like the Pueblo and Navajo, had ancient traditions of ceremonial painting, but these practices had never been the personal expressions of "artists." American Indians had learned the Studio style as a skilled trade in the government Indian Schools, and thought of their paintings primarily as commodities for white consumption, rather than as expressions of their worldview. They were not poised to respond to abstract expressionist attempts to express Native American metaphysics through painterly forms.

A few significant exceptions to this rule exist, however; most importantly, the work of Pueblo artist Joe Herrera.[69] After attending the Santa Fe studio school in the 1930s, Herrera studied art at the University of New Mexico in the early 1950s. He adopted the idea, rare among American Indian painters of his time, of the artist as an interpreter of his culture. In a radical departure from the Studio style, his paintings were abstract compositions of symbols culled from his Pueblo heritage of petroglyphs and kiva murals (fig. 2.9). As he explained in 1952, "My studies in anthropology . . . have accented my natural leanings to a more symbolic expression of the esthetics of my culture."[70] Clearly, Herrera was participating in the abstract expressionist discourse. René d'Harnoncourt offered to exhibit his work at the Museum of Modern Art in 1953.

Herrera's paintings created new possibilities for American Indian art, which would gain political significance in the early 1970s. In the interim,

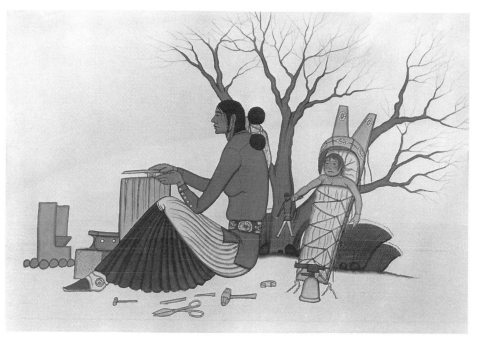

2.8. Beatien Yazz, *Lady Silversmith*, 1948

the assimilationist "Termination" policy adopted by the federal government encouraged a depopulation of the reservations, attenuating tribal traditions. At the same time, tribes experienced increased pressure to relinquish the rights to natural resources on their lands.[71] These pressures, combined with continued social discrimination, led American Indians to follow the example of the black civil rights movement. The American Indian Movement (AIM) that emerged in 1969 included a strong cultural dimension, focused on asserting pride in the Indian cultural heritage.

In his book *God Is Red*, from 1973, Indian activist Vine Deloria, Jr., asserted the radical differences distinguishing American Indian cultures from Western civilization. He characterized this difference along much the same lines that the wartime avant-garde had delineated. Deloria identified two focal points of Indian activism: their land and their religion; the two converged, he explained, in a worldview that understood the natural environment not as an object of manipulation but as an extension of the tribe. Explicitly citing the ideas of Carl Jung, Deloria recovered participation mystique as the basis of a postcolonial worldview.[72]

In conjunction with such assertions of a new pride in Native American culture, a number of American Indian painters turned to the painting style of Joe Herrera as an alternative to the perceived commercialism of

2.9. Joe Herrera, *Petroglyph Turtle,* 1952

the Studio style. These artists sought to create psychologically and so-
cially meaningful works bringing their traditional cultures into the pres-
ent. The Artist Hopid, an arts collective organized in 1973, echoed René
d'Harnoncourt and the abstract expressionists when they declared: "We,

the Hopis, have a lot to offer from a spiritual standpoint and as a living force. We are hoping that from the presentation of our traditions and from the interpretations of the Hopi way in our art and paintings a new direction can come for American spirituality."[73] Works by members of the collective clearly show the influence of Herrera's art (fig. 2.10).

Thus the elements of American Indian culture that attracted abstract expressionists were later used by American Indians themselves for the similar purpose of opposing the dominant culture. As Sioux artist Jaune Quick-to-See Smith stated in 1992, "Contemporary native people, including myself, are doing the same thing that Pollock and Newman did in taking images from native cultures."[74] Abstract expressionists took advantage of the fact that American Indian cultures lay outside the dominant, Western tradition; American Indian artists took advantage of the high-art status the abstract expressionists achieved.

Charles Olson's "The Kingfishers"

In the 1940s, Charles Olson's poetic odyssey followed a trajectory identical to that of abstract expressionist painting: from New Deal politics through Jungian psychology to American Indian cultures. On leaving politics, Olson defined his cultural work as an "archeological" project aimed at making the past "spatial" rather "temporal." By this he meant that it should be possible to reclaim past ways of life for their potential contributions to the present. In his personal notebook from the winter of 1939–40, Olson had paraphrased Jung's ideas of the archetypes of the collective unconscious.[75] Apprehending Jung's interest in the archetypal meanings of medieval tarot cards, he embarked on a series of poems inspired by the tarot images. But after the war, his impulse was to reach out to societies that had flourished beyond the range of European influences. As he wrote to Robert Creeley from Maya archaeological sites in Guatemala and Mexico's Yucatán peninsula: "The substances of history now useful lie outside, under, right here, anywhere but in the direct continuum of society as we have had it (of the State, same, of the Economy, same, of the Politicks."[76]

Olson went twice to the Yucatán: first in the winter of 1950–51, with funds he had scraped together through teaching, and then again in 1952, with funding from the Wenner-Gren Foundation. In his efforts to decipher the Maya heritage, he found himself working against mystifications perpetrated by primitivists of an earlier era. He advised Creeley: "[D]on't let even [D. H.] Lawrence fool you (there is nothing in this Mexican deal, so far as 'time in the sun' goes: the way I figure it, it must have seemed attractive at a time when the discouragement, that the machine world goes

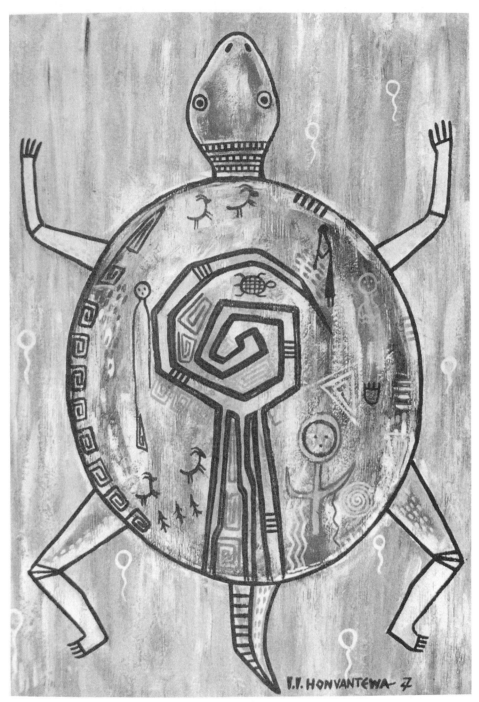

2.10. Terrance Talaswaima, *Petroglyph Turtle*, 1974.

on forever, was at its height." Olson, by contrast, found the present condition of the Indians far from romantic:

> This is a culture in arrestment, which is no culture at all. . . . when I say that, however, I give these people much more head, than their recent slobberers
>
> for the arrestment, surely, was due to the stunning (by the Spanish) of the Indian, 400 yrs ago.

From what he observed of their condition, Olson thought the Mexican peasantry a likely field for Communism along the Maoist model. He thought it probable that, like the Chinese, the Mexicans would seize upon the Communist ideology not in its original form but as a tool of indigenous cultural revolution:

> [S]urely, Mao makes Mexico certain, ahead (Communism, here, by the way, is solid, but is, as not in the States, nor, so far as I have been able to judge, in Russia or Europe either, a *cultural* revolution, or at least the weapon of same, the only one the Indian (like the Chinese?) has been able to get his hands on.[77]

Searching in the ruins of Copan for keys to the Maya civilization, Olson became excited about the history of Kulkulkan, the Maya priest-king. The mythical Kulkulkan symbolized to Olson the possibility of social power through cultural authority. He wrote to Creeley:

> Are not the Maya the most important characters in the whole panorama . . . simply because the TOP CLASS in their society, the bosses, were a class whose daily business was KNOWLEDGE, & its OFF-SHOOT, culture? . . .
>
> and that any such society goes down easily before a gun? . . . ((The absolute quote here, is, one prime devil, Goebbels, who sd: "When I hear the word 'kultur' I reach for my gun."))[78]

This statement of Olson's turned the myth of progress on its head. The most desirable cultures, he asserted, fell most readily before the weapons of Goebbels and his kind. The idea suggests an inversion of social Darwinism, for it implies that colonizing powers are, as a rule, inferior to the cultures they displace. This is the possibility considered in Olson's seminal poem, "The Kingfishers," written in 1949.

Against T. S. Eliot's Fisher King, presiding over the decline of Western civilization in Eliot's poem "The Waste Land," Olson pitted the kingfisher, a symbol of regeneration in many American Indian cultures.[79] Olson began "The Kingfishers" with a credo affirming the impulse to renewal: "What does not change / is the will to change," he insisted. This principle is symbolized by the kingfisher, which makes a nest of "rejectamenta" in

which "the young are born." The accumulation of material from which
the kingfisher's nest is built, "excrement and decayed fish," only presages
the nest's abandonment: "Not accumulation but change . . . is the law."[80]

The narrative of "The Kingfishers" is a chain of associations that pro-
gresses into the past. The narrator thinks back from the moment of awak-
ening after a troubled night. In Jungian fashion, he first remembers a
dream—of birds loose from their cages, associated vaguely with disap-
pointed and ill-conceived plans for future generations:

> He
> remembered only one thing, the birds, how
> when he came in, he had gone around the rooms
> and got them back in their cage, the green one first,
> she with the bad leg, and then the blue,
> the one they had hoped was a male.

This dream memory develops into a more pointed social criticism. The
narrator recalls how the previous evening a foreign archaeologist named
Fernand had spoken oracularly at a cocktail party before "sliding along
the wall of the night, losing himself / in some crack of the ruins." Fernand
had posed the challenging question: "The kingfishers! / who cares / for
their feathers / now?"

Fernand had tried to suggest the different world of value connoted by
a culture in which "the kingfishers' feathers were wealth." "The pool is
slime," Fernand had insisted. This statement collapsed the pretensions by
which modern civilization distinguished its cultural refinement ("the
pool") from the primordially organic ("slime"). The pool *is* slime, as birth
occurs in the kingfisher's nest; because human culture is *in* nature, not
above it. Fernand's provocative remark at last brings the partygoers to "lis-
ten" to him—though still they do not "hear" or "pay attention." But it is
just at this moment that the archaeologist, impeded by the language, can-
not articulate his thoughts any further:

> he repeated and repeated, could not go beyond his thought
> "The pool the kingfishers' feathers were wealth why
> did the export stop?"

The memory of Fernand's urgency brings the narrator to ponder what
the kingfisher's devaluation might signify:

> the E
> cut so rudely on that oldest stone
> sounded otherwise,
> was differently heard
>
> as, in another time, were treasures used

Olson's "E" referred to a prehistoric glyph at the temple of the oracle at
Delphi. As Guy Davenport has explained, "For Olson the import of that
conical, ancient stone was precisely that . . . we have lost the meaning of
the writing upon it. . . . [We are] dissociated . . . from the *complex of ideas*
in which it occurs."[81] Similarly, the cultural logic that made "treasures" of
the kingfisher's feathers has been lost to us. Thus not only the "treasures"
themselves have been lost, but a whole different way of "hearing" and
"use" through which their value was maintained.

Olson implied that this loss had occurred because European civiliza-
tion identified its progress solely with wealth as defined by the accelerated
exchange of commodities; as a result, all other standards of value faded
before an accumulative desire. "The Kingfishers" continues with a cata-
logue from the accounts of a conquistador: a list of ritual treasures from a
conquered civilization. In the conqueror's list, the two birds from the nar-
rator's original vision reappear, commodified as booty of war:

> "a large wheel, gold, with figures of unknown four-foot
> and worked with tufts of leaves, weight
> 3800 ounces
>
> "last, two birds, of thread and featherwork, the quills
> gold, the feet
> gold, the two birds perched on two reeds
> gold . . .

The entries emphasize the weight in precious metals of these ritual ob-
jects, the other meanings of which are "unknown" and forgotten.

In a dialogical passage immediately following this catalogue, Olson as-
serted the importance of his "archaeological" project to recover these lost
ways and meanings. The two voices in dialogue within the poem compare
Olson's cultural work to Mao's revolution in China, as if to weigh the value
of two strategies:

> I thought of the E on the stone, and of what Mao said
> la lumiere"
> but the kingfisher
> de l'aurore"
> but the kingfisher flew west
> est devant nous!
> he got the color of his breast
> from the heat of the setting sun!

"The light of the dawn is before us," Mao is quoted as saying, equating
hope with the East and the future. Mao urges his listeners to action ("nous
devons / nous lever / et agir"), but the other voice of the narrator balks,

questioning. This voice argues that hope lies not in a radical break with the past but in a selective recovery of it—even underfoot, in the Americas, there are clues to social alternatives that suffered untimely destruction. The West still has possibilities, despite the long dominance of European culture ("the whiteness / which covers all"): "The light is in the east. Yes. And we must rise, act. Yet / in the west, despite the apparent darkness (the whiteness / which covers all), if you look, if you can bear, if you can, long enough . . . / so you must, and, in that whiteness, into that face, with what candor, look. . . ."

As befits a dialogic poem, Olson's meditation on the relative merits of the two strategies is inconclusive. Olson implies that Maoism is voluntaristic to a self-deceiving extreme: too sure that its own violence comprises a clean break with the past. He himself is more wary. Like Jung, he observes that all civilizations develop rituals designed to structure or to appease the seemingly irrational. The Aztecs structured their violence through the ritual of human sacrifice; the conquistadors brought their own gods; modern America and Maoist China had yet others of their own. By what criteria could one choose among them?

> (of the two who first came, each a conquistador, one healed, the other
> tore the eastern idols down, toppled
> the temple walls, which, says the excuser
> were black from human gore)

Finally, Olson is able to assert only a continuing quest for "candor": an awareness of how the benefits of different systems of social stability are offset by their costs.

> contemplate
> the flower
> whence it arose
> with what violence benevolence is bought
> what cost in gesture justice brings
> what wrongs domestic rights involve
> what stalks
> this silence

Directing this scrutiny toward his own society, the United States of the 1940s, Olson concluded "The Kingfishers" with an assertion of his status as a cultural outsider. "I am no Greek, hath not th'advantage," he wrote, echoing William Carlos Williams's criticism of Eliot. Instead he searched the ruins of pre-Columbian cultures—not for answers, but for possibilities.

> Despite the discrepancy (an ocean courage age)
> this is also true: if I have any taste

> it is only because I have interested myself
> in what was slain in the sun
>
> I pose you your question:
>
> shall you uncover honey / where maggots are?
>
> I hunt among stones

Olson's poetic meditation on the kingfisher reiterated his quest for an alternative humanism rooted in a different metaphysical outlook. Like early abstract expressionist painters, he associated the quality of perception that he sought with the "participation mystique" of Native American cultures, which situated humans *in* nature, rather than (as in Western science and religion) outside and above it. The ritual power of the kingfisher symbolized the Native American attitude. "The legends are / legends," Olson wrote; "Dead, hung up indoors, the kingfisher / will not indicate a favoring wind, / or avert the thunderbolt." Western science, with its passion for taxonomy and taxidermy, had failed to avert social catastrophe. A recovery of this different rationality now seemed overdue.

3 Ideogram

> When you go looking for what is lost, everything is a sign.
>
> —Eudora Welty, "The Wide Net" (1943)

The preceding chapter tells how the spontaneous aesthetic was linked, in the early 1940s, to a quest for the "participation mystique" believed to characterize Native American experience. After 1943, although members of the avant-garde continued to refine their interest in participation mystique, they began to abandon allusions to particular Native American symbols in favor of more abstract "ideographic" forms. Thematically, the works exchanged among Charles Olson, Ben Shahn, and Katherine Litz at Black Mountain College in the summer of 1951 were connected by their allusion to the "glyph" or ideogram. In the concept of the glyph, several ideas and desires central to the cultural project of the avant-garde converged. Ideographic painting and glyph poetry were meant to recover the metaphysical orientation implied in "participation mystique" without explicit reference to the "primitive." As a means of communication rooted in sensory experience and materiality, ideograms were thought to structure experience differently than the abstractions of modern language. Through them, the avant-garde hoped to challenge the hegemony of abstract reasoning in American culture.

FROM ARCHETYPE TO SEMIOLOGY: ICONOGRAPH MAGAZINE

Robert Motherwell wrote in *Dyn* magazine in 1944 that the future of modern painting lay in a refinement of the

"psychic automatism" of surrealism into what he called "plastic automatism," emphasizing the importance of engaging the paint as a material medium.[1] The increasingly nonfigurative quality of Jackson Pollock's painting in the mid-1940s indicates that he, too, began to qualify his allegiance to unconscious Jungian symbols with a more sensuous approach to the act of painting.

Pollock's work developed along a trajectory from what Wolfgang Paalen called "passive mimetism" (mask imagery) to "active mimetism" (dancelike gestures of which the painting serves as a record).[2] The culmination of this trajectory was the palimpsest that became Pollock's signature style (plate 4). In the course of this progression, what Pollock imagined as the ritual *process* of American Indian art replaced specific symbolic references.

In works of the middle period, between totemism and palimpsest (roughly the war years, 1942–45), Pollock filled his paintings with a kind of spontaneous picture-writing alluding to a prehistoric stage of written communication. These hieroglyphics appear accompanied by such titles as *Stenographic Figure* (1942), *Guardians of the Secret* (1943), and *Search for a Symbol* (1943) (fig. 3.1). As the titles imply, these paintings embody a struggle to articulate experience without recourse to the ready-made ideas provided by language—neither aided nor restricted by them. Pollock was one among many members of the avant-garde interested in prehistoric semiabstract signs.

As the decade of the 1940s progressed, art magazines associated with the culture of spontaneity in American art continued to treat American Indian art as a topic of primary importance. But one significant development in the course of the decade was the virtual disappearance of references to the "primitive." Artists were undoubtedly sensitive to the changing winds of discourse, including the eclipse of the romantic anthropology of Lucien Levy-Bruhl and his era by the more empirically-minded studies of Franz Boas and his followers. Although the motivation for artists' interest in pre-Columbian art remained linked to ideas of the "participation mystique," more and more their ideas focused on the semiotics of the art itself.

The trend toward semiotics was exemplified by the appearance of *Iconograph* magazine, published in New York City in 1946 and 1947. In the seminal essay of its first New York issue, "This is the Spring of 1946," the editor, Kenneth Beaudoin, asserted, "*Iconograph* will make it its business to look at language." *Iconograph* appeared that spring in conjunction with an exhibit at Beaudoin's Galerie Neuf on East 79th Street. In addition to the paintings of Peter Busa, Robert Barrell, Gertrude Barrer, Oscar Collier, Howard Daum, Ruth Lewin, Lillian Orloff, and Robert Smith, the exhibit included a Haida totem pole. As if to mark the transition in

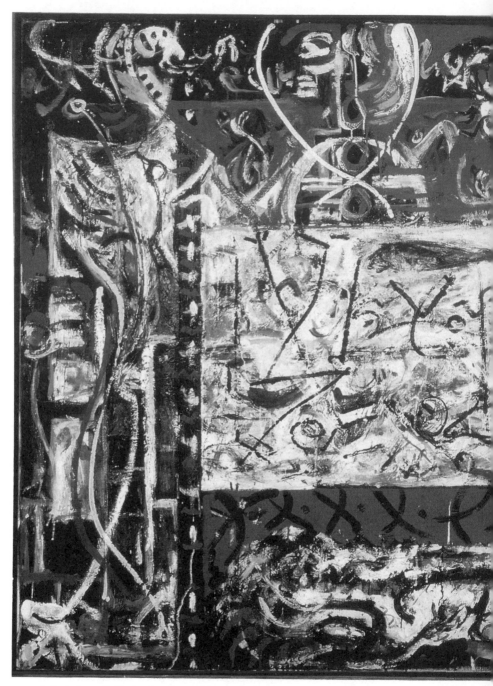

3.1. Jackson Pollock, *Guardians of the Secret,* 1943

sensibility, Beaudoin gave the show two names: "Eight and a Totem Pole" and "Semeiology." The first name pointed back to the basis of the new American painting in Native American totems and rituals. The second pointed forward to the idea of a painterly "language" that could grasp and convey an alternative metaphysics. In keeping with this interest, issue no. 4 of *Iconograph* published a reproduction of Pollock's *Search for a Symbol*.

Beaudoin linked the new form of painting to the language experiments of what he called the "Ezra Pound through Henry Miller anglo-saxon-four-letter-word-romantic Freud-consciousists." But Beaudoin, a French American from New Orleans, saw the real future of semantic art in the adaptation of American Indian signs. "We are looking at new runes this year," he wrote, describing the intellectual atmosphere surrounding his "Eight and a Totem Pole, or Semeiology" exhibit.

> In New York this spring Wheeler, Barrell, Busa, Collier, Barrer, De Mott, Sekula, Lewin, Orloff, Daum, Smith are painting a new magic out of old stardriven symbols rooted in an understanding of pre-columbian American Indian art . . . [and] dependent upon the use of a symbol-integer rooted in an understanding of human and visual realities.[3]

The group of painters surrounding the Galerie Neuf used surrealist automatism as a means for developing their imagery (plate 1). Peter Busa, a first-generation American whose father had been a painter of church murals in Sicily, was one of the few Americans to actually become intimate with Breton's surrealist circle. He was also involved with Matta and Motherwell in their automatist experiments in the winter of 1941–42. He had developed an interest in American Indian art from reading Franz Boas's book on the subject and, later, through the surrealism exhibited at Peggy Guggenheim's Art of This Century gallery, where Busa had his first one-man show in 1946.[4]

Howard Daum, who originally coined the term "Indian Space" to describe this style of painting, later regretted that the term obscured the influences of surrealism and cubism.[5] Among European artists, Daum particularly admired the work of Joán Miró, who alluded to prehistoric sign systems in such gestural works as *Signs and Symbols* of 1938. Sidra Stich has written about this aspect of Miró's work: "The term 'sign' denotes a pictorial element envisioned at a primary, sensory stage wherein form and meaning are undifferentiated. At this stage, an element is neither purely abstract nor clearly representational. It is charged with an inborn energy, a potential, and it has a provocative but ambiguous significance." Miró's quixotic sign-symbols embodied two important propositions: first, that the psychology of language is not logical but, rather, associative and metaphorical; and second, that semiabstract symbols evoke the same kind of thinking that had been associated with "participation mystique."[6]

The ideas shared by Beaudoin's group of New York painters were articulated elsewhere in *Iconograph* by James Dolan. In a piece entitled "Typography," Dolan discussed the evolution of writing from the pictogram through the ideogram to the abstract phonetic symbol. The first of these forms, the pictogram, relied completely on mimetic representation. Pictograms, wrote Dolan, included: "human forms drawn pictorially in the act of making gesture-signs and in significant action and attitude and combinations of these, together with natural and artificial objects which represent work or the result of work."[7] The next stage of writing, the ideographic (also variously referred to as "ideagram" or "ideogram" by painters, and as "hieroglyph" or simply "glyph") was most significant to the cultural project undertaken by the postwar avant-garde. The ideogram preserved the material reference of the pictogram, but transformed its meaning through metonymic or metaphoric conventions. Freed from the literal reference foregrounded by the pictogram, the ideogram could take on a complex of associated meanings.[8] Yet because the ideographic sign avoided the complete abstraction of phonetic alphabets (in which signs referred only to sounds), it would never be entirely divorced from the material referent that was the original basis of this meaning complex. The ideogram would always, as Charles Olson noted to himself in 1945, "bear its metaphor on its face."[9]

The artistic project to create a "language" of painting and the poetic project to restore "spatiality" to writing converged in the use of ideograms. In *Iconograph*, Beaudoin tried to forge a link between the new American painting and the experimental American literature that aimed to free poetic language from the conventions of syntax. To this end, he appointed Abraham Lincoln Gillespie, Jr., as *Iconograph*'s honorary literary editor. Gillespie had been a contributor to Eugene Jolas's *transition*, a little magazine from the late 1920s that was among the first to bring Jungian thought to America.[10] In 1942, Gillespie had sent Beaudoin a piece entitled "The Syntactic Revolution" which asserted, "[T]he MIND's ActuaRycording (polassyomage'd) CREAT-MOME . . . als is harmatterly burst-bloomive." Translated into linear prose, this meant roughly that the mind actually engages reality in multiple ways simultaneously. Gillespie therefore went on to ask, "save for ConchStream Subservation (and the Henry-MILLER and MALRAUX ALSOBSERVATS) what DECENCE of CONCRE-ATIVRITEX is being done?"[11]

IDEOGRAMS AGAINST "ABSTRACT MAN"

Charles Olson's spontaneous glyph poetry would have satisfied Gillespie's challenge. It was inspired by Ernest Fenollosa's ideas about the Chinese ideogram, which Olson redirected toward Maya glyphs. In 1945, Olson read Fenollosa's essay for the first time and copied it into his note-

book virtually verbatim. Ezra Pound had had a similar reaction thirty years earlier, when his first reading of Fenollosa's manuscript convinced him that the poetic method he had described first as "imagism" and then as "Vorticism" truly ought to be called "ideogrammic."[12]

Pound, in defining his poetic method in 1914, had explicitly differentiated the "image" from the symbol. Symbols, he asserted, referred to known associations, whereas images articulated unfamiliar structures of meaning: "The symbolist's symbols have a fixed value, like numbers in arithmetic. . . . The *image* is itself the speech. The image is the word beyond formulated language. . . . It is a radiant node, or cluster; it is what I can, and must perforce, call a VORTEX, from which, and through which, and into which, ideas are constantly rushing."[13] Reading Fenollosa's manuscript in 1915, Pound immediately recognized the Chinese ideogram as such a vortex.

Ernest Fenollosa, who had died in 1907, looked forward, like Wolfgang Paalen, to "world-embracing cultures half-weaned from Europe."[14] One contribution of the Chinese to this universal culture, he suggested, would be the poetic capacity of their written language. He felt that Chinese writing surpassed phonetic sign systems both in the vividness of its imagery and in the manner through which it constructed meaning.

"In reading Chinese," Fenollosa wrote, "we do not seem to be juggling mental counters, but to be watching *things* work out their own fate." This was because many Chinese calligraphic figures, unlike phonetic letters, incorporated qualities of their referents into the signs themselves. Fenollosa used as an example the sentence "Man Sees Horse," illustrating how each of these three ideograms conveyed information about the *nature* of man, of seeing, and of horses, respectively.[15]

Another virtue of the ideogrammic style of notation lay in its ability to represent all nouns as containing the seeds of action. "A true noun, an isolated thing, does not exist in nature," wrote Fenollosa; "Things are only the terminal points, or rather the meeting points of actions, cross-sections cut through actions, snap-shots. Neither can a pure verb, an abstract motion, be possible in nature. The eye sees noun and verb as one: things in motion, motion in things, and so the Chinese conception tends to represent them." As an example, Fenollosa presented the Chinese ideogram "sun-and-moon," which can function simultaneously as a verb (to shine), a noun (sheen), and an adjective (shining). A sentence, wrote Fenollosa, should be understood as a "unit of process," and a noun as a "bundle of functions." Instead, European notions of grammar, fixated on logical categories, obscured the polyvalent quality of things in nature. Words in English, calcified as one of several "parts of speech," no longer appeared as records of an active experience. "It is only when . . . we are forced to translate into some very different language, that we attain for a moment

3.2. Chinese ideogram, *guang,* "to ramble"

the inner heat of thought, a heat which melts down the parts of speech to recast them at will."

Ideograms retained an ability to convey the multiple functional relationships between things. This was because ideogrammic writing relied on an implied relation between juxtaposed elements to construct abstract meaning. In compound ideograms like sun-and-moon, "two things added together do not produce a third thing but suggest some fundamental relation between them." This was in direct contrast to the phonetic method, in which general, abstract categories erased the original relations on which the abstraction was based. As Ezra Pound editorialized: "Get your 'red' down to rose, rust, cherry if you want to know what you are talking about."

In a letter to a friend, Pound shared his enthusiasm for the communicative capacity of the compound ideogram, giving as an example the Chinese sign *guang:* "the ideogram for the verb 'to visit, or ramble' is a king and a dog sitting in the stern of a boat" (fig. 3.2).[16] This image of travel, retaining references to king, dog, and boat, conjures up a social and cultural complex in which the act of visiting or rambling is embedded, all of which

is communicated through the sign itself. By contrast, the phonetic sign, r-a-m-b-l-e, communicates through symbols that are more abstract, divorced from any material referent or cultural context.

Pound believed that the weak evocative capacity of European languages was both a cause and a symptom of Europe's cultural decline. It was a weakness linked to the emphasis of commercial exchange over other social values.

> Languages today are thin and cold because we think less and less into them. We are forced, for the sake of quickness and sharpness, to file down each word to its narrowest edge of meaning. Nature would seem to have become less like a paradise and more and more like a factory . . . A late stage of decay is arrested and embalmed in the dictionary.

As an example of the forgetting encouraged by phonetic languages, Pound seized on the word "personality." "We forget," he wrote, "that personality once meant, not the soul, but the soul's mask."[17] Recalling Jung's designation of the persona as an unstable, consciously projected identity, Pound's statement contained a thinly veiled criticism of American corporate-liberal culture. The rise of "personality" as a personal value was historically linked to the growth of consumer capitalism and advertising.[18]

The possibility of suggesting abstract meaning through the spatial juxtaposition of figurative elements is, in Western culture, a painterly idea. The compound ideogram was therefore a form that abstract expressionist painters persistently developed. But the ideogram also suggested a new form for poetry, despite the limitations imposed on the poet by the necessity of working with a phonetic language. Between true ideogrammic writing and phoneticism, wrote James Dolan in *Iconograph*, was an intermediate stage he called "syllabism," in which each sign stood for the sound of a syllable. In syllabism, the syllable functioned as both a phoneme and a morpheme: though used as a sound, it still worked as a unit of meaning. This idea became the basis of Charles Olson's spontaneous poetry. In Olson's view, many words in modern English resonated with layers of meaning evoked by syllabic morphemes. These words possessed buried linguistic associations of which the ear-mind complex was unconsciously aware. In his essay "Projective Verse" he paraphrased Fenollosa: "'Is' comes from the Aryan root, *as*, to breathe. The English 'not' equals the Sanscrit *na*, which may come from the root *na*, to be lost, to perish."[19]

Olson therefore insisted that it was the syllable, not the word, that was the fundamental building block of poetic language. "It would do no harm," he wrote, "as an act of correction to both prose and verse as now written, if both rime and meter . . . were less in the forefront of the mind than the syllable . . . I say the syllable [is] king." To focus on the syllable,

Olson maintained, was "to engage speech where it is least careless—and least logical." That is to say, where it was most rooted in human encounters with natural processes. The ideogram, as a means of communication that demonstrated the process of its own development, defined the common basis of Ben Shahn's palimpsest painting and Olson's glyph poetry, which they exchanged at Black Mountain College in the summer of 1951 (fig. 3.3).

Olson was foremost in developing the implications of the ideogram for a poetry of spontaneous association. But Pound, Williams, and Olson all adopted the compound ideogram as a model of poetic structure, creating images not through analogy or metaphor but through synecdoche and parataxis. Laszlo Géfin has described this technique as the art of "plac[ing] particulars in a working relationship where each will affect the other and establish conceptual links while preserving the sovereign identity of each functional unit."[20] This was the structural formula that served as the basis for Pound's *Cantos*, Williams's *Paterson*, and Olson's *Maximus* poems. As Williams explained his method in the first book of *Paterson*, published in 1946:

> . . . a mass of detail
> to interrelate on a new ground, difficultly;
> an assonance, a homologue
> triple piled
> pulling the disparate together to clarify
> and compress[21]

Williams's description of the ideogram as "a homologue / triple piled" emphasizes the relation of this ideogrammic form to the palimpsest.[22]

Charles Olson and the Maya Glyph

Olson's cultural-political project of "reaching back and down," as he described it to Ruth Benedict in 1945, echoed a theme that William Carlos Williams had suggested on the eve of war in 1939. "In the search for present-day solutions is the question of origins," Williams had insisted. "If, as writers, we are stuck somewhere, along with others, we must go back to the place, if we can, where a blockage may have occurred. We must go back in established writing, as far as necessary, searching out the elements that occur there. We must go to the bottom."[23]

Pursuing this agenda of examining the culture of writing to its roots, in the winter before the "glyph exchange" at Black Mountain, Olson had traveled to Mexico to study Maya glyphs (fig. 3.4). Fenollosa and Pound had cued Olson to understand phoneticism as a cultural decline implemented in Western civilization for the sake of commercial and military ef-

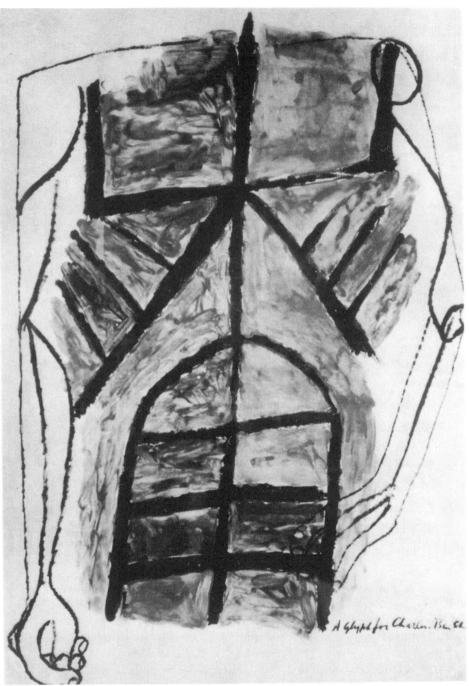

3.3. Ben Shahn, *A Glyph for Charles*, 1951

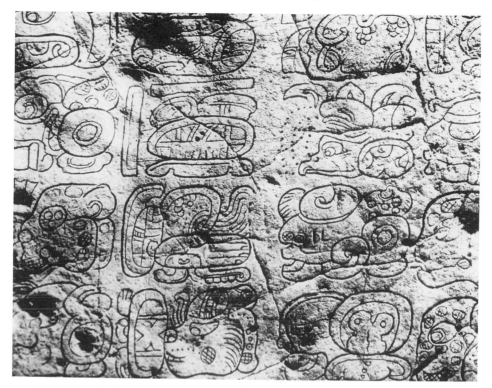

3.4. Maya glyphs

ficiency. As Olson wrote in 1952 in an essay entitled, "The Attack, Now, in Painting and Writing":

> Western Man (as distinct from the Maya, the Chinese, and—maybe—the Egyptian[)] . . . bred what he was—what he has been, Abstract Man, when, in two instances, the axis of his language shifted from the vertical of the basic pictogram, and became, in the Sumerian case, syllabic (that happened about 2500 [BC]) and in the "Phoenician" case [alphabetic phonemes: consonants and vowels].[24]

As opposed to abstract modern languages, Olson maintained, the ideogrammic quality of the Maya glyphs situated their meanings in a material reality.

Olson understood the Maya glyphs as both recording and constructing the Maya way of life. He saw evidence in the glyphs of the disposition of psychological energy encouraged by the culture. The glyphs were "ideographic" and not "pictographic," Olson wrote, and so "kept the abstract alert" without descending to the "stereotype" and formalism of complete

abstraction.[25] In his 1951 application to the Wenner-Gren Foundation, which would sponsor his second trip to the Yucatán, he asserted: "The Mayan imagination did very exactly maintain in the hieroglyphic writing the two things which the art of it seems to have demanded of them: the face and the proportion of nature in the glyph, [and] resistant time in the composition of the glyph, the block and the stone."[26]

Olson's analysis of the work of the glyphs on the Maya imagination emphasized their power to maintain "the face and proportion of nature" and its "resistant time" before the mind of the viewer. These two cultural values, he believed, were embodied in the very form of the glyph: demanded by the processes of inscribing and reading it. This quality of "attention" constituted a refinement on the idea of "participation mystique" upon which Olson hoped to base his revision of humanism. Olson believed that he had found, in the way the Maya interacted with their natural environment, a cultural "bias of attention" that offered an alternative to the dominant American worldview.

What was at stake, Olson believed, was the way the members of any culture distributed their mental capacity: on what their awareness was focused, and for how long. "It is not a question of either intelligence or spirituality, but another thing . . . a form or bias of attention," he wrote;

> Once . . . there was a concept at work, not surely "sacred," just a disposition to keep the attention poised in such a way that there was time to . . . be interested in expression & gesture of all creatures including at least three large planets enough to create a system of record which we now call hieroglyphs, . . . [and] to fire clay, not just to sift and thus make cool water, or, to stew iguana, or fish, but to fire it so that its handsomeness put ceremony where it also belongs, in the most elementary human acts.[27]

Olson's "other humanism" is encompassed in this reference to "the most elementary human acts" as worthy of dignity and "attention." It is an idea that combined the democratic populism of Olson's early politics with the critique of commodity fetishism that he developed in the war-driven prosperity of the 1940s. The commodity and its associated value of convenience, Olson maintained, robbed elementary acts of the attention they deserved, and so encouraged the abstract and impersonal quality of attention on which corporate capitalism was founded. As he wrote to Creeley:

> This is not easy to state, I guess. BUT OF EXTREME IMPORTANCE. For I come on, here, what seems to me the real, live clue to the results of what I keep gabbing about, *another* humanism. For it is so much a matter of resistance—like I tried to say, about . . . *buying* the improve-

ments so readily available at the corner. You buy something all right, but what gets forgotten is, that you sell, in that moment of buying—you sell a whole disposition of self which very soon plunders you just where you are not looking.[28]

Olson took pains to differentiate his sense of Maya culture from any notion of "spirituality" that posited a dichotomy of body and spirit. Nor, he asserted, had what distinguished the Maya anything to do with degrees of intelligence or of psychological evolution. "What has to be battered down completely," he wrote, "is, that this has anything to do with stage of development."[29] This quality of attention, he believed, could be as useful in the future as it had been in the past.

Because he saw embodied in the Maya glyph the potential for encouraging this bias of attention, Olson took the glyph as a model for his own poetic project. The result, he hoped, would be a poetic form distinctly different from the print-bound verse styles of the past.[30] For Olson, the lesson of the Maya glyphs was to point poetry toward a philological project that involved recovering (and in the process, disclosing) the material histories of word-concepts.

"Breath has a double meaning which Latin had not yet lost," Olson wrote in "Projective Verse," alluding to the Latin *animus,* in which the idea of "spirit" coexists with the idea of respiration. Like Pound's remark on "personality," Olson's recovery of this etymology was designed to remind the reader of an important truth. The word *animus* holds in juxtaposition a complex of associations that the English word "breath" does not preserve. It was such words, with multiple but related meanings that evoke an idea-complex, that Olson valued for their implications about the origins of cultural thought-structures. These words were the bases of his "glyphs."

Olson's poem "Glyph," which he gave to Ben Shahn in the summer of 1951, exemplifies this technique. The poem is a spontaneous meditation on the meaning of "race." In the poem, Olson proposes the word "race" as an abstraction with multiple meanings marking an emotionally charged idea-complex in American culture. His poem attempts to reconstruct the complex of meanings surrounding the word, by providing an ideogrammic image that locates "race" in the context of a specific utterance and telescopes it outward.[31]

The poem's image centers around a seemingly minor event in Olson's own life. One day in the summer of 1951, he was wandering through the town of Black Mountain, North Carolina, with Alvin, a young nephew of the college's African American cook. Together they had stumbled into a building where an auction was in progress, and both stood suddenly transfixed.

GLYPH
(for Alvin,
& the Shahns)
Like a race, the Negro boy said
And I wasn't sure I heard, what
Race, he said it clear

 gathering
into his attention the auction
inside, the room
too lit, the seats
theatre soft, his foot
the instant it crossed the threshold
(as his voice) drawing
the whites' eyes off
the silver set New Yorkers
passed along the rows for weight, feel
the weight, leading
Southern summer idling evening folk
to bid up, dollar by dollar, I

beside him in the door[32]

The poem surges by without a full stop, intent on creating the entire scene simultaneously from multiple perspectives: that of the young black boy, that of Olson as narrator, that of the bidders suddenly interrupted by this alien presence in their midst. Alvin, a young Negro keyed to survival, keenly "gathers into his attention" the entire scene before him. It is out of his full attention that the poetic act actually emerges: his unconscious mind grasps the situation and responds with the compressed syllable, "race." Olson, charged with comprehending the meaning of this glyph, feels that he has entered into an ongoing conversation in which most of the dialogue is passing over his head. "I wasn't sure I heard, what / Race," he puzzles. But Alvin, Olson acknowledges, "said it clear."

Olson's train of thought begins by making the metaphorical leap comparing the auction to a footrace ("his foot / the instant it crossed the threshold"). This rather innocent association evokes a more sinister connection to social Darwinism, an ideology that sanctioned racial oppression as a divinely ordained natural competition. The colonialist model of world politics as a race among the races was far from dead in the United States in 1951, particularly in the socially segregated South.

In the event recorded in Olson's poem, the powerful force of such "racial" distinctions draws the attention of the white bidders away from their business, toward the young black boy standing in the door. As they sit in a modern counterpart of the Roman coliseum, in the luxury of "the

room / too lit, the seats / theatre soft," the bidders' sudden focus on Alvin draws him into equation with the commodity they are bidding on. The result is an echo of the slave auction. Olson thus links the "bias of attention" encouraged by commodification with objectification and the loss of human value. The bidders cast themselves as subjects, and what confronts them is the object and the racial Other.

Unlike Olson and Alvin, the bidders have narrowed their attention to a single-minded consideration of the commodity value of the objects that fall within their ken. Encouraged by traders from New York (the center of financial capitalism) who are sponsoring the auction, they have focused their eyes and minds on "the silver set . . . passed along the rows for weight." Like the conquistador whose inventory Olson quoted in "The Kingfishers," they "feel" only this weight. By encouraging this bias of attention, the New Yorkers succeed in "leading . . . [them] to bid up, dollar by dollar." When Alvin and Olson step into the doorway, they become the new objects of this attention, but the quality of the attention remains the same.

In this way, the poem dramatizes not only racial identity but also the alienation felt by Olson and other members of the Black Mountain arts community in the rural South. As Robert Motherwell confided to an interviewer, the college faculty and students often came into conflict with the local population, which saw them as "a bunch of what we now would call hippies, homosexuals, New York Jews."[33] Olson constructed his personal experience in the auction house that summer afternoon as a synecdoche for the experience of artists in a society that measured worth by the exchange value of commodities. In the poem, the narrator feels the attention of the bidders, settled first on Alvin, turning next to him: "to bid up dollar by dollar, I // beside him in the door."

In their common experience as objects of this fetishization, however, Olson and Alvin establish a communion based on their resistance to it. In this sense, the poem's final focus on the two of them standing together in the doorway, where Alvin's voice and bodily presence have just disrupted the proceedings, offers yet a third understanding of "race": as that humanity which unites them in the "human race." The narrator of "Glyph" opposes the social Darwinist model of competition with an image of two mutually supportive human objects: "I // beside him in the door."

Olson, who saw a connection between the increasing depersonalization of modern society and the abstraction of phoneticized language, felt that the tangibility of ideogrammic writing contradicted the impulse of corporate liberalism. He hoped that a recovery of the communicative capacity of glyphs could restore an element of reality to a language that had been appropriated by advertisers and military strategists. His glyph poetry was a self-conscious attempt to root the "universe of discourse" once

more in a phenomenal universe: in that "human universe" where language originated as a tool of thought and communication.[34]

THE IDEOGRAPHIC PICTURE

In painting, the trend toward ideographic representation that was first acknowledged in Beaudoin's *Iconograph* was furthered by an exhibition at the Betty Parsons Gallery in January 1947, helpfully named "The Ideographic Picture." The show included work by nine artists, including Barnett Newman, Mark Rothko, Hans Hofmann, Ad Reinhardt, Theodoros Stamos, and Clyfford Still. Barnett Newman helped to organize the exhibition and wrote the program notes, in which he quoted a definition of "ideographic" from the *Century Dictionary:* "Ideographic—Representing ideas directly and not through the medium of their names; applies specifically to that mode of writing which by means of symbols, figures, or hieroglyphics suggests the idea of an object without expressing its name." Ideographic painting was intended to express truths incommunicable through conventional language; the ideographic image, Newman wrote, acted as a "vehicle for an abstract thought complex."[35] The ideographic painter used the "abstract shape" as a "plastic language" through which to arrive at "metaphysical understanding."

As with the Poundian vortex and the Jungian archetype, the authority and authenticity of the "ideographic" picture was seen to exist exactly in the impossibility of reducing it to a consciously known quantity, describable in existing terms.[36] Any such terms would of necessity invoke the cultural thought structures and the sequential thought process that the image was meant to transcend. Precisely because it could not be reduced to the familiar visual codes used in that painting which called itself realist, Newman maintained, the ideographic image was truly "real rather than a formal 'abstraction' of a visual fact, with its overtone of an already-known nature." Hence the artists included in the exhibit were "not abstract painters, although working in what is known as the abstract style." In the opening paragraph of the program notes, Newman connected the metaphysics of ideographic painting once again to the art of the Northwest Coast Indians, as if to enlist the Kwakiutl as allies in the battle of aesthetics among realists, abstract artists, and abstract expressionists.

One painter participating in the "Ideographic Picture" exhibit, Theodoros Stamos, immediately followed the group show at Betty Parsons Gallery with a solo exhibition in February 1947. The trajectory of Stamos's career exemplifies the development of abstract expressionist painting. Stamos was born in 1922, in New York City, to Greek immigrant parents. In 1947, the titles of some of his paintings were "Petroglyph," "Petrographic Fragments," "Monolith," and "Ascent for Ritual," suggest-

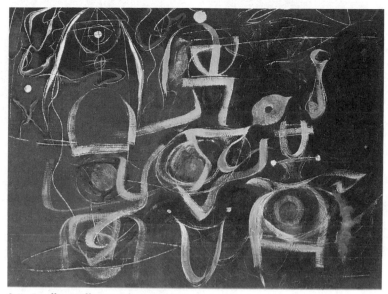

3.5. Bradley Walker Tomlin, #3, 1948

ing the cultural nexus of primitivism and Jungian psychology. That spring, probably with money earned from his first solo exhibition, he traveled to Taos, New Mexico, and then to the Northwest Coast, to see American Indian art. The next year he would paint a canvas entitled "The Saga of Ancient Alphabets," connoting an interest in the semiology of ideographs. In 1950, he taught at the Black Mountain College summer institute, where Charles Olson was also thinking about ideograms and planning a trip to study Maya culture on the Yucatán peninsula.[37]

By the late 1940s, many artists had begun to paint ideograms or glyphs in a wide variety of styles. Bradley Walker Tomlin introduced ideographic imagery into his painting in the mid-1940s, after experimenting with automatism since 1942 (fig. 3.5).[38] Franz Kline, like the "Indian space" painters associated with *Iconograph* magazine, asserted the "all positive" structure of his pictorial space, distinguishing his work from the more calligraphic styles of Tomlin or Mark Tobey on that basis.[39] Lee Krasner painted a group of paintings known as the "little image" series during the late 1940s, referring to them as "hieroglyphics of some sort" (fig. 3.6). Stephen Polcari has characterized these works as "metalanguage painting, . . . concern[ed] with an elemental, archetypal archaic visual and verbal image."[40] Willem de Kooning painted *Orestes* in 1947 (fig. 3.7). In this painting, letters organized conceptually in the space of the picture recover something of the glyph's ambient significance.

Adolph Gottlieb's "Pictographs," which he began painting in 1941, shared significant characteristics of the ideogram. From the outset, Gott-

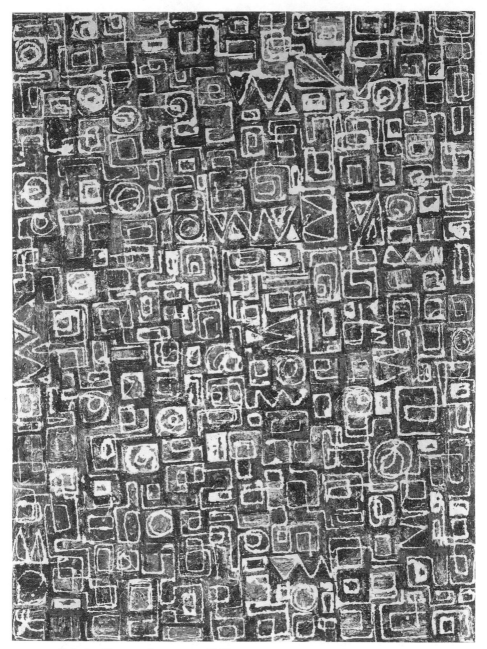

3.6. Lee Krasner, *Composition*, 1949

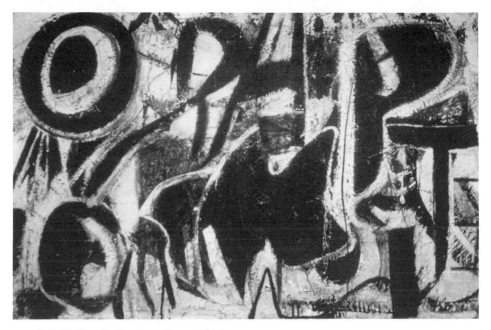

3.7. Willem de Kooning, *Orestes*, 1947

lieb's Pictograph images were semiabstract and communicated meaning synecdochically. Still, paintings such as *Letter to a Friend*, from 1948, demonstrate Gottlieb's progression from the original pictograph to what could, with greater accuracy, be termed an ideograph (fig. 3.8). Compared to earlier works like the *Pictograph* of 1942 (fig. 2.7), *Letter to a Friend* is more gestural and calligraphic. The painter's vocabulary has been increased considerably by the addition of allusive but more abstract forms such as the cross within the circle at bottom left. In May 1948, Gottlieb asserted his link to avant-garde poetry and its philological search for origins with a question posed in a lecture at the Museum of Modern Art: "If the origin of painting was the making of marks or poetic signs should we consider the painter an artisan-poet or is he the artisan-architect of a formal structure? or both?"[41]

The work of many of these painters was reproduced in *Tiger's Eye*, a magazine of art and literature which began publication coincident with the last issue of *Iconograph*. *Tiger's Eye* 5, published in October 1948, featured ideogrammic art of the Indians of the Peruvian Andes in addition to abstract expressionist work. An editorial linked the two through the problem of language:

> Language is a primary abstraction that continually is being taken for granted. . . . Actually the dictionary is the great history of man's belief

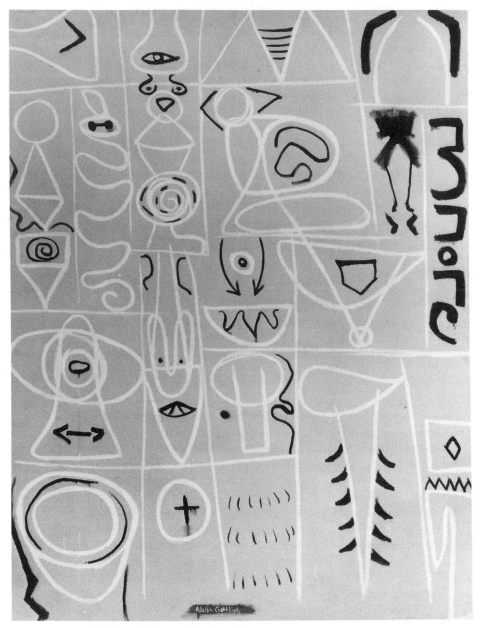

3.8. Adolph Gottlieb, *Letter to a Friend*, 1948

and of the reality he has created. Words such as *window, fire-tongs, gun, coat* show inventions he has considered necessary, while others such as *oblige, botany, run, sequence, early* express his choice of what is meaningful. To look at them objectively is to marvel, for each word is proof of a mutual decision.

If we limit ourselves to a conception of language as a written medium, however, we will be unable to understand the Incas and many tribes that compose the Andean civilization, or other races that, like them, have not used the written word as we know it . . . As we look at their art—at its diverse spontaneity, its ease in humor, its imaginative elasticity—we must realize that a sentence is not the only pack-mule for an idea. It is in the realm of the pictorial where language can find new expressions of reality.[42]

Tiger's Eye exemplifies how, in the course of the decade, the avant-garde moved away from Jungian ideas of archetypal symbols and the "archaic" mind, focusing their interest on the semiotics and creative method that they identified as the essential ingredients of American Indian art: the ideogram and the palimpsest. From the earlier concept of "participation mystique," they distilled an interest in the way language, and particularly written language, constructed the cognitive process. In the "ideographic" sign, writers and painters saw a means of developing perceptions that their own culture had devalued. The ideogram suggested a cultural reorientation grounded in the reintegration of physical, emotional, and intellectual experience.

The power of ideographic imagery to attract interest at the end of the decade was not confined even just to abstract painters. In 1948, graphic designer Alvin Lustig's fabric pattern "Incantation," which he had produced for the Laverne Originals "Contempora" series, was designated a Good Design Selection by the Museum of Modern Art. "Incantation," which alluded to prehistoric writing, could be purchased printed on Peruvian linen or on textured rayon with gold or silver lamé.[43] In 1951, even the social realist painter Ben Shahn, who a few years earlier had ridiculed the work of Adolph Gottlieb as "abstract notations on totemic calligraphy," developed his own version of the ideographic palimpsest while summering at Black Mountain College.[44]

PART TWO

The Energy Field

4

Subjectivity, Existentialism and Plastic Dialogue

From now on the word "existing" is used always in opposition to that which is only thought of, only contemplated; as the concrete in opposition to the mere abstract; as the individual in contrast to the mere universal. Which means nothing more nor less than that philosophy, which since Plato has thought only in concepts, has now become mistrustful of the concept itself. Henceforth, philosophers never get rid of their bad conscience, so to speak, in the pursuit of philosophy.

—Hannah Arendt, "What is *Existenz* Philosophy?" (1946)

Critics of the postwar aesthetic of spontaneity have tended to mistake its social content because they have misunderstood its philosophical roots. Some Marxist critics of abstract expressionist painting (Serge Guilbaut is the most widely read) have tended to deny the ability of abstract art to convey a vision of sociality.[1] Intellectually oriented contemporaries of abstract expressionism, for their part, tended to misread it through the lens of their own existentialist preoccupations. These misreadings are still pervasive in our understanding of the art. Once restored to its proper intellectual context, however, some abstract expressionist art emerges as more socially engaged and more radical than previous critics have made it seem.

It is true that existentialists shared the abstract expressionist desire to articulate a reality that exceeded conventional concepts and forms, as the above quotation from Hannah Arendt illustrates. Indeed, Arendt's words suggest that art may be superior to philosophy as a mode of metaphysical investigation, since only through materials and individuals can the truth be grasped; thus philosophers, yoked to words and concepts, are incapable of addressing the "real." This attitude, condemning abstract thinking as a falsification

of experience, indicates a common ground shared by existentialist and avant-garde agendas.

However, existentialism was far less central to the work of the postwar avant-garde than it has been made out to be.[2] William Barrett, who once spoke about existentialism at the abstract expressionists' Eighth Street "Club" at the request of Elaine de Kooning, did not feel that his disquisition made much of an impression, despite the attentiveness of his audience.[3] The philosophical sources tapped by the avant-garde during the postwar period ranged from existentialism to the "process philosophy" of Alfred North Whitehead, the "gestalt therapy" of Paul Goodman, and even Zen Buddhism.

Unlike existentialism, these other philosophies can be classed as "field" theories, for they posit the existence of a continuous field of energy that is prior to any experience of individuality. The significant influence of field theories on the aesthetic of spontaneity will be explored in subsequent chapters. The present chapter establishes that within the broad confines of abstract expressionist gesture painting, two types of approach can be discerned: the school of Willem de Kooning (existential) and the school of Jackson Pollock (field).[4]

Artists of both schools used their painting as a medium for grappling with the problem of subjectivity. Their exploration of subjectivity entailed a potentially radical rethinking of the relation of the individual to his or her social and material environment—an investigation embodied in the artistic form of the palimpsest. Painting was for abstract expressionist gesture painters an act requiring "honesty" and entailing both aesthetic and psychological "risk."[5] Each painting rehearsed the psychological interactions through which individual subjectivity was formed, emerging as a repeatedly reinscribed surface.

Existentialism and the Paintings of Willem de Kooning

In his influential essay "The American Action Painters," Harold Rosenberg used an existentialist vocabulary to describe abstract expressionist gesture painting.[6] The propensity to link abstract expressionism with existentialism has persisted, sometimes abetted and sometimes resisted by the artists themselves.[7] It remains for today's reader to distinguish what was and was not to the point in Rosenberg's venture into a new vocabulary of art criticism.

Rosenberg's essay of 1952 challenged the formalist readings of abstract expressionism that his fellow art critic Clement Greenberg had used to legitimate the new movement five years earlier. Greenberg had emphasized abstract expressionism's debt to cubism, particularly its effort to assert the

"flatness" of the picture plane. But he had neglected the metaphysical and social issues that such aesthetic concerns encoded, suppressing the central role that surrealist automatism had played in the evolution of the new American painting. Rosenberg was the first critic (aside from the painters themselves) to assert the primary importance of what Robert Motherwell had called "plastic automatism."[8]

What distinguished abstract expressionist art from both surrealism and cubism, according to Rosenberg, was its intense dramatization of the process of painting, as if to imbue each gesture of the painter with the quality of a difficult moral decision:

> At a certain moment the canvas began to appear to one American painter after another as an arena in which to act—rather than as a space in which to reproduce. . . . [H]e went up to it with material in his hand to do something to that other piece of material in front of him. The image would be the result of this encounter . . . What matters always is the revelation contained in the act.

Appreciating this type of painting, he continued, required a new attention to the artist's physical gesture as embodied in the poured or painted line. Each stroke should be examined for "its inception, duration, direction"; these formal characteristics in the line suggested psychological dynamics in the painter: "concentration and relaxation of the will, passivity, alert waiting."

This still seems an accurate description of abstract expressionist gesture painting. But Rosenberg was less adept in defining how the "action painters" intended their art to relate to life. He manifested his concern on this point with an epigraph which suggested that action painting might be too easy a solution to difficult social problems.[9]

The former Trotskyite's reservations were rooted in his understanding of gesture painting as "a movement away from" the social consciousness of the past decade. "Art as action rests on the enormous assumption that the artist accepts as real only that which he is in the process of creating," he observed. This Promethean effort was what Rosenberg admired in the art; it was also the source of his ambivalence about the art's ultimate social value. Intent on defining the subject matter of this painting wholly through its emphasis on "action," Rosenberg jumped to the conclusion that it endeavored to *supplant* the outside world with the microcosm of the painted canvas. "The lone artist did not want the world to be different, he wanted his canvas to be a world," he wrote. "Liberation from the object meant liberation from the 'nature,' society and art already there."

Rosenberg's difficulty on this point stemmed from his overidentification of the new art with the recently arrived philosophy of existentialism. Existentialist vocabulary is everywhere present: in his description of

action painting as a "refusal" and as an effort "to nullify [the artist's] promissory notes to the past"—even down to his invocation of Kierkegaard's "anguish of the esthetic." Concerning the relation of art to society, Rosenberg's existentialist framework implied that the new art constituted a principled attempt at liberation *from* society. Some painters "take advantage," Rosenberg complained, when "having insisted that their painting is an act, they then claim admiration for the act as art." Only through the prism of existentialist thought does this statement make sense. Plainly, "acts" can be qualitatively different, and painting is an act of a particular, artistic sort that, like some acts but unlike others, has as its goal the communication of certain perspectives or conditions. But such distinctions seem unavailable to Rosenberg, who persisted in misunderstanding "the act" as an existentialist gesture of "freedom." Rosenberg's problem in fully comprehending spontaneous art lay in his excessive allegiance to understanding the "action" of action painting within an existentialist framework.

Existentialism, however, was but one extreme of a continuum of philosophies from which members of the avant-garde drew their understandings of the relationship of the individual to the social and physical world. Our continuing sense of existentialism's unparalleled importance to postwar American arts and letters is a misperception that derives from existentialism's popularity among established intellectuals and writers of the era, whose interests set the tone for later interpretations.[10] Readers of the *Partisan Review*, for instance, were introduced to existentialism in 1946, through a series of essays by William Barrett, Hannah Arendt, Simone de Beauvoir, and Jean-Paul Sartre and an excerpt from Sartre's existentialist novel *Nausea*.[11] In 1947, William Barrett published a book-length treatment entitled *What Is Existentialism?*. In the same year, Camus's *The Stranger* was translated, and Sartre's plays *No Exit* and *The Flies* were produced in New York City.

In literary circles, existentialism appealed particularly to the New Critics and to writers in the T. S. Eliot tradition of modernism, to which the culture of spontaneity was often self-consciously opposed.[12] W. H. Auden's 1947 poem "The Age of Anxiety" announced in its very title the wish to be considered an existentialist work. This mock epic poem in dramatic dialogue describes the plight of the alienated individual. Four lonely people meet in a bar during wartime and get happily drunk together; two of them contemplate a sexual liaison. But all eventually realize that they are trapped within their own worlds, and that the communion they hunger for will never occur.[13] Existentialism in art focused on themes of alienation: the mixed feelings of desire and disgust toward the body; the wistful but doomed search for human community; and the effort of the conscious mind to transcend history and material circumstance. When

Rosenberg described the "action painters" as trying to "liberate" themselves from nature, society, and the past, he was describing an attitude more in keeping with these themes from Auden's work than with the main impulse of gesture painting.

Existentialism and the aesthetic of spontaneity were most similar in their shared condemnation of the way fixed conceptual structures truncated and falsified reality. Existentialism insisted that human experience exists prior to conceptualizations about it, and in fact cannot be wholly encompassed by such concepts. "Existence," then, refers to the capacity to have experiences that exceed such mental projections.[14] Existentialists struggled to live "authentically," open to the possibilities of existence, and to avoid enslavement to the dictates of conceptual structures and social norms.

Yet the basic difference between existentialism and most gesture painting is revealed in their attitudes toward the body. Significantly, the human body is present in Auden's poem only as the site of hopeless and slightly shameful longings. Existentialism characteristically preserved vestiges of a Cartesian dichotomy between the thinking mind and the material body. Sartre's masterwork, *Being and Nothingness*, was subtitled *A Phenomenological Ontology*, implying that existentialism, like phenomenology, attributed "reality" only to the subjective experiences (or phenomena) of human existence: the actual interface between the conceptualizing consciousness and material facts. But in fact, in Sartre's writings the material world and consciousness remain separate, locked in a tug-of-war that defines "existence."[15]

Despite their insistence on the mind's limitations, existentialist writers reserved a key role for consciousness. Only beings with consciousness could have freedom, because the conscious mind had a unique and mysterious power to choose among potential actions. Through such choices, humans could transcend and defy the "meaningless" determinism of the physical universe. According to William Barrett, "In the Sartrean view, our life is a free project which we launch into the world: we choose the self that we become, and the authenticity of the life is to be measured by the fullness of our commitment to our freely chosen project."[16]

This dichotomy between the freedom of conscious choice and the determinism of inert matter sheds light on characteristic existentialist idiosyncrasies. Existentialists valued dramatic choices in extreme and symbolic moments as vindications of freedom. Also, because they identified experience with *conscious* experience, they assumed angst to be the thoughtful person's inevitable fate. "Angst" denoted a sense of the inherent aloneness of the individual consciousness, doomed to isolation and ultimately to death, yet charged with the monumental task of creating meaning and moral sense in a godless and purposeless (or "absurd") uni-

verse.[17] Such an idea makes sense only if one posits a radical disjunction between the individual mind and its surroundings, including the body in which the mind is "housed."

The existential "I" confronted material existence with mixed feelings of desire, apprehension, resignation, self-irony, and disgust. Sartre's piece in the *Partisan Review* described nature as "Soft, bare disorderly masses, monstrous and obscene in their frightful nudity. . . . These great ungainly bodies . . . it was the World, the naked World which had suddenly shown itself, and I was choking with rage against this huge absurd thing."[18] An existentialist who managed to evade the tyranny of concepts risked "nausea," being overwhelmed by the sheer physicality of existence.

If we approach abstract expressionist painting armed with the interpretive apparatus of existentialism, the works of Willem de Kooning stand out as the most fully realized expression of the movement.[19] The above quotation from Sartre's *Nausea* seems an excellent gloss for the *Woman* series that de Kooning painted between 1948 and 1955 (plate 2). These palimpsests record the constantly permuting encounter between the artist and his model, fulfilling de Kooning's stated intent to capture "the emotion of a *concrete* experience."[20] They depict the human body not as the container of an ideal essence, but as organic matter that confronts the mind of the painter: these are messy bodies, spilling outside projected boundaries, leaking into their surroundings, leeringly imposing their presence. The figures' large breasts, strongly demarcated pubic areas, and predominant flesh tones emphatically evoke a desirable but threatening female sensuality. Their overpainted surfaces, slashed by strong brushstrokes, dramatize the blend of eagerness and frustration attending the artist's effort to represent these bodies on canvas. Their almost obsessive reworking implies that the artist conceived of the task as impossible or never-ending, a version of the mind's struggle to impose order on existence.

De Kooning developed a painting technique designed to enhance this sense of struggle between the artist and his materials. He purposely used brushes that were very difficult to paint with, preferring brushes with handles two feet long and bristles that were "dead": boiled in water until "blubbery." This gave his painting a tortuous and uncontrolled quality; "They have a certain awkwardness," he stated, ". . . which I like."[21]

Not surprisingly, Harold Rosenberg felt that Willem de Kooning was the quintessential "action painter."[22] He wrote that de Kooning's greatness derived from his determination "to court the undefined, to keep his art and his identity in flux":

> Rejecting any external definition of himself or preconception as to the direction of his work, his sole concern has been to maintain touch

with himself. . . . Painting for de Kooning is . . . a real action comparable to crossing an ocean or fighting a battle. . . . Each confrontation of the drawing board or canvas is a singular situation calling for a new act—and the act and the artist are one.[23]

De Kooning's own statements about his painting also relied heavily on existentialist constructions. In 1949, for instance, he stated: "Sometimes I find myself having become desperate . . . One is utterly lost in space forever . . . to tremble in it is maybe the best. . . . The idea of being integrated with it is a desperate idea."[24] At another time, he described his painting as an almost arbitrary leap toward meaning in the face of the absurd: "It's really absurd to make an image, like a human image, with paint, today, when you think about it, since we have this problem of doing or not doing it. But then all of a sudden it was even more absurd not to do it."[25]

Though he professed an arbitrariness with regard to subject matter, de Kooning's preference for taking women (and, later, landscapes) as the starting points for his palimpsests distinguishes his work in an important way from the paintings of Jackson Pollock. De Kooning's work presents his subjective experience of things that are external to his consciousness and impinge upon it. It is therefore truly deserving of the name "abstract expressionism." De Kooning used the traditional technique of abstract art which involved taking a recognizable object and breaking it down into brushstrokes and abstract shapes. He complicated this traditional style by constructing the figure as a composite not only of shapes and planes, but also of shifting memories, concepts, and perceptions, so that the painterly act vies with the figure itself for preeminence as the subject of the painting. This emphasis on the perceiving mind confronted with the (inconstant) object of perception bespeaks de Kooning's alignment with an existential perspective.

In the "gesture-field" palimpsests of Pollock, by contrast, no outside object is taken as the starting point. Pollock's palimpsests are not about an existential meeting between the painter-subject and the painted object. Rather, they attempt to present a state of awareness prior to the articulation of a conscious subject and a fixed object of attention. When Hans Hofmann asked Pollock whether his painting had any relation to nature, Pollock responded: "I *am* nature"—implying that Hofmann was wrong to think of nature as an object external to Pollock-as-painter.[26]

JACKSON POLLOCK'S GESTURE-FIELD PAINTINGS

Because of his extensive academic training, Robert Motherwell was probably more familiar with existentialism than most members of the postwar avant-garde were. He was friends with the "*Partisan Review* crowd" be-

tween 1946 and 1948, when that magazine introduced existentialist thought to American readers.[27] But Motherwell countered Rosenberg's existentialist interpretation of the new American painting with references to "an energetic field of force":

> [T]he content of abstract expressionism has to do with energy . . . an energetic field of force. . . . All that we abstract expressionists were doing was shifting from the object to forces [and to] . . . emphasis on "process" . . . which is all Rosenberg's loaded p[ublic] r[elations] term "action painting" can mean if you look at the pictures instead of being hypnotized by his rhetoric.[28]

Motherwell was alluding to the influence of field theories that will be explained in the next three chapters. Most gesture painters were not swayed by the existentialist idea that conscious choice was the only source of freedom in a meaningless physical universe. They were interested in the continuum between mind and body that provided a common foundation for conscious and unconscious thought.

Jackson Pollock's palimpsests epitomize this tendency. They developed from his mid-decade experiments with ideographs.[29] Ideographic paintings aimed to create spatial representations of unconscious idea-complexes beyond the communicative capacity of written language. Pollock's palimpsests took this idea one step further, engaging the unconscious mind through its locus in the human body.

One key innovation was Pollock's idea to put the unstretched canvas on the floor and to paint while walking around it and even onto it. In the summer of 1946, Pollock created a series of paintings (*Sounds in the Grass*) using this technique.[30] As he explained, "I feel nearer, more a part of the painting, since this way I can walk around it, work from the four sides and literally be *in* the painting."[31]

The structure of *Sounds in the Grass: Shimmering Substance* (plate 3) immediately anticipates the "all-over" palimpsest painting that became Pollock's signature style. In earlier paintings, Pollock's gestural markings overwrote a central quasi-figurative image, but the image continued to be the focus of the painting's composition. In the new paintings, by contrast, the overwriting had become the image. In *Shimmering Substance*, the right half of the yellow circle that comprises the primary visual structure threatens to break free of the picture plane, but is reincorporated into the fabric of the whole by the shorter marks overwriting it. These tensions between figure and ground, as the figure emerges or recedes in conjunction with the quality of attention of the viewer, *are* the subject of the painting.

Such energy dynamics were presented in even greater complexity in the palimpsests that began to emerge from Pollock's barn studio around New Year's Day, 1947 (plate 4). In these, there is no single figure that

emerges from an undifferentiated ground, but a multitude of potential "figures" which cumulatively form the "ground." After the summer of 1946, most of Pollock's paintings consisted of such entwined gestural strokes.[32]

In Pollock's gesture-field paintings, there is a constant dynamic of change between figure (what the viewer's perceptual apparatus makes the focus of attention) and ground (other stimuli that recede from the viewer's awareness).[33] Strokes merge into figures, which soon dissolve while new combinations of strokes assert themselves as figures. This dynamism contrasts sharply with traditional representational painting, in which a static and hierarchical figure-ground distinction is defined by the painting's composition, with the subject of the painting foregrounded. Complicating the relationship of figure and ground was of course not original to Pollock. It had been the subject of painterly experiments by Cézanne, Matisse, and the synthetic cubists. But none of these earlier works challenged the viewer to constantly reorient figure and ground as Pollock's paintings do. As Lee Krasner observed of the figure-ground dynamic of Pollock's painting, "It breaks once and for all the concept that was more or less present in the Cubist derived paintings, that one sits and observes nature that is . . . out there. Rather it claims a oneness."[34]

RADICAL SUBJECTIVITY

Krasner's statement identifies what was potentially radical about abstract expressionist formulations of subjectivity. The idea that "one sits and observes nature that is . . . out there" is fundamental to the scientific method, which posits a dichotomy between the dispassionate, observing mind and objective, observed matter. Although the technologies that this scientific attitude had made possible were the basis of postwar America's unprecedented "standard of living," they were equally implicated in the engineered destructiveness of the Holocaust, the atom bomb, and the Cold War. In its search for social alternatives, the avant-garde rejected this "objective" mind-set in favor of a different humanistic paradigm.

Abstract expressionist gesture painters emphasized the subjectivity of experience through the trope of painterly "dialogue." A subjective epistemology privileges dialogue over logical exposition as a means of communication.[35] The logical exposition of an argument implies an objective perspective governed by a universal order. Subjectivity suggests that there is no ultimate truth to be arrived at—only differing perspectives that can perhaps be synthesized. This is how a dialogue is structured.

Harold Rosenberg correctly assessed action painting as a kind of dialogue between the painter and the emergent work of art. "A good painting in this mode leaves no doubt concerning its reality as an action and its re-

lation to a transforming process in the artist," he wrote. "The canvas has 'talked back' to the artist not to quiet him with Sibylline murmurs nor to stun him with Dionysian outcries but to provoke him into a dramatic dialogue."

In his survey of American thought and culture in the 1940s, William Graebner has noted: "Many forties intellectuals proposed to do battle with totalitarianism not in the name of an opposing ideology such as capitalism, but by investing themselves in a series of purportedly nonideological processes: debate, inquiry, critical dialogue, discussion."[36] Gestural palimpsest painting, with its translation of values such as openness, dialogue, and integrity into painterly processes, can be seen as one manifestation of this broader intellectual phenomenon. But it is important to realize that, for many artists employing the spontaneous aesthetic, the word "capitalism" in the first clause of Graebner's statement could have been exchanged for "Communism," with corporate liberalism identified as the "totalitarian" regime. Amidst the confusing political tides of the Cold War era, many found themselves incapable of joining enthusiastically on any side. Painter Jack Tworkov summed up his political beliefs in 1948 by stating that the choice between Communism and capitalism amounted to little in the struggle for the betterment of humankind; more important, and potentially antithetical to both, was the cultivation of "material, spiritual, and cultural integrity," which he defined as respect for one's materials, regard for the community of all humans, and the ability to explore new ways.[37]

Existentialism, because it emphasized the subjective quality of experience, challenged the dominant myth of objectivity to some extent. According to existentialists, the best way of living could not be calculated by any universally valid system; each person could define good only through the subjective process of living. The antinomian iconoclasm of existentialist subjectivity was potentially subversive in America's Cold War society. Sartre had developed his philosophy as a vindication of resistance against the Nazi occupation of France, and its modes of resistance were equally suitable for contesting the authority of American experts and officials claiming to define America's "national interests." Existentialism encouraged defiance against the conformity of Cold War anti-Communism and the regimented work culture of corporate liberalism.

Though Willem de Kooning did not explicitly address such issues, he presented this attitude through a painterly idiom that his contemporaries understood. As Harold Rosenberg wrote of de Kooning's work: "Unbending adherence to individual spontaneity and independence is itself a quasi-political position—one condemned by Lenin, outlawed in totalitarian countries, and repugnant to bureaucrats, conformists, organization men, and programmers."[38]

In some ways, though, existentialism's challenge to the postwar American social order was dubious. Existentialism was traditionally liberal in its formulation of subjectivity as a situation that pitted the individual against the constraints of society. This attitude was a legacy of existentialism's mind/matter dualism: implicitly it is a version of the angst-ridden struggle between the individual consciousness and a hostile environment. But American intellectuals and demagogues alike already honored the principle of individualism—in theory, if not always in practice—and used it as an ideological justification for the postwar social order.

Because of existentialism's individualistic bent, the importance of dialogue or *inter*subjectivity was almost an afterthought in existentialist theory. It was developed belatedly as an antidote to the philosophy's potential for solipsism, and it remained an ethical directive that was more prescriptive than descriptive.[39] By contrast, in the field theory that informed the art of Jackson Pollock and his followers, intersubjectivity was not a moral choice but an inescapable fact, intrinsic to human experience.

This can be seen in the paintings themselves. Willem de Kooning's *Woman* palimpsests do not present a dialogue between the painter and the Woman. They present an exclusively internal conversation in which the artist's subjectivity emerges through his struggle on the canvas with his *image* of Woman. She is, phenomenologically speaking, his mind's "intentional object." Pollock's palimpsests, however, are dialogues in which the subjectivity of the artist emerges only through the "plastic" world around it, represented synecdochically by the materiality of the paint. Here I use the term "plastic" the way Robert Motherwell and, before him, William James used it, to describe a quality of relative resistance. As William James wrote:

> Plasticity . . . means the possession of a structure weak enough to yield to an influence, but strong enough not to yield all at once. . . . The material in question opposes a certain resistance to the modifying cause, which it takes time to overcome. . . . [W]hen the structure has yielded, the same inertia becomes a condition of its comparative permanence in the new form, and of the new habits the body then manifests.[40]

Pollock's painting presents a model of subjectivity in which the human organism and its environment shape one another, engaging through the body in a continuous plastic dialogue. There is no "individual" external to the process.

As opposed to the Cartesian dualism, Pollock's paintings dramatize the holistic connection between "mind" and "body" in human experience. His technique of controlled pouring allowed him to use his whole body in dialogue with the paint. Hans Namuth's documentary film from 1952

shows Pollock moving rhythmically around the canvas, waving his arms as a thread of paint spools from the tip of a stick he is holding. This method has been accurately described as "physiological automatism."[41] As Matthew Rohn has explained, "His body's neural feedback mechanisms, which allow the mind to react to movement and constantly changing situations, abetted the visual acuity on which an artist who has planted his body as a fixed stanchion relies almost exclusively."[42]

Because plastic dynamics are integral to Pollock's gesture-field painting, it is misleading to call it "abstract" painting simply because it is not figurative. As George McNeil observed in 1956: "'Abstract art' is an unfortunate misnomer—it is actually the most concrete of art styles."[43] Indeed, its insistent materiality was intended as a radical counterstatement to the "abstract" quality of the scientific method.

Viewing one of these paintings is a form of serious play, an exercise in awareness. It is an instance of the way the human organism experiences reality—and experiences itself—by creating objects of awareness amidst the field of stimuli in and around it. Some of Pollock's titles refer to this process by alluding to the way our bodily senses isolate sensory "figures" from the complex web of sensory stimuli: *Scent*, from 1955; and of course the crucial transitional series, *Sounds in the Grass*, of 1946–47.

Pollock's work implies that human subjectivity is a phenomenon in and of the "energy field." The gestural field of the painting exists prior to the emergence of any figure: a synecdoche for the existence of the energy field prior to the emergence of subject-object relations. (Hence Pollock's statement, "I am nature.") Donald Kuspit has commented that gesture-field paintings record the "dialectical moment in which subjective and objective inextricably condition one another" through the plastic medium of paint. A recognition of this dialectic, he continues, "prevents us from misreading [Pollock's art] as rank subjectivism" and hence as "expressionism." Its fundamental premise of a continuity between mind and body is far from existentialist solipsism.[44]

The avant-garde's sources of field theory were several. French phenomenologist Maurice Merleau-Ponty was one thinker connected to existentialist circles who did engage the question of the body's role in experience.[45] Merleau-Ponty's work synthesized phenomenology with ideas from gestalt psychology, a branch of experimental psychology devoted to studying perception. Among the postwar American avant-garde, though, the most influential source of gestalt theory was the psychology of Paul Goodman. Many artists also investigated Taoism (which was another of Goodman's primary sources) and its Japanese variant, Zen Buddhism. And the "process philosophy" of Alfred North Whitehead greatly influenced the thinking of Charles Olson and Robert Motherwell, affecting other writers and artists indirectly through them.

Gesture-field painting's reformulation of subjectivity to reject the culturally predominant mind/body dualism is the most radical aspect of abstract expressionism. It challenges the myth of liberal individualism and calls us to rethink our environmental and social relations, but not in the name of "scientific socialism." Most obviously, the ideological split between mind and matter has been at the root of a whole set of structural dichotomies favoring social groups associated with the "mind" or spirit over others associated with the "body": White/Negro; Christian/heathen; male/female; and white collar/blue collar. Gesture-field painting implies that cultural efforts to "free" particular oppressed groups from associations with the body are less useful than rooting out this ideological dualism and restoring bodily status equally to all.[46]

THE SCHOOL OF DE KOONING
AND THE SCHOOL OF POLLOCK

Most postwar gesture painting can be typed as belonging either to the school of de Kooning or to the school of Pollock.[47] Franz Kline presided, along with de Kooning, over the social scene at the Cedar Tavern in Greenwich Village, where second-generation abstract expressionists congregated.[48] Like de Kooning, Kline used landscape as a point of departure for large, multireferential, palimpsest paintings. His painting transformed such landscapes into broad gestures in black and white; still, many works preserve "architectural" structures and titles alluding to industrial landscapes (fig. 4.1). Several second-generation abstract expressionists took Kline and de Kooning as their mentors. These included many who moved away from abstraction to return to figurative subjects; Irving Sandler has called these artists "Gestural Realists." Among the most notable were Grace Hartigan, Larry Rivers, and Joan Mitchell, who characterized her own painted landscapes as "a memory of a feeling."[49]

Among the best-known painters of the school of Pollock were Jack Tworkov, James Brooks, and Helen Frankenthaler. Their work, as gesture-field painting, defines the main stream of the postwar culture of spontaneity. Jack Tworkov's biography reveals elements common to many members of this cultural formation. The experience of ethnicity was central to his identity: he was born in Poland, in 1900, as Jacob Tworkovsky, and his family emigrated to New York City's Lower East Side in 1913. He always thought of himself, as he wrote of Chaim Soutine, as "a transplanted shtetl Jew in cosmopolis."[50] From 1934 to 1941, he worked in easel painting for the WPA. In 1935 he began writing a book on the social meaning of art, which he never completed.

From 1948 to 1955, Tworkov worked in a studio next door to Willem de Kooning's.[51] Beginning with experiments in cubism, he developed in

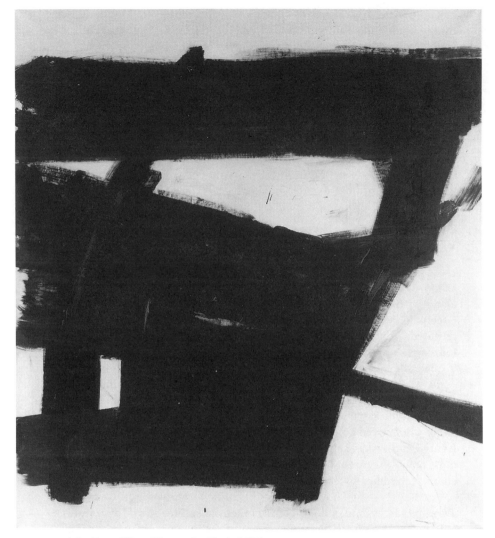

4.1. Franz Kline, *Wanamaker Block,* 1955

the late 1940s toward a painting style very like de Kooning's at that time. His *Sirens,* 1950–52, shows marked similarities to de Kooning's *Woman* series. In the mid-1950s, however, Tworkov began increasingly to make plastic and physiological automatism the subject matter of his painting.[52] His conversion to the gesture-field style was complete by the late 1950s; as he stated in 1959, "Much of my work is based on linear energy becoming mass . . . It is really what I have in common with so different a painter as Pollock." Describing his painting as a synecdoche of experience, Tworkov

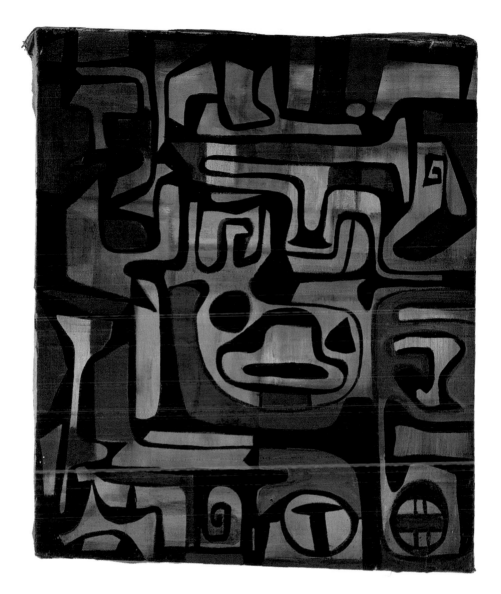

1. Howard Daum, *untitled #264*, c. 1946

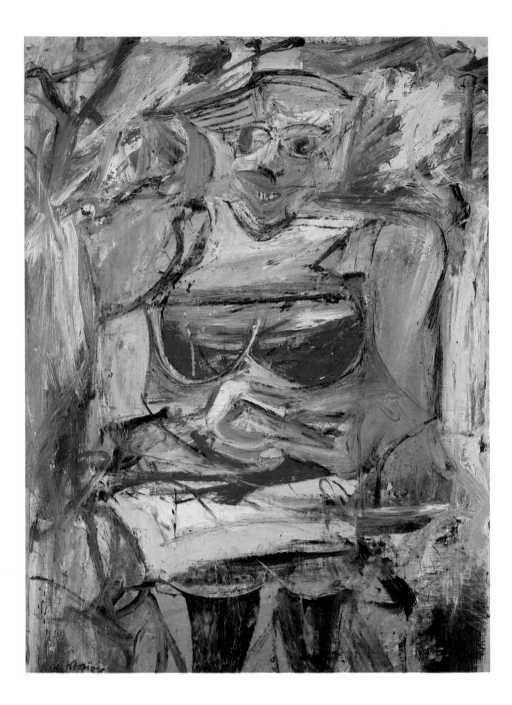

2. Willem de Kooning, *Woman V*, 1952–53

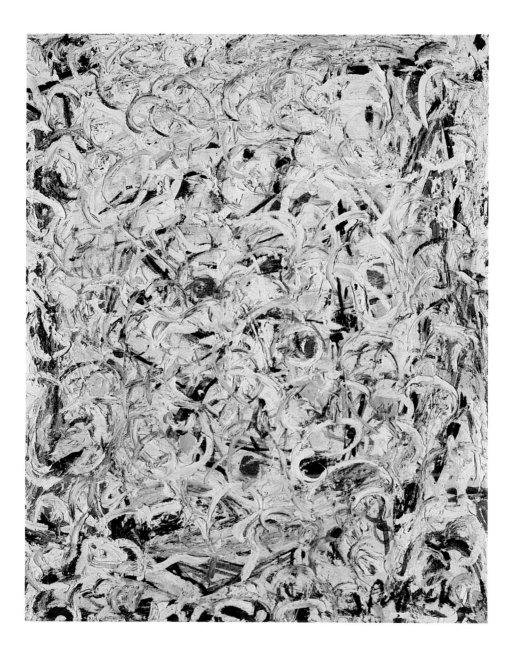

3. Jackson Pollock, *Sounds in the Grass: Shimmering Substance*, 1946

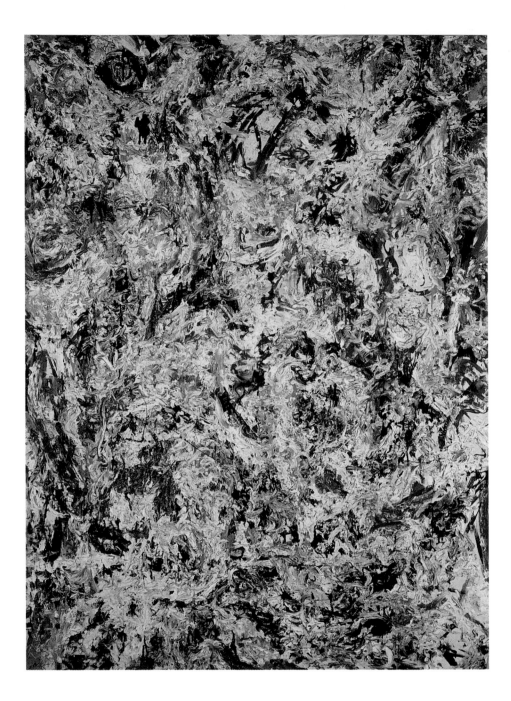

4. Jackson Pollock, *Scent*, c. 1955

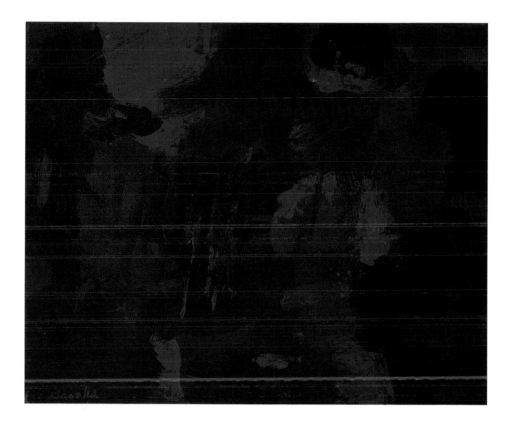

5. James Brooks, *A-1953*

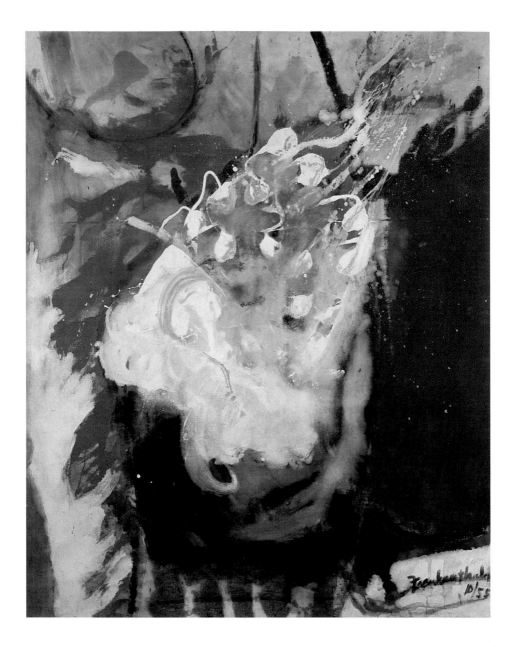

6. Helen Frankenthaler, *Holocaust*, 1955

7. Robert Motherwell, *Yellow Envelope*, 1958. © 1997 Dedalus Foundation Inc./Licensed by VAGA, New York, NY

8. Lee Krasner, *Blue Level*, 1955

rejected the dramatic cachet of "action painting" in favor of the image of a continuous field of energy, asserting, "My painting does not speak of the moment of crisis, but of any moment in an endless action."[53]

The principles of energy field, plastic dialogue, and synecdoche are equally evident in the works of James Brooks. Born in St. Louis in 1906, Brooks moved to New York City at the age of twenty, and worked as a muralist for the WPA during the 1930s. His associates included Pollock and Krasner, Philip Guston, and Bradley Walker Tomlin. He began experimenting with abstract painting in 1945. In 1946, when the Pollocks moved to Springs, Long Island, Brooks moved into Pollock's New York City studio.

Between 1948 and 1949, Brooks's work developed from a modified cubism, like that of the Indian space painters, to a looser, more gestural style. This formal change was rooted in a new reliance on plastic and physiological automatism. He described his new painting process as taking off from accident, "done with as much spontaneity as possible."[54] He based the forms in his paintings on bodily gestures; as a result, he insisted, his paintings were of a piece with nature, rather than representations of it (plate 5).[55] Brooks was unusually articulate in stating his principles in terms indicating the influence of field theory. As he wrote:

> The conflict between spontaneous and deliberate behavior, a great dualism of modern times, is felt keenly by the artist. It is also probably resolved most successfully by him because he deals with the actual form of the process of development, in which the static concepts of subject and object, spirit and matter, freedom and necessity, the immediate and tradition, have become harmless paradox.[56]

Whereas Pollock and Tworkov both began their paintings with linear strokes and gradually built up densities, Brooks would begin with densities, such as stains soaking through the canvas, and develop them into gestures. This approach was also used by Helen Frankenthaler, who used pools of paint to create broad stains on the canvas, so that she has sometimes been classed as a "color-field" painter.

Born in 1928, Frankenthaler is a second-generation abstract expressionist. She was introduced to many of the first-generation painters by Clement Greenberg around 1950. On first seeing Pollock's gesture-field paintings, she felt as if she had suddenly entered a foreign country that intensely interested her; "I *had* to live there," she has said, "and master the language."[57]

In an interview with Henry Geldzahler, Frankenthaler explained why she chose to paint in the style of Pollock rather than in that of de Kooning: whereas de Kooning had a "manner" within the genre of conventional easel painting, Pollock had an "attitude" that moved beyond that generic

form. As she put it, "De Kooning made enclosed linear shapes and 'applied' the bush. Pollock used shoulder."[58] Frankenthaler saw Pollock's work as springing from the physicality of the whole body, allowing the greater scale, power, and openness that she coveted. She also saw, in Pollock's plastic automatism, the possibility of engaging the actual processes of nature, not just the image of nature-as-object: "I thought that Pollock was really the one living *in* nature, much more than Bill." Frankenthaler adopted Pollock's method of all-over composition, spreading large canvases on the floor of her studio to enable herself to work "into the field."[59] By pouring paint onto unprimed canvas and letting it soak in, she accomplished the integration of surface and image that Pollock achieved with his "drip" technique (plate 6).

Because her method of handling paint was not as vigorous as de Kooning's or Pollock's, during the 1950s Frankenthaler was not accorded recognition as an "action painter." Harold Rosenberg, with his existentialist leanings, was clearly incensed by her disinclination to assert her will over the paint to the extent he thought necessary. In a review of her work, he wrote:

> With Frankenthaler, the artist's action is at a minimum; it is the paint that's active . . . Apparently, Miss Frankenthaler has never grasped the moral and metaphysical basis of action painting, and since she is content to let the pigment do most of the acting, her compositions fail to develop resistances against which a creative act can take place.[60]

Once we have defined the genre not as "action" painting but as "gesture-field" painting, however, there can be no question of Frankenthaler's centrality.[61] Perhaps, in her dialogue with the paint, she listened more than she spoke. Certainly she understood her painting as a synecdoche of her bodily experience. In an interview with Barnett Newman, she explained: "Since the painting was made by me, it is my echo, or mirror, or Gestalt."[62] Critics other than Rosenberg have recognized the gestural quality of her work. Carl Belz wrote, "Its physical range extends from body to arm to wrist to fingertip."[63] New York poet Frank O'Hara, who admired both Frankenthaler and Paul Goodman, saw affinities between Frankenthaler's style and Goodman's gestalt therapy. O'Hara wrote in the early 1960s: "Her major works signify the whole psychic figure and it is all there: back, shoulder, arm, hand, and eye."[64]

Other painters who should be numbered among the school of Pollock include Philip Guston, Michael Goldberg, and Norman Bluhm. All appeared along with many other gesture-field painters in *It Is: A Magazine for Abstract Art*, which was published thrice yearly between 1958 and 1960. This magazine championed the cause of abstract expressionism af-

ter its short-lived hegemony had been challenged by pop art and the revival of figurative painting.

In the end, it is probably impossible to assess the degree to which the many gesture-field painters of the 1950s and 1960s were aware of the metaphysical and social contents of their style. At the same time, at least some of them were quite clear about it. In a symposium on all-over painting published in the second issue of *It Is* magazine, Martin James summarized what he understood as the "assumptions, content, and consequences" of gesture-field painting, calling it "a meaningful integration of plastic solutions and attitudes to the world." James identified two convergent trends that had led to the development of the style. The first was an impulse toward "*immediacy*, the unbroken flux of experience . . . the expression of energy, the inter-involvement of artist, work and viewer, toward a concreteness that short-circuits symbolism and complex thought." The second trend was the desire to put painting in the service of "a philosophical—an epistemological—quest," for "*truth*, and the revolutionary consequences of truth for culture." But unlike previous avant-garde movements, James wrote, the new painting did not strive for or lay claim to any *fixed* truth or universality. Instead, "It is an inter-subjective event (lest we utter the forbidden word 'communication'); it possesses not truth but *efficacy*—or validity or viability or conviction or power."[65]

The impetus of postwar gesture-field painting drew away from the ideal of timeless art that was expressed in high-modernist abstractions like Mondrian's, and toward a conception of the best art as the record of a contextualized subjectivity. Conditioned as we are to equate value with longevity in art, we may still find it a challenge to accept the revision that some spontaneous art proposes: that the most socially significant art is exactly that art which is ephemeral, interpersonal, and speaks powerfully in the moment and situation for which it is created—an art, in short, with no afterlife; an art of occasion and of "presence." As Oscar Collier wrote in 1946 in *Iconograph* magazine: "Does it matter whether culture in America is temporary or contemporary, in the final analysis? As I said recently in a letter . . . 'Great Art may bore me but never my own.'"[66]

5

Subjectivity in the Energy Field: The Influence of Alfred North Whitehead

The naive old refrain, the *one-two-three* of the Dialectic, ended in a death-dance; and the "primacy" of matter over thought cannot even be discussed any more at a time when science has given up thinking of matter otherwise (to speak popularly) than as a transitory state of energy. . . . Perhaps it was necessary to possess the conclusive proofs of contemporary physics to comprehend *objectively* the perfect, irrefutable reciprocity between causes and effects, in order to know definitely that every separation between means and ends is arbitrary and erroneous.

—Wolfgang Paalen, *Dyn* (1942)

As the above text from Wolfgang Paalen's *Dyn* magazine illustrates, the avant-garde of the 1940s rejected the "dialectical materialism" of Marxism as the basis of their opposition to corporate-liberal culture. Paalen's writings were influential among those artists who during the war years seized on the idea of "participation mystique" to define their efforts to construct an alternative metaphysics through art. In the late 1940s and through the 1950s, this notion of "participation mystique" became amalgamated with the idea of the "energy field." As opposed to the atomistic individualism of classical liberalism, the energy field model of human experience defined it as emerging from a "field of force" that was prior to any individual identity.

As Paalen's above words suggest, the avant-garde's most important source of the "field" model of social relations was twentieth-century physics, which defined objects as events constituted by a field of energy in space-time. In classical (Newtonian) physics, an electromagnetic field was defined as an arrangement of discrete, electrically charged particles. This field exerted a

force on each particle determined by the position of the particle in relation to the others.[1] But modern (Einsteinian) physics inverted this concept, defining "particles" themselves as stable patterns of electromagnetic waves. This model viewed the energy field as primary, and the "objects" in it as complicated perturbations of that field.

It was from the writings of Alfred North Whitehead, who taught philosophy at Harvard during the 1930s, that the avant-garde culled their ideas of the human and social implications of the new physics. Whitehead had developed a comprehensive metaphysical system based on the new physics, which has come to be known as "process" philosophy after the title of his book, *Process and Reality*, published in 1929.[2] Whitehead came to philosophy from a background in mathematics. Faced with the loss of a son during World War I, he had become frustrated with the inability of abstract mathematical logic to address social realities. He turned his attention away from the fantasies of non-Euclidean geometry to address the empirical question "Which [geometrical system] is demanded by the actual facts of nature?"[3] This question led him to Einsteinian physics.

In 1947, Barnett Newman would employ this very distinction between math and physics to differentiate abstract expressionist art from its European predecessors. Like physics, Newman asserted, abstract expressionism referred to lived experience in a way that surrealism and neoplasticism did not. "If I may make an analogy," he argued in a description of the new American painting, "it is as if we were to compare an Einsteinian formula to a non-Euclidean geometry. In [the former] the formulas are symbols that evoke . . . the imagined idea-complex that is Einstein's vision of a cosmos. In the other we have a pure world of esoteric mathematical truth, a fantasy in symbolic logic." Newman insisted that it was not fantasy but metaphysics that led the American avant-garde to experiment with new forms. "The Americans evoke their world of emotion . . . without the props of any known shape," he wrote; "This is a metaphysical act."[4]

The energy field model of human experience led painters and poets to develop artistic forms consistent with "composition by field," including gesture-field painting, projective verse, and collage. The social vision expressed through these forms, articulated most clearly in the poems of Charles Olson, defined society itself as a plastic medium with which the artist grappled.

The Energy Field

Barnett Newman was far from the only painter to refer to the field theory of Einsteinian physics as a description of abstract expressionist art. Jack Tworkov announced, "Much of my work is based on linear energy be-

coming mass."[5] Robert Motherwell concurred: "[T]he content of abstract expressionism has to do with energy . . . an energetic field of force."[6] These statements can be relied upon as an accurate description of a general trend.

Throughout the 1940s, Motherwell's painting career was closely linked to developments in abstract expressionism. In 1940, he had experimented with surrealist automatism with Matta, Pollock, de Kooning, Baziotes, and Hofmann. The next year, he visited Wolfgang Paalen in Mexico and helped to edit the influential *Dyn* magazine. In 1943, he contributed to *VVV*, the magazine of American surrealism. In 1944, he introduced the concept of "plastic automatism" to supplant Breton's "pure psychic automatism." He also corresponded with William Carlos Williams.[7]

Prior to these activities, Motherwell had studied for one year as a graduate student in philosophy at Harvard. Also, in 1937, Alfred North Whitehead had just retired from the Harvard faculty, and Motherwell read Whitehead's work and attended a lecture series the philosopher delivered at Wellesley. Whitehead's influence on Motherwell's thought is clear from his frequent mention in the artist's writings.[8]

Motherwell's formulations often connected Whitehead's ideas with those of another contemporary Harvard philosopher, pragmatist John Dewey. Dewey's work dealt with "experience" as the activity of a unified "body-mind." His ideas about art and its relation to the perceptual acts of the body-mind were set forth in the book *Art as Experience*, published in 1934.[9] In these two philosophical expressions of human experience as the activity of a body in an energy field, Motherwell found a direction for the avant-garde's artistic pursuit of an alternative metaphysics. He wrote, "The content of art is feeling; . . . [and] feelings are neither 'objective' nor 'subjective,' but both, since all 'objects' or 'things' are the result of an interaction between the body-mind and the external world."[10]

In the same way that the concept of the ideogram or glyph first connected the postwar avant-garde across the boundary between painting and writing, so too the energy field model of modern physics appealed to poets and artists alike. In an essay published in 1948 entitled "The Poem as a Field of Action," William Carlos Williams cited Whitehead and the new physics in calling for a new modernist poetry.

Williams proposed that it was time for modernist explorations of consciousness to reemphasize the social and physical environment. He associated earlier strains of modernism with an ineffectual mode of social critique—ineffectual because it was rooted in the construction of an individual subjectivity alienated from its social surroundings. "Look at Mr. Auden's earlier poems as an example," he wrote, "with their ruined industrial background of waste and destruction. But even that is passing and becoming old-fashioned with the new physics taking its place."[11]

Williams implied that his own writing, characterized by the "variable foot," moved beyond the cultural impasse created by this dualism of the individual consciousness and its surroundings. "[Meter] is precisely where we come into contact with reality," he wrote;

> Einstein had the speed of light as a constant—his only constant— What have we? Perhaps our concept of musical time. . . .
>
> What we are trying to do is . . . to seek (what I believe is there) a new measure or a new way of measuring that will be commensurate with the social, economic world in which we are living as contrasted with the past.

Charles Olson's essay "Projective Verse," of 1950, advocated a method of automatic writing that he called "COMPOSITION BY FIELD."[12] This method emphasized, he wrote,

> the *kinetics* of the thing. A poem is energy transferred from where the poet got it (he will have some several causations), by way of the poem itself to . . . the reader. Okay. Then the poem itself must, at all points, be a high energy-construct and, at all points, an energy-discharge.

According to Olson, the poet's effort to track the flux of energy across his unconscious mind was what created the imperative to keep *in* time— that is, to write spontaneously so as to keep the act of writing abreast of thoughts as they occurred. "ONE PERCEPTION MUST IMMEDIATELY AND DI-RECTLY LEAD TO A FURTHER PERCEPTION," Olson wrote. It was through Olson's sense of "time" as real, psychological time—not Williams's sense of time as poetic meter—that Einstein's notions of a space-time continuum would be most effectively incorporated into postwar American poetry.

The poetics of spontaneity that Olson called "composition by field" influenced many Black Mountain and beat poets. Ed Dorn wrote to Olson in 1960, "You say it I think in all that about *field*, and by the way I like the nice clear way you put it ie. 'that the choice of word or particle will be spontaneous' which it is."[13] Robert Creeley offered, as a gloss on Allen Ginsberg's lines "I always wanted / to return / to the body / where I was born," the observation that "[t]hat body is the 'field' and is equally the experience of it. It is, then, to 'return' not to oneself as some egocentric center, but to experience oneself as *in* the world."[14] Robert Duncan wrote, "Referred to its source in the act, the intellect actually manifest as energy . . . is the measure [of a poem's power]." Duncan went on to compare projective verse to abstract expressionist gesture painting on this basis—pointing out "the difference between energy referred to (seen) as in the Vorticist and Futurist work . . . and energy *embodied* in the painting (*felt*), which is now muscular as well as visual, *contained* as well as apparent: [as in] the work of Hofmann, Pollock, Kline. . . ."[15]

Charles Olson became acquainted with Alfred North Whitehead's phi-

losophy through the works of William Carlos Williams and Robert Motherwell; but he did not actually read Whitehead's writings until 1954, when Macmillan and Co. reissued *Adventures of Ideas*. At that time, Olson seized on Whitehead's cosmology as an articulation and vindication of his own theories, much as Ezra Pound had grasped Ernest Fenollosa's work on the Chinese ideogram. "I am the more persuaded of the importance and use of Whitehead's thought," Olson stated in 1956, "that I did not know his work—except in snatches and by rumor . . . until last year. . . . Whitehead has written the metaphysic of the reality we have acquired."[16]

The Cosmology of Alfred North Whitehead

Avant-garde artists and writers found the general attitude of Whitehead's philosophy congenial in two respects. One was the tempered optimism of his radicalism. In a chapter of *Adventures of Ideas* entitled "Cosmologies," Whitehead staked out an intellectual position very like that of American artists in their encounter with surrealism during the early 1940s. This was a disposition to entertain radical alternatives to conventional thinking— tempered by the conviction that not every fantasy constituted a meaningful alternative. Whitehead considered it likely that there were several equally coherent systems of thought by which we might order our understanding of the world. He wrote: "There is . . . a certain amount of convention as to the emergence into human consciousness of sorts of Laws of Natures. The order of emergence depends upon the abstract sciences which civilized mankind have in fact chosen to develop." The natural connections that had never been organized into systematic sciences presented themselves to our disciplined thinking as mere hunches or feelings, indicating potential alternative constructions of reality. But, he continued, "such 'convention' should not be twisted to mean that any facts of nature can be interpreted as illustrating any laws that we like to assign." Like Harold Rosenberg and other American contributors who chastised surrealism in *VVV* magazine, Whitehead insisted that empiricism, not arbitrariness, was the means to discovering such alternatives.[17]

The other general disposition of Whitehead's thought that appealed to the avant-garde was his distrust of conventional forms of communication. Everyday language, Whitehead wrote in *Adventures of Ideas*, denoted mainly the superficial variables of experience that entered into consciousness. It was inadequate for articulating complexes of thought and feeling beyond the socially constructed reality that it helped to maintain. "There are other elements in our experience, on the fringe of consciousness, and yet massively qualifying our experience," he insisted.[18] It was of utmost importance to Whitehead that his reasoning remain as close as possible to a description of this unconscious experience, and not become

a mere manipulation of verbal abstractions. He therefore developed his own new and difficult vocabulary. His neologisms aimed to prevent both himself and his readers from succumbing to the "danger of a logic which presupposes linguistic adequacy."[19]

This same effort to develop a language free from the ideological biases of their society motivated the practices of the avant-garde, from the "ideographic" painting and poetry of the 1940s to the palimpsests and collages of the 1950s. In 1947, Barnett Newman asserted that the basis for the painterly act was to communicate "the emotion of an experienced moment of total reality." Where words were inadequate, paintings could succeed: "The American painters under discussion create an entirely different reality to arrive at new unsuspected images. They start with the chaos of pure fantasy and feeling . . . and they bring out of this chaos of emotion images which give these intangibles reality."[20] Similarly, in a lecture that he delivered at Hunter College during the 1950s, Robert Motherwell asserted that "think[ing] *in* painting," was a means of circumventing the expressive "deficiency of language" that Whitehead had noted.[21]

The mistrust of language and the skeptical but optimistic radicalism that characterized Whitehead's thinking were the direct implications of his field theory. His adventure of ideas had begun with efforts to formulate a geometry consistent with Einstein's theory of matter.

The various geometries of the nineteenth century were all based on a Euclidean model of space, which they shared with Newtonian physics. Euclidean geometry defines space as an infinite number of imaginary but discrete locations, called "points," that exist independent of time. In physics, the equivalent notion is of particles or atoms. In Newtonian physics, each particle exists independently of every other particle; matter interacts only occasionally, and then in predictable ways, like colliding billiard balls.

Whitehead proposed instead a "topological" definition of space, in which volumes are primary. Points and lines are loci defined by overlapping volumes with duration in time. An event can be said to have a source in space-time, but extends indefinitely out from this center in all directions at the speed of light. Whitehead wrote:

> Modern physics has abandoned the doctrine of Simple Location. The physical things which we term stars, planets, lumps of matter, molecules, electrons, protons, quanta of energy, are each to be conceived as modifications of conditions within space-time, extending throughout its whole range. There is a focal region, which in common speech is where the thing is. But its influence streams away from it with finite velocity throughout the utmost recesses of space and time.

Significantly, this means that the old truism which holds that two things cannot occupy the same place at the same time is profoundly false. "[W]ith the denial of simple location we must admit that within any region of space-time the innumerable multitude of these physical things are in a sense superposed."[22] Every point is a palimpsest.

Whitehead's geometry also breaks down the distinction between objects and actions and, by implication, between identity and society. Whitehead envisioned the cosmos as a vast pool of energy passing through time and space.[23] The most fundamental building blocks of nature are not enduring "atoms," but "events" or occasions defined by overlapping fluxes of energy in space-time. These events might be organized as the objects of human perception, although most events were "nonuniform," conforming to no pattern. "Uniform" events, creating perceptual or physical objects like colors or monkeys, were all stable patterns or communities of such microcosmic events. "The real actual things that endure," wrote Whitehead, "are all societies."[24]

In defining human identity, Whitehead's philosophy gave center stage to the body. Whitehead believed that the primary act of identity consisted not in a Cartesian self-consciousness (*cogito ergo sum*), but in "a vaguer sense of environing realities pressing in upon us," mediated kinesthetically by the body, including the nervous system and sense organs. Only on rare occasions did this process reach consciousness.[25]

Compared to other theories with which the avant-garde was familiar, Whitehead's philosophy offered the most useful solution to the problem of individual subjectivity. On one hand, to the existential question of whether individual experience was a hopelessly self-referential monologue, Whitehead answered that the physical organization of the body testified against this possibility. The structure of the human body, he believed, must be seen as having developed in the context of surrounding nature, and in response to it.

> Our dominant inheritance from our immediately past occasion is broken into by innumerable inheritances through other avenues. Sensitive nerves, the functionings of our viscera, . . . break in upon [our thoughts and feelings]. . . . The human body is indubitably a complex of occasions which are part of spatial nature. It is a set of occasions miraculously coördinated so as to pour its inheritance into various regions within the brain.[26]

As Jackson Pollock commented, "I *am* nature."[27]

On the other hand, Whitehead insisted on the integrity of the individual human subject, against the prevailing materialist dogma denying an active role to the individual. Other materialists followed David Hume in

understanding experience as impressions of sensation received through the sense organs—a model that reduced all human acts to reflexlike reactions.[28] Whitehead's model of human beings as stable societies of occasions recovered the reality of a continuous identity. "Consider our derivation from our immediate past of a quarter of a second ago," Whitehead wrote; "We are continuous with it, we are the same as it, prolonging its affective tone, enjoying its data . . . This is the mystery of personal identity, the mystery of the immanence of the past in the present."[29]

Because people and objects were events with pattern, memory, or coherence, they were not completely passive in the flux of nature. They had the power to direct and to organize energy. In his lectures at Wellesley, which Robert Motherwell attended, Whitehead defined identity as a "concrescence of prehensions"—from *concrescere*, "to grow together," and *prehendere*, "to grasp"—the latter term denoting an active, but not necessarily conscious, engagement with surrounding events.[30] This "concrescence of prehensions" was the model for the "plastic dialogue" that abstract expressionist gesture painters engaged in with their paintings.

Whitehead's model of human experience fit seamlessly into his model of the physical universe. This allowed him to posit the fundamental unity of all forms of energy. As he stated, "the energetic activity considered in physics is the emotional intensity entertained in life."[31] The postwar avant-garde found Whitehead's philosophy attractive because it asserted that the emotional matter that an artist or poet engaged was as "real" in every sense as the "matter" of a physicist. The avant-garde artist articulated felt patterns in nature that the existing sciences failed to notice.

OBJECTISM: THE POETICS AND SOCIAL THEORY OF CHARLES OLSON

As a model of society, field theory suggests an immanent natural law that governs not the *place* of all objects, but the dynamics of all *relations* among objects.[32] Charles Olson felt that the idea of people as "objects" or events in a field of force offered a model for the revisionist humanism he sought. It obviated the flaws of the earlier humanism, which posited an ideal of human rationality divorced from its physical context.

In his poem, "La Préface," of 1945, Olson had first linked the idea of a revised humanism to an emphasis on the body as the locus of identity.[33] This poem was inspired by sketches made by Corrado Cagli, one of the first American soldiers to enter the Nazi death camp at Buchenwald.[34] It haltingly lamented the victims of fascist social engineering and intolerance. In the poem, the narrator, carrying bodies to burial, has an insight

that seems to offer the foundation of a new ethics: a recognition that he and his fellow are, most fundamentally, two human organisms. "It is the radical, the root, he and I, two bodies." Olson's line echoed the same quotation from Karl Marx's early writings that Dwight Macdonald had used as an epigraph for his essay "The Root Is Man": "To be radical is to grasp the matter by its root. Now the root for mankind is man himself." [35]

In 1951, Olson wrote to Robert Creeley from Central America, linking the Maya glyphs that he saw there both to the worldview that he sought and to the notion of an energy field:

> What continues to hold me, is, the tremendous levy on all objects as they present themselves to human sense, in this glyph-world. And the proportion, the distribution of weight given same parts of all, seems, exceptionally, distributed & accurate. . . .
>
> That is, what you & i have been (all along) talking about—viz., man as object in field of force declaring self as force because is force in exactly such relation . . .
>
> which, I take it, is precise contrary to, what we have had, as "humanism," with man, out of all proportion of, relations, thus, so miscentered, becomes, dependent on, only, a whole series of "human" references which, so made, make only anthropomorphism, and thus, make mush of, *any* reality, conspicuously, his own. . . .[36]

Olson understood the careful attention to nature evident in the glyphs as indicative of an acute awareness of the energy field.

Olson often hypothesized a connection between the pre-Columbian and post-Newtonian worldviews. His formulation of the Maya "placement toward nature" owed much to the Jungian elaboration of "participation mystique." Olson went beyond Jung, however, in linking this attitude to the ontological model suggested by modern physics.[37]

He poetically expressed this link in the poem "He / in the dark stall" of May 1952. In that poem, which is an Olson "glyph" on the word-image "bull's eye," the poet derides the anomie of his contemporaries, comparing it with the plight of a blind bull in the stables at Black Mountain College. Sight and sexual energy both serve as figures for the exchange of energy in a field. This exchange is asserted to be synergetic: the whole is greater than the sum of its parts. The poem defines social good in terms of such a synergy, and criticizes modern civilization for forgetting such reciprocal energy relations. The idea-image of the "bull's eye" makes the loss of sight function as a synecdoche for this problem of "attention":

> each of us present die, our head, heart, cock, feet fall
> that little which is the world when force in another dies: this
> is the loss, the too little noticed loss . . .

> I mean no ancientness or primitivism as equal of what we ourselves here
> have:
> I mean only, where were those two men's eyes last night that they
> could lose, for any instant, their own strength, their contribution
> back to force where each of us is propelled from, that bow
> of which we are the arrows as well as we are users of the same . . .[38]

In this poem, Olson clearly rejects a primitivist nostalgia ("I mean no . . . primitivism as equal of what we ourselves here have"). At the same time, he insists that the celebrated advances of liberal civilization have produced an atrophy of attention to the field of "force" in which humans are situated, "that bow / of which we are the arrows as well as . . . users."

In his essay "Projective Verse," published in 1950, Olson further defined the "disposition toward reality" that he identified with the Maya and named it "objectism." To the fineness of outward perception demanded by William Carlos Williams's poetic "objectivism," Olson's "objectism" added a demand for acuteness of "proprioception," which literally means a perception of oneself, but which further connotes a physical as opposed to an intellectual knowing.[39] "The use of a man," Olson wrote in "Projective Verse," "by himself and thus by others, lies in how he conceive his relation to nature, that force to which he owes his somewhat small existence."[40]

Olson argued that objectism was the key to creating a poetry of social significance: one that solved the impasse of lyrical verse, which he defined as the construction of an alienated subjective sensibility, "the private-soul-at-any-public-wall." Objectism accomplished an end to this alienation by relinquishing the special status accorded to humanity in Judeo-Christian tradition and in its secularized counterpart, liberal humanism:

> getting rid of the lyrical interference of the individual as ego, of the
> "subject" and his soul, that peculiar presumption by which western
> man has interposed himself between what he is as a creature of nature
> . . . and those other creations of nature which we may, with no dero-
> gation, call objects. For a man is himself an object, whatever he may
> take to be his advantages.

In poetic practice, objectism translated into two principles: Olson's spontaneous "composition by field" and the return of poetry to an oral medium. Composition by field meant that the poet was to treat each word—or better, each syllable, each morpheme—as an event in a field of force of which the poet was the center. Faithfully describing this field meant writing with the speed of unconscious thought. The poet acted as a gatherer of forces: a society of events in space-time. The words that the

poet compelled into arrangement were objects "found," as it were, within the poet's reach—each bearing a valence or weight conditioned by a collective history. According to Olson, "The objects which occur at every given moment of composition (of recognition, we can call it) are, can be, must be treated exactly as they do occur therein . . . , must be handled as a series of objects in field." This poetic act was possible only because of the very physicality of the poet's body-mind, which situated him or her as an object in place and time.

This physicality was further emphasized by Olson's insistence that poetry was an oral art form and that each line of a poem corresponded to a single breath of the poet. Walter Ong's work on *Orality and Literacy* helps to clarify the connection between Olson's idea of the poem as an energy construct and his emphasis on breath as a vehicle of language. According to Ong,

> Sound cannot be sounding without the use of power. A hunter can see a buffalo, smell, taste, and touch a buffalo when the buffalo is completely inert, even dead, but if he hears a buffalo, he had better watch out: something is going on. In this sense, all sound, and especially oral utterance, which comes from inside living organisms, is "dynamic."
>
> The fact that oral peoples commonly and in all likelihood universally consider words to have magical potency is clearly tied in, at least unconsciously, with their sense of the word as necessarily spoken, sounded, and hence power-driven. Deeply typographic folk forget to think of words as primarily oral, as events, and hence as necessarily powered: for them, words tend rather to be assimilated to things, "out there" on a flat surface. Such "things" are not so readily associated with magic, for they are not actions, but are in a radical sense dead, though subject to dynamic resurrection.[41]

Olson's project of returning poetry to an oral form aimed at such a resurrection.

After reading Whitehead's *Adventures of Ideas* in 1954, Olson developed objectism still further, emphasizing the fusion of the historical with the physiological in the creation of an identity. Linking Whitehead's ideas to the cultural geography of Carl Sauer, Olson adopted "topology" as an artistic principle.[42] *Topos*, the Greek word for a place of emotional significance, functioned for him as a kind of glyph encompassing the two meanings of topology: geographical (the detailed description of a place in relation to its history) and mathematical (the transformation of geometric shapes through continuous remappings). Olson understood topology as a model for the way a self or a society changes over time.

This topological approach to poetry, emphasizing the intersection of physical and historical events, was most fully realized in Olson's magnum

opus, the three-volume *Maximus* sequence. *Maximus* developed out of an ambitious book idea that Olson had conceived in 1947, and for the writing of which he had received a Guggenheim grant in 1948. Tentatively entitled *Red, White, and Black*, the book was to be, like William Carlos Williams's *In the American Grain* of 1925, a work "on the morphology of the American kultur" exploring the settlement of the West. [43] Ultimately, the "West" of Olson's original vision was narrowed to the town of Gloucester, Massachusetts. He decided that Gloucester, as his hometown, was the key to connecting his experiential self (which was the ground of his poetry) through the local history and ecology to the collective whole.

These connections are most explicit in the *Maximus* poem "The Ridge," written on Pearl Harbor Day in 1954. [44] The poem begins with memories from Olson's childhood: of his parents set in the local landscape: "I come back to the geography of it, / the land falling off to the left / where my father shot his scabby golf." It continues with the pronouncement:

> This, is no bare incoming
> of novel abstract form, this
>
> is no welter or the forms
> of those events, this,
>
> Greeks, is the stopping
> of the battle
>
> It is the imposing
> of all those antecedent predecessions, the precessions
>
> of me, the generation of those facts
> which are my words, it is coming
>
> from all that I no longer am, yet am,
> the slow westward motion of
>
> more than I am . . .

Olson's references here are to Whitehead's *Adventures of Ideas*. He paraphrases Whitehead's critique of Humean sensationalism, in which Whitehead paired Hume with the ancient Greeks because both ignored the memory stored in the body (what Whitehead termed "personal unity") as a factor in experience. Whitehead wrote:

> It was the defect of the *Greek* analysis of *generation* that it conceived it in terms of *the bare incoming of novel abstract form*. This ancient analysis failed to grasp the real operation of the *antecedent* particulars imposing themselves on the novel particular in process of creation. . . .

In addition to the notions of the *welter of events and of the forms* which they illustrate, we require a third term, personal unity.[45]

Olson, like Whitehead, wanted to emphasize the nature of the body as a locus of unconscious knowing. In the poem, his parents are identified as the "antecedent particulars" of his own "generation." They are his predecessors, or (to replace the personal suffix "-ors" with one that does not distinguish people from objects) his "predecessions." This neologism leads Olson, with his background in Maya astronomy, to think of "precession," which means the act of preceding, but also refers to the "slow westward motion" of the equinoxes as the earth gyrates on its axis. Thus the body, as it exists and changes from moment to moment ("all that I no longer am, yet am") is that which links Olson to his own past, to the general historical past that is its context, and to the rest of the cosmos proceeding through time from moment to moment, "the slow westward motion of / more than I am."

This last connection is not an obvious one, and again requires recourse to Whitehead for its elaboration. In the next section of the poem, Olson adopts Whitehead's assertion that the body, as a part of nature, tangibly links internal experience to external reality. Whitehead had written: "The human body is indubitably a *complex of occasions* which are part of *spatial nature*."[46] Olson's poem continues:

> An American
> is a complex of occasions,
> themselves a geometry
> of spatial nature.
> I have this sense,
> that I am one
> with my skin
> Plus this—plus this:
> that forever the geography
> which leans in
> on me I compell
> backwards I compell Gloucester
> to yield, to
> change
> Polis
> is this

The final verses here present Olson's mature understanding of the nature of social change—an understanding conditioned by the concept of the energy field. His 1949 poem "The Kingfishers" had suggested the possibility of a radical break with the immediate past. "Not accumulation but

change," Olson had asserted there, was the law of natural systems. But the energy field model of reality connoted the impossibility of a complete break with the past. Like the human body, human society, understood within this model, is a complex pattern of occasions, a "concrescence of prehensions" with a diachronic unity. It is, in this later poem, "forever the geography that leans in on me."

Instead of the image of an alienated individual pitted against society from without, "The Ridge" suggests a modified pluralist model of the individual pushing for change from within. Like a single event in a force field, each act of the individual subtly affects the larger configuration. "I compell Gloucester / to yield, to / change," Olson wrote. By misspelling "compell," he called attention to the word's etymological basis, meaning: "to push or pulse in unison." "Yield," too, is a complex word, a glyph referring simultaneously to the slow change of a plastic medium and to a vision of ultimate fruition. "Polis," or democracy, Olson suggested, "is this."

Throughout *Maximus*, Olson used "polis" to designate his ideal of social organization. He envisioned the polis as polymorphic and cosmopolitan, but with an economy and a culture rooted in local history and the local environment.[47] But this was the contrary of what he saw developing under the dominant corporate and advertising culture, which played on localist xenophobias while encouraging the erosion of local economies. As he wrote in "Maximus to Gloucester, Letter 3":

> not that mu-sick (the trick
> of corporations, newspapers, slick magazines, movie houses,
> the ships, even the wharves, absentee-owned
>
> they whine to my people, these entertainers, sellers
> they play upon their bigotries (upon their fears. . . .[48]

Another poem, "The Story of an Olson, and Bad Thing," from the spring of 1952, clarifies Olson's idea of the role of the poet as a force for social change in such a context. In this poem, Olson cast his writing career in terms of a vision-quest or walkabout. After an arduous journey, the poet-protagonist reemerges from the wilderness:

> when he came out . . . he carefully took the things he had made (despite
> Bad Thing, and his botherings) and instead of disposing of them in
> so many ways that would occur to you, he merely set them out there
> where the rest of the causes of confusion are.[49]

The poem's protagonist did not enter into direct combat with "the causes of confusion," but simply "set out" "the things he had made," making them available as an alternative or counterforce.

This is an intensely democratic cultural vision, in which the role of the seer is not to dictate the meaningful forms and objects of attention, but simply to make some personally authentic statements. As objects in a field of force, their energy would eventually reconfigure the surrounding discourse. In Olson's poetic act, the texts of his poems must therefore be seen as inseparable from the little magazines he supported, the school he ran, the lectures and readings he gave, and the correspondences he maintained. All these acts contributed to his effort to combat the hegemonic sway of corporate capitalist attitudes and of advertisements touting technological progress and white American ethnocentrism. His life's work was a rearguard action against their effort at closure, their monopolization of Americans' attention. As he continued in "The Story of an Olson, and Bad Thing":

> This act of his
> is as interesting a proof as anything you shall find, of what we
> might call, thinking of the people, and their problems, the other
> doctrine, the contrary one
> . . . viz.,

> multiple observation at the same instant that others
> make less multiple observations, is the difference . . .

> it is
> the biz-i-ness NOW, you
> who care, who can
> endure, it's
> "bring the head 'round, keep
> the wind, citizen! . . .

COLLAGE

Alfred North Whitehead's notion of subjectivity as a "concrescence of prehensions" encouraged new experiments with the practice of collage in both painting and poetry. In the mid-1950s, Robert Motherwell and Lee Krasner developed collage into an art form equal in significance to Jackson Pollock's gesture-field painting. The development of abstract expressionism in the late 1950s toward assemblage, combines, and happenings owed much to these pioneers of collage.

In 1943, when other abstract expressionists were beginning to paint spontaneous ideograms, Robert Motherwell embarked on a series of collages, inspired perhaps by an exhibit of surrealist collages at Peggy Guggenheim's Art of This Century gallery. Like automatism, collage was a

method with antecedents in surrealism and dada. But Motherwell's mature collages (particularly after 1955) differed from those of his cubist and surrealist predecessors in that Motherwell approached collage as a method of "plastic automatism," intended to embody the spontaneous physical interaction of the artist with his material environment.

Earlier artists were concerned more with the symbolic uses of images than with the tangibility of their materials. Picasso and Braque were most interested in undermining traditional painterly aesthetics by substituting manufactured prints such as wallpaper and faux wood grain for the painstaking illusions of trompe l'oeil.[50] Max Ernst described the purpose of surrealist collage as the radical juxtaposition of disparate images: "the fortuitous encounter upon a non-suitable plane of two mutually distant realities."[51] Motherwell's work was closer in theory to the futurism of Umberto Boccioni and Carlo Carrá, who had described futurist collage as an intuitive self-definition of the artist among objects: "We Futurists seek, with the force of intuition, to immerse ourselves in the center of things, so that our 'I' forms a singular complex with their uniqueness."[52] But the futurists had always subordinated collage elements to a drawn or painted composition, afraid that, as Giovanni Papini warned, pure collage negated art by "returning to brute nature."[53]

Motherwell was content to let the pasted paper be the primary element in his work. He emphasized the tactile qualities of the paper, not its use in figural representation. As he explained in 1946,

> The sensation of physically operating on the world is very strong in the medium of the papier collé or collage, in which various kinds of paper are pasted to the canvas. One cuts and chooses and shifts and pastes, and sometimes tears off and begins again. In any case, shaping and arranging such a relational structure obliterates the need, and often the awareness of representation. Without reference to likenesses, it possesses feeling because all the decisions in regard to it are ultimately made on the grounds of feelings.[54]

Motherwell consistently used the term "feelings," as in this statement, to refer to the combined intellectual, emotional, and physical engagement of the body-mind with its environment.[55] For Motherwell, collage was not just "brute nature," but nature as it organized and was organized by the emerging subjectivity of the artist.

Yellow Envelope, from 1958, is a perfect example of Motherwell's technique (plate 7). Torn paper fragments referring to Motherwell's life—the blue wrappers of his French cigarettes; a Bavarian beer label; a page of text proclaiming in French "The adventure of abstract art"—are superposed with other fragments inside a sharp-edged, strongly painted "frame." As

in Pollock's all-over paintings and Gottlieb's Pictographs, the viewer's attention is drawn back and forth among these various objects as it seeks imaginatively to bring them together. There is a powerful suggestion that only the painted boundary prevents the collage from losing even this slight claim to unity.

Motherwell used collage as Pollock and others used gesture-field painting: as a form of dialogue between a plastic subject and an equally plastic environment. The continuities between collage and gesture-field painting are many. Motherwell often used gestural painting in his collages, especially after 1958.[56] Pollock also used found objects in his paintings. *Full Fathom Five*, of 1947, for instance, incorporates nails, tacks, buttons, keys, combs, cigarettes, and matches into the oil painting.

Yet because Motherwell's collages consist mainly of found materials, they communicate the impact of the surrounding environment on the artist differently than gesture-field painting does. Papers are usually *from* somewhere; they have an indexical meaning that refers to their source in an outside world, as the paint in gesture-field painting does not. The material of collage is also not as malleable as paint is; solid rather than liquid, papers must be cut, torn, crumpled, or folded into shape, emphasizing the resistance and even recalcitrance of material reality.

Motherwell made use of this concreteness of the medium to confine his artistic statements in collage to a very local and personal level. He remarked that his collages were more particularly autobiographical than his paintings.[57] His collages are clearly more autobiographical than those of Kurt Schwitters, whose work suggested a programmatic redemption of junk objects (as Schwitters stated, "The waste of the world becomes my art").[58] Motherwell's artistic materials are not the world's objects, but his own.

Thus Motherwell's collages contain a twofold emphasis: first, on the firm structures of reality that only reluctantly yield to the artist's will; and second, on the intense individuality of experience as each person engages these structures. The result is an art that awards primary importance to the emotional power or "feelings" of this engagement. Like Charles Olson's poem "He / in the dark stall," Motherwell's collages implicitly define such feelings as the basis of humanistic values. An early collage of 1943 was titled *The Joy of Living*. As he stated in 1963: "I do feel more joyful with collage, less austere. . . . The main thing is not to be dead. And nearly everyone is dead, painter or not. . . . The problem of inspiration is simply to be fully alive at a given moment."[59]

In her collages, Lee Krasner expanded on Motherwell's work, to explore the possibilities of *inter*subjectivity through the collage medium. The intersubjective implication of field theory is that to find a voice is really to develop a place among voices.[60] Krasner's collages dramatized this

process. In 1955, the works at her one-woman show at the Stable Gallery combined heavy black shapes reminiscent of Motherwell's *Elegies to the Spanish Republic* with other elements suggesting the works of Clyfford Still, Barnett Newman, Willem de Kooning, and Jackson Pollock (plate 8).[61]

In many respects, Krasner's path to cultural authority was typical of the postwar culture of spontaneity. She was born Lenore Krassner, in Brooklyn in 1908—the fourth child of Jewish immigrants from Odessa, and the first family member to be born in the United States. During the 1930s, she worked with Willem de Kooning, painting murals for the WPA. Along with Harold Rosenberg, she belonged to the CIO-affiliated Artists Union; and she read the writings of Karl Marx, though she rebelled against the Stalinist line condemning abstract art as insufficiently proletarian. During the Second World War, she worked briefly at painting war propaganda posters, until that work was taken over by corporate advertisers. The influences of John Graham and Jungian psychology redefined her work in the early 1940s; the new direction was reinforced, after 1942, by her relationship with Jackson Pollock.[62] Her "Little Image" paintings of the late 1940s exemplify the ideographic painting of that time.

But Krasner was unusual among abstract expressionists in her refusal to equate artistic integrity with the creation of a purportedly sui generis vocabulary of images. In her collages, subjectivity emerges from among the materials of the physical world, but also from among the "feelings" expressed by others.

In the medium of poetry, William Carlos Williams and Charles Olson also used collage to situate themselves among diverse materials.[63] In *Paterson*, of the late 1940s, "found" reality first made its appearance in Williams's poems, in the form of letters and historical accounts lifted whole from their original sources and incorporated into the lyrical body of the poem. *Paterson's* poetic collage is a kind of dialogic or "open" poetry, in that it defies literary closure. It presents Williams's voice in oblique conversation with other voices from the present and the past. (Book 5 includes a letter from the young Allen Ginsberg.[64]) Often those other voices even have the last word—a dynamic particularly striking in book 2, where several letters from the poet "C" charge Williams with sexism and hypocrisy.

Charles Olson took the poetic project of *Paterson* as a model for his own work, though he criticized Williams for failing to "spatialize" the past. *Paterson*, Olson felt, did not adequately develop the links between past and present, self and other. He wrote to Creeley from the Yucatán peninsula, "Bill HAS an emotional system which is capable of extensions & comprehensions the ego-system . . . is not. Yet . . . Bill completely licks himself, lets time roll him under."[65] The poet's lyric voice in *Paterson*

does indeed lead an inviolate existence separate from the "found" elements of the collage, as exemplified by this section from the beginning of book 2:

Walking—

> Thickets gather about groups of squat sand-pine,
> all but from bare rock . . .
>
> —a scattering of man-high cedars (sharp cones),
> antlered sumac.
>
> —roots, for the most part, writhing
> upon the surface
> (so close are we to ruin every
> day!)
> searching the punk-dry rot

Walking—

The body is tilted forward from the basic standing
position and the weight thrown on the ball of the foot,
while the other thigh is lifted and the leg and opposite
arm are swung forward (fig. 6B). Various muscles, aided.

Despite my having said that I'd never write to you again, I do so now because I find, with the passing of time, that the outcome of my failure with you has been the complete damming up of all my creative capacities in a particularly disastrous manner such as I have never before experienced.

For a great many weeks now (whenever I've tried to write poetry) every thought I've had, even every feeling, has been struck off some surface crust of myself which began gathering when I first sensed that you were ignoring the real contents of my last letters to you, and which finally congealed into some impenetrable substance when you asked me to quit corresponding with you altogether without even an explanation.

That kind of blockage, exiling one's self from one's self—have you ever experienced it? I dare say you have, at moments; and if so, you can well understand what a serious psychological injury it amounts to when turned into a permanent day-to-day condition.[66]

In this excerpt, the poet's voice begins with a lyrical description of walking in the park on a Sunday. Soon, his observation of "roots writhing upon the surface" in search of sustenance sparks an analogy with human life: "so close are we to ruin every / day!" he muses. This thought is then supplemented by a technical description of walking. The juxtaposition sets up an ironic tension between the scientific assurance of the excerpt

and the poet's implication that walking is a kind of "writhing" of the limbs. The sense of the closeness of ruin is then reinforced by another excerpt: a letter in which the correspondent complains of writer's block. Williams's phrase, "writhing / upon the surface" is echoed by the letter's reference to alienation ("exiling oneself from oneself") as a kind of writhing on the "surface crust" of the self.

The structure of this representative fragment of the poem is such that there is no integration of the subjective poetic voice with the larger history represented by the "found" elements. The found fragments parallel the poet's own thoughts, lending them a kind of external validation. But there is no reciprocal influence. The poet positions himself as aware of the history, yet not "of" the history. This sense of the subject-object relation in the poem is borne out by an explicit statement at the beginning of book 2:

> Outside
> > Outside myself
> > > there is a world,
> he rumbled, subject to my incursions
> —a world
> > (to me) at rest,
> > > which I approach
> concretely—[67]

Charles Olson, by contrast, subordinated the collage technique to a project of cultural morphology in which the origins of his own present were always being sought. In this, he sacrificed something of the open quality of Williams's poetry. But the voices that appear in Olson's poems are taken to have a more direct bearing on the poet himself. The *Maximus* poem "The Song and Dance Of," from April 1953, exemplifies Olson's cultural-morphology-cum-autobiography technique.[68] In this poem, Olson begins with his own intellectual background, making ironic reference to childhood reading that valorized Indian-fighters and sports heroes. He then moves to wider ground, as he disparagingly compares the ethos of such books to the politics of the Truman administration, which to him symbolized the defeat of democratic leftism by corporate and advertising interests:

> Altschuler
> taught us how to fight Indians, but Barbour,
> Ralph Henry, that is, warned us
> what sports are, how they breed only
> blondes.
> And tin horns.
>
> I mean merchandise men,
> who get to be President

after winning, age 12,
cereal ad
prizes . . .

 The upshot is
(and this the books did not tell us) the race
does not advance, it is only
better preserved

The remainder of the poem provides a historical explanation, based on early European settlement patterns, for the triumph of "merchandise men" in American society. Olson contrasts European activity in the Americas along a North-South axis, beginning with a quotation from Columbus's description of the Caribbean:

"Always the land
was of the same beauty,
and the fields
very green"

Columbus's attention to the beauty of the islands leads Olson to assert (as he had in Mexico) the different quality of awareness encouraged by different climatic or ecological conditions. In this connection, he links Columbus to Ezra Pound's description of "Mediterranean man": "The senses at first seem to project for a few yards beyond the body. Effect of a decent climate where a man leaves his nerve-set open, or allows it to tune in to its ambience, rather than struggling, as a northern race has to, for self-preservation to guard the body from assaults of weather."[69] On this basis, he contrasts the Mediterranean conquest of the Caribbean with the British conquest of North America:

Northward,
no pearls as necklaces on the necks of, no value
to be trod on, no slaves . . .

 Venus
does not arise from
these waters. Fish
do.
 And from these streams,
fur.

 It was the hat-makers of La Rochelle, the fish-eaters of Bristol
 who were the conquistadors of my country, the dreamless
 present

The poem in the end returns to Olson, the poet in search of a description of himself and his country in the "dreamless present." In this way, Olson used the collage technique to link his personal identity to the larger context represented by the found texts he gathered.

The collages of *Maximus* represent Olson's final effort to express subjective experience within the energy field. Like the collages of Motherwell and Krasner, they embodied a vision of human society as a field of intersecting occasions—as a plastic medium "compelled" by the actions of every individual. True democracy might then be defined as a synergy, in which the energies of individuals were excited and fulfilled in relation to the whole. Spontaneous collage offered a counterforce to the dominant culture's pathological "bias of attention" by encouraging a sensitivity to the energy field.

6 Gestalt

Of course my body is a thing among other things,
but by naming it, by speaking to it, I raise it above
the anonymous realm of mute things. I enter into
relationship with it; in fact, the self is nothing but a
relationship, a dialogue, with the body.

—Alfred Duhrssen, *It Is* (1959)

The "energy field" model of human experience was central to the postwar culture of spontaneity. During the 1950s, this paradigm generally replaced earlier surrealist and Jungian notions of a collective unconscious accessible through archetypal myths and images. At Black Mountain College in the early 1950s, Charles Olson defined spontaneity in terms of multiple foci of attention in a constantly changing field. Others among the faculty there influenced a younger generation of avant-garde artists and writers with thinking along similar lines. Robert Motherwell, who taught painting at Black Mountain in the summer of 1950, undoubtedly expressed his ideas on the implications of field theory for the visual arts. John Cage and Merce Cunningham created performance pieces that embodied Zen Buddhist versions of this concept.

Paul Goodman, who also came to Black Mountain in the summer of 1950, made a unique impression with his psychology of spontaneous awareness in a cognitive field or *gestalt*. Poet Joel Oppenheimer later recounted what he learned in Goodman's class at Black Mountain: to try to relax fully, and then, becoming aware of muscular tension in some part of his body, to focus his awareness on that area and begin free association. He recalled "suddenly realizing that my left hand was tight-fisted and my right hand was open-handed. And I discovered what being stiff-necked was . . . it was marvelous."[1]

142

Goodman's "gestalt therapy" combined elements of gestalt, existential, and Reichian psychologies into a coherent whole linked to his radical social vision. Robert Motherwell had suggested as early as 1946 that gestalt psychology might provide the basis for a new theory of the social role of art, which would distinguish the new American painting from surrealism. He wrote,

> For the goal which lies beyond the strictly aesthetic, the French artists say the "unknown" or the "new," after Baudelaire and Rimbaud. . . . "Structure" or "gestalt" may be more accurate: reality has no degrees nor is there a "super" one (*surréalisme*). . . . Structures are found in the interaction of the body-mind and the external world, and the body-mind is active and aggressive in finding them.[2]

In his book *Gestalt Therapy*, Goodman used the field paradigm of gestalt psychology to reassert the link between avant-garde art and politics. He advocated an awareness of material plasticity and verbal prosody as the basis for constructive social change.

Cold War Corporate Liberalism as the "Introjection" of Authority

Common elements in the lives of Charles Olson and Paul Goodman imply the collective experience of an intellectual generation. Paul Goodman was born a year after Olson, in 1911, and he died two years after him, in 1972. In the early 1940s, both men lived on the fringe of bohemia as writers in New York: Olson wrote brochures and magazine copy for the ACLU and the antinativist Common Council for American Unity; Goodman wrote pacifist essays, one of which was published, heavily edited (Goodman said censored), in the *Partisan Review*.[3] In 1943, while Olson was working at the Office of War Information, from which he resigned in frustration, Goodman was teaching at a progressive boarding school, from which he was dismissed for homosexual activity. After the war, Olson immersed himself in poetry and began his research into Jungian psychology and American Indian cultures. Goodman embraced anarchism, advocated draft resistance, and wrote articles for Dwight Macdonald's *politics* magazine and the libertarian periodicals *Why?* and *Retort*.[4] Eventually Goodman turned to psychology as well, as he questioned the ability of postwar politics to address significant social issues.

Goodman's loss of faith in politics was precipitated by conditions of the Cold War era. An attitude of "political realism" dominated the postwar American political scene. Leaders in politics and intellectual life preached the need for a skeptical belligerence in power relations; political idealism was frowned upon as dangerously naive. In books like *The Children of*

Light and the Children of Darkness (1944) and *The God That Failed* (1950), Americans told themselves that it was necessary to be cautious and conservative in order to defend their values against betrayal.[5]

The new vogue of distrustfulness contributed to the escalation of the second Red Scare from a political red herring to the defining event of a decade. In 1947, Harry Truman initiated the "federal employee loyalty program" to defend himself against Republican claims that he was "soft on Communism." Fueled by political opportunism and social anxieties, the threat of Communist subversion engulfed American imaginations. Between 1947 and 1962, over five million Americans were investigated by the FBI or by Congressional committees for possible Communist affiliations; often, merely attracting the attention of investigators was enough to threaten one's social standing or one's job. Twice in 1952, FBI agents toiled up the long dirt road to Black Mountain College to quiz Charles Olson about his associates in Roosevelt's 1944 reelection campaign.[6] The Red Scare and the issue of "naming names" bred a cultural climate of fear and betrayal that affected an entire generation.[7]

Because Karl Marx had identified Communism with atheism, Americans of the fifties claimed religiosity as a patriotic symbol, adding God to the pledge of allegiance in 1954. As head of the FBI, J. Edgar Hoover admonished parents, "Since Communists are anti-God, encourage your child to be active in the church." The relationship of cause and effect in this pronouncement is strikingly obscure: was he advising parents how to prevent their children from becoming Communists, or how to prevent themselves from becoming the targets of an FBI investigation? During the Cold War, Americans joined religious congregations in unprecedented numbers, but "belonging" was more important than believing. Religious affiliation indicated one's participation in the postethnic "triple melting pot" of Protestants, Catholics, and Jews.[8]

As the case of religion exemplifies, the rejection of overt doctrinal or ideological commitments was part of the postwar American ideology. America was best, the argument went, because Americans were not governed by ideologies as in totalitarian societies. "They" had a set of principles that distorted their reality; "we" developed policies on an ad hoc basis, through a democratic equilibrium created by the pressures of multiple interest groups. They had ideologies, whereas we had "consensus." As Daniel Bell wrote in *The End of Ideology:* "In the Western world . . . there is today a rough consensus among intellectuals on political issues: the acceptance of a Welfare State; . . . a system of mixed economy and of political pluralism. In that sense . . . the ideological age has ended."[9]

The corollary of this belief in the American consensus was a universalism that took the American system as a desirable model for all the world's societies. If Americans were uniquely free of ideological biases, it fol-

lowed that their social and political system evolved only from natural aspirations shared by all of humankind. Cold War culture therefore emphasized the similarities among peoples, with this ethnocentric slant: that the United States stood as a unique champion of universal human values on the international political scene.[10]

The influential "Family of Man" photographic exhibit sponsored by the United Nations exemplified these assumptions. The sequence of photographs devoted to education, for instance, began by comparing an African storyteller to a European lecturer—with no acknowledgment of the potential differences in the *contents* of their teachings. It ended by glorifying atomic physics as a culmination of the universal human pursuit of learning. All sorts of "work" were also presented as variations on a universal activity, eliding the relations of production that entailed some people's working *for* others.[11]

Among the values that the United States of the fifties was committed to uphold were: "democracy," defined by such institutions of indirect, electoral democracy as structured the United Nations; "free market" economies (in fact, mixed economies along the corporate-liberal model); liberal religion; and advanced scientific technology ("Better Living Through Chemistry"). By 1950, the year Paul Goodman found himself at Black Mountain College, these attitudes had brought the United States to war in Korea; and, by 1954, to war in Vietnam.

In fact, of course, postwar American culture did not represent a uniquely nonideological solution to the problem of human fulfillment. Corporate liberalism was the seldom acknowledged ideology behind the American program. Political and economic leaders of the postwar period equated America's national interest with the stabilization of the corporate-liberal system.[12] Government activities in support of private industry underlay most of the sources of America's postwar affluence. Postwar government policies encouraged economic consolidation, increasing the social power of large corporations. Foreign aid provided American industries with foreign markets necessary to accelerated growth. Tax breaks, highway programs, and federally guaranteed loans encouraged Americans to escalate their consumption patterns by moving to the suburbs. Government-sponsored research into fields like electronics and plastics led to new consumer technologies. The Taft-Hartley Act of 1947 rolled back the New Deal leftism of the 1935 Wagner Act, effectively eliminating the strike as a weapon in the struggle of labor against management; unions, if they were to survive, would survive as just another form of big business, subject to the same disciplines of bureaucratic control as any other corporation.

The GI Bill and federal research sparked the rapid growth of higher education, which became a junior partner in the joint efforts of the gov-

ernment and big business to promote economic growth. These efforts were so successful that even President Eisenhower, upon his retirement from the White House in 1960, felt compelled to warn Americans of the immense social power wielded by what he named the "military-industrial complex."[13]

In his 1951 work *White Collar*, sociologist C. Wright Mills described the psychological atmosphere created by this postwar corporate liberalism. Mills had the temerity to suggest that the political quietude of Americans represented not consensus but conformity. Certainly the ethnocentric universalism of Cold War America and the growth of Freudian psychoanalysis had combined to create a therapeutic mind-set that equated dissent with deviance, more fittingly consigned to the psychiatrist's couch than admitted to the political forum.[14]

Heterosexual monogamy and the suburban nuclear family served as primary symbols of normal emotional fulfillment within postwar corporate liberalism. Homosexuals like Paul Goodman were specifically targeted by both the repressive intimidations of McCarthyism and the normative imperatives of orthodox psychology; these social powers debated between themselves whether homosexuality was a crime or an illness. Domesticity and the mass-consumption economy were conflated with freedom in the Cold War American mind, as epitomized by the 1959 "kitchen debate" between Vice President Nixon and Soviet Premier Khrushchev, during which Nixon argued for the superiority of the American way of life on the basis of the convenience of its kitchens and the beauty of its housewives.[15]

In two articles that he wrote for *Why?* and *politics* in the summer of 1945, Paul Goodman decried this corporate-liberal culture as a complex shell game, with American leaders as its confidence men hawking a fulfillment that was perpetually elusive. He condemned the American system as one characterized by "monster factories, streamlined satisfactions, and distant representative governments." Its culture of abundance, he wrote, constituted a form of industrial oppression unforeseen by Marx: "Industrial authority does not exercise the same forms of oppression when there is a technology of surplus as it used when there was a technology of scarcity. In surplus, the problem is . . . to compel and control an artificial 'high' standard of living that will clear the shelves." Cultural conditioning perpetuated the requisite artificial desires: "This is again pure authoritarian compulsion, but exercised especially by psychological means, advertising, education, and rousing the spirit of emulation. The result is that men find themselves even more enslaved in their time, choice, invention, spontaneity, and culture than in the black days of want."[16]

In these essays, Goodman took the neo-Freudians Karen Horney and Erich Fromm to task for advocating "a psychology of nonrevolutionary

social adjustment," which they couched in a rhetoric extolling the "free personality" and "personal spontaneity." Fromm and Horney stressed the importance of rational authority in the healthy development of the individual. Consistent with this, they wanted to define "freedom" as total self-consciousness: free and healthy actions were those with motives completely transparent to the mind of the actor.[17] Goodman, for his part, did not credit this definition. "Are we to conclude that the free person has no unconscious?" he scoffed.[18]

In Goodman's eyes, Fromm and Horney were merely formulating a kind of America-is-best argument. Their valorization of "rational authority" and "the free personality" served as a justification of America's bureaucratic-industrial mode of production. Indeed, Fromm invoked the "modern industrial system" as the embodiment of the rational authority he idealized, and he advocated centralized social planning with the assertion that "society must master the social problem as rationally as it has mastered nature." Goodman complained, "Many of the propositions of this school look like the ancient deviation of Adler, but [they] . . . aim at adjustment not so much to existent society as to the kind of rationalized sociolatry towards which the imperialist nations are headed in their domestic policy."

Goodman faulted the neo-Freudians for trying to construct a psychology without reference to the organic drives that Freud originally posited as the source of psychic energy, or libido. Severed from these drives of the organism, their ideal person had only Horney's pale need for "reassurance" to motivate choices and actions. David Riesman, who later authored the influential sociological study *The Lonely Crowd* (1950), corroborated Goodman's assertion that there was little to distinguish between the imperatives of such "reassurance" and the specter of conformity.[19] As Goodman charged, "Where is there a place in this hall of mirrors for either personality or fraternity?"

To restore content to the rhetoric of "interpersonal relations" and "freedom," Goodman insisted on the socially transformative role of organic drives and the unconscious:

> Freedom consists not, as Fromm says, in the agreement to participate as an equal member in a vast social system, but in the continuing revolution of new demands and ideas as they emerge from the depths, called forth by and transforming the reality, including institutions. A free society is one that is peacefully permeable by this revolution.

According to Goodman, authoritarian societies, including his own, subverted such demands in order to preserve the status quo. He condemned "the ways in which natural energies are absorbed, sublimated, and verbally gratified in our corporative industrial states."[20]

Identifying the dominant values as oppressive, Goodman inverted the assumptions of conventional therapeutics; he argued that corporate-liberal "normality" was itself a pathological condition. In *Gestalt Therapy*, a book he coauthored in 1951, he therefore called for a science of "abnormal anthropology" to study how the norms of a culture become neurotic. "If we speak, as we must, of a social and epidemic neurosis," he wrote, "it is not the symptomatic social eccentricities . . . that are pathologically important, but the *normal* knowledge and technique, the *average* way of life."[21]

On the average, wrote Goodman, oppressive societies demanded the "introjection" or unassimilated acceptance of prescribed values on the part of individual citizens—training them, metaphorically speaking, to swallow things whole. To facilitate this introjection, such societies repressed the healthy levels of aggression that would prompt the individual organism to ruminate on (literally, chew over) or reject an unsatisfying code of behavior.[22] As a result, this aggression was turned inward, and the mind's "I" became an internalized deputy of the social authority, bullying and manipulating the hapless organism. The result was a neurotic condition in which "self-control" was often pitted against the organic needs of the individual, leaving human identity split against itself.

Like other members of the avant-garde, Goodman contrasted his own culture unfavorably in this light to other cultures that Americans conventionally regarded as inferior and "primitive." The invidious notions embodied in the primitive/civilized dichotomy were, he contended, only a cultural enforcement of neurotic urban-industrial reality.

> With regard to the adjustment of the mature person to reality, must we not ask—one is ashamed to have to mention it—whether the "reality" is not rather clearly pictured after, and in the interests of, western urban industrial society, capitalist or state-socialist? Is it the case that other cultures, gaudier in dress, greedier in physical pleasures, dirtier in manners, more disorderly in governance, more brawling and adventurous in behavior, were or are thereby less mature?[23]

This was a rhetorical question to which he answered a resounding no.

Goodman contended that in the corporate-liberal socioeconomic system, important human faculties had been truncated, with potentially disastrous results. He saw violent extensions of introjection manifested all around him, in everything from sadomasochistic comic books to a dispassionately belligerent foreign policy. He worried that "the wars we acquiesce in are continually more destructive and less angry." He wondered "what of human nature has been 'lost' and [how], practically, to devise experiments for its recovery."[24]

The theory of introjection led Goodman to suggest that recovering an awareness of the organism's "instinctual drives" was the basis of meaning-

ful political opposition. He cast the human body as the site of an unarticulated struggle between the faulty social order and human possibility. This was a refinement on the theories of Wilhelm Reich, an erstwhile Marxist and Freudian who had been expelled from the International Psychoanalytical Association in 1933.[25]

Reich had deviated from orthodox Freudianism by arguing, in 1928, that the repression and sublimation of genital sexuality was not, as Freud had claimed, the necessary origin of human culture and achievement. He pointed out that many societies functioned well without the moral strictures on sexuality that were the norm in Freud's Austria. Such repression, Reich argued, formed only "the mass-psychological basis for a *certain* culture, namely, the *patriarchal authoritarian* one." The repression of sexuality led to antisocial impulses that justified authoritarianism, and to the withdrawal of psychic energy from real contact with the environment in favor of intellectual "pseudo-contacts" in a process that Reich called "armoring." "Body armor" was the bodily expression of such learned psychological defenses, manifested in muscular tension and rigidity. Breaking this cycle would bring a return of authentic contact with one's surroundings and doom the authoritarian aspects of the social order.[26]

Focusing not on the body's sexuality but on its aggressive contact with the gestalt field, Goodman adapted Reich's belief that bodily awareness could be the mechanism of social revolution. As he wrote in *politics* in 1945: "[Reich] demonstrates in case reports that persons restored to sexual health and animal spirits simply will not tolerate the mechanical and routine jobs they have been working at, but turn (at whatever general inconvenience) to work that is spontaneous and directly meaningful."[27] In *Gestalt Therapy*, Goodman would expand on this notion of the "spontaneous," using the term to refer to a plastic engagement of the attention with the gestalt field, by which consciousness was restored to its proper function in the service of the organism.

Gestalt Therapy

Paul Goodman coauthored *Gestalt Therapy* with Paul Hefferline and Frederick Perls, a German Jewish psychoanalyst who had fled the Nazis and had come to the United States in 1946. Perls, like Goodman, had found Reich's ideas influential. He sought out Goodman in 1947, and the two found a common ground in their open bisexuality. Perls soon became acquainted with Goodman's social circle, including Dwight Macdonald, Merce Cunningham and John Cage, and Julian Beck and Judith Malina of the avant-garde Living Theatre (Julian Beck would credit Perls with inspiring *Paradise Now*, a participatory theater improvisation that brought political nudism to the streets of America in 1968.)[28]

In *Gestalt Therapy*, Perls and Goodman insisted that the traditional perceptual dichotomy of subject and object obstructed a true understanding of the nature of human experience in what Goodman called the "social-animal-physical field." Their notion of this field was derived from gestalt psychology, which had established empirically that cognition organized perceptions, as well as vice versa. That is, experiments indicated that different people could perceive the same "objective" situation differently, since each one subjectively structured the perceptual field into "figure" (the focus of attention) and "ground" (the background or context). Individual behavior was thus a function of the "gestalt formation," meaning the configuring relationship established between the perceiving subject and his or her environment. "Only the *interplay* of organism and the environment constitutes the psychological situation, not the organism and environment taken separately," the introduction to *Gestalt Therapy* asserted.[29]

Goodman and Perls pioneered "third force" psychology—third, after behaviorism and psychoanalysis.[30] Other prominent names associated with third force psychology in the 1950s and '60s were Victor Maslow, founder of the Human Potential movement, and Timothy Leary, who made a name for himself at Harvard with his writings on the "existential-transactive matrix" before becoming involved in the experiments with hallucinogens that ended his academic career.

Third force psychology participated in the avant-garde's appropriation of field theory as the basis for a revised humanism. Whereas Freudian psychoanalysis had posited a hierarchical dichotomy within the therapeutic relationship, opposing the psychoanalyst as interpreting subject and the patient as interpreted object, third force psychology avoided this dichotomy by replacing "interpretation" with an intersubjective "encounter" or "event." As Timothy Leary wrote in his autobiography,

> Existential means you study natural events as they unfold without prejudging them with your own concepts. You surrender your mind to the events. Transactional means you see the research situation as a social network, of which the experimenter is a part. The psychologist doesn't stand outside the event but recognizes his part in it.[31]

The "humanistic" or "encounter" psychiatry of the 1960s developed out of this reformulation of the role of the therapist from an invisible authority to a participant in a dynamic interaction. The first actual "encounter group" was a training group of lay therapists at Frederick and Laura Perls's Gestalt Institute in New York City in 1950. Among its members was Paul Goodman.[32]

In a journal entry made in 1955, Goodman contrasted the Einsteinian

and Newtonian models of physics, attributing to each a different vision of the self. Here, and in *Gestalt Therapy*, he associated the atomic-particle model of Newtonian physics with the manipulative techniques of a science that relied on isolating and controlling the variable factors of experience. Its social equivalent was the manipulative "human engineering" ideal associated with behavioral and Freudian psychologies, central planning, public relations campaigns, and advertising. "Continuous or field theories and discrete or particle theories seem to be contrasting attitudes of observation, one relying on the flow of spontaneous energy, the other on deliberate interventions and impositions," he wrote.[33]

Human experience in the gestalt field was a complex interplay of environmental stimulus and organic response, organic demand and environmental supply. In the healthy individual, the relation between figure and ground was a flexible one, "a process of permanent but meaningful emerging and receding" as circumstances of the social-animal-physical field fluctuated within and around the organism. In neurosis, this healthy plasticity of the figure/ground relation was replaced by the rigidity of a fixation, or by the lack of figure formation that constituted anomie.[34]

The gestalt model led Perls and Goodman to redefine "body armor," substituting a cognitive argument for Reich's exclusively sexual emphasis. Every person, they argued, seeking survival and fulfillment, organized an outlook on the world. This outlook eventually became routinized and receded from awareness; but it remained active in structuring the gestalt formation, including the physical attitude of the body.[35] Thus, "detailed interrelatedness of various parts of the body vary with each personality." Muscular tensions and "blind spots" in proprioception represented learned inhibitions and self-aggressions, the physical counterparts to rigidities in mental attitude.[36] The "encounter" exercises of gestalt therapy were designed to dissolve these automatic routines in order to restore spontaneous awareness.

Significantly, gestalt therapy contrasted spontaneity both to the automatic and to the conscious act. Spontaneity was characterized by a flexible awareness tuned to the gratification of organic needs. "Spontaneity is the seizing on, and glowing and growing with, what is interesting and nourishing in the environment," Goodman wrote. By contrast, the automatic act was one that the self performed while unaware of it. Consciousness, at the other extreme, represented the mental distancing that emerged from excess nervous energy when the organic drives were diverted. According to Goodman, "Awareness is simple presentness, both perceptual and motor. . . . Consciousness is limitation of presentness to the subvocal and the safe perceptions, and the confining of motor re-

sponse to the deliberate and the delaying, excluding the stronger passions which are motoric."[37]

Conscious "concentration" and spontaneous awareness or "absorption" were distinguished by the quality of attention associated with each. In the first, attention was deliberate: a kind of fixed determination that dissipated the energies through the effort of self-mastery. "In deliberateness much energy is extrinsically employed in inhibiting other activity, in *paying* attention rather than being 'distracted' (attracted elsewhere)," Goodman wrote.[38] Such discipline was trained so deeply into the minds and bodies of contemporary Americans that to relinquish it was difficult; their psychological lives were composed of "thousands and thousands of struggling motions so minute. . . , but we see them in the delicate tendons taut and in the pitiful eyes. . . . It is hard to do the easy thing . . . as an artist draws the easiest line."[39]

The more a person learned to rely on spontaneous awareness, however, the more of this energy devoted to controlling the attention would be released for active engagement with the gestalt formation. The result of positive contacts would be a synergy indicating personal and social health. In a prose poem written in October 1945, entitled "The Emperor of China," Goodman attacked Freudian notions of the libidinal economy in favor of a gestalt or field model, in which the spontaneous expenditure of energy is seen to lead only to more energy:

> It's not the case, if we spend our strength for a free stroke, that there's nothing left for another! . . . And there is not a reservoir of force, but force is welling in the soul. And if we use our strength in love, there is still more strength for beautiful collaboration, and even for idiosyncratic strokes—and always we are ready to the present.[40]

The avant-garde magazine *Possibilities*, edited jointly by Robert Motherwell, Harold Rosenberg, and John Cage, published "The Emperor of China" in 1947. Motherwell liked it so much that he borrowed its title for one of his paintings.[41]

Like Motherwell's collages and Olson's poetry, Goodman's psychology assigned final value to the capacity for such synergy. And, because emotions arose directly from contact with figures in the gestalt formation, once a healthy awareness was established feelings could be trusted as the basis for social decisions. "Emotion, considered as the organism's direct evaluative experience of the organism/environment field, is not mediated by thoughts and verbal judgments, but is immediate. As such, it is a crucial regulator of action, for it . . . furnishes the basis of awareness of what is important."[42] Emotional responses grounded in awareness could inspire actions that the introjected intellect would otherwise disallow. Recovering emotion as a basis of judgment would thus ultimately be both

personally therapeutic and, in the context of corporate liberalism, socially revolutionary.

GESTALT THERAPY AND THE ARTS

In Goodman's political rehabilitation of feelings, spontaneous art played an important role. Because the mind was not identical with the self, it was not enough merely to understand the dynamics of one's gestalt intellectually. What was more important was to *enact* an increased spontaneity of attention and motion. Addressing their readers in the second-person singular of a self-help format, the authors of *Gestalt Therapy* looked forward to "a genuine change in your perspective of events, the *feeling* that you are a *continuous flow* of processes."[43] For this reason, Goodman valued spontaneous art and poetry, which he believed could train people away from their neurotic patterns of attention.

Goodman insisted on the unique social power of modernist art and literature. In "Advance-Guard Writing in America: 1900–1950," an article he wrote for the *Kenyon Review*, he set forth a psychological argument that reversed the accepted distinction between naturalism and modernism in this respect. Naturalism was conventionally considered a literature of political and social engagement, whereas modernism was deemed personal and apolitical. But Goodman maintained that the very "grimness" of naturalism's confrontation with social reality precluded its ability to mobilize radical change. The "euphoric, libidinous" quality of modernism, however, operated according to the necessary psychological mechanisms: "To attack the institutions and ideology as the naturalists did, was to be infected with the guilt and punishment of instinct that had first resulted in the introjections [of the dominant ideology]. But to 'pierce the character-armor' as did the Revolution of the Word, was to release pent-up drives."[44]

In his journal, Goodman criticized the photographic exhibit "The Family of Man" for likewise succumbing to the fallacy of transparent representation. "Most of the photographs in *The Family of Man* tell us nothing," he wrote. "You don't show 'man's labor' by a picture of a man hammering; you must somehow convey the difficulty and necessity of the task itself, perhaps by bringing out the resistance of the matter worked on." As suggested by this statement, Goodman's approach to the visual arts privileged an art of "plastic dialogue" embodying the interface between the human artist and the surrounding gestalt field.[45]

In *Gestalt Therapy*, Goodman acclaimed the painter's plastic engagement with his or her medium as a model of spontaneous absorption. In a healthy individual, Goodman wrote, the spontaneous assimilation of novelty resulted in a continually new gestalt formation "containing new

material from the environment . . . just as the work of an artist becomes unpredictably new to him as he handles the material medium."[46] In manipulating the paint, an artist manifested the natural levels of aggression that Goodman understood as necessary to the health of the organism in its creative engagement with the social-animal-physical field.

> The working up of the real surface, the transformation of the apparent or enchoate theme in the material medium, is the creativity. . . . But this is true of every perception and manipulation that confronts any novelty and forms a gestalt . . . And the disgrace of our generation is that . . . [detached] ego is so epidemic that what the artist does seems *extra*ordinary.[47]

Like many others among the avant-garde, Goodman distrusted words as somewhat too easily separated from the organic experience that gave them meaning. Of the awareness to be achieved through gestalt therapy, he insisted that "a crucial part . . . is non-verbal and must remain such."[48] Words were useful as tools for differentiating the various objects, emotions, and motor states present in the gestalt formation. But if the sense of "felt contact" weakened, the hazard of words was manifested, for words functioned to mask this loss of contact, replacing real experience with the purely verbal and symbolic.[49]

A counterforce to this propensity, Goodman proposed, lay in the communicative properties of prosody. Prosody refers to the contents of a vocal utterance other than what is symbolized by the words; it includes syntax, and musical elements such as rhythm, pitch, and timbre. According to Goodman, although words could be used in the absence of an affective engagement or "contact" with the gestalt figure, prosody was more immediate and less susceptible to detachment. Like a painting style, prosody communicated something of how the mind of the speaker structured reality: "It is useful to define 'personality' as a structure of speech habits . . . most thinking is subvocal speaking; basic beliefs are importantly habits of syntax and style." In authentic interpersonal contact, prosody functioned in distinctive ways conditioned by the specific dialogical encounter. The "I" of each speaker was present in "the style and especially the *rhythm*, animation, and climax, expressing the organic need of the speaker"; while the emergent response of the listener(s) was manifested in the "rhetorical attitude" of the "interpersonal situation": the *tone* (whether wooing, confrontational, etc.) that characterized the exchange.[50]

Goodman was not backward in identifying modernist poetry as the one cultural pursuit dedicated to the communication of authentic prosody. Describing the mode of speech that would have to be developed to counter the affectless attitude of his times, he wrote: "It is full of the passional tones of childhood speech, its words are complex functional struc-

tures like the words of primitives, and its syntax is poetry."[51] The "complex functional structures like the words of primitives" that he referred to suggest the "ideograms" of the avant-garde.

Goodman's connections between bodily experience and art had much in common with Olson's poetics of spontaneity. Just as Olson, in "Projective Verse," had insisted on the "kinetics" of the poetic act, Goodman contrasted the dissipation of energy caused by neurotic verbalizing with the concentration of energy accomplished in poetry. As Olson had asserted the need to "keep in speed" with "the nerves, . . . the perceptions, . . . the whole business," relying on the unconscious for the selection of syllables, Goodman wrote that "Poetry, the art of expressive speech, resides in the ability to maintain silent awareness of need, image, feeling, memory, at the very time that the words are welling up, so that . . . the words when uttered are plastically adapted to a richly experienced figure." Goodman also shared with Williams and Olson the poetic imperative to the "defamiliarization" of language; as he asserted, "instead of being verbal stereotypes, the words [in poetry] are plastically destroyed and combined toward a more vital figure."[52] His attention to prosody allowed him to think of poetry, as they did, as analogous to the plastic arts in its engagement with a resistant, physical medium: language as breath.

In *Gestalt Therapy*, Goodman valorized painting and poetry as synecdoches of how a healthy individual should function in the social-animal-physical field. In writing about the artist's spontaneous creativity, he described a process specific to the "plastic dialogue" that was being pioneered by his friends and contemporaries. What he produced in his writing was therefore less a general theory of the psychology of art than a social and psychological vindication of avant-garde techniques. More clearly than either Clement Greenberg or Harold Rosenberg, he divined the relation between the philosophical contents and formal characteristics of abstract expressionist painting. His distinction between spontaneity and automatism identified a crucial theme of the postwar culture of spontaneity. He insisted:

> The important part of the psychology of art is not in the dream or in the critical consciousness, it is . . . in the concentrated sensation and in the playful manipulation of the material medium. With bright sensation and play in the medium as his central acts, the artist then accepts his dream and uses his critical deliberateness . . . The artist is quite *aware* of what he is doing . . . he is not unconscious in his working, but neither is he mainly deliberately calculating.[53]

In contrast to the Freudian and Jungian psychologies that earlier influenced the avant-garde, Goodman's psychological model placed the body at the center of cognitive experience and therefore at the root of uncon-

scious identity. "The surface tells the deep secret," he wrote in the avant-garde magazine *Instead*, asserting that the body gives physical form to unconscious attitudes.[54] This association between physicality and expressiveness, implicit in gesture-field painting and spontaneous collage, would be developed further in media that intrinsically engaged the body to an even greater degree: specifically, clay pottery and modern dance. The recovery of an awareness of human experience as *embodied* experience became one of the most insistent themes of the postwar culture of spontaneity with potential political implications.

The Body in Plastic
Dialogue: Dance and
Ceramics

I believe that the squelching of the "person" and his
spontaneous intuitive response to experience
is . . . at the root of our timidity, our falseness. . . .
The handcrafts stand to perpetuate the living
experience of contact with natural elements—
something primal, immediate, personal, material,
a dialogue between our dreams and the forces of
nature.

—Mary Caroline Richards, *Centering* (1964)

The postwar avant-garde developed forms of "plastic dialogue"
to generate the texts of a new humanism that was to replace
the discredited humanism of modern Western civilization.
The older humanism constructed dichotomies between the human and
the natural, subjective and objective, intellectual and emotional. By
contrast, plastic dialogue relied on an understanding
of human experiences as the events of a body-mind in
an "energy field." Texts recording this experience were
meant to serve as a counterforce to the ideological falsi-
fications and truncations prevalent in the dominant cul-
ture.

In the 1950s, the practice of plastic dialogue spread
from painting and poetry to other media. Some painters,
including Robert Rauschenberg, Allan Kaprow, and
Jim Dine, expanded on the bodily motions used in
gesture-field painting and collage until their work
elided the boundary between painting and perfor-
mance arts like theater and dance. Other artists turned
to ceramics, informed by the aesthetics of Zen Bud-
dhism.

At Black Mountain College between 1950 and 1952,
the boundaries separating painting from the plastic and
performing arts were breached in collaborations like the
1951 "glyph exchange," the 1952 Summer Institute in
ceramics, and the Sound-Light-Performance work-
shops. Charles Olson supported all these undertakings

157

as investigations in the new humanism he called "objectism," based on the idea of humans as objects in a field of force. As he wrote to Marguerite Wildenhain, a potter who participated in the 1952 Summer Ceramics Institute:

> *Dance*, here ([Katherine] Litz and [Merce] Cunningham . . .), *music*, & *theatre* represent . . . a wing of action alongside of which I would poise the workshops (pottery, weaving, graphics, & architecture), as all conspicuously reinforcing any present drive in the more immaterial arts back to object, away from that wretched lyricism.[1]

K I N E S I S : D A N C E

Dance critic Roger Copeland has called Hans Namuth's film of Jackson Pollock "one of the world's most significant *dance* films." It demonstrates, he contends, that "the fundamental impulse behind abstract expressionism was *the desire to transform painting into dancing*."[2] While this description of abstract expressionism will strike the art historian as oversimplified, Copeland has nevertheless described an important facet of this style of painting. The interest in bodily gesture that characterized gesture-field painting brought painting closer to dance and theater than it had ever been.

This development had its complement in the world of modern dance itself, as a new generation of choreographers broke away from the concern for narrative representation that had been the focus of earlier dance. The new modern dance aimed toward pure "kinesthetics." As a result, the 1950s and 1960s witnessed many collaborations in which painting and dance blended into a common practice.

In his book on abstract expressionism, Stephen Polcari has emphasized the congruity of Martha Graham's dance with abstract expressionist painting, even to the point of insisting that one cannot understand the paintings without having read Graham's *Notebooks*.[3] Polcari bases his argument on the fact that Martha Graham, like the abstract expressionists in the early 1940s, used Jungian psychology as the basis of her work. Her dances bear titles such as "Errand into the Maze," "Night Journey," and "Dark Meadow of the Soul."[4] Furthermore, like the gesture-field painters, she used a sense of movement rooted in the unconscious as the basis of her artistic expression.

In the 1930s, however, Graham's dances had been in the style of Americana, with such dances as "American Document" and "Appalachian Spring."[5] Dances from this period celebrated the American folk heritage, much as the painting of the American regionalists did. Although her subject matter in the 1940s had much in common with the abstract expres-

sionists', Graham's dependence on narrative was carried over from this earlier period into her later dances. She did not abandon narrative representation in favor of a "dialogue" with the physical properties of her medium, as became increasingly important in abstract expressionist painting after 1946. Nor did her works share in the self-reflexive dramatization of the creative process that characterizes such paintings. In the field of dance, these explorations were undertaken by a younger generation of choreographers including Merce Cunningham, Erick Hawkins, and Katherine Litz.

In the summer of 1951, Katherine Litz participated in the "glyph exchange" with Charles Olson and Ben Shahn at Black Mountain College, contributing a dance entitled "The Glyph." In this dance, she appeared sheathed in a tube of synthetic cloth that stretched as she moved about in it, creating a mixture of humorous and pathetic effects with striking visual images. Dance historian Don McDonagh has described how Litz dramatized the physical properties of her medium, undercutting the conventions of symbolic representation on which narrative dances rely:

> At the moment when she should be portraying a powerful emotion in theatrical terms, she becomes aware that in order to do so she has had to assume a posture or attitude of body that in and of itself has little to do with the emotion being framed. Thus, bent over backwards with grief, she follows the logic of the gesture and collapses in a heap. All thoughts of grief are dispelled and one has to deal with a young lady in a somewhat inelegant pile on the floor. She operates at a balance point where theatrical reality and physical reality collide . . . allowing her this twofold aspect of commenting on what she is doing while she is doing it.[6]

For Litz, the body was first of all a physiological phenomenon, composed of bone, tendons, ligaments, muscles, and other tissue. Its use as an expressive medium was dependent on its nature as a repository, artifact, or fact of individual experience. It was this content, rather than some external narrative, that the dancer set out to communicate.

Charles Olson's review of Litz's "Glyph" dance, published in the *Black Mountain Review*, focused on this aspect of her work. He credited Litz for her pursuit of "an investigation of the body as instrument."[7] "The Glyph," he wrote, exhibited "the possibilities of the body's parts . . . so that . . . their physicality . . . is in front of you so clean of all reference that it is like when the finest painter confronts you with paint in the power of itself as pigment." In his review, Olson urged Litz to proceed even further in removing narrative or symbolic references from her choreography in favor of a presentation of the "kinetics of the body." Nature, he wrote, is not an external or internal event to which art holds up a mirror; it "is merely a les-

son which any of us learns . . . from the work that we do on ourselves seeking to know function and assert it."[8]

In a number of writings from the early 1950s, Olson stressed the importance of dance as a tool of the new humanism. In a poem from the summer of 1951, "Applause (for Nick Cernovich)," he asserted the power of spontaneous dance to oppose the abstract epistemology of "discourse" that had sundered the rational from the physical:

> you who dance,
> who dance so, is borner
> for all men on the four seas burdened,
> confused by discourse, her
> false clarities . . .
> by going, as you go now before my eyes by feet alone, by throw
> of what works under, the bobbing
> of your exact head, the droppage
> of an arm as hinge, you show a heart the old heart stays as . . .
> what has long been unknown[9]

In *Apollonius of Tyana*, a dance-drama written that same summer, Olson proposed a holistic definition of health, rooted in "kinesis," that was at once mental and physical, individual and social. He wrote: "Any kind of healing, like any kind of usable discovery, starts with the human body, its complicated and animal structure. . . . To heal, is also how you find out how—somehow—to maintain your resistance . . . how to act fiercely but, with dignity."[10]

In the all-important field of kinesis, Olson maintained, artists were forging ahead of scientists in their investigations and in the creation of texts that would communicate their findings: "We have doctors for the mind and doctors for the body and neither of them know what a dancer now has to know, or a composer, or a poet, if any of these latter craftsmen are honestly attacking their craft." He opposed a kinetic knowledge of the human body and of human experience to that knowledge which was merely descriptive.[11] The descriptive or representative mode assumed a noninteractive, static relation between the investigator and the object of investigation. In this sense it was inherently limited. An accurate knowledge of human experience depended on kinetic enactment. "There is only one thing you can do about [the] kinetic, reenact it," Olson proclaimed.[12] This is why he felt that artists and dancers led the way in the quest for humanistic knowledge.

Merce Cunningham, who taught dance at Black Mountain College during the 1950s, had studied with Martha Graham in the early 1940s. But he left the Graham dance company in 1945, to develop in his own di-

rection. He wanted to present movement in itself, and not as an allegory of "inner" emotions. He strove to free dance from its dependence on both music and narrative, in order to concentrate on exploring the subjectivity of the human body and the full range of its expressive possibilities. In 1953, he presented his first season of dances with his own company in Greenwich Village. It was completely ignored by reviewers.[13]

One of the structural features of Cunningham's dances that differentiated them from previous styles was their avoidance of a single central focus. As McDonagh has observed, "There is always a variety of things to look at in a Cunningham dance, and attention is not compelled or directed to the same spot at all times."[14] Cunningham's are "all-over" dances, like gesture-field paintings; there is no center stage or hierarchy of position. Cunningham himself has related this structure to what his long-time companion and musical director, John Cage, called "polyattentiveness."[15] In this, his reliance on an aesthetic of the "energy field" is evident. As Cunningham stated: "The logic of one event coming as responsive to another seems inadequate now. We look at and listen to several at once."[16]

Cunningham's statements about his choreographic method reveal it as a kind of plastic automatism. The kinetic impulse originates in the body rather than in the mind. "I 'step' with my feet, legs, hands, body, head— that is what prompts me, and out of that other movements grow," Cunningham has said; "This is not beginning with an idea that concerns character or story, a *fait accompli* around which the actions are grouped for reference purposes. I start with the movement."[17] From these origins, the dance assumes an expressive character that derives from the choreographer's materials—the dancers' bodies—in improvisational interaction or "conversation" with one another:

> I ordinarily start with myself; not always, it may be with one or two of the dancers. But then out of this the action begins to assume its own proportions, and other possibilities appear as the dance proceeds. New situations present themselves—between the dancers, the dancers and the space, the space and the time. It is not subject to a prearranged idea as to how it should go any more than a conversation you might have with a friend.

In keeping with this conversational model, Cunningham's dances present an interplay among the dancers; within this dynamic each dancer develops a unique "voice." In training, Cunningham's dancers are supplied with a movement vocabulary, but they are encouraged to let their own style of movement emerge as a contribution to the work. Each expresses individuality and yet participates in the overall dance. Cunningham has

pointed out that this entails a high degree of intersubjective awareness, or trust:

> [E]ach dancer is a separate entity . . . there is not a chorus along with which there are soloists, but rather . . . each in the company is a soloist, and in a given dance we may act sometimes separately and sometimes together. I would like to allow each dancer to appear in his way as a dancer, and that implies a good deal of trust between us.

In a successful dance, the result is complementarity resulting in a high level of energy. According to the choreographer, "It is an interdependence that brings about what you speak of as intensity." The imperative to poly-attentiveness, a give-and-take of information freed from narrative pre-conceptions, is what creates the characteristic look that many critics have observed in Cunningham's dancers: alert, poised, and ready to move in any direction.[18]

Roger Copeland has argued that Cunningham's separation of dance from music and his use of chance compositional elements proceeded from a desire "to root the natural out of his dancing."[19] But this is incorrect. Cunningham used his body as a found object, but not as a "ready-made" in the tradition of Marcel Duchamp, in which the subjectivity of the artist is minimized in order to emphasize the act of aesthetic consumption. Rather, like Motherwell with his collages, Cunningham used the object to make an expressive, physical statement, one in which movement could develop independently of musical or thematic materials. When he used chance, particularly in the early 1950s, it was in order to isolate body parts and their motions, so as to break down rote combinations of movement conditioned by everyday life and to explore alternative movement possi-bilities. In this sense, his artistic project had much in common with the therapeutic program of Paul Goodman, who also wanted to wrest the ex-pressive body out from the net of habit. As Cunningham has stated: "I be-gan to use random methods in choreography to break the patterns of personal remembered physical co-ordinations [so that] . . . the resource-fulness and resiliency of a person are brought into play. Not just of a body, but a whole person."[20]

In the 1960s, another generation of choreographers would pursue the spontaneous aesthetic even further. Ann Halprin pioneered the use of or-dinary bodies as opposed to those of trained dancers. Steve Paxton further democratized the choreographic process, doing away with the privileged position of choreographer in favor of an unguided exploration of group movement. The resultant form, known as "contact improvisation," was one in which the art of dance most closely approached the activity of "en-counter group" therapy: both emphasized self-expression in a group sit-uation, a continuum of mind and body, and a process of risk-taking,

reality-testing, and trust. As one participant-observer remarked of these dance forms, "often, what unfolds is deeply connected to one's own intricate patterns of relating and being in the world (in fact it will be if it is authentic)."[21]

The affinity between abstract expressionist art and the new modern dance was manifested in collaborations between Merce Cunningham and Robert Rauschenberg. Their alliance began at Black Mountain College, where Rauschenberg studied painting in the early 1950s. There he learned the practice and principles of gesture painting from Jack Tworkov and Franz Kline. He developed the theme of the body in action in his "Black Paintings" from this period: newspaper comics torn into strips and crumpled into wads, then coated with black paint in a gestural style.[22] The "Black Paintings" were shown in New York in September 1953, along with works by Jackson Pollock, Willem de Kooning, Robert Motherwell, and Franz Kline.

In the mid-1950s, Rauschenberg pursued the direction marked out by these "action collages." He expanded on them, producing collages, assemblages (sculptures made of found objects), and "combines" (mixtures of painting and sculpture) indexical of the human body, including *Hymnal* and *Bed* (fig. 7.1). Like Jim Dine and Allan Kaprow, who also began their careers as gesture painters, Rauschenberg moved incrementally from "action-collage" toward the performing arts. He said that he was drawn by the capacity of performance to fulfill "the idea of having your body and its activity be the material."[23] As Allan Kaprow described the trajectory of his own artistic evolution:

> I developed a kind of action-collage technique, following my interest in Pollock. These action-collages . . . were done as rapidly as possible by grasping up great hunks of varied matter: tinfoil, straw, canvas, photos, newspaper, etc. I also cut up pictures which I had made previously, and these counted as autobiographical fragments, as much as they were an intended formal arrangement. The straw, the tinfoil, occasional food, whatever it was, each of these had, increasingly, a meaning that was better embodied in the various nonpainterly materials than in paint.[24]

These action-collages expanded into environments, leading soon to performances within those environments. Kaprow, Jim Dine, and Claes Oldenberg formed a workshop together in 1959 to explore the possibilities of this medium.[25]

Rauschenberg's formal collaboration with Merce Cunningham began in 1954, when he made the combine *Minutiae* as the set for a Cunningham dance of the same name. He appeared with the company for the first time in 1961, as part of a theater event in which he constructed a collage on-

7.1. Robert Rauschenberg,
Bed, 1955

stage. This collage was turned away from the audience for the entire performance so that it could not be seen, but it was fitted with a microphone to magnify the sounds of Rauschenberg at work.[26] By its exclusive reliance on the sound as opposed to the sight of the collage, this performance piece took the principles of bodily gesture, energy-transfer, and plasticity beyond the limits of "visual art."

In his autobiography, Rauschenberg has attributed his interest in dance to the sense of interpersonal collaboration that Cunningham emphasized in his "conversational" improvisational method.[27] Such interactions were for him a joyous change from the solitary creative life of a painter. In 1964, Rauschenberg was quoted in an interview as saying that the Merce Cunningham Dance Company was his "biggest canvas."[28] Although this statement might be construed as claiming undue credit for his creative role in the company, it can be understood within the discursive context of "plastic dialogue" as a tribute to Cunningham's choreography for its furtherance of gesture-field painting's humanistic vision.

POTTERY AND ZEN

The gravitation of gesture-field painters toward performance reflects how an artist's objectives can influence his or her choice of a medium. The aesthetic of spontaneity led artists to explore media that responded quickly or easily to the impulse of a moment, improving the artist's chances of recording, expressing, and communicating the fleeting gesture. In his gesture-field paintings, for instance, Jackson Pollock preferred to use commercial Duco paint rather than painter's oils, since its thinner consistency made it easier to pour. Another medium that lent itself to the imperatives of spontaneous expression was clay. In the 1950s, under the influence of abstract expressionism, the craft of clay pottery was lifted to the status of a high art.

A number of factors made clay a likely substance for the further extension of gesture-field painting. Like paint, clay is plastic and so affords the possibility of physical "dialogue." Malleable yet resistant, it responds quickly to the artist's gesture and yet has limits beyond which it cannot be forced. Manipulating it requires a high degree of bodily involvement and sensitivity. Also, unlike other sculptural media such as wood and metal, clay can be worked for only a relatively short time. According to Peter Voulkos, the most famous of abstract expressionist potters, "You try to keep the spontaneity. You can't sit there and think about it for long. You don't have that kind of time with clay."[29] These properties made clay an ideal medium for the enactment of a "conversation" between the artist's will, the artist's unconscious, and the material environment—a guiding principle of the aesthetic of spontaneity. As Charles Olson oracularly

commented on the medium: "Speech as Solid. Kinetic. Movement. Honor."[30]

Because of the triumph of the aesthetic of spontaneity in other media, particularly painting, pottery began to be counted among the fine arts in America during the 1950s. In the preindustrial era, pottery had been a necessary handicraft. With the advent of industrial methods for producing ceramics, the craft had waned until it was revived by the Arts and Crafts movement around the turn of this century.[31] The influence of the Arts and Crafts movement was attenuated in the 1930s and 1940s by an influx of people and ideas from the German Bauhaus movement. Whereas the Arts and Crafts aesthetic had valorized the handcrafted appearance of a work, the Bauhaus aesthetic emphasized the clean lines of industrial design. For a time this infusion of International Style modernism and the machine aesthetic supplanted the antiindustrial impulse as the ideal of American pottery craft. After World War II, however, a surprising combination of Japanese aesthetics and a resurgent British crafts movement gave new life to the older ideal.

It was British potter Bernard Leach who was largely responsible for this renaissance. Born in 1887 in Hong Kong, he was old enough to have fallen under the influence of William Morris's craft-revival ideals in their first heyday.[32] He had also traveled extensively in East Asia, and had studied pottery techniques and philosophies for eleven years in Japan. In June 1952, Leach organized an International Conference of Potters and Weavers in England. That October, with his Japanese friends Shoji Hamada and Soetsu Yanagi, he undertook a demonstration tour of the United States.

The visit of these Japanese potters to the U.S. coincided fortuitously with a sudden growth of pottery education in this country, as American universities expanded in response to postwar government programs such as the GI Bill. The first stop on Leach's tour was Black Mountain College. The potters also visited sites in Minnesota, Montana, and California, before returning to Japan.[33] The Americans they influenced, including Warren Mackenzie and Peter Voulkos, would become the vanguard of a new movement in American pottery that relied heavily on Japanese Buddhist aesthetics.

The Ceramics Institute at Black Mountain College in the fall of 1952 featured Leach, Hamada, Yanagi, and Marguerite Wildenhain, who had been active in the Bauhaus and was now living in California. Wildenhain may have felt herself outnumbered by the joint influence of the other three. The emissaries of Japanese culture that Leach brought with him, like William Morris and unlike the Bauhaus, did not identify good artisanship with clean geometrical form. They favored imperfection, asymmetry, and idiosyncrasy.

Soetsu Yanagi was an important cultural figure in Japan, having coordinated the revival and preservation of Japanese folk arts after they had been marginalized by industrialization and an excessive admiration for all things Western during the Meiji period. When he arrived with Bernard Leach and Shoji Hamada, it was not Yanagi's first visit to the United States. He had lectured on Buddhist art and aesthetics at Harvard during the 1929–30 term. As a champion of folk traditions, Yanagi stressed the aesthetic attribute of *mingei*, or unself-conscious craftsmanship. He praised the anonymous artisan, who produced beautiful articles for everyday use, over the artistic genius who valued cleverness and originality.[34]

Hamada and Leach tempered these ideas with a more modern ideal of personal expression. Hamada had begun his artistic training as a painter, and was not averse to the cultural status of the artist. Leach also felt that pottery ought to be considered on a level with other fine arts.[35] All three agreed, however, on following the pottery aesthetic of Zen Buddhism, which had its basis in the Zen tea ceremony formalized in the sixteenth century.[36]

Of all the philosophical and theoretical schools influencing the postwar avant-garde, Zen Buddhism was the least subject-centered. Existentialism emphasized the individual act of will. Alfred North Whitehead's cosmology and Paul Goodman's gestalt therapy, while denying a fixed distinction between self and other, stressed the active role of the self in constantly redefining its boundaries. Zen, by contrast, considered the boundary between self and not-self an illusion to be shattered. Among members of the avant-garde, however, subscription to the ideas presented by these philosophies was quite eclectic. Their possible incompatibilities seemed less significant than their general similarities.[37] Gestalt therapy, for instance, synthesized existentialism and Taoism, which was also an important influence in Zen.

Important affinities existed between Zen Buddhism and the culture of spontaneity developed after 1940 in the United States. Like abstract expressionism in its pursuit of a plastic language, Zen insisted on the inadequacies of verbal communication. Bodhidharma, who according to legend founded Ch'an (Zen) Buddhism when he emigrated from India to China in the fifth century, practiced his religion without explanation, cautioning, "Devise no word."[38] *Satori*, or Zen enlightenment, is often prompted by physical actions or blows, and can be expressed verbally only through paradox. Daisetz Suzuki, whose explications of Zen Buddhism have done much to establish its intellectual legitimacy in the United States, explained that "Zen is not necessarily against words, but it is well aware of the fact that they are always liable to detach themselves from realities and turn into conceptions. . . . And this conceptualization is what Zen is against . . . Zen insists on handling the thing itself and not

an empty abstraction."[39] Zen discipline cultivated an unself-conscious unity between mind and body, and between self and surroundings, emphasizing spontaneous responsiveness. Suzuki described the Zen ideal as a "structure or mentality which is made always ready to respond instantly, that is, im-mediately, to what comes from the outside. . . . No reflecting whatever. . . . As soon as you tarry, the whole thing gives away."[40]

The tea ceremony that was at the root of the Zen pottery aesthetic was designed to exercise the awareness of participants, by exposing them to subtle differences of sensual experience that invited the "exploration of nuance and materiality." According to Shuko, the sixteenth-century tea master, cultivating this form of attention was ultimately an act of social good, not mere personal pleasure. It was meant "to begin with the mutual reception and communication between friends which will eventually lead to the ideal of universal peace."[41] In this faith, as well, Zen shared the hope of the postwar American avant-garde.

These shared precepts gave rise to common aesthetic standards. Unintentionality, rapid execution, and imperfection were valued as characteristics demonstrating the artist's transcendence of intellectual dichotomizing and self-consciousness. In the best work, Soetsu Yanagi asserted, "art and accident play an undifferentiated role." This unwillingness to distinguish between art and accident was also expressed by Jackson Pollock in 1950, when he defended his pouring technique by stating, "With experience it seems to be possible to control the flow of the paint to a great extent, and . . . I don't use the accident—'cause I deny the accident."[42] The Zen painting tradition had something of a counterpart to Jackson Pollock's physiological automatism in the "flung ink" painting style developed in the sixteenth century. Sherman Lee has described the style in a way that brings out this likeness:

> [I]t is a manner that must be sensed as a combination of materiality (ink) and subtle but immediate suggestion (brush-muscle, head and heart) . . . the significant accident, the finding of the form in the wayward ink plays its part. Again, the beholder must provide a large share of sympathetic participation.[43]

Hamada's pot decorations exemplify the affinity between Zen brushwork and the gestural style of abstract expressionism (fig. 7.2).

In Zen arts, as in the postwar American culture of spontaneity, the creative process is ideally valued more than the artifact itself.[44] The Zen pottery aesthetic favors tea bowls in which the dripping, cracking, and discoloration of the glaze and clay dramatize the processes of clay throwing, glaze application, and firing. Such "imperfections," as Thomas Hoover has written, "invite us to partake of the process of creation."[45] By recalling the user's attention to the hand of the workman, they resist the

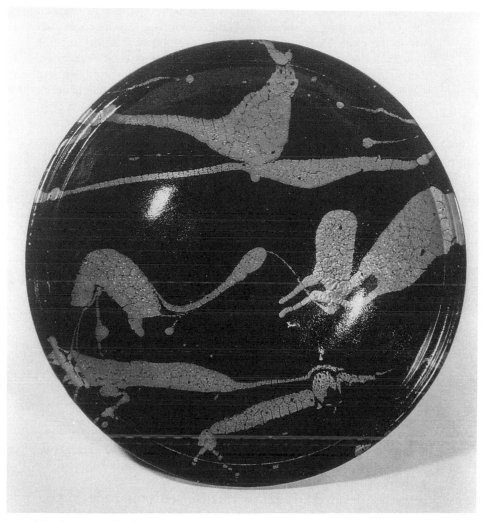

7.2. Shoji Hamada, plate, 1962

fetishization of the tea bowl as an object or commodity. Yanagi, para-phrasing the sixteenth-century *Book of Tea*, explained the unfolding of process as a humanistic concern: "the precise and perfect carries no overtones, admits of no freedom; the perfect is static and regulated . . . we in our human imperfectness are repelled by the perfect, since everything is apparent from the start."[46] The Zen aesthetic, he wrote, aimed neither for perfection nor for imperfection, but appealed to a frame of mind "before the beautiful and the ugly were differentiated."[47]

American artists practicing the aesthetic of spontaneity assimilated their understanding of Zen to the other ideas, forms, and practices already within their ken. Mary Caroline Richards, who learned pottery at Black Mountain College, described her artistic philosophy using elements of Zen, field theory, and existentialism. In her book, *Centering* (published in 1964), she alluded to the well-known Zen *koan* "What is the sound of one hand?"[48] to invoke the familiar trope of plastic dialogue between artist and clay.

> Potter and clay press against each other. The firm, tender, sensitive pressure which yields as much as it asserts. It is like a handclasp between two living hands, receiving the greeting at the very moment that they give it. It is this speech between the hand and the clay that makes me think of dialogue. And it is a language far more interesting than the spoken vocabulary which tries to describe it, for it is spoken not by the tongue and lips but by the whole body, by the whole person, speaking and listening.[49]

Richards, like Goodman, suggested that the plastic dialogue between an artist and her medium constituted a de facto education in metaphysics. The title of her book, *Centering: In Pottery, Poetry, and the Person*, implied that the art of pottery functioned as a synecdoche of personal development. (Goodman had asserted as much for painting and dance.) Pottery, she wrote, "requires certain kinds of energy, certain capacities of taking the world into our consciousness." For her, "consciousness" implied a distinct quality of attention related to full bodily participation, akin to Goodman's "awareness." She placed the educational value of this consciousness above the acquisitive accumulation of knowledge that characterized most American education: "Knowledge is like a product we consume and store. . . . By consciousness, I mean a state of being 'awake' to the world throughout our organism."[50]

Richards followed Charles Olson in seeing the potter's plastic dialogue with clay as an education in "resistance," the basis of a new humanism. As she wrote,

> You can do very many things with [clay], push it this way and pull that, squeeze and roll and attach and pinch . . . But you can't do everything with it. You can go only so far, and then the clay resists. To know ourselves by our resistances—this is a thought first expressed to me by the poet Charles Olson.
>
> And so it is with persons. You can do very many things with us . . . but there comes a point when you can do no more. The person resists, in one way or another (if it is only by collapsing, like the clay). His own will becomes active.

This is a wonderful moment, when one feels his will become active, come as a force into the total assemblage and dynamic intercourse and interpenetration of will impulses. When one stands like a natural substance, plastic but with one's own character written into the formula, ah then one feels oneself part of the world, taking one's shape with its help.[51]

Although M. C. Richards's thoughts on pottery would be widely read among potters in the 1960s, it was the pottery practice of Peter Voulkos and Toshiko Takaezu in the 1950s that did the most to integrate the craft of pottery with the postwar aesthetic of spontaneity. Voulkos was born to Greek immigrant parents in 1924, making him a contemporary of the beat poets and of second-generation abstract expressionist painters. He was studying painting at Montana State University on the GI Bill when he became fascinated with the plasticity of clay and traded pottery for painting. In 1952, when Hamada, Yanagi, and Leach left Black Mountain College to continue their tour of the United States, they met Peter Voulkos in Montana. Voulkos's work at that time was still rather tight and formal; Hamada, who had himself come to pottery from painting, advised Voulkos to "allow the clay to speak more."[52]

The following summer, Voulkos joined Warren Mackenzie and Daniel Rhodes at Black Mountain College for a second Ceramics Institute.[53] Rose Slivka has written that those three weeks changed Voulkos's art and his life.[54] At Black Mountain, Voulkos met Olson and Tworkov, Rauschenberg, Cunningham, and Cage. At the conclusion of the institute, he traveled with M. C. Richards to New York City to visit Kline, de Kooning, and other painters who socialized at the Cedar Tavern.

The question of how he would integrate into his art everything that he had seen and learned was not resolved until the fall of 1955, when Voulkos began combining large-scale, "heroic" throwing with the "plastic transformation of pots, thrown and then shaped, changed, altered."[55] Beginning with pots a foot and a half high, which required the whole body's muscular involvement to produce, by the end of the decade Voulkos had come to making sculptural "pots" eight feet high. From the mid-fifties onward, he decorated his works with spontaneous brushstrokes and emphasized the qualities of unself-consciousness, imperfection, and a dialogue between the "resistances" of artist and clay (fig. 7.3).

Voulkos emphasized spontaneity in his teaching at the Otis Art Institute in Los Angeles, where he founded a ceramics department in 1954. In particular, he recalled one exercise:

We used to have contests to see who could throw the fastest teapot. We tried to make a teapot in two minutes complete—throw it on the wheel, make a lid, a spout, real fast. We were always trying to beat the

7.3. Peter Voulkos, plate, 1959

two-minute mark. Had some of the weirdest-looking teapots you ever saw, some of them fantastically good. You couldn't start fooling around with it. You had to go by sheer instinct.[56]

A student, Paul Soldner, compared Voulkos's technique to dancing, commenting, "He is in absolute touch with the material, with himself."[57]

Voulkos's art and teaching contributed to the broader cultural impact of the aesthetic of spontaneity, as the "beat" counterculture began to make inroads into American artistic and intellectual life on both coasts after 1956. As Soldner has recollected, "We were feeling the Oriental influence,

Zen, we were swept up in the beatnik period. We were part of that, but we didn't know it until later." Voulkos himself took up the serious study of jazz guitar at this time, spending five hours a day exploring bebop harmonies and rhythms.[58]

Critics were not slow in associating Voulkos's new style of work with the themes of abstract expressionist painting. Rose Slivka, writing in 1960 for the journal *Craft Horizons*, hailed Voulkos for pioneering a new area of plastic expression that she called "sculpture painting": "The potter manipulates the clay itself as if it were paint—he slashes, drips, scrubs down or builds up for expressive forms and textures."[59] Marguerite Wildenhain, formerly of the Bauhaus, responded to Slivka's celebration of Voulkos by canceling her subscription to *Craft Horizons*.[60]

Toshiko Takaezu, who approached the clay with less aggression than Voulkos, did not arouse the same levels of animosity. Like Voulkos, Takaezu was a child of immigrants: she was born in 1922, to Japanese parents who worked in the Hawaiian sugar plantations. Japanese was her first language. She studied pottery in 1950 at the University of Hawaii, where Bernard Leach's book on pottery was consulted, she said, "like a bible." At the Cranbrook Academy of Art in Michigan, where she continued her studies in the early 1950s, she later met Leach, Hamada, and Yanagi. Under the tutelage of Finnish potter Maija Grotell, at Cranbrook Takaezu developed a personally expressive pottery style influenced by Japanese tradition.[61]

In 1955, Takaezu traveled to Japan, both to study the art of making ceremonial tea bowls and to strengthen her sense of identity with her parents' culture of origin. With her sister, she lived for a month at a Zen temple at the Daitokuji complex in Kyoto. As she recalled,

> I decided at that time that there were a few things that I really wanted to know about my heritage . . . and going to Japan was one way—not only of learning how to do pottery, [but]—being with potters you can talk to them. And all communication would be something that was part of our medium. Communication, other things would happen. That's what I was interested in.[62]

During the 1950s, she began, like Voulkos, to increase the scale of her pieces, and to alter her thrown forms in nontraditional ways: by adding coils of clay, or by slapping or even gouging the thrown form. She directed much attention to applying the glaze, a process that she likened to painting on the surface of the pot. "It's like a canvas to me," she said, "a three-dimensional canvas that I would brush and paint" (fig. 7.4).

In the course of her career, she gradually achieved greater looseness and spontaneity in her brushstroke, as self-conscious design was supplanted by a reliance on bodily gesture. As she explained: "I just want to

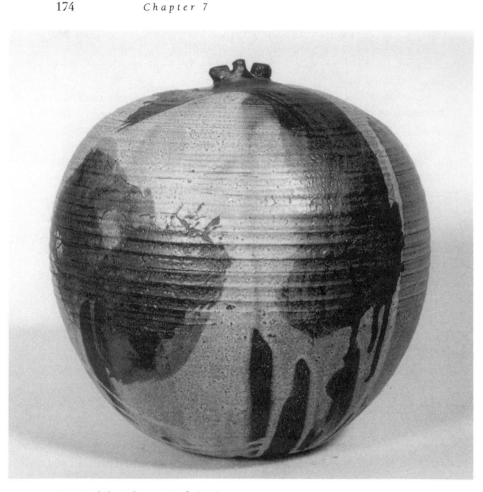

7.4. Toshiko Takaezu, *Mask*, 1960

flow; . . . You need that kind of freedom, of a certain type. Your whole body gets to be part of everything, and you become free." "Freedom," for Takaezu, is thus paradoxically inseparable from a disciplined but spontaneous engagement with her medium. It is this interrelation that she credits for the quality of *shibui* in her work, a Zen term that she understands as "understated aliveness." As she said, "You can't force [the clay] completely . . . So you're in tune. You play. It's interrelation, interplay with the clay. But the clay has much to say on its own. You can't really control that. . . . And when you finish a piece, . . . the piece is alive."

Like many others, Takaezu has compared this plastic dialogue to danc-

ing. Explaining her reasons for beginning to create works of larger, even human, scale, she observed:

> You become part of it . . . when you make bigger things. . . . You can move along the piece, around it . . . The brush can flow, can be free, you can walk around, and throw the brush around. And there is a kind of feeling that you dance with the piece, there's a feeling that you're in tune with the piece, with the motion of the dance, with the glaze and the brushstroke.

In contemporary America, Zen is reputed to be a form of Eastern mysticism. But Takaezu described the relation between herself and the clay as a physical, not a mystical one: "You see, the connection is through the brush." Pottery, like dance, emerged in the 1950s as an art form that extended the pursuit of "plastic dialogue."

Spontaneous Bop Prosody

8 Bebop

There then came down in the ugly streets of us
inside the head & tongue
of us
a man
black blower of the now
The vectors from all sources—slavery, renaissance,
bop charlie parker,
nigger absolute super-sane screams against reality
course through him
AS SOUND!

—Amiri Baraka, "Am/Trak" (1968)

In the 1930s, When Lester Young began to experiment with new tone qualities in his saxophone playing, a fellow member of Count Basie's swing band taunted him. Young retorted by tapping his forehead, saying: "There are things going on up there, man—some of you guys are all belly."[1] His words attest to the bebop impulse to reinvent jazz as an intellectual pursuit.

Bebop shared the disposition of other spontaneous art movements at midcentury to develop an alternative to corporate-liberal culture rooted in intersubjectivity and body-mind holism. Bebop embodied these principles in formal attributes emphasizing the African American musical idiom: polyrhythm, timbre, and a structure of call-and-response. Compared to the swing jazz from which it grew, bebop was a conversational music, played best in small ensembles rather than in big bands. Intersubjective reality was manifested in the way the music emerged, as each player maintained a spontaneous awareness of voices within and without. Bebop innovators also worked to integrate mind and body by exploring the realm of prosody: that boundary between ideas and feelings where music becomes an utterance, and words become pure sound.[2]

THE EMERGENCE OF BEBOP

The swing jazz of the "big band" era, dating roughly from the mid-1930s to the mid-1940s, had adapted the racy

legacy of New Orleans jazz to the high-culture format of the concert or-
chestra, as epitomized in Norman Granz's popular "Jazz at the Philhar-
monic." Swing became a crossover phenomenon of unprecedented size in
American music. Large swing dance bands became the defining feature of
a musical era, playing for both white and black audiences and for U.S. ser-
vicemen overseas.[3]

By contrast, bebop jazz, emerging at the beginning of World War II,
turned away from the European orchestral model and expanded on char-
acteristically African American musical elements. In his book *Blues
People*, LeRoi Jones identified these elements as antiphony (or call-and-
response), polyrhythm, and prosodic tone. Jones, an African American
intellectual and a prominent poet, wrote of bebop that it represented a
healthy separatism and autonomy on the part of black culture, after the
commercialized assimilationism of swing.[4]

Bebop developed between 1939 and 1941, during after-hours jam ses-
sions at nightclubs in black Harlem: Monroe's Uptown House and, par-
ticularly, Minton's Playhouse, on 118th Street between 7th Avenue and
Saint Nicholas. Musicians who played as "sidemen" in the swing bands—
that is, among the orchestral sections devoted to reeds, brass, strings, or
percussion—would congregate to play together after their night's work
had ended.[5] Jam sessions brought back some of the fun of being a musi-
cian, which could be lost in the workaday playing culture of the big bands.

Jam sessions offered professional camaraderie and the opportunity to
learn new techniques or to hear a new melodic sequence (or "lick"). They
also gave musicians a chance to hone their skills through the competitive
give-and-take of "cutting," a kind of musical dueling related to the verbal
sparring of "playing the dozens."[6] Cutting had been a part of black musi-
cal culture at least since the days of ragtime; but in the swing era it took
place almost wholly at the aggregate level of band against band, as in the
"Battles of the Bands" at the Savoy Ballroom. Cutting as a test of skill and
creativity between individual musicians had been for the most part elimi-
nated from the performance culture of swing, in which only a few musi-
cians got the chance to solo, while the rest played background harmonies
or "riffs" in unison.

Most importantly, jam sessions offered a forum in which to practice im-
provisation. The fact that improvisation must be practiced need not be
taken as a paradox. Improvising jazz solos does not consist mainly in in-
venting new licks, but in stringing together learned licks and references in
new and appropriate combinations—just as new usages and phrasings are
a greater part of the poet's work than coining neologisms is.

As a subgenre of jazz, bebop began in earnest in 1941, when its attrac-
tion began to be so powerful as to draw talented musicians away from

their paying jobs in swing bands. In 1941, Charlie "Bird" Parker quit the Jay McShann band. He had been playing with the band at the Savoy Ballroom and jamming after hours at Monroe's. But when it came time for the band to go on the road, he decided to stay on in New York.[7] Lester Young, known as "the Pres," left the prestigious Count Basie band in December 1940.[8] Between 1941 and 1943, when he was drafted into the army, he worked with small ensembles that offered him less money but more musical freedom. His creative stamina became legendary in Greenwich Village, where he would appear and improvise chorus after chorus.[9]

As the war ended, bebop became a national phenomenon. In 1944, it was brought from Harlem to the predominantly white clubs in midtown Manhattan: the Three Deuces, the Onyx, the Downbeat Club, the Spotlite, the Famous Door, the Yacht Club, and Kelly's Stable.[10] In the same year, the first bebop record, a performance of "Bu-Dee-Daht" featuring Dizzy Gillespie, was cut on the Apollo label.[11] Before that, wartime restrictions on materials, along with a recording ban by the American Federation of Musicians (on strike over royalties payments), had prevented recordings of the new jazz. In the next couple of years, the wide distribution of bebop records would gain national recognition for bebop musicians, particularly Charlie Parker and Dizzy Gillespie.

The centers of bebop in those years were the war-swollen metropolises of St. Louis, Chicago, Los Angeles, and New York.[12] There, the music quickly gained association with a new, urban black consciousness demanding greater recognition for African American contributions to American society. A. Philip Randolph's "Double V" campaign and the federal government's push for national unity in the war effort had combined to create a new atmosphere of assertiveness among American Negroes. The excitement and pride of those years was linked, especially in the minds of the younger generation, to the new jazz sound.[13] As Dexter Gordon recalled:

> In a sense the cats were thinking this music was so great and so wonderful and putting all their hearts and souls into it, talking about a new and better world, and more colorful, more interesting, offering all this. . . .
>
> I really think it was the start of the revolution, the civil-rights movement, in that sense, because that's what the music is talking about. This is all the young generation, a new generation at that time. And they're not satisfied with the shit that's going down. Because they know there should be changes being made. And actually it was a time of change because it was wartime and people were moving back and forth all over the United States and constantly traveling—armies, war

jobs, defense jobs. It was a time of great flux. And it was a time of change, and the music was reflecting this. And we were putting our voice into what we thought was about to be the thing.[14]

This social meaning of the music contributed to the attitude projected by bebop musicians onstage. Bebop players comported themselves less as entertainers than as serious musicians and intellectuals. They followed an unwritten rule to avoid the traditional image of Negro entertainers. Dizzy Gillespie earned Charlie Parker's lasting ire for "Tomming" or clowning at the head of his band. According to Allen Tinney: "If you what they called 'showboated,' if you did any kind of fancy tricks or anything, you were really sort of isolated, you were banned from the crowd. You just had to stand there and be real serious about it. It was taken right out of the entertainment role."[15]

Charlie Parker's erratic behavior and his heroin addiction have given him an undeserved reputation as an antiintellectual. Those who knew him well saw him otherwise; as Milt Hinton told Ira Gitler: "Charlie, to me, was a great philosopher. . . . For some reason, we always got into [talking about] politics . . . between sets we would play classical music . . . we would talk about politics and race and really deep things like the solution for blacks in America."[16] Miles Davis has offered the explanation that Parker used his antiintellectualism as a protective mask:

> He was an intellectual. He used to read novels, poetry, history, stuff like that. And he could hold a conversation with almost anybody on all kinds of things. . . . He was real sensitive. But he had this destructive streak in him that was something else. . . . [H]e used to talk a lot about political shit and he loved to put a motherfucker on, play dumb to what was happening and then zap the sucker. He used to especially like to do this to white people.[17]

The persistent refusal to accord bebop musicians the status of serious artists stemmed from biases within "middlebrow" and "highbrow" culture—the commercial mass media and the established intellectuals to whom the culture of spontaneity was self-consciously opposed. Like other forms of spontaneous art, bebop did not fare well in either the popular or the intellectual press. Henry Luce's *Time* magazine ridiculed Dizzy Gillespie in a 1948 article entitled, "How Deaf Can You Get?"[18] In the same month, Weldon Kees wrote of bebop in the *Partisan Review*: "I have found this music uniformly thin, at once dilapidated and overblown, and exhibiting a poverty of thematic development and a richness of affectation."[19]

The academic establishment refused recognition to modern jazz, although it vociferously defended modern European music and its practitioners this side of the Atlantic.[20] In fact, however, bebop marked the first

sustained engagement of jazz musicians with avant-garde music. Charlie Parker listened carefully to the works of Béla Bartók, Richard Wagner, and Igor Stravinsky—particularly to Stravinsky's *Firebird Suite* and *The Rite of Spring*.[21]

European musical modernists were searching for ways to break out of the restrictive system of "functional tonality" that had governed Western composition since the eighteenth century. In functional tonality, also known as harmonic tonality, prescribed series of harmonic sequences provide the basis for musical composition. Musical structures are built on the principle of creating and relieving "tonal tension." This is achieved through the introduction of "dissonance" and its subsequent "resolution" into "consonance." By the end of the nineteenth century, the expressive possibilities of this system of composition seemed outmoded, if not exhausted.

In the early years of the twentieth century, Stravinsky developed an alternative "neotonality" that formed the structural basis for works like *The Rite of Spring*. Development through stages of dissonance and consonance no longer took precedence. Instead, patterns of rhythm and harmonic repetition established an independent musical vocabulary.

> The way things happen is determined by the almost kinesthetic impact of violent rhythmic articulation and accents organized in asymmetrical, shifting patterns. . . . Ideas based on simple, insistent repetition gain long-range power and significance through the juxtaposition of contrasting patterns . . . and through their constant rhythmic and metrical reinterpretations.[22]

This description by Eric Salzman of Stravinsky's *The Rite of Spring* reveals the similarity of neotonality to the structure of modern jazz.

Bebop's "modern changes" often substituted the dissonances of extended chords (notes of the harmonic overtone series beyond the perfect fifth) for the simple consonances of the popular standards from which they were derived. Of the twelve possible musical intervals in the diatonic octave, nineteenth-century European music theorists ranked these five most dissonant: the minor second; the major seventh; the major second (equivalent to the raised or harmonic ninth); the minor seventh (harmonic seventh); and the flatted fifth (harmonic eleventh). Bebop soloists would commonly end on such tones, defying the conventional imperative to tonal resolution.[23] For example, the Lee Konitz solo transcribed and analyzed by Charles Hartman in his book, *Jazz Text*, ends on the note of G in the key of A flat—a major seventh.[24] The flatted-fifth interval, in particular, became a bebop trademark. Chords using these extended harmonies blurred the line between harmony and dissonance, creating "polytonality."

Of course, bebop musicians did not learn the art of polytonality from European modernism. Listening to Stravinsky and Bartók only helped to legitimate and confirm what they had already heard in their instruments and imaginations. As Mose Allison has attested: "Nobody knew any names until later years—the raised ninths, flat fives."[25] And Thelonius Monk commented, "If you can't *hear* it [the relation of the melodic tone to the harmonic series], ain't no use *tellin'* you about it."[26] Beboppers consistently described a process of integrating aural intuition with an intellectual grasp of harmonic structure, as in Charlie Parker's description of his "invention" of bebop in December, 1939:

> I'd been getting bored with the stereotyped changes that were being used at the time, and I kept thinking there's bound to be something else. I could hear it sometimes but I couldn't play it. Well, that night I was working over "Cherokee" and as I did I found that by using higher intervals of a chord as a melody line and backing them with appropriately related changes, I could play the thing I'd been hearing. I came alive.[27]

Bebop's challenge to functional tonality was much less of a purely intellectual exercise than was avant-garde music like Schoenberg's twelve-tone scale. The challenge of jazz was spontaneous improvisation. Charlie Parker admonished Sonny Criss in 1947: "Don't think. Quit thinking."[28]

Although the beboppers made use of their knowledge of modern music theory, they approached music from a very different social ground than the high-modern avant-garde did. As Henry Pleasants has observed, most European experimental music represented cultural conservatism "masked by a fulsome profession of modernism."[29] These modernists, despite their formal innovations, were wholly invested in revitalizing and preserving the institutional apparatus of nineteenth-century European musical culture: the symphony orchestra.

The circumstances of orchestral performance reinforced established social hierarchies and social virtues. Symphony hall architecture symbolically separated the physical spaces occupied by listeners of different social classes: upper-class listeners in the box seats, burghers in the orchestra, and plebeians in the balcony. Concert hall decorum equated listening with an attitude of deference.[30] Moreover, the performance technology of the symphony orchestra was text-based; precision and accuracy in following the printed score were among the key virtues of a symphonic musician. Self-expression was subordinated to a joint expression of the conception of the composer. The conductor was a manager charged with "orchestrating" the musicians in this task.

By contrast, the performance culture of bebop emphasized immediacy and spatial intimacy and encouraged expressions of appreciation at any

point in the performance; this was its legacy from jazz, as a popular-culture form. In addition, the "given" text in bebop was minimal. Unlike most European concert music, most jazz was learned by ear from live performances or recordings. Such aural transmission was especially central to bebop, because its nuances of rhythm, tone, and timbre could not be captured in musical notation.[31] Finally, bebop performers "spoke" for themselves, not for the composer. The fixed authority of the conductor was replaced by a format in which the musicians passed authority among themselves according to flexible but reliable patterns. Ultimately, bebop embodied a more radical cultural stance than European modernist music, because it provided for a more democratic and participatory form of musical expression.

A Formal Contrast of Bebop and Swing

Methodologically, one of the best means of identifying the social content of any music is to compare it to the music from which it immediately derives.[32] In the case of bebop, this is swing. A rejection of the Western cultural norms encoded in the symphony orchestra was implicit in the emergence of bebop as a reaction against big-band swing; for swing had succeeded by assimilating jazz to orchestral techniques. In the narrower historical context, the formal differences between swing and bebop embodied spontaneity's challenge to America's wartime corporate-liberal culture.

The differences that generally distinguish bebop from swing jazz can be deduced from the specific differences distinguishing two versions of the same tune. In 1939, Charlie Barnet's big band recorded a popular rendition of the standard "Cherokee."[33] "Cherokee" is built on a basic 64-bar structure of four 16-bar phrases in an AABA sequence (the first phrase is played three times, twice before the "bridge" and once after). Late in 1945, Charlie Parker's Reboppers recorded a bebop version of "Cherokee" that they renamed "KoKo."[34] "KoKo" was created from "Cherokee" in two phases: first, modern chord changes were substituted for the conventional harmonies of the standard; then a completely new melody was improvised to accompany the new changes. Therefore it is possible to hum the melody of "Cherokee"—at a faster tempo—over the harmonic changes of "KoKo," though the original melody is nowhere in evidence.

Charlie Barnet, like all band leaders in orchestral jazz, aimed to provide his audience with music that they could dance to. The tempo and the conceptual simplicity of his "Cherokee" are suited to this aim. As the big-band equivalent of the orchestra conductor, Barnet worked to achieve a pleasing blend of sound, to which the voices of individual musicians were subordinated. For the most part, in Barnet's "Cherokee" the melody and

countermelody are carried by whole sections of the band playing in unison. One soloist introduces the melody in the first two 16-bar phrases and returns in the second phrase of the second chorus to provide a countermelody, but these solos follow the rules of harmonic tonality, blending easily into the sound of the whole.[35] There is, moreover, an orderliness or deference in the way the band showcases the soloist—who is, not incidentally, Charlie Barnet himself.

Like most band leaders, Barnet worked with "arrangers" who developed orchestrations tailored to the style and resources of his band. Arrangers provided the band members with written scores, which were then carefully rehearsed. The orchestral quality of Barnet's "Cherokee" is especially featured in an eight-bar transitional phrase between the two choruses, during which the sections work together like a fine precision drill team.

The success of big band performances depended on a well-drilled unity, supported by practices like those described above. The organizational features audible in the music were present in the performance culture of big band swing as well. Band uniforms emphasized visual unity. Band leaders fined musicians for lateness or infractions of neatness or comportment. Individual section players could be replaced easily and often were. As Sonny Criss observed, "You're part of the establishment in big bands. Part of an assembly line and they restrict you."[36]

The corporate image cultivated by the big bands was not just for show; it was a mechanism of survival. The business side of the swing music industry was dominated by corporate booking agents who provided the band leaders with live gigs and radio spots. The fate of a band was intimately linked to its fortune with a few large entertainment empires, like those of Moe Gale (the owner of the Savoy Ballroom), MCA, and the General Artists Corporation.[37] Composer-arrangers who wrote big band music also worked in other forms of corporate middlebrow media, writing Broadway musicals, movie scores, and serials and commercials for television.[38]

For the individual sideman, playing for most big bands was an unhappy compromise between creative urges and financial necessities. Big bands systematically showcased leading soloists and offered little opportunity to other band members for artistic or professional advancement. Trumpeter Tony Frusella, for instance, compared the musical culture of Charlie Barnet's big band to the regimentation of army life. "When I got out of the army . . . I got this hot-shit gig with Charlie Barnet. It was a big band and I was in the trumpet section. But like it was bull shit because all you'd do was get up and blow the same notes with a bunch of other guys. It was just like the army."[39]

By contrast, the bebop adaptation of "Cherokee" into "KoKo" fore-

grounds improvisational solos. What is immediately obvious in the piece by Charlie Parker's Reboppers is the greater range and freedom of the soloists. After a 32-bar introduction shared by Parker and Dizzy Gillespie, Parker improvises across two 64-bar choruses, mixing in dissonant notes and quotations from other pieces, all at approximately twice the tempo of Barnet's "Cherokee."

The polyrhythmic complexity and irregular phrasings that characterize bebop jazz are signals that it is a music meant for listening and not for dancing. Miles Templar made this point in defending bebop to the readers of the *Partisan Review* in 1948. "One need not go 'trucking on down' the aisle of Town Hall at a jazz concert to show appreciation for the music," Templar wrote. "The bopper's enthusiasm is a quiet thing. He wants to dig everything that's being done and he knows that distractions will cause him to miss the thread of whatever the musician is building. You see this enthusiasm on all hands and on all faces during a bop concert or session."[40]

Listeners trying to track the "thread" of the solos in "KoKo" had to pitch their attention at a high level of nervous excitement. This was definitely not the easygoing sound of Barnet's "Cherokee." The fast tempo and high energy level of bebop restricted it to a skilled coterie of musicians and encouraged those musicians to take creative risks. In bebop, the spontaneous articulation of new musical ideas was valued above precision or accuracy. As Bud Johnson stated: "I'd like to hear a guy go after something and make a mistake sometimes. That's excitement too. Not just be too perfect."[41]

Bebop was a style in which control of the music belonged not to the conductor or the arranger but to whoever was soloing. Because of this, some reviewers criticized bebop as solipsistic. As important as the virtuoso soloist was to bebop, however, the dynamics of the small ensemble were more so. "KoKo" begins and ends with 32-bar segments (AA) of conversational give-and-take between Parker and Gillespie. Each of these segments is divided into 4 eight-bar phrases; the first and last are rehearsed duets, but in between are sixteen bars in which the two engage in an improvisational antiphony, or call-and-response. Each has eight bars in which to make a musical statement; this was known as "trading eights."

The relations among the musical voices in bebop music are quite different from those in swing. The riffs of the players in the background "carry" the soloist less deferentially. In "KoKo," the drummer, Max Roach, "drops bombs," punctuating Parker's horn playing with comments and encouragement. Dizzy Gillespie on the piano does the same. Parker responds to these comments in passing. The close coordination of listening and voicing involved in playing bebop was called "picking up on" the other musicians.

Beboppers defended the intersubjective quality of their music against critics who heard only the soloist. When the *Partisan Review* character-ized bebop as insincere, detached, and solipsistic, Miles Templar wrote in rebuttal:

> The back-up is not a subordinate thing in bop. Bop back-ups are es-sential to the solo. It's those sustained chords behind Diz that make his solos wistful. Those saxes are analogous to the chorus in a Greek tragedy. They raise their voices, questioning the protagonist, agreeing with him on certain points, wondering about others.[42]

Miles Davis emphasized the intersubjective dynamic among a group he assembled late in 1957:

> One voice can change the entire way a band hears itself, can change the whole rhythm, the whole timing of a band, even if everyone else had been playing together forever. It's a whole new thing when you add or take away a voice. . . .
>
> Because of the chemistry and the way people were playing off each other, everybody started playing above what they knew almost from the beginning. Trane [John Coltrane] would play some weird, great shit, and Cannonball [Adderley] would take it in the other direction, and I would put my sound right down the middle or float over it, or whatever. And then I might play real fast, or buzzzzz, like Freddie Webster. This would take Trane someplace else, and he would come back with other different shit and so would Cannonball.[43]

In its emphasis on solos within a small ensemble, bebop marked a re-turn to the pre-swing jazz of New Orleans, rooted in the African American cultural heritage. Some modern jazz musicians saw the interdependence of group improvisation as a more "African" alternative to the Western or-chestral tradition. Archie Shepp, for instance, has written of "a certain communal intelligence expressed in the music . . . deeply rooted in . . . [Afro American] tradition."[44] Miles Davis similarly contrasted the West-ern method of orchestral arrangement to the group improvisation that characterized Charlie Parker's creativity: "He didn't conform to Western ways of musical group interplay by organizing everything. Bird was a great improviser and that's where he thought great music came from and what great musicians were about . . . just the opposite of the Western con-cept of notated music."[45]

On the whole, bebop musicians preferred this attitude in the band leaders they worked with. Lennie Tristano remarked that he would rather work with Parker than with Gillespie (who formed a bebop big band) or with Thelonius Monk. Those two insisted on having more personal con-trol over the music. Charlie Parker, said Tristano, "based his approach on

having you learn to improvise and how to express feeling sponta-neously."[46] The ideal bebop number was like a musical conversation among the musicians.

Once a conversational dynamic is understood to be the structural model for bebop, it becomes clear that other bebop innovations devel-oped to enhance the conversation. The asymmetrical phrasing of bebop soloists that replaced the "square" four-bar phrasing of swing allowed a greater range of musical utterances, much as if we had all suddenly de-cided to stop talking in rhyming couplets. Thus Miles Templar wrote in the *Partisan Review:* "The most important thing in bop is the phrasing."[47] And Miles Davis, making the same point, remarked that the model for be-bop phrasing was the cadences of speech.[48] Davis recalled hearing Dizzy Gillespie and Charlie Parker play in Billy Eckstein's band in 1944, with Sarah Vaughan singing. It was a revelation to him how the three voices en-twined, collapsing the distance between the horn solos and the human voice.[49]

Bebop musicians further increased the expressiveness of their solo ut-terances by developing a larger vocabulary of rhythms, tones, and tim-bres. As Henry Pleasants described this aspect of the music:

> Trumpets were played higher than they had ever before been played, saxophones were made to yield a thousand or so notes a measure, along with uncouth grunts and squeals at the extremes of the range. Double-bass players developed a dexterity beyond the wildest imag-ining of any symphony orchestra bassist, and drummers opened up an entirely new world of rhythmic and percussive variety.[50]

Bebop's return to African-based polyrhythms was pioneered by drum-mer Kenny Clarke, who played with Dizzy Gillespie in Teddy Hill's big band between 1938 and 1942. Around 1940, Clarke experimented with keeping the basic rhythm on the top cymbal rather than, as was tradi-tional, on the bass drum. This innovation made the rhythm more subtle and at the same time easier to complicate with half-beats or even quarter-beats. It simultaneously freed the bass drum from its role as a metronome, so that it could be used to complement the soloists with the accents that came to be called "bombs."

Kenny Clarke led the way for Max Roach. By playing the sock cymbal with the right hand rather than the left, Roach and the bebop drummers after him freed the left hand in turn from the need to keep the beat, leaving it independent to drum out polyrhythms. In this way, the drum became a solo instrument. In "KoKo," Max Roach takes a drum solo after Parker's two choruses and before the 32-bar conclusion. In the combination of Roach's asymmetrical phrasing and polyrhythmic drumming, the basic meter of the piece seems to disappear entirely.

In the dynamic of the ensemble, the modern style of drumming emphasized the need for the other musicians to keep their attention poised in order to pick up on the beat. With Clarke's drumming style, the horn players could no longer rely on a loud marking of the time by the bass drum; they had to keep the meter in their heads.[51] At the same time, the drum became a significant voice encouraging the other soloists. As Bud Johnson recalled:

> The drums played a great part in creating. . . . If a cat is saying [imitates drummer], you're liable to say [imitates horn]. You'll fall behind it and fit with him, actually you're really creating together . . . But if a drummer's just sayin' [imitates another drumming style, just keeping the time], then . . . it's very difficult for a guy to play. So anyway this transition all came through, I would say, the drums.[52]

To encourage the conversational dynamic, bebop not only expanded the expressive range of each instrument, but also provided for each instrument to have its own register in the overall arrangement of sound. The drummer, by keeping time with the cymbals instead of the bass drum, complemented the bass fiddle rather than drumming over it. Bebop piano, pioneered by Bud Powell and Thelonius Monk, also moved up into midrange, so that the bass, left alone in the lower register, could be heard as a solo voice. When the pianists moved to midrange, they simultaneously freed their left hands, which before had kept rhythm, for use in improvisation.[53] Leaving the midrange to the piano, the horns explored extended harmonics high up on the tonal register.

With its conversational dynamics and emphasis on the cadences of speech, bebop can be understood as a music in which the instruments are the "voices" of musicians speaking through prosody alone. Bebop's aspiration to pure prosody is reflected in the scat singing that often accompanied it.[54] Beboppers recorded numbers with titles like "Bu-Dee-Daht"; "Oop-Bop-She-Bam" (Kenny Clarke with Fats Navarro, Sonny Stitt, and Bud Powell, 1946); and "Oop-Pop-a-Da" (Dizzy Gillespie and Orchestra, 1947).

The pure prosody of bebop was in many respects the musical equivalent of the "ideograph" in painting. It was a nonverbal communication grounded in sensual perceptions and intended to appeal to unconscious emotions rather than to the intellect. Its challenge to corporate liberalism and to the "Western" mode of thinking was implicit in this alternative "bias of attention," connoting the value system of a minority culture (in this case, the African American subculture).[55] In *Blues People*, published in 1963, LeRoi Jones contrasted the culture of jazz to that of "Western man and his highly industrialized civilization," arguing that jazz encoded "the opposing *Weltanschauung* of the African."[56]

BEBOP AS A CULTURAL ALTERNATIVE

The "Africanisms" that LeRoi Jones identified in African American music—antiphony, polyrhythm, and prosodic tone—embodied the values of intersubjectivity and body-mind holism that were central to the postwar avant-garde. As a vision of sociality, the antiphonal structure of bebop suggests an intersubjective dynamic, one in which the individual and the community empower one another. Each presence enlivens the others, creating a whole that is animated by a collective energy without which the individual expression would not itself exist.[57] There is no dichotomy pitting the individual against the group; to have a voice among other voices entails no fundamental conflict. Nor is unity of purpose enforced by a hierarchical authority structure. Intersubjectivity implies that participatory democracy is the form of political economy with the greatest vitality and the most potential power. According to anthropologist John Szwed:

> Jazz requires that musicians be able to merge their unique voices in the totalizing, collective improvisations of polyphony and heterophony. The implications of this esthetic are profound and more than vaguely threatening, for no political system has yet been devised with social principles which reward maximal individualism within the framework of spontaneous egalitarian interaction.[58]

As a bias of attention (to return to Olson's phrase), intersubjectivity prioritizes face-to-face, personal interactions. One "situates" oneself through these interactions rather than in relation to some abstract social scaffolding.[59] This was the cultural politics that Dwight Macdonald called for in his essay "The Root Is Man," and that the culture of spontaneity pursued through a variety of artistic media. The participatory ethic of bebop radically opposed the attitude of passive spectatorship encouraged by corporate-liberal culture in the 1940s.[60]

The second of Jones's "Africanisms," polyrhythm, emphasizes the intersubjective nature of time. Time is a perception that has to do with what phenomenologists have called *mitwelt:* the coordination of our internal, subjective reality with external processes. Phenomenologically, time is a sense of how our internal rhythms or paces jibe with those of the things and people around us. Clock time is an abstraction (a social construct) that facilitates the efficient conduct of *mitwelt* transactions—enabling us, for example, to be on time for appointments, or to sell our time on an hourly basis.[61] Clock time is the psychological state of *mitwelt*, reified and given objective status in the culture. As the corporate industrial economy has grown more complex and totalizing, time in American society has become increasingly abstract: standard time zones were established to facilitate rail transportation in 1883; daylight savings time was introduced

during World War I, and then permanently reinstituted during World War II.[62]

Rhythm, by contrast, preserves the sense of *mitwelt* time as relational and intersubjective. George Lipsitz has asserted that the polyrhythms of African American music encourage the listener "to think of time as a flexible human creation rather than as an immutable outside force."[63] Bebop reemphasized the polyrhythmic aspects of jazz, in reaction against the orchestrated *mitwelt* of swing. Charlie Parker was renowned for blowing phrases that began on the eleventh bar of a twelve-bar blues, thus inverting the rhythm (which emphasizes every second measure).[64] The other soloists had to maintain an awareness of how Parker's solo related to the structure of the whole, or they would enter the piece a measure too late or too early. This is a specific instance of a quality of attention that Charles Keil has observed in African American culture generally: being "on time" is less important than being "in time." Proper timing "requires that individuals coming in keep 'careful track of the pulse.'"[65] Thus LeRoi Jones wrote in a letter to Charles Olson in 1958 that he was sending Olson a poem "about *time*. the phenomenological concept of time. from *my* birth *til* my death. time consisting not of any foolishness like minutes or hours or any abstract (as external, imposed) thoughts. but the time that is *event*."[66]

An intersubjective worldview is the necessary correlative of an attitude of body-mind holism. (For once the mind and the body are conceived as a unity, how can the "objective" be separated out from subjective experience?) Jones in his letter to Olson referred to time as a phenomenon of the integrated body-mind.[67] And rhythm is exactly that: time as experienced through the body. Indeed, Miles Davis wrote that good jazz music was always "up in the body" of the musician.[68]

Ethnolinguists have linked the primacy of rhythmic perception to other cultural qualities associated with body-mind holism; particularly, the "subordination . . . of representation to action [and] of concept to attitude." This complex of associations, which ethnolinguists have dubbed "oral" culture, is characteristic of the culture of spontaneity, as well.[69] By contrast, musicologist John Shepherd has described Western industrial societies as dominated by the opposite biases:

> The emphasis placed by industrial societies on rational, verbal objectivity has led these societies to relegate to insignificance the realizations of any symbolic mode which implicitly challenge their dominant world sense. The unspoken—or, more appositely, unwritten—assumption is that everything that is real can be expressed in objective, rational language and its extensions, and that reality as embodied in

the rational word is somehow higher than, or ontologically prior to any other evidence of reality accruing from other sources.[70]

Bebop, by emphasizing and extending the realm of prosody, offered a model of "oral" values in the midst of industrial America. LeRoi Jones asserted in *Blues People* that African American music maintained the "psychological correlative" of an oppositional "socio-economic psychological disposition," through its attention to the prosodic qualities of rhythm, tone, and timbre.[71] He traced African American musical prosody to the "talking drums" of Africa and the ideophones of African languages, which similarly cultivated a sensitivity to nuanced sound.[72]

The complex vocalizations of bebop offered a model of "secondary orality" or postliteracy: the possibility of asserting the values of an oral culture within a culture already conditioned by writing. In his novel *On the Road*, Jack Kerouac described a Slim Gaillard performance in which Gaillard used spontaneous scat syllables and drumming in an avant-garde strategy of defamiliarization:

> He does and says anything that comes into his head. He'll sing "Cement Mixer, Put-ti-Put-ti" and suddenly slow down the beat and brood over his bongos with fingertips barely tapping the skin as everybody leans forward breathlessly to hear; you think he'll do this for a minute or so, but he goes right on, for as long as an hour, making an imperceptible little noise with the tips of his fingernails, smaller and smaller all the time till you can't hear it any more and sounds of traffic come in the open door.[73]

In reestablishing the values of orality in the United States, the beboppers were engaging in a cultural project that was the complementary inverse of the "modernization" of African societies in their contact with the industrialized West. The jazz clubs were their "middle ground," as Richard White has named the geographical and social zone in which a cross-cultural dialogue takes place and the dominance of no single culture is established.[74]

The bebop "revolution" in jazz assumed different guises between 1940 and 1960, as its recovery of orality intersected with the racial politics of the times. Around 1949, cool jazz developed as an offshoot of bebop, heralded by the Miles Davis album *Birth of the Cool*. Cool was an elaboration of the tone and phrasing of Lester Young; its slower rhythms did not evoke the same high levels of nervous excitement that bebop did. But the distinction between bebop and cool jazz was not a definite one. Many musicians moved easily between the more frenetic sound of bebop and the more "laid back" style of cool.

As the 1950s progressed, however, it became clear that the more re-laxed or reserved mood of cool jazz made it more appealing to white mu-sicians and audiences. In the mid-1950s, black musicians including Art Blakey, Horace Silver, J. J. Johnson, and Sonny Rollins initiated a reaction against the more mellifluous aspects of cool jazz, returning to the driving rhythms of bebop. Their style came to be known as "hard bop." The ad-vent of hard bop coincided with new developments bringing race rela-tions to the forefront of American domestic politics: the Supreme Court decision barring Jim Crow segregation in *Brown v. Board of Education*; the rise of the Southern Christian Leadership Conference in the Montgomery, Alabama, bus boycott; and the murder of fourteen-year-old Emmett Till in Mississippi, for allegedly flirting with a white woman. In the smaller world of jazz musicians, increasing competition for employment among "cool" jazz musicians had begun to take on racial overtones. The year 1955 also marked the death of Charlie Parker from heroin addiction, at-testing to the difficult life of the black musician in a racist society.[75]

Hard bop reasserted the African and Afro-Caribbean connections of bebop, as in Cannonball Adderley's "Jive Samba."[76] Horace Silver's father had immigrated from the Cape Verde islands; Art Blakey had lived in West Africa between 1947 and 1949. Hard bop's strong downbeats also attest to an influence from rhythm-and-blues: the popularity of cool jazz favored white musicians in the competition for jazz gigs, so more black musicians had begun to play R&B.[77]

The experimental harmonies and meters of bop were extended even further in "free jazz," introduced in 1958 with the near simultaneous re-lease of *Free Jazz* by Ornette Coleman and *Milestones* by Miles Davis and John Coltrane.[78] Free jazz added atonality to the polytonality of the be-bop repertoire, and distanced its prosodic utterances even farther from the regimen of time signatures, metronomes, and measures. Ornette Coleman, born in 1930, had come to jazz through R&B. In the early 1950s, in Los Angeles, he had begun playing experimental atonal melodies on a toy plastic alto sax, with Don Cherry accompanying him on a miniature trumpet.

Painters and poets who were actively pursuing the aesthetic of spon-taneity in their own media congregated at the Five Spot, the Cafe Bo-hemia, Arthur's Tavern, and the Village Vanguard in New York City, to hear the jazz experiments of Charlie Parker, Thelonius Monk, Charles Mingus, Sonny Rollins, Cecil Taylor, Ornette Coleman, and many others. Modern jazz aficionados in abstract expressionist circles included Jack Tworkov, Grace Hartigan, Alfred Leslie, Willem de Kooning, Mike Gold-berg, Norman Bluhm, Joan Mitchell, Franz Kline, and Frank O'Hara. Larry Rivers was himself a bebop saxophonist. Peter Voulkos taught him-self jazz guitar. Lee Krasner has asserted the profound influence of bebop

on Jackson Pollock's painting during the crucial year, 1946, when he developed his gesture-field style of painting: "He would get into grooves of listening to his jazz records—not just for days—day and night, day and night for three days running. . . . He thought it was the only other really creative thing happening in this country."[79] The beat poets, especially, took bop prosody as the basis of their spontaneous poetics, as the following chapter describes.

The Beats

"Which is more important, the idea or the prose?"
"Prose."
"You *better* say that."
"Ideas come a dime a dozen."

—Jack Kerouac, Al Cohn, Zoot Sims, *Blues and Haikus,* jazz poetry recording session (1958)

The "beats" helped to transform the late modernism of the avant-garde into the youth counterculture of the 1960s. Jack Kerouac's best-selling novel, *On the Road*, published in 1957, became the guidebook for a restless "beat generation." In 1955, Allen Ginsberg ignited the San Francisco poetry renaissance with his poem "Howl"; twelve years later, he helped to plan the Human Be-In at Golden Gate Park, a "happening" that epitomized the counterculture's "politics of ecstasy."[1]

The beats sought to develop literary forms by which to communicate both experienced reality and the emotional energy that went with it. They hoped that the result would be an utterance that was nothing less than an action: a motivating, energizing force with potential social effects. They based their work on their own dialogues and on bebop jazz prosody, culminating in the practice of oral poetry performances.

An avant-garde interest in exploring the dynamics and sensory dimensions of intersubjectivity led the beat writers to develop strong connections to bebop jazz. Ginsberg called Kerouac's writing "spontaneous bop prosody." He himself modeled the structure of his poem "Howl" on the tenor saxophone playing of Lester Young, asserting: "The ideal . . . was the legend of Lester Young playing through something like sixty-nine to seventy choruses of 'Lady Be Good,' you know, mounting and mounting and building and building more and more in-

telligence into the improvisation as chorus after chorus went on."[2] Beat poetry and bebop jazz shared a common cultural project: to oppose the culture of corporate liberalism with a spontaneous prosody embodying the tenets of intersubjectivity and body-mind holism.

THE BEAT CULTURAL POSITION

Although Kerouac and Ginsberg came to authorship within a cultural nexus defined by Greenwich Village bohemia and Columbia University literary contacts, their writing insistently foregrounded the jazz clubs of Harlem and the drug users of Times Square.[3] The two aspiring writers met at Columbia University in 1944, when Kerouac was twenty-two and Ginsberg only eighteen. But Kerouac had already quit college, and Ginsberg was later suspended. It was wartime, and American institutions of higher education had stepped up their commitment to the military-industrial complex, developing a symbiosis that continued throughout the Cold War period. The result, as Ginsberg later recalled, registered as an intellectual life characterized by the anxieties and rigidities of war corporatism: "Consciousness within the academy was narrowing down . . . it was the initiation of the cold war theoretics for them."[4]

In response to this academic situation, the beat writers developed a sensibility that regarded marginal status not as a failing but as an asset. The survival strategies of the dispossessed are more valued in their writings than sophistication, or even the ability to negotiate the social world with equanimity. In contrast to the Columbia faculty, whom Ginsberg described as "fighting and scrambling to get ahead and making atom bombs," these dispossessed seemed to share an ethos that did not focus on achievement.[5] The beat attitude was grounded in encounters with figures like Herbert Huncke and Neal Cassady between 1944 and 1946; while Ginsberg's classmates at Columbia affected the decadence of the French symbolist poets, Huncke the addict and Cassady the joy rider represented the true inhabitants of America's social margins.[6]

As with many members of the midcentury avant-garde, the beat writers' distrust of the cultural establishment was informed by their ethnic identities. Ethnic self-consciousness encouraged their affinity for marginalized subcultures, as it had for Charles Olson and William Carlos Williams. Ginsberg asserted "the simple political and social awareness that centralization is a failure, is a loss, a loser. And that decentralized energy forms, and decentralized cultural forms are . . . as [William Carlos] Williams points out, the richest."[7] As their cultural project gained direction during the postwar decade, Kerouac and Ginsberg increasingly stressed their Catholic and Jewish roots, respectively. Kerouac began an

intense involvement with Buddhism in 1953, but always reconciled it with a mystical Catholicism. Ginsberg, after 1955, mixed Judaism with projective verse in championing a poetry of "Hebraic-Melvillian bardic breath."[8]

Beat opposition to the dominant culture focused on communicating subjective experience in a way that revealed the ideological contradictions of corporate-liberal society. Kerouac's original conception of *On the Road*, for instance, was as the nighttime confessions of an American businessman whose conscience would not let him sleep. Against the compartmentalization of mind and emotion enforced by the dominant culture ("Moloch in whom I am a consciousness without a body!" Ginsberg wrote in "Howl"), the beats posed a method of spontaneous composition that integrated conscious and unconscious experience. They worked to develop new literary forms to express the conflations and contradictions of unconscious experience in a way that the conscious mind could grasp. "The mind's cracked, as anybody can see in a hallucinated high," Kerouac insisted; "but how about an explanation of the crackedness that can be understood in a workaday moment?"[9]

Spontaneity of feeling therefore served as the grounds on which the beats attacked the "well-crafted" academic poetry of their day. "FEELING is what I like in art, not CRAFTINESS and the hiding of feelings," Kerouac told an interviewer. Later, Ginsberg recalled that this sentiment was what led them to begin their explorations of conversational prosody. As he explained:

> The first perceptions that we were separate from the official vision of history and reality began around '45, '46, '47. We realized that there was a difference between the way we talked—Jack [Kerouac], [William] Burroughs, myself, as comrades among ourselves in order to get information and . . . share experience and find our ultimate heart or vision—and what we heard on the radio if any president or congressman or even literary person began talking officialese. The air was filled with pompous personages orating and not saying anything spontaneous or real from their own minds, they were only talking stereotypes.[10]

For the beats, as for Paul Goodman, recovering spontaneous prosody as an element of speech would increase the "reality" content of utterances. So spontaneous prosody became their weapon against the psychological splitting imposed by the Cold War cultural establishment. As LeRoi Jones wrote in 1959: "We want to go into . . . the "Projective Verse" of Olson. . . . [T]he diluted formalism of the academy (the formal culture of the U.S.) is anaemic and fraught with incompetence and unreality."[11]

BLACK MOUNTAIN AND BEAT

The relation of beat poetry to Charles Olson's projective verse reflects the semiautonomous development of a common aesthetic. As Ginsberg recalled:

> I learned mostly from Kerouac, and then put a patina of literary categorization over it later on, having dealt with Williams and Creeley and Olson. . . . I don't think that Olson would claim that Kerouac was writing projective verse. I think that Olson would say that "projective verse" is his terminology for this kind of writing.[12]

Among the beats, it was Ginsberg who was most willing to do his homework in literary history. He initiated correspondence and meetings with Olson, Williams, and Ezra Pound. He repeatedly expressed his sense of continuity with their earlier work, in order to combat the reputation of juvenile delinquency with which the beats were saddled: "We were carrying on a tradition, rather than being rebels. . . . We were rebelling against the academic abuse of letters but we went to the living masters ourselves for technique, information and inspiration."[13] Ginsberg first wrote to William Carlos Williams in March 1950. They met two years later and discussed their mutual interest in Southwest Indians and Maya culture.[14] In 1956, Williams penned an introduction for Ginsberg's book *Howl and Other Poems*, brought out by Lawrence Ferlinghetti's City Lights press in San Francisco. Ginsberg's correspondence with Olson began that same year, and was important enough to Ginsberg to impel him to write Olson during the three-day writing marathon that produced his next major poem, "Kaddish."[15]

But in addition to the Williams-Pound heritage stressed by Olson, the beats were subject to a separate influence from a group of poets centered in San Francisco. Ginsberg came to San Francisco in 1954, with a letter of introduction to Kenneth Rexroth provided by William Carlos Williams.[16] Rexroth, born in 1905, was part of a literary circle that included Kenneth Patchen, William Everson, Philip Lamantia, and Jack Spicer. A number of these San Francisco poets had spent World War II together in a work camp for conscientious objectors in Waldport, Oregon. In addition, Rexroth put Ginsberg in touch with a younger cadre of "literary anarchists and marijuana addicts" connected to Reed College in Portland, Oregon, whom Kerouac would later describe in his novel *The Dharma Bums;* these included Lew Welch, Gary Snyder, and Philip Whalen.[17] The West Coast poets cultivated strong interests in non-European cultures: Rexroth published poems translated from the Japanese; Snyder traveled to Japan to study at a Zen monastery; and Philip Lamantia and Philip Whalen studied American Indian cultures.

Olson was not on the best of terms with the San Francisco poets, having alienated Rexroth through a negative piece in the first issue of Black Mountain's literary magazine, *The Black Mountain Review*.[18] But there were some links between the two circles. Robert Duncan was one, whom Olson had befriended on a visit to the West Coast in 1947. The final issue of *The Black Mountain Review*, published in 1957, was another.

In the exodus of Black Mountaineers from North Carolina, as Black Mountain College disintegrated in 1956, Robert Creeley, who edited the magazine, found his way to San Francisco.[19] The last issue of *BMR* was assembled there, with Ginsberg and Olson both listed as contributing editors. The issue included objectivist poems by William Carlos Williams and Louis Zukofsky; poems by Black Mountain poets Denise Levertov, Ed Dorn, and Jonathan Williams; and poems by San Francisco poets Philip Whalen, Gary Snyder, and Michael McClure. It also prominently featured the beats. Ginsberg's poem "America" and Kerouac's "October in the Railroad Earth" accompanied a letter written by William Burroughs describing his search for hallucinogenic *yage* in Mexico. The *Review* also included an outline of beat poetics by Kerouac entitled "Essentials of Spontaneous Prose," which had caught the attention of the Black Mountain poets for its similarities to projective verse.

According to Ginsberg, it was this essay of Kerouac's that had first precipitated the connection between Black Mountain and beat circles: "When I came to San Francisco in 1954," he recalled, "I had [Kerouac's essay] pinned on the wall of my hotel room and Robert Duncan came to look at a little book of poems I had and saw it on the wall."[20] But letters between Ed Dorn and Charles Olson indicate that, whatever Duncan knew in '54, it was not until 1956 that Olson heard of Kerouac's essay. Dorn wrote to him from San Francisco that Robert Creeley had visited, bringing with him "another writer, Jack Kerouac, who is a great man, I am sure (I read some note-statements of his on prose that were as much as to say how you do it if you want with no bullshit)." Kerouac and Creeley, Dorn reported, had become good friends, "and they stay out at Mill Valley in Marin County on the weekends in among the Eucalyptus trees and on the sides of hills. Listening to Indian (Asiatic) sounds." Olson wrote back to Dorn, "This guy Kerouac sounds good. How about getting me a copy of this thing you speak of, to see?"[21]

Olson tried his best to claim the beats as the fulfillment of the poetic movement he had prophesied in 1950 in "Projective Verse." He included Kerouac and Ginsberg among the faculty of the university that he imagined creating after the demise of Black Mountain College.[22] Compared to the beat subculture, though, Olson's literary radicalism was learned and pedantic, and he had difficulty dealing with their street smarts. He could not overlook the fact that Ginsberg had worked in advertising—which, to

Olson, was tantamount to trading with the enemy—and he considered Gregory Corso a punk who enjoyed harassing him. He felt more of an affinity with Kerouac, and copied long passages from *On the Road* into his notebooks of autumn 1958.[23] After 1958, he also developed a strong professional bond with LeRoi Jones, whose little magazines *Yugen*, *Kulchur* (1960), and *Floating Bear* (1961) served as vehicles for Olson's later speculative writings.[24]

Despite some social frictions, Olson was right to assert that he and the beats shared a common aesthetic that showed their thinking to be along the same lines. The beats believed in what Olson called "proprioceptive immanence": the idea that the body was the unifying locus of transpersonal forces that together constituted the self.[25] This idea led to a common concern with prosody, understood as an element of communication governed by the body. According to Allen Ginsberg:

> [W]hatever really great poetry I wrote, like *Howl* or *Kaddish*, I was actually able to chant, and use my whole body, whereas in lesser poetry, I wasn't, I was talking . . . So from that point of view, poetry becomes less intellectual or verbal and also becomes a physiological thing. Something where you actually *use* your body, use your breath.[26]

In the letter he wrote to Olson while composing "Kaddish," Ginsberg explained his plan to concentrate on the breath patterns of emotional extremity rather than of everyday speech:

> I began with short prose seed poems talking to Williams & knowing no ideas but in things etc & admire that as a historic purification process—I say to Williams I am however (now) interested (perhaps for my own nutty queer reasons etc) in getting to a basic maybe Hebrew groan eli eli rhythm. For just as Williams seeks out measure from observation of normal speech what if you observe abnormally excited speech, wailing, crying, as at mother deathbed or moments of extreme emotional stress, you'll find various archetype real fixed rhythms to work with poetically . . . a *hard* hysterical structure. . . . The rhythms of supreme emotional stress will also dictate strange shapes to poems.[27]

Like Olson, the beats defined spontaneous composition as an unselfconscious process of fitting the body-mind's subjective apprehensions to a communicative medium. Ginsberg called his poem "Wichita Vortex Sutra" (1966) a "*collage* of the simultaneous data of the actual sensory situation," which he edited only in order to bring forth an "emotional feeling-center with a clear idea." Such a collage, Ginsberg insisted, was not abstract or expressionistic but in fact the closest approximation possible to truth or reality. He felt that collage was in this respect superior to

conventional literary forms, which perpetuated distortions linked to a false, Newtonian worldview:

> Montage is logical—montage was at first considered to be illogical, and irrational . . . until everybody realized that what really was irrational was a rearrangement of the actuality of mind consciousness into syntactical forms which didn't have anything to do with what was going on in the head, . . . So it may turn out that we've been undergoing centuries of . . . Newtonian thought [versus Einsteinian].[28]

The beats, like Olson, conceived of the body-mind as communicating through a physical field of energy. Kerouac wrote that he wanted his writing to create an empathic flow of energy in the reader. Thus the first rule for the writer was, as in projective verse, to write only what created a high level of personal excitement: "Satisfy yourself first, then reader cannot fail to receive telepathic shock and meaning-excitement by same laws operating in his own human mind," wrote Kerouac in "Essentials of Spontaneous Prose."

The feeling of excitement functioned for the beats as an index of "authenticity," defined as communicating close to the bone of physical-psychological need. Kerouac and Ginsberg therefore tried to write on the edge of consciousness, where inarticulate emotions threatened to take over and reduce their writing to the "howl" of pure prosody. Kerouac equated writing with sexual orgasm, instructing his friends to "write excitedly, swiftly . . . in accordance with laws of orgasm, Reich's 'beclouding of consciousness.' *Come* from within, out—to relaxed and said."[29]

The beats valued sex, Buddhist meditation, and ritual American Indian drugs such as marijuana and peyote for their capacity to unseat the discriminating intellect, thereby increasing sensitivity to the surrounding energy field. Kerouac recounted in his novel *The Subterraneans* how one friend would "walk down the street in her flip [marijuana high] and actually feel the electric contact with other human beings (*in her sensitivity recognizing a fact*)."[30] In 1960, Ginsberg joined Timothy Leary's experiments with psilocybin, a synthetic equivalent of the hallucinogenic mushrooms used in Mexican Indian rituals. He brought Olson to a psilocybin session that December.[31] Olson later endorsed the mind-altering effects of psilocybin, marijuana, peyote, mescaline (the synthetic equivalent of peyote), and LSD.[32] Notes by a student on a lecture of Olson's from 1963 reveal how he integrated this new, beat element into his poetics of a decade earlier. To him, such drugs provided a means for the recovery of the "ideogrammic-experiential" qualities of language, which Western civilization had forfeited in the name of scientific progress: "[We] boxed in i-e [ideogrammic-experiential] language to order a society. fucked lan-

guage up—science can now write with it (recent). . . . get high-write everything (new hip writing) is back to i-e language sense."[33]

San Francisco beat poet Michael McClure, who studied poetry under Robert Duncan in the mid-1950s, was one writer who cogently merged the vocabularies of projective verse and beat poetics. McClure wrote in Don Allen's anthology of *New American Poetry*, published in 1960: "I want a writing of . . . the direct emotional statement from the body (from the organs and from the energy of movements). . . . The emotions push me to discoveries that afterwards I recognize intellectively to be truths. Glimpses of my physiology." Grounded in the body, truth was, for McClure, inherently intersubjective. "There is no logic but sequence of feelings," he wrote, and "The answer to feeling is my feeling." In a poem from 1957, he compared the poetic act to the gesture painting of Jackson Pollock and Franz Kline on this basis, writing: "I am the body, the animal, the poem / is a gesture of mine."[34]

McClure followed Olson in defining the self in Alfred North Whitehead's terms, as a process of apprehension: "The organism is what Whitehead and Olson would think of as a point of novelty comprehending itself or experiencing itself both proprioceptively and at its tissue's edges. . . . There is no separation between body and mind."[35] Yet McClure's poetic practice was more closely akin to that of the beats. For, though Olson and the beats agreed on the metaphysical concept of the energy field, they differed on the degree to which physicality or emotion should govern the content of a poem.

Olson had stated in "Projective Verse": "the HEAD, by way of the EAR, to the SYLLABLE / the heart, by way of the BREATH, to the LINE." For him, the selection of the literary morpheme (the syllable) was a process governed by the unconscious mind, which could "hear" the connotations embedded in a word's history. But the beats were inclined to extend the realm of "breath" to the sub-line level as well, suggesting that words could approach pure prosody—could possess meaning primarily as musical elements with physical origins and effects. Ginsberg compared his poetry to Sanskrit mantra syllables in which sound was the audible correlative of "a physiological body yoga." The deployment of these syllables, he claimed,

> physiologically in the body . . . is . . . the key to suddenly wakening up . . . a whole Reichian chain of muscular reactions . . . if you have a prosody built on *that*, . . . it's like having the basic patterns of physiological reactions built into the language, into the alphabet. . . . In the Moloch section of *Howl*, or parts of *Kaddish* . . . , the rhythmic units that I'd written down were basically breathing exercise forms which if anybody else repeated would catalyze in them the same *pranic* breath-

ing physiological spasm that I was going through and so would presumably catalyze in them the same *affects* or emotions.[36]

For Olson, excessive physicality or emotionality in poetry failed to achieve the poetic unity of "HEAD" and "HEART": "the grave danger of sheep-guts, or any mere physicality, is enormous," he asserted.[37] But from the beat point of view, which took this unity for granted, Olson's work was excessively pedantic. Kerouac told an interviewer: "I formulated the theory of breath as measure, in prose and verse, never mind what Olson, Charles Olson says, I formulated that theory in 1953 at the request of Burroughs and Ginsberg. Then there's the raciness and freedom and humor of jazz instead of all that dreary analysis."[38]

Spontaneous Writing and Beat Intersubjectivity

Jack Kerouac began in the spring of 1951 to develop the technique of spontaneous writing that he later summarized for his friends in "Essentials of Spontaneous Prose." At the time, he was struggling to find a literary form that could communicate the complex associations constituting his subjective reality. For four years, as John Clellon Holmes described it, Kerouac had been writing "astonishing sentences that were obsessed with simultaneously depicting the crumb on the plate, the plate on the table, the table in the house, and the house in the world." But he was continually getting bogged down in syntax.[39]

The novel that Kerouac was struggling to write eventually became *On the Road*. He was using, as a model for the kind of thought-flow that he wanted to imitate, some letters that Neal Cassady had written to him in the spring of 1947, which Cassady had characterized as "a continuous chain of undisciplined thought" in "a spontaneous groove."[40] But Kerouac's lingering aspirations for recognition by the established literary community made him cling simultaneously to the model of Thomas Wolfe's writing, which he had used in his first published novel, *The Town and the City* (1950). It was not until 1951 that the "factualism" of William Burroughs's autobiographical *Junkie* convinced him at last to do away with such "phony architectures."[41] Experience, he came to believe, had a shape of its own, which he called "*deep* form . . . the way the consciousness *really* digs everything that happens."[42] In April 1951, while high on Benzedrine, Kerouac inserted a continuous role of paper into his typewriter, and over the following three-week period he produced a 120-foot scroll of single-spaced typescript. This burst of spontaneous writing established the language and basic plot structure of the final *On the Road*.

In "Essentials of Spontaneous Prose," Kerouac used a phrase of

William Carlos Williams's to describe his spontaneous writing method: "time and how to note it down." He explained that the key was to avoid searching for words and imposing structures, but to let these spontaneously emerge as one strove to keep in time with one's thoughts: "Not 'selectivity' of expression but following free deviation (association) of mind into limitless blow-on-subject seas of thought, swimming in sea of English with no discipline other than rhythms of rhetorical exhalation."[43] He compared the emergent rhythms to the phrasings of a jazz solo: "A tenor man drawing a breath and blowing a phrase on his saxophone, till he runs out of breath, and when he does, his sentence, his statement's been made . . . that's how I therefore separate my sentences, as breath separations of the mind."[44]

In October 1951, revising his continuous-roll draft of *On the Road*, Kerouac hit upon the further technique of "sketching," by which he was able to increase the amount of information he communicated without disturbing the spontaneous flow of the narrative. Focusing on a remembered visual "image" in the text, he could spin out a stream of associations and then return to pick up on another, divergent stream. Now he could (to paraphrase John Clellon Holmes) depict the crumb in relation to the world by a method that, because it was spontaneous, would preserve "100% honesty."[45] As he advised in "Essentials of Spontaneous Prose": "Follow roughly outlines in outfanning movement over subject, as river rock, so mindflow over jewel-center need. . . ."[46]

Kerouac would use this combination of two spontaneous composition techniques (stream-of-consciousness and sketching) in future works. The basic story line of *Doctor Sax*, for instance, was set down in a tape-recorded monologue in the spring of 1952; he completed the text by sketching while high on marijuana during the following months.[47] *Doctor Sax* begins with an invocation of the sketching method equivalent to the traditional invocation of the muse:

> The other night I had a dream that I was sitting on the sidewalk on Moody Street, Pawtucketville, Lowell, Mass., with a pencil and paper in my hand saying to myself "Describe the wrinkly tar of this sidewalk, also the iron pickets of Textile Institute, or the doorway where Lousy and you and G. J.'s always sittin and dont stop to think of words when you do stop, just stop to think of the picture better—and let your mind off yourself in this work."[48]

In keeping with its intention to communicate the flow of subjective reality, beat spontaneous writing had a strong personal element that might be called "confessional." John Clellon Holmes wrote in a letter to Allen Ginsberg in 1949 that all dialogue in novels ought to be confessional. But beat works do not invoke what Michel Foucault called "the rituals of con-

fession," which assume an "authority who requires the confession, prescribes it and appreciates it, and intervenes in order to judge, punish, forgive, console, and reconcile." As assertions of subjective reality, they elicit not a judging authority but an intersubjective "moment of rapport."[49]

Not spontaneous confession but revision, Ginsberg asserted, was what entailed the intervention of an introjected authority: "Lionel Trilling's mind or Allen Tate's mind, or Brooks and Warren's mind, the critics' minds . . . you forget what you were thinking, and you'll think what you were supposed to be thinking." Kerouac in "Essentials of Spontaneous Prose" likewise warned against the act of "afterthought" by which one might try "to 'improve' or defray impressions, as, the best writing is always the most painful personal . . . honest, ('ludicrous.')."[50] The capacity of the unconscious mind to reveal ludicrous associations was an idea that the beats inherited from surrealism; following Breton, Ginsberg explained the oxymoronic phrases in his poetry as the "spontaneous irrational juxtaposition of sublimely related fact." For the beats, however, such incongruities did not reveal a "higher" truth, as implied by surrealism, but rather the hidden contradictions of the socially constructed psyche. As Ginsberg wrote to Olson: "I just type fast, hoping to catch all angles including contradiction."[51] Details that elicited shame and embarrassment, tempting the writer to revision, were precisely those that manifested the presence of contradiction, constituting "that very area of personal self-recognition . . . which formal conventions, internalized, keep us from discovering in ourselves & others."[52]

The unique structure of beat confessions derives from their particular function as tools of social disclosure. Their social dimension entailed linking personal experience to a larger social and historical context. Their structure is therefore that of an opening out and returning: opening out from the personal moment of writing, into subjective associations of the past and the social, and then returning again to the present. This is how the long lines and anaphora in Ginsberg's "Howl" and "Kaddish" function. This is also the "deep form" of Kerouac's sketches. As he explained the function of such passages about his African American lover, "Mardou," in *The Subterraneans:*

> Her own little stories about flipping . . . which held so much terror for her . . . formed just the background for thoughts about the Negroes and Indians and America in general but with all the overtones of "new generation" and other historical concerns in which she was now swirled just like all of us in the Wig and Europe Sadness of all.[53]

The "sketch" in which Kerouac describes taking Mardou home for the first time to her apartment in Greenwich Village exemplifies the uses of the form. In a running cadence, the sketch encompasses descriptions of

the particular physical environment, Kerouac's positive and negative re-
actions to it, and the associations it held for him in relation to the broader
culture:

> . . . [W]e found the Russian dark sad door of Heavenly Lane a great
> iron gate rasping on the sidewalk to the pull, the insides of smelling
> garbage cans sad-leaning together, fish heads, cats, and then the Lane
> itself, my first view of it (the long history and hugeness of it in my soul,
> as in 1951 cutting along with my sketchbook on a wild October
> evening when I was discovering my own writing soul at last I saw the
> subterranean Victor who'd come to Big Sur once on a motorcycle, was
> reputed to have gone to Alaska on same, with little subterranean chick
> Dorie Kiehl, there he was in striding Jesus coat heading north to Heav-
> enly Lane and all the long talks I'd been having for years with people
> like Mac Jones about the mystery, the silence of the subterraneans, "ur
> ban Thoreaus" Mac called them, as from Alfred Kazin in New York
> School lectures back East commenting on all the students being inter-
> ested in Whitman from a sexual revolution standpoint and in Thoreau
> from a contemplative mystic and antimaterialistic as if existentialist or
> whatever standpoint, the *Pierre*-of-Melville goof and wonder of it, the
> dark little beat burlap dresses, the stories you'd heard about great
> tenormen shooting junk by broken windows and starting at their
> horns, or great young poets with beards lying high in Rouault-like
> saintly obscurities, Heavenly Lane the famous Heavenly Lane where
> they'd all at one time or another the beat subterraneans lived, like Al-
> fred and his little sickly wife something straight out of Dostoevsky's
> Petersburg slums you'd think but really the American lost bearded
> idealistic—the whole thing in any case), seeing it for the first time, but
> with Mardou, the wash hung over the court, actually the back court-
> yard of a big 20-family tenement with bay windows, the wash hung
> out and in the afternoon the great symphony of Italian mothers, chil-
> dren, fathers BeFinneganing and yelling from stepladders, smells, cats
> mewing, Mexicans, the music from all the radios whether bolero of
> Mexican or Italian tenor of spaghetti eaters or loud suddenly turned-
> up KPFA symphonies of Vivaldi harpsichord intellectuals perfor-
> mances boom blam the tremendous sound of it which I then came to
> hear all the summer wrapt in the arms of my love—walking in there
> now, and going up the narrow musty stairs like in a hovel, and her
> door.[54]

In this series of associations, certain links stand out as significant or piv-
otal points: the mysterious appeal of the urban bohemians, the genera-
tional interest in Thoreau and Whitman, the mentor figure of Alfred
Kazin lecturing in New York; then a second stream of associations arises

from the same physical context: an "urban pastoral" celebration of the working-class ethnic neighborhood and its diverse cultural life.

Kerouac's work typically skirted the pointed social criticism that informed Ginsberg's "Howl." But the subjective associations pursued in a "sketch" might address the cultural shortcomings of modern America, as in the following sketch from *Visions of Cody*:

> I worked as a waiter in a basement Bohemian restaurant with candles on oilcloths in Greenwich Village and got high with the dishwasher in the kitchen on tea, talk and dancing, the dancing he did himself, he was an African primitive dancer, his hands were long as nails, he was a colored maniac; I'd muse on him as I wended my way snowward. Not soon after that, though, I'll bet I began to look around. the sins of America are precisely that the streets . . . are empty where their houses are, there's no sense of neighborhood anymore, a neighborhood quarter or a neighborhood freeforall fight between two streets of young husbands is no longer possible except I think in Dagwood Bumstead and he ain't for real, he couldn't—beyond this old honesty there can only be thieves. What is it now, that a well-dressed man who is a plumber in the Plumber's Union by day, and a beat-dressed man who is a retired barber meet on the street and think of each other wrong, as the law, or panhandler, or some such cubbyhole identification, worse than that, things like homosexual, or dopefiend, or dope pusher, or mugger, or even Communist and look away from each other's eyes with great tense movements of their neck muscles at the moment when their eyes are about to meet in the normal way that eyes meet on the street, and sometimes with their arm muscles all tense too from the feeling that there might have been contact, which arises from vague abstract mental suspicion that there's going to be a sudden fist-fight or assault with deadly weapon intent, followed by the same old excuses when the moment of meeting is past and both parties realize it was just two fears meeting on the street.[55]

This passage moves through several associated topics: an interracial encounter; a lament for neighborhood street life; and fears of the cultural Other. These issues were recurrent themes in Kerouac's writing—examples of the psychological experience of living in corporate-liberal America that he described as "paranoia preceding reality, reality flirting with paranoia."[56]

But if the "common sense" of the dominant culture was suspect, how could the truth be discerned? The beats relied on an intersubjective epistemology that arrived at truth through honest dialogue. Their spontaneous writings thus represent but half of an interpersonal dynamic, the other half of which was to be supplied by the reader. Because the sponta-

neous confession in beat writing aimed at intersubjectivity, it was structured not only as a comprehensive expression of subjective reality, but also as an invitation. As Kerouac wrote in *The Subterraneans*: "Another confession must be made, as many I must make ere time's sup—I am crudely malely sexual and cannot help myself and have lecherous and so on propensities, *as almost all my male readers no doubt are the same.*"[57]

The letters of Neal Cassady upon which Kerouac based his spontaneous prose were themselves modeled on the marathon dialogues of 1947 between Cassady and Allen Ginsberg. In *On the Road*, Kerouac had the Ginsberg character describe these conversations: "Dean and I are embarked on a tremendous season together. We're trying to communicate with absolute honesty and completeness everything on our minds. We've had to take benzedrine."[58] The beats relied on the honest exchange of impressions and associations as an epistemological tool that could define a shared reality, the potential basis for a new common sense.

In order to record intersubjective reality more fully, in the fall of 1952 Kerouac extended the scope of his spontaneous "sketching" technique to focus not only on visual memories but on the particulars of spoken dialogue. Following William Carlos Williams, he insisted in "Essentials of Spontaneous Prose" on the importance of "the *sounds* we hear."[59] He would attend parties only to sit silently in a corner, listening intently to the multiple conversations and noting them down in his memory. His attention to capturing the speech patterns of particular individuals and social groups is evident in such works from the fall of 1952 and the spring of 1953 as "October in the Railroad Earth" and *The Subterraneans*. In the former work, Kerouac described a San Francisco restaurant through the speech patterns of the people who ate and worked there:

> The prices were incredible, but one time I had the beefstew and it was absolutely the worst beefstew I ever et it was incredible I tell you— dah—ehtoutl [spitting]. . . . I tried to convey to the geek back of the counter that I wanted but he was a tough sonofabitch, ekch ek- outkc,—ti ti I thought the counterman was kind of queer especially he handled gruffly the hopeless drooldrunks, the now paw you'd think you knifing you think you can come in here and cut like that for god s sake act like a man wont you and eat or get out-t-t—I always did wonder what a guy like that was doing working in a place like that because, but why some sympathy in his horny heart for the busted wrecks, acit all yup that.[60]

The imperative to record intersubjectivity accounts for the fact that dialogue often functions not as a mere plot device but as the central fulcrum of beat writing. Kerouac informed the reader in *Visions of Cody*: "Now what I'm going to do is this—think things over one by one, blowing on the

visions of them and *also* excitedly discussing them as if with friends."[61] Similarly, the centerpiece of *The Subterraneans* is when Mardou tells the story of her life. Trying to "pick up on" Mardou's experience as a black woman in America, Kerouac characterizes himself as "a great . . . lover and bigger, more awful listener and worrier."[62]

Yet *The Subterraneans* encapsulates a general problem of literary inter-subjectivity, evident also in *On the Road*. It is a problem that is not present in truly conversational art forms like improvisational dance and bebop jazz. This is that the novelistic form masks the power dynamics implicit in speaking for others. The authorial voice in the text inevitably creates pre-dominantly one-sided "conversations."[63]

Kerouac was aware of this problem, and in *Visions of Cody* he grappled with it directly. The predominance of dialogue over plot in his novels probably reached an apex in this work, which juxtaposes his accounts of dialogues to actual transcripts from wire recordings, allowing the reader to compare Kerouac's memories to the taped versions. In these dialogues, moreover, the participants often begin by reading transcripts of their ear-lier conversations, in order to pick up on previous trains of thought. Thus the "novel," if you can call it that, is really a palimpsest of dialogue.

Jazz and Literature

Aside from their own conversations, the most influential model of inter-subjectivity for the beat writers was bebop jazz. In his poetic sequence *Mexico City Blues*, written in 1955, Kerouac called Charlie Parker

> A great musician and a great
> creator of *forms*
> That ultimately find expression
> In *mores* and what have you.

Kerouac introduced Ginsberg to the music of Charlie Parker when they first met in 1944. He himself had discovered bebop upon being dis-charged from the navy in 1942. The year before his death, in 1968, he claimed to own every record Charlie Parker had ever made.[64]

The beats' appreciation for modern jazz was multifaceted. In its several aspects, this appreciation made its way into their writings. They seem to have remained willfully innocent of the racial power dynamics structur-ing their reception of the music—dynamics that allowed them to move more freely between African American and white social spaces than many black jazz musicians themselves. Their descriptions of the bebop subcul-ture reveal strains of primitivism. But overall they express an excited recognition of bebop as a cultural tool embodying the principles of inter-subjectivity and body-mind holism.

The primitivist fantasies of Kerouac and John Clellon Holmes are easily recognized. At times, their writing associated bebop with imaginary African jungle sexual rituals. Holmes wrote in his novel, *The Horn*, from the 1950s, of a trumpet played "like some ritual phallus bewitched upon a jungle altar . . . repeating (of itself, it seemed) 'Zonky! Zonky! Zonky! Zonk!' in thin, high-pitched squirts of sound that said a clear and untranslatable 'Yes!' to everything that was not of the mind."[65] Kerouac in *Visions of Cody* described playing the bongo drums with some African American musicians at a party in his apartment:

> For one hour we really had a jungle (as you can imagine) feeling running around, and after all there I was with my brand new FINAL bongo or rather really conga beat and looked up from my work which was lifting the whole group (as if in prophecy of the fact that you and I could be great jazz musicians *among* jazz musicians) (they yelled GO) and what do I see but this tall brown gal with a long white gleaming pearl necklace hanging down between her black tits clear to her black bellybutton, walking into parlor on padding black feet, looking at me.[66]

On closer analysis, however, there is more to these quotations than the obvious primitivist connotations of terms like "jungle," "padding," and even "black tits." They are informed by a Reichian discourse of sexuality, in which sex is seen as a spontaneous, instinctive act of the body ("of itself, it seemed"), which frees the self from ideological inhibitions in order to allow the reintegration of body and mind on terms of mutuality. Holmes's word "untranslatable" further suggests the status of jazz as a form of sensuous, nonverbal communication: communication through the energy field, not through mental conceptualizations. In the same vein, Kerouac describes his conga playing as "lifting the whole group" though its energetic rhythms.

Other writings attest to the beats' appreciation for bebop's distinctive African American heritage without alluding to the dichotomy of "civilized" and "savage" implied in primitivist notions. In "The Beginning of Bop," written for *Esquire* magazine in 1959, Kerouac wrote of the displacement and dispossession experienced by black Americans, characterizing bebop musicians as

> talking eloquent like great poets of foreign languages singing in foreign countries . . . and no one understands because the language isn't alive in the land yet—Bop is the language from America's inevitable Africa. . . .
> The band realized the goof of life that had made them be not only misplaced in a white nation but mis-noticed for what they really were

and the goof they felt stirring and springing in their bellies, suddenly Dizzy spats his lips tight-drum together and drives a high screeching fantastic clear note that has everybody in the joint look up.[67]

In "The Beginning of Bop," Kerouac suggested that the African American experience that motivated bebop was the same that produced the black nationalist Nation of Islam: "'When you say Race bow your head and close your eyes.' Give them a religion no Uncle Tom Baptist—make them wearers of skull caps of respectable minarets in actual New York."

The beats appreciated bebop solos as musical expressions of subjectivity. In his novel, *The Horn*, John Clellon Holmes attempted verbal interpretations of bebop utterances. At one point, for example, he described the "voice" of the character, Edgar, who was modeled on Lester Young:

> It had a singularly human sound . . . they would hear a wild goose honk beneath his tone—the noise, somehow, of the human body; superbly, naturally vulgar; right for the tempo. And then out of the smearing notes, a sudden shy trill would slip, infinitely wistful and tentative . . . [a] sinister strain of self-ridicule behind the phrase [revealing] . . . the presence of a secret.[68]

Kerouac conscientiously avoided such translations, leaving the music to speak for itself to those who cared to listen. He wrote more concretely of the process of listening itself, describing it as an act of aural intersubjectivity:

> Best of all [were] the workingman tenors, . . . they seemed to come on in their horns with a will, saying things, a lot to say, talkative horns, you could almost hear the words and better than that the harmony, made you hear the way to fill up blank spaces of time with the tune and consequence of your hands and breath and soul.[69]

In their descriptions, Holmes and Kerouac both emphasized the fundamentally intersubjective nature of playing bebop, with its structural reliance on an improvisational give-and-take among the musicians. The first chapter of Holmes's *Horn* is structured as a dramatic choice between two different personal strategies: a self-protective irony versus the "willing[ness] to risk [one]self in the tenuous, hair-breadth rapport of improvisation so that the unnameable truth of music . . . might happen."[70] Holmes described the bebop jam session as an exploratory expedition beyond the limits of convention—an intersubjective odyssey made possible by mutual trust, and at the same time making mutual trust possible.

> . . . listening, listening; and then, in the afternoons, sitting at the piano with lax-jawed, intent self-trust, letting his fingers find the next chord in a strange, keyless progression, and muttering an involuntary "Um-

m-m" of recognition at the logic of it. Their minds run on together—half-fooling, half-seriously pushing at the limits they had always known—and Curny would suddenly grunt "Uh, uh" between phrases, chinning the staggered off-beats of the drums, to splatter a fusillade of copper-clear notes, like machine-gun fire on the ceiling, curiously arbitrary and released. Wing swerved off the line in fleet answer until, for just a moment, they were all chasing one another in sudden disregard of everything, to come down together, amazed, on the same surprising beat, with the intoxicated glee of inquisitive boys discovering an abstract truth.[71]

In *Visions of Cody*, Kerouac and Cassady exhibit the same excitement over group improvisation while discussing a recording of Coleman Hawkins's "Crazy Rhythm." Their comments on the music imply that what they were listening to was a recording made by Hawkins and Benny Carter in Paris in 1937, with Django Reinhardt playing guitar, Stephane Grappelly on piano, André Ekyan on alto sax, and Alix Combelle on tenor saxophone.[72] All the soloists "pick up on" the others: Benny Carter takes a theme from Combelle's bridge and works it into the first eight measures of his chorus. Subsequently, the other musicians adopt this theme to provide a riff behind Carter's solo. Coleman Hawkins uses the first bars of his chorus to establish a different riff. At the end of that chorus, Django Reinhardt shouts to Hawkins to "go on," and Hawkins takes a second chorus, with Django providing some supporting riffs, in what we can assume was to be Django's solo break.

These dynamics delighted Cassady and Kerouac. In the book, Cody begins the listening session by telling Jack, "The only reason that I'm playing this record is 'cause now you're high and you're gonna hear . . . you're gonna hear the *different* things they play." Kerouac inserted italicized notes describing the action that accompanied the dialogue: "(*they listen to the ensemble beginning to work*) . . . Did you hear that riff? (*puts music back, on alto solo*) when they begin—listen to here . . . Now Coleman comes in . . . listen to Coleman. (*Coleman comes in low toned, fast*) Hee hee hee way down there (*gesturing low at waist*) . . . Hear it? (*they laugh and gloat*)."[73]

The beats also celebrated the capacity of jazz to communicate directly with the body through pure prosody. Kerouac described in *The Subterraneans* the experience of listening to jazz while high on marijuana, allowing the voices of the musicians to penetrate on an almost visceral level:

She stood in drowsy sun suddenly listening to bop as if for the first time as it poured out, the intention of the musicians and of the horns and instruments suddenly a mystical unity expressing itself in waves . . . screaming with palpable aliveness the direct word from the vibra-

tion, the interchanges of statement, the levels of waving intimation, the smile in the sound.[74]

In *Horn*, Holmes described a jazz performance that culminates in an unconscious gesture uniting the soloist with the audience through their bodies:

> Blowing "Zonk, zonk, zonky, zonk!" with all the joyful certainty of discovery, knowing that was it, feeling the rightness of it in himself, and in the rhythm that quickened behind him, and the throng that yelled "Ah-h-h" in front, and so roaring out "Zonk! Zonk! Zonky! Zonk!" on top of the careening drums. . . . When his shoulder lifted in such trusting arch to hit the single sweet note in the shrieking "zonk-zonk-zonk!" . . . a sympathetic tranced response to what was in him lifted every other shoulder that was there—the gesture and the note so wedded that though everyone felt his own shoulder lift, no one was conscious that it had.[75]

Ascribing primacy to the communicative power of the body motivated the beats' interest in bebop rhythms. This interest became the source of the stereotype of the bongo-playing beatnik. Carolyn Cassady recalled that Kerouac in the early 1950s

> never stopped drumming, whether or not an actual drum was available. He did very well on the bottoms of assorted cooking pans or oatmeal cartons. . . . Jack would sit for hours experimenting with the tape recorder, singing both lyrics and "scat," accompanying himself on a tiny pair of bongos I'd given him for a joke.[76]

The intersubjectivity of time in bebop rhythm (see chapter 8) was an experience that never failed to thrill Kerouac and Cassady. Holmes recorded in *Go* how Kerouac and Cassady would drum together on the dashboard of his car: "Pasternak [Kerouac] would take up the beat on his end of the [dash]board, varying it somewhat. Hart [Cassady] would respond, the action seeming no longer just a time-killer but something secretly edifying and communicative."[77] Kerouac himself wrote in *Visions of Cody* about such moments: "I suddenly looked from myself to this strange angel from the other side (this is all like bop, we're getting to it indirectly and too late . . .) of Time."[78]

Although John Clellon Holmes excelled in describing the qualities of bebop admired by the beats, other writers went further in their efforts to adapt the very forms of the music to the task of literary communication. Jack Kerouac declared in a note at the beginning of *Mexico City Blues*, "I want to be considered a jazz poet, blowing a long blues in an afternoon jam session on Sunday. I take 242 choruses."[79] Like the bebop musicians,

Kerouac and Ginsberg experimented with rhythm and tone, trying to maximize the meaning carried by those sensuous elements of language. Kerouac wrote in *The Subterraneans* of moments in which he seemed to grasp, in his imagination, the rhythms and tones that he sought:

> Great words in rhythmic order . . . go roaring thru my brain, so I lie in the dark also seeing also hearing the jargon of the future worlds— damajehe eleout ekeke dhdhkdk dldoud . . . mdoduldltkdip— baseeaatra—poor examples, because of mechanical needs of typing, of the flow of river sounds, words, dark, leading to the future.[80]

Following bebop rhythms, the beats explored asymmetrical and syncopated phrasings. Kerouac's "October in the Railroad Earth," for instance, creates moods by lengthening and shortening the phrase. The opening sketch communicates the fast pace of "commuter frenzy" by a progressive shortening of the lines, followed by a release (the line breaks are mine):

> There was a little alley in San Francisco back of the Southern Pacific station at Third and Townsend / in redbrick of drowsy lazy afternoons with everybody at work in offices / in the air you feel the impending rush of their commuter frenzy / as soon they'll be charging en masse from Market and Sansome buildings on foot and in buses . . . / not even enough time to be disdainful, / they've got to catch 130, / 132, / 134, / 136 / all the way up to 146 / till the time of evening supper in homes of the railroad earth / when high in the sky the magic stars ride above the following hotshot freight trains.[81]

In the album notes for *Howl and Other Poems*, a recording of his poetry made by Fantasy Records in 1959, Ginsberg wrote that "Howl" was written as "long saxophone-like chorus lines I knew Kerouac would hear the *sound* of—taking off from his own inspired prose line."[82]

Bebop and scat singing offered the beats a model for the expressive qualities of tone as well. Ginsberg described the final lines of "Kaddish" ("Caw Caw Caw Lord Lord Lord") as "pure emotive sound."[83] He claimed Lester Young as a model for the prosody of "Howl"; Miles Davis's words on Young's playing style help to pinpoint what Ginsberg may have meant: "Lester had . . . that running style of playing and singing. . . . It floods the tone . . . and places emphasis on one note."[84] As Ginsberg explained: "you can make a music out of the . . . significant syllables. And you can pay attention to the tone leading of the vowels. It's not pay-attention-to-the-tone, but you *can* pay attention because EACH . . . THING . . . MEANS . . . SOME . . . THING."[85]

In his essay "The Beginning of Bop," Kerouac used assonance (the repetition of a vowel sound) to maintain the unity of a sentence as he stretched

it beyond the logic of syntax. The *a* sounds, particularly the short *a*, hold this sentence together toward the end, as its sense fractures into associative images: "Dizzy or Charley or Thelonius was walking down the street, heard a noise, a sound, half Lester Young, half raw-rainy-fog that has that chest-shivering excitement of shack, track, empty lot, the sudden vast Tiger head on the woodfence rainy no-school Saturday morning dumpyards, 'Hey!' and rushed off dancing."[86] With onomatopoeia, Kerouac approached the pure prosody of scat singing, as in this description of Charlie Parker's solos: "grim like factories and atonal at any minute and the logic of the mad, the sock in his belly is sweet, the rock, zonga, monga, bang. . . . 'Skidilibee-la-bee you,—oo, -e bop she bam, ske too ria—Parasakiliaoolza—menooriastibatiolyait—oon ya koo.'"

With such passages, Kerouac was approaching what is now known variously as "sound poetry," "text-sound," or "concrete writing," in which the sound of a word, not its symbolism, communicates sense. Kerouac included passages of text-sound in every work after *On the Road*, as in "Old Angel Midnight" from 1956: "[T]he Old Midnacker snacher tired a twit twit twit the McTarty long true—the yentence peak peck slit slippymeek twang twall I'd heerd was flip. . . ."[87] In *Mexico City Blues* he used assonance to develop associations or "meanings" for particular vowel sounds, which he could then exploit later in the text; as in, "O the ruttle tooty blooty / windowpoopies / of Fellah Ack Ack / Town that russet noon."[88] Kerouac's sound poetry was founded on the idea, put forward in the 107th Chorus of *Mexico City Blues*, that sensation is the most immediate form of experience, preceding (in order) "Perception," "Discrimination," and full "Consciousness."[89]

Finally, the form of bebop as a series of solo choruses offered the beats a model for structuring longer works. In "Howl," the repetition of the anaphora "who" provided an open structure that enabled Ginsberg to add phrase upon phrase, in the same way that a bebop ensemble can continue from chorus to chorus indefinitely, each chorus building on the others. As Ginsberg explained, "I depended on the word 'who' to keep the beat, a base [bass?] to keep measure, return to and take off from again onto another streak of invention"; "Once you get something going like that you can always come back to the same thing and add another one."[90] This is the same structure that Ezra Pound termed "ideogrammic" and that he used to structure his *Cantos,* each new canto modifying the meaning of the whole series.[91] Kerouac used it in *Mexico City Blues*, self-consciously comparing his choruses to Pound's *Cantos* in the 75th Chorus. (But "Cantos oughta sing," Kerouac insisted.)[92]

Some Black Mountain poets adopted bebop as a model for their work as well. In 1950, Robert Creeley wrote Charles Olson a letter pointing out the correlations between Olson's "Projective Verse" essay and modern

jazz. Creeley wrote that Charlie Parker, Max Roach, Miles Davis, and Bud Powell were undertaking extensions of form analogous to those that Olson was proposing for verse. In particular, he singled out bebop's sensitivity to rhythm and tone: "Some notes on the thing abt the projective verse [re: voice] . . . Two things we have yet to pick up on—with the head: a feel for TIMING, a feel for SOUND." Creeley praised bebop as embodying a countercultural sensibility, calling it an "example, of what timing variation, & sound-sense can COMPLETE . . . a precise example of the consciousness necessary."[93]

Creeley, having been born in 1927, was a contemporary of the beats, and almost a full generation younger than Olson, who was born in 1910. He had been active in poetry circles as an undergraduate at Harvard, but in 1944 he had interrupted his college education to serve as an ambulance driver in Burma. In Burma, Creeley began using marijuana; when he returned from the war, he discovered Charlie Parker. At that juncture, he dropped out of Harvard to follow the Boston jazz scene. As he explained: "This was where I was hearing things said in terms of rhythmic and sound possibilities."

As a professional poet, Creeley listened to bebop as part of his writing method. "I used to play records all the time," he later recalled; "I'd put on the records that I then much valued, as Charlie Parker and what not—but just because that rhythmic insistence, I think, kept pushing me, I kept hearing it." His long prose work *Island*, which he dedicated to Olson, was written while listening to Bud Powell, John Coltrane ("where you get deliberate dissonance and you get fragmentation"), and Billie Holiday.[94]

The shared pursuit of prosodic intersubjectivity in avant-garde poetry and modern jazz led eventually to collaborations between poets and jazz musicians. In the spring of 1957, at Circle in the Square in Greenwich Village, Philip Lamantia and Jack Kerouac performed their poetry with musicians Howard Hart and David Amram. According to Amram's account in his autobiography, Kerouac could improvise words on the spot to go along with the music.[95] More often, however, the jazz-poetry performances of the late 1950s were not so much true collaborations as poetry readings with musical accompaniment, in which the musical voices were subordinated to a prepared poetic text. Bebop music moves more quickly than any poetry but scat-singing can; its multiple voices cannot be "picked up on" by a poet trying to express verbal concepts, no matter how fast that poet thinks. Most jazz-poetry performances were undertaken with the quieter "cool" jazz; but even so, the dynamics among the voices tended to be those of an unequal conversation, if not entirely hierarchical.[96] Perhaps scat singing is the closest one can come to an authentically collaborative jazz-poetry.

A Poetics of Presence

By the mid-1950s, the emphasis of projective and beat poetics on "how you sound" (as LeRoi Jones put it) moved poetry inevitably toward performance, just as gesture painting developed into the performance environments of Robert Rauschenberg, Allan Kaprow, and Jim Dine. As early as 1951, the year of the "Glyph exchange," Charles Olson had proposed a "SINGLE ACTOR DRAMA as starter or PROJECTIVE ART base—DANCE, as body, but total, to ears, eyes AND VOICE." The social purpose of such a performance, he wrote, would be a recovery of "timbre," "tone," "stress"—in short, "prosody" and "voice."[97] Poetry readings among the beats removed poetry from its accustomed status as a written text and returned it to its older status as a community event. In poetry readings, the emphases on intersubjectivity and on the physical dimensions of communication were combined. As Paul Zumthor has written, in oral poetry "the *object* to be fabricated [that is, the poetic text] is no longer sufficient; it is a matter of reviving another *subject* [the auditor]."[98]

Particularly in beat poetry, performance is an important dimension of poetic form, and one that cannot be preserved in printed texts. Beat poetry can be fully apprehended only by those participating in the performance space. This is one of the central attributes by which the beat poets distinguished their work from the academic poetry valorized by the New Criticism. Academic criticism like the book you are reading privileges the written artifact. But beat poetry shared with improvisational jazz an aesthetic of presence.

Beat poetry readings were inspired in part by the Welsh poet Dylan Thomas, who came to the United States in the 1940s. Thomas joined Greenwich Village bohemia, drank at the White Horse Tavern, and helped to reestablish the idea that poetry was meant to be heard. But beat poetry readings began on the West Coast; In October 1955, Ginsberg gave his first public reading of "Howl," at the Six gallery in San Francisco. Michael McClure, Philip Lamantia, Gary Snyder, and Philip Whalen also read at that event, with Kenneth Rexroth acting as the master of ceremonies. By 1959, public poetry readings were established on the East Coast as well, in coffee houses like the Village Gaslight founded for that purpose.[99]

Poetry readings contributed to the energy of the avant-garde community, providing palpable evidence that cultural work was "happening." Readings circumvented the time lag associated with publishing, which could be crucial in a medium as perishable as avant-garde poetry. Although there were several little magazines associated with the culture of spontaneity by the mid-1950s, they inhabited a marginal space between the worlds of bohemia and business. The vicissitudes associated with publishing them sometimes meant long delays. The *Black Mountain Re-*

view, for instance, folded when the school closed for lack of funds. The *Chicago Review* was suppressed by administrators at the University of Chicago when it published excerpts from William Burroughs's *Naked Lunch* in 1958; its editors had to reorganize to form the little magazine *Big Table*.[100] The usual lag of six months, a year, or even more between the moment of a poem's composition and its appearance in a little magazine could completely destroy the sense of a poetry "movement" as a coherent and continuous cultural effort.

Besides increasing poetry's presence on the cultural scene, readings maximized spontaneity. In a performance, the poem could be altered or even composed on the spur of the moment; but once spoken, the word could not be erased or revised. In this sense, performance was more than an ancillary practice of the beats. It was a model for their poetry. Ginsberg spoke of open verse as

> the introduction of courage and openness in the writing so that you'd realize you were already in eternity . . . and whatever you said at that moment was whatever you said at that moment. So in a sense you couldn't change, you could go on to another moment. . . . I remember Robert Duncan got up and walked across the room and then said, "After I've walked, how can I change my step?"[101]

As events taking place in real space and time, readings shared with life itself an element of contingency that written texts lacked.

Paul Zumthor has suggested that the culture of orality differs from the culture of literacy in that orality entails a process of "remembrance" rather than memorization. Memorization connotes the imperative to reproducibility that is the foundation of the scientific method's "objective" epistemology, in which discrete events are abstracted from their contexts in place and time in order to be equated or compared.[102] In remembrance, by contrast, communicated knowledge derives its authority not from the privileged status of the text (logocentrism) but from the act of retelling, in which the knowledge is each time freshly synthesized in the mind of the storyteller, and so made new.[103] Ginsberg saw each reading as an opportunity to imaginatively reenact the event of a poem's creation: "When I get up and read those [phrases] I just make believe I'm trying to think of the next phrase. And so actually that leads the listener . . . in an oral interpretation . . . it leaves the mind of the . . . listener to be hovering with mine."[104]

The reception of a spoken poem, like its delivery, is bound to the particularities of the performance space and time. The listener cannot look forward to what will come next, or to the end, or back to a previous point.

For these reasons a performance does not have the unity of written work. Printed texts obscure, by the simple means of omission, the truth

that much of the meaning of a text is constituted by the complex phenomenon of its reception. By contrast, experiences of a performance, as Zumthor has written, are clearly "multiple, cumulative, many-colored, sometimes diverse to the point of being contradictory." Performances, more openly than written texts, succeed or fail on the basis of whether a rapport is established between listener and speaker: "My presence and his in the same space put us in a position of dialogue, whether real or virtual."[105]

Beat poetry readings were unquestionably characterized by the absence of the traditional, imaginary "fourth wall" separating the performers from the audience. The dramatic intersubjective dynamics achieved in particular performances have become a major part of beat lore—that is, of the stories that surround the literary works themselves and constitute an important facet of the beat subculture. There is, for example, the oft-told story of Allen Ginsberg's first reading of "Howl" at the Six gallery. Every version tells how Jack Kerouac collected donations from the audience to buy wine, and how everyone drank and listened while Kerouac shouted "Go!" between the lines as Ginsberg read.[106] As a counterpoint, there is the story of Ginsberg's reading of "Howl" in Los Angeles a year later, when the poet triumphed by taking his clothes off and challenging a heckler to do the same.[107]

Performances magnify the indeterminacy of a poem's meaning, but also make possible the communication of more meaning than can be transmitted through print.[108] The capacity of the oral poem to "make sense" includes prosodic effects like timbre, pitch, rhythm, inflection, even gesture. Attenuated in the written word, these elements contribute much to the message communicated in face-to-face contact.

Oral poetry exercises the listener's ability to synthesize meaning from all these sources. According to Paul Zumthor,

> The thread that connects so many signals or experientially determined markers to the text is stretched to the breaking point. Whatever referential strength remains in the poem stems from its focusing on the contact between subjects bodily present in performance: somebody whose voice carries and somebody who receives it.[109]

By focusing attention on physical presence in this manner, poetry readings participated in the cultural work of the postwar avant-garde.

Through their spontaneous poetry, the beats sought to subvert the psychological splitting and "desensitization" that they observed in corporate-liberal culture. To them, poetry was not a discrete pursuit, but was embedded in a whole set of practices that defined a countercultural lifestyle. Smoking marijuana, holding long personal conversations, listening to jazz and playing on bongo drums, writing spontaneous poetry

and reading it aloud—these practices were linked by a logic that this chapter has tried to make clear. The next chapter focuses on how the emerging culture of spontaneity faced off against the dominant culture of the Cold War period, as the escalation of the arms race renewed concerns of an endemic "social neurosis."

10

Battling the Social Neurosis

Appearances are hazy.
Smart went crazy,
Smart went crazy.

—Allen Ginsberg, "Bop Lyrics" (1949)

Dictionary definitions of spontaneity refer to impulsive, uncon-
strained, and unpremeditated behavior. The spontaneous art
of the 1940s and '50s was spontaneity with a purpose. Visual
artists, dancers, writers, and musicians explored the cultural possibili-
ties of an oppositional metaphysics emphasizing intersubjectivity and
body-mind holism.

Still, the mainstreams of popular and academic cul-
ture at midcentury attacked the culture of spontaneity
as ignorant and irresponsible. Spontaneous artists were
paradoxically accused both of excessive alienation and
of mindless conformity. Both abstract expressionist
painters and bebop jazz musicians incurred this criti-
cism; but the brunt of it was directed at the beats, who
were reinvented in the popular imagination as "beat-
niks."

The reason for this virulent and contradictory recep-
tion of spontaneous art is that spontaneity served as the
scapegoat of both "highbrow" and "middlebrow" critics
locked in their own cultural struggle during the postwar
period. These two camps defined themselves in opposi-
tion to one another; yet their debate together must be
seen as a single discourse that shaped critical standards
of the era.

In the supposedly classless society of midcentury
America, social alliances were defined more readily by
questions of taste than by questions of class. Thus, high-
brow journals like the *Antioch Review* and the *Partisan*

Review condemned the antiintellectualism and conformity encouraged by the middlebrows controlling the mass media. The middlebrows in turn rebelled in the name of democracy against the authority of ivory-tower elites to define public taste. In the battle between mass culture and academic high culture that raged at midcentury through terms like "highbrow" and "middlebrow," "egghead" and "philistine," the spontaneous avant-garde did not identify themselves with either side, and so drew the fire of both.

Serge Guilbaut has argued that abstract expressionism achieved success by offering itself as a cultural tool of corporate-liberal imperialism. As the linchpin of his argument, he cites a speech given by René d'Harnoncourt in 1948 to the American Federation of Arts. Guilbaut interprets d'Harnoncourt's words on the social function of art as "the reconciliation of the ideology of individuality, risk, and the new frontier as forged by Rothko and Newman, Greenberg and Rosenberg, with the advanced liberal ideology set forth by Schlesinger in *The Vital Center*."[1] But d'Harnoncourt's speech can more accurately be read as his effort to articulate the radical social vision of intersubjectivity for a middlebrow audience. "The dilemma of our time," d'Harnoncourt asserted,

> can be solved only by an order which reconciles the freedom of the individual with the welfare of society and replaces yesterday's image of one unified civilization by a pattern in which many elements, while maintaining their own individual qualities, join to form a new entity. . . . The perfecting of this new order would unquestionably tax our abilities to the very limit, but would give us a society enriched beyond belief by the full development of the individual for the sake of the whole. I believe a good name for such a society is democracy, and I also believe that modern art in its infinite variety and ceaseless exploration is its foremost symbol.

D'Harnoncourt asked his audience to accept that, despite its difficulty, the new American painting ought to be distinguished, by virtue of its social vision, from run-of-the-mill "highbrow" art—reminding them that "if we were to judge the social consciousness of an artist or of a creative thinker by the number of his contemporaries who understood his work, many [geniuses] . . . would have to be dismissed as irresponsible highbrows."[2]

"Cooptation" is too simplistic a notion for conceptualizing the fate of spontaneity amidst the powerful midcentury clash between highbrow and middlebrow critics and advocates. In the tripartite struggle between high culture, mass culture, and the culture of spontaneity, all sides agreed that the United States suffered from a prevailing "social neurosis." But each side defined this supposed neurosis differently, linking the other two camps to the source of the problem and its own values to the remedy.

THE SANE SOCIETY? AMERICA
IN THE LATE 1950s

The cultural battle was joined during a time of relative prosperity. The corporate-liberal socioeconomic system that had been developed in the 1920s and reinvigorated by the Second World War continued to function admirably through the late 1950s. The federal government offset two minor economic recessions in 1958 and 1960 by increasing expenditures while cutting taxes. Labor relations continued to be characterized by the willingness of management to concede better wages and benefits to workers, in return for the cooperation of the government and organized labor in securing new markets, achieving new efficiencies of scale, and instituting bureaucratic controls in the workplace. Average hourly earnings for the American worker rose 22.2% between 1955 and 1960, at roughly twice the rate of inflation. Two-week paid vacations became the norm for even blue-collar employees. The federal government's new interstate highway system facilitated the national integration of the economy and eased local traffic snarls as Americans circulated in their new automobiles between workplaces, vacation sites, and new homes in the suburbs.[3]

Although McCarthyism had ended in 1954, anti-Communism remained a powerful social force. The "working class" had neither the power nor the will to assert itself except as a junior partner in the corporate-liberal system. In 1955, the Congress of Industrial Organizations (CIO), renowned for its radical organizing during the 1930s, merged with the more moderate American Federation of Labor (AFL) led by the confirmed cold warrior, George Meany. Several of the largest unions, including the International Longshoremen's Association and the International Brotherhood of Teamsters, were plagued by corrupt leaders tied to organized crime. In 1959, Congress cited this reason in mandating close government supervision of union activities—and took the opportunity to extend provisions of the Taft-Hartley Act restricting the right to strike.[4]

Throughout the era, the Cold War with the Soviet Union dominated newspaper headlines. Advertisers and political leaders alike linked nuclear deterrence with consumer goods to define an "American way of life" in which high technology symbolized both the benefits of democracy and the means of securing it. Vice president Richard Nixon visited Moscow in 1959 in conjunction with a traveling exhibit of American home furnishings, and took the opportunity to proclaim the self-evident superiority of the American culture of abundance. Not Communism, Nixon insisted, but America's "44 million families with their 56 million cars, 50 million televisions and 143 million radios" constituted the true "classless society."[5]

Anxiety loomed, however, behind such material victories. Despite

widespread prosperity, personal money worries increased as Americans followed patriotic exhortations and their own inclinations to spend more than they earned.[6] The wide availability of consumer goods also brought heightened definition to old social tensions: middle-class Americans from diverse ethnic backgrounds strove to "keep up with the Joneses"; general affluence intensified the deprivation felt by have-nots on the periphery of the corporate-liberal system, including particularly African Americans in the rural South; and as the first baby boomers reached adolescence, a cultural generation gap encouraged by mass-culture youth marketing was revealed.[7] Moreover, many Americans found their new kitchen appliances cold comfort in view of the superior rocket technology of the Soviets, which conceivably left the U.S. vulnerable to a sudden, devastating nuclear attack.

Because of its intersection with several of these themes of late-fifties culture, the public debate over open-air testing of the hydrogen bomb serves as a valuable example of the way in which the culture of spontaneity challenged dominant political and intellectual discourses. In 1954, most Americans welcomed the newly developed hydrogen bomb as a reassuring symbol of their military superiority: it was a thousand times more powerful than the original atom bomb, exploding with a force of megatons rather than kilotons of TNT. But it soon became clear that a blast of such magnitude was of minimal strategic value; it gave an edge of advantage only if the destruction of entire populations was contemplated. Its unsettling premise was one of total warfare against civilian targets. When, after less than a year, the Soviets countered with an H-bomb of their own, the "top secret" testing of newer and better versions by both sides signaled a terrifying acceleration of the arms race.[8]

This dizzying series of events led the National Committee for a Sane Nuclear Policy, or SANE for short, to become the first antiwar organization since the beginning of McCarthyism to attract a significant membership.[9] Linus Pauling, a Nobel Prize–winning biochemist, took a leading role in organizing SANE to bring an end to open-air H-bomb testing. In 1958, Pauling challenged Edward Teller, who had developed the H-bomb, to televised debates on the possibilities of genetic mutation resulting from radiation fallout.[10] The specter of mutant children proved a powerful emotional tool in raising Americans' doubts about the need for further H-bomb testing.

The debate between Pauling and Teller on the dangers and merits of nuclear warfare delineated the scope of the dominant discourse. Although Pauling's antiradiation rhetoric took a stand against atomic brinksmanship, it did not challenge the arms race on an ideological level. Like the military-industrial complex itself, SANE appealed to a faith in high technology and insisted on the authority of trained experts as the

only ones qualified to assess the situation. Linus Pauling's book, *No More War!*, published in 1958, proposed that the arms race be supplanted by a World Peace Research Organization which would conduct "research on how to solve great world problems, problems of the kind that have in the past led to war. . . . It should include many scientists, representing all fields of science, and many other specialists—economists, geographers, specialists in all fields of knowledge."[11]

Furthermore, SANE did not challenge the logic of fear on which the "sublime irony" of nuclear deterrence was based.[12] Like proponents of the arms race, SANE assumed that the biggest fear translated into the best motive for political action. It simply proposed to trump the fear of Soviet invasion with the fear of genetic mutation resulting from radioactive fallout.

Because SANE did not challenge the cultural premises of deterrence, its arguments were easily contravened by "specialists" who argued from a position of official authority that the Soviets indeed posed a greater threat than radioactive fallout did. The head of the Atomic Energy Commission, Willard Libby, asserted in the *New York Times* that the health risks of radiation would simply have to be accepted as an inevitable part of the modern American way of life. Like highway deaths and smoggy air, fallout was a socially contracted cost of "our pleasures, our comforts, and our material progress." "It would be far more dangerous," Libby maintained, "to run the terrible risk of abandoning the defense effort which is so essential under present conditions to the survival of the free world." President Eisenhower concurred, endorsing the position that "if there are to be atomic weapons in the world, we must have the best, the biggest, and the most."[13]

In contrast to SANE, the avant-garde's cultural strategy presented a more radical though less immediate challenge to the Cold War status quo. Black Mountain poet Ed Dorn voiced his dismay that Linus Pauling imagined a panel of scientific specialists invested with international authority to preserve the peace. To Dorn, Pauling's technocratic-liberal position marked the disappointingly narrow boundaries of America's political Left. In a letter to Charles Olson, he remarked that the debate between Pauling and Teller smacked of professional rivalry, with both parties equally invested in maintaining the mystique of scientific expertise. From Dorn's point of view, the scientist's narrow focus of attention was itself part of the problem: the hallmark of a system of social organization that made the hydrogen bomb possible.[14]

Some members of SANE might have agreed. The organization's name had in fact been coined by sociologist Erich Fromm, a former Marxist who in 1955 had published a cultural critique of America entitled *The Sane Society*. In that work, Fromm argued that modern society encour-

aged and normalized a collective neurosis akin to emotional alienation. In naming SANE, he remarked that the absence of a general protest against the hydrogen bomb could only be attributed to the kind of "schizophrenic indifference" that he had suggested was characteristic of the times.[15]

Fromm's description of what he termed "the pathology of normalcy" supported the avant-garde's logic of addressing social problems through cultural rather than political channels. As with any neurotic behavior, Fromm implied, the main hope for changing American nuclear policy lay not in rational argument, but in an investigation of the irrational psychological motivations behind it. Beat poet Gregory Corso volunteered to undertake such an investigation in his poem "Bomb," which was published as a broadside (so as to emphasize its political nature) in San Francisco in 1958.

The kind of knowledge pursued in Corso's poem is not the objective, scientific knowledge idealized by Linus Pauling. Rather, it is a subjective knowledge, tracing the unconscious associations informing Corso's personal attitude toward the H-bomb. Leaving open the question of whether his psyche exactly matched those of most Americans, Corso offered the reader a social diagnosis by way of as honest and complete a response to the hydrogen bomb as he was capable of recording. To this end, he wrote spontaneously, so as to suspend guilt, elude repression, and capture the metaphorical logic of his unconscious mind. Corso's poem revealed how the bomb was embedded in complex associations linking it not only to fear but also to novelty and desire:

> I sing thee Bomb Death's extravagance Death's jubilee
> . . . Impish Death Satyr Bomb . . .
> I want to kiss your clank eat your boom
> . . . BOOM BOOM BOOM BOOM BOOM
> . . . Yes Yes into our midst a bomb will fall
> Flowers will leap in joy their roots aching. . . .[16]

Operating outside the logic that defined the positions of both Edward Teller and Linus Pauling, Corso's poem engaged the problem of deterrence through a cultural strategy that might be termed "disclosing the social neurosis."

DISCLOSING THE SOCIAL NEUROSIS: PARTICIPANT-OBSERVERS IN THE NEUROTIC SOCIETY

The beat writers, like other proponents of the culture of spontaneity, sought to explore—and in the process perhaps to alter—the psychologi-

cal associations underlying their lived experience. Often, the beats used spontaneity to unmask the ideological contradictions by which they lived, turning their expressions of subjective reality into criticisms of corporate-liberal America. Many contemporary critics conflated the neurotic content of beat writing with the social problem of juvenile delinquency. But the beat writers understood themselves as participant-observers within American society, not just as rebels against it. Their cultivated neurosis was meant to serve as a profound cultural query.

The beats belonged to a generation born in the mid-1920s. They reached maturity in a time dominated by the fact of the Second World War. The war appears in their writings not as a rumor of horror (as in Olson's poem, "La Préface"), but as a condition of young adulthood, shaping their personalities. In his novel *Go*, published in 1952, John Clellon Holmes wrote of the fear and excitement, dislocation and regimentation that was the American home front as he experienced it:

> All around them were the midwestern waitresses and secretaries who had come by bus or train to see their men shipped out after a few wild days of reunion, and who had stayed on hopelessly, earning enough to live but not to get back home; the teeming streets at night when hungers and loneliness reduced small town, decent boys to vandals; the abandon that seized all these young people who had been torn up at the roots, regimented, shunted back and forth across the nighttime wilderness of a nation at war; intimidated by Shore Patrols, jackedup prices and annoyed civilians; who searched in bars and movie balconies and deadend streets for home and love, and, failing to find them, forgot.[17]

The beats wrote about the war from the perspective of participant-observers.

Jack Kerouac and Allen Ginsberg believed that the war anticipated Oswald Spengler's predicted "decline of the West."[18] After the First World War, Spengler, a German historian, had gloomily foretold the decay of Enlightenment civilization and a return to the primitive life of the "fellaheen." The beats found reasons to celebrate this possibility rather than bemoan it. William Burroughs, who was their mentor in this, had studied pre-Columbian cultures in a master's program at Harvard before leaving academia in 1936. Like other marginalized intellectuals, he reacted to the onset of World War II with a sense that the paradoxes involved in the American war effort were not mere surface phenomena, but symptomatic of underlying ideological contradictions that affected all of Western civilization.

In 1944, developing this idea, Allen Ginsberg wrote a short prose piece that he called "A Vision of the Apocalypse." It treated the "castoffs of bour-

geois society" who wandered New York's Times Square as symbols of the West's decline. They were "the final scenes of disintegrative decay . . . all the children of the sad American paradise." Kerouac inserted the piece into his first published novel, *The Town and the City* (1950):

> It goes on all night, everyone milling around uncertainly among the ruins of bourgeois civilization, seeking each other, don't you see, but so stultified by their upbringings somehow, or by the disease of the age, that they can only stumble about and stare indignantly at one another. . . . All the neurosis and the restrictive morality and the scatological repressions and the suppressed aggressiveness has finally gained the upper hand on humanity—everyone is becoming a geek![19]

Compared to the description of wartime in Holmes's *Go*, the Ginsberg-Kerouac version clearly emphasizes the idea of social neurosis.

It was during the war that Kerouac and Ginsberg both began to define identities based on the neurotic manifestation of general ideological contradictions. Ginsberg later explained that only if one willingly lent oneself to "a definite shrinkage of sensitization, of sensory experience, and a definite mechanical disorder of mentality" could the ideological contradictions of the war and later the Cold War be borne be equanimity.[20] The beats refused to adopt this compartmentalized "disorder of mentality," and so arrived at mental disorder by another, perhaps more honest route. Kerouac enlisted in the navy in 1942, but was discharged after a period of psychiatric observation as "a schizoid personality" with "angel tendencies" following an episode in which he left the drill field to go read at the base library.[21] In March 1945, Ginsberg was suspended from Columbia for writing "Fuck the Jews" and drawing the skull and bones, with a cock and balls, in the dust on his dormitory window.[22] In 1955, he would write in his most famous poem, "Howl," of an intellectual generation "who passed through universities with radiant cool eyes hallucinating Arkansas and Blake-light tragedy among the scholars of war / who were expelled from the academies for crazy & publishing obscene odes on the windows of the skull."[23] In the sixties, such acts might have been characterized as "political." But in the forties, they were simply personal attempts to maintain coherence in the face of contradiction.

The strategy of disclosing the social neurosis helps to explain the beat aesthetic of psychosis—what Norman Mailer characterized as "hallucinations, delusions, manic flight of ideas, confusion, disorientation."[24] Ginsberg felt that the distorted perspectives of the dominant culture compelled anyone with intelligence and integrity toward madness. What masqueraded as sanity, he maintained in the poem "Kaddish," was merely "a trick of agreement" with the status quo. He expressed his solidarity with constructions of reality that did not succumb to the selective awareness

that ideology mandated. "I'm a schizophrenic fairy," he boasted to Charles Olson in 1958.[25]

The theme of madness was common among the beat writers, both in their lives and in their literature. Kerouac wrote in *On the Road*: "The only people for me are the mad ones, the ones who are mad to live, mad to talk, mad to be saved."[26] Ginsberg's "Howl" begins with the assertion: "I saw the best minds of my generation destroyed by madness"—an opening line that simultaneously positions the author as a seer of superior intelligence, as the voice of a generation, and as a sufferer from unbearable psychological contradictions that the poem will go on to explore.

Spontaneous beat writing pursued an integration of conscious and unconscious thought processes; it thus brought to awareness the ideological contradictions normally hidden from the conscious mind. As Ginsberg explained his poetic technique to Ezra Pound: "You manifest the process of thoughts—make a model of the consciousness, . . . with all the dramatic imperfections, fuck-ups—anyone with sense can always see the crazy part."[27] This technique of disclosing the social neurosis criticized the dominant culture from within.

Kerouac's description of Times Square in *On the Road* encapsulates the complex insider-outsider relationship entailed in disclosing the social neurosis. It demonstrates the development of Kerouac's perspective since "A Vision of the Apocalypse," in which the narrator clearly distanced himself from the "geeks" of Times Square.

> I had traveled eight thousand miles around the American continent and I was back in Times Square; and right in the middle of a rush hour, too, seeing with my innocent road-eyes the absolute madness and fantastic hoorair of New York with its millions and millions hustling forever for a buck among themselves, the mad dream—grabbing, taking, giving, sighing, dying, just so they could be buried in those awful cemetery cities beyond Long Island City.[28]

In this passage, the narrator positions himself as an innocent, purged by his eight-thousand-mile road trip across the American continent, coming face-to-face with the unreflective profit motive at the financial center of the country. He denigrates the suburban ideal as a kind of burial. Yet the "hustl[e]" of Times Square also elicits the excited prose that is Kerouac's highest form of praise. He at once rejects and identifies with "the absolute madness and fantastic hoorair of New York." The neologism, "hoorair," encompassing hints of hooray and horror, is a fitting coinage to describe his mixture of social critique, self-critique, and celebration.

The same attitude of the participant-observer informs Ginsberg's mature poetry, evincing a love-hate relationship with the society of which he is part. "Mad Generation!" he wrote in "Howl," ". . . I'm with you in Rock-

land / where we hug and kiss the United States under our bedsheets the United States that coughs all night and won't let us sleep."[29] His short poem, "America," written in January 1956 and published in the final issue of the *Black Mountain Review*, begins, "America I've given you all and now I'm nothing . . . I can't stand my own mind. . . ."

> I'm addressing you.
> Are you going to let your emotional life be run by Time Magazine?
> I'm obsessed by Time Magazine.
> I read it every week . . .
> It occurs to me that I am America.
> I am talking to myself again.[30]

Ginsberg's "America" is a dialogical poem in which the author engages his society in conversation. Significantly, the two sides of the dialogue are not clearly demarcated, since "America" is in the author and the author is in America. Many of the lines might be spoken either by the oppositional voice of Ginsberg or by the "voice" of the dominant culture. The meaning conveyed is different in each context. In the following lines is Ginsberg speaking to America, or America to Ginsberg? Evidently both:

> I don't feel good, don't bother me.
> I won't write my poem till I'm in my right mind . . .
> I'm sick of your insane demands . . .
> Are you being sinister or is this some form of practical joke?
> I'm trying to come to the point.
> I refuse to give up my obsession . . .
> My mind is made up there's going to be trouble . . .

Almost inevitably, the poem develops into an exploration of Cold War paranoia. Ginsberg discloses racial fears at its roots:

Asia is rising against me.
I haven't got a chinaman's chance. . . .
America it's them bad Russians.
Them Russians them Russians and them Chinamen. And them Russians.
The Russia wants to eat us alive. . . . Him make Indians learn read. Him
 need big black niggers. Hah. Her make us all work sixteen hours a day.
 Help.

At the poem's culmination, the poet temporarily assumes the position of an objective observer, looking on in wonder as the social neurosis is laid bare. He adopts the voice of a diagnosing psychiatrist: "America this is quite serious. / America this is the impression I get from looking in the television set. America is this correct?" But he concludes by embracing the role of participant:

I'd better get right down to the job.

It's true I don't want to join the Army or turn lathes in precision parts
 factories, I'm nearsighted and psychopathic anyway.

America I'm putting my queer shoulder to the wheel.

Ginsberg's "America" exemplifies how the beat writers ultimately
thought of themselves as participant-observers in American society. This
was the assumption that enabled them to link their personal psychologi-
cal investigations to social criticism. Their work endeavored to amplify
the cultural dynamics like a microphone, bringing to public awareness
the contradictions and fallacies by which the society operated.

Ginsberg's poetry was first published in *Neurotica*, a little magazine
that explicitly adopted a participant-observer's stance toward the social
neurosis. John Clellon Holmes described the magazine thirty years later
as "an unholy alliance of existentialists, surrealists, radical sociologists,
psychoanalysts, playwrights and musicians."[31] Other contributors in-
cluded Kenneth Patchen, Larry Rivers, Henri Michaux, William Barrett,
Judith Malina, Otto Fenichel, Marshall McLuhan, and Leonard Bernstein.
Jack Kerouac proposed an issue devoted to bebop that was never devel-
oped.[32] *Neurotica's* editorial policy was defined by Gershon Legman, a
marginalized intellectual dedicated to furthering the Reichian revolution.
It was Legman who directed its content toward the criticism of popular
culture, including Marshall McLuhan's critique of *Time* and *Life* maga-
zines and Legman's own analysis of sadomasochism in the comics.

As the "Editorial Gesture" of Autumn 1949 attested, *Neurotica* pro-
posed to analyze the neurotic society from within:

> We define neurosis as the defensive activities of normal individuals
> against abnormal environments . . . We give space to the description
> of the neuroses with which human beings defend themselves from an
> intolerable reality. But it is with this reality that we are primarily con-
> cerned. It is our purpose to implement the realization on the part of
> people that they live in a neurotic culture and that it is making neu-
> rotics out of them. . . . We want to describe a neurotic society from the
> inside.[33]

Neurotica published nine issues from 1948 until 1951, when it was sup-
pressed as obscene by the U.S. Post Office. After *Neurotica's* demise, beat
writing would persevere in the cause.

Highbrow, Middlebrow, and Other

Beat writing came to prominence in conjunction with a widespread anxi-
ety among intellectuals and the general public over postwar social ills. In
particular, two strains of sociological critique predominated in the 1950s.

One focused on conformist tendencies among the new middle class. This was the subject of such works as David Riesman's *The Lonely Crowd* (1950), C. Wright Mills's *White Collar* (1951), Will Herberg's *Protestant, Catholic, Jew* (1955), and William Whyte's *The Organization Man* (1956). The other focused on juvenile delinquency, seeking to describe the roots of alienated behavior among America's youth. One such study was Frederic Wertham's *Seduction of the Innocent* (1954); but more influential were Hollywood treatments like *The Wild One* (1954), *The Blackboard Jungle* (1955), *Rebel Without a Cause* (1955), and *West Side Story* (1961). The predominance of these two formulas meant that the beat technique of disclosing the social neurosis was quickly interpreted as symptomatic of conformity and/or alienation.

The relation of the beat subculture to the sociological mainstream is intimated by the contrast between Fredric Wertham's study of comic book violence, *Seduction of the Innocent*, and Gershon Legman's analysis of the same in *Neurotica*. Wertham condemned the comic book industry for the sadomasochistic images it produced for children's consumption, blaming these for the violence of youth gangs and for the poor "mental hygiene" of America's youth.[34] Legman, however, argued that violent comics were merely symptomatic of the violence and sexual repression endemic in American society.[35] Wertham's book led to a public outcry resulting in a voluntary censorship code for the comic book industry. Legman's writings were themselves suppressed by the U.S. Post Office as obscene.

In order to understand the interactions of this diverse group of cultural agents—postal censors, sociologists, literati, movie-makers, comic-book publishers, and the avant-garde—it is necessary to see that the 1950s rhetoric of conformity and alienation encoded a power struggle between two social factions: the highbrows and the middlebrows, each representing a particular canon of taste as the basis of American democracy. The success of corporate liberalism had tempered class divisions through a general affluence.[36] But the expansive mass-culture technologies that it promoted (including radio, glossy magazines, television, and Hollywood movies) brought about a reconfiguration of social tensions on a cultural level. The social distinctions that had once been associated with economic status were translated in the 1940s and '50s into cultural positions, as an elite defended its "higher" tastes, whether modern or genteel, against the onslaught of abundance. Russell Lynes, writing in *Harper's* magazine in 1949, asserted: "The old structure of the upper class, the middle class, and the lower class is on the wane. . . . What we are headed for is a sort of social structure in which the highbrows are the elite, the middlebrows are the bourgeoisie, and the lowbrows are *hoi-polloi*."[37]

The reproach of the highbrows against the middlebrows carried a tone of moral indignation. They condemned the creators of mass culture as

mercenaries who cared for art and literature only as a means of profit and advancement. Middlebrow entertainments and advertising, they maintained, had usurped the authority of the fine arts, overshadowing high culture's positive moral influence. If not conspiratorially malicious, middlebrow works were nonetheless socially irresponsible: they catered to immature sensibilities and they fostered emotional insensitivity and a philistine antiintellectualism.[38] Clement Greenberg, writing in 1939 in the *Partisan Review*, had identified mass culture with "kitsch," which he described as: "ersatz culture . . . destined for those who [are] insensitive to the values of genuine culture. . . . [Kitsch] welcomes and cultivates this insensibility. It is the source of its profits."[39] In 1958, Richard Chase, a cultural critic who wrote for *Dissent, Commentary*, and the *Partisan Review*, expressed similar fears that "all forms of expression and feeling, above the level of the mass media, [are] being boiled down into a sort of middlebrow mush where all distinctions are lost."[40]

The highbrows felt that middlebrow entertainments pandered to people's basest instincts while lulling them into feelings of powerlessness and complacency. Greenberg decried kitsch's "faked sensations" as "the epitome of all that is spurious in the life of our times."[41] In 1951, Marshall McLuhan criticized *Time* magazine along similar lines, lamenting that the technologies of cultural production had shifted into the hands of corporate executives, from whose "irresponsible manipulation of these arts and techniques as entertainment" a "mindless, helpless, entranced audience emerges."[42]

According to the highbrows, the middlebrows were alienated—not from the commercial civilization their mass culture had helped to create, but from their own best selves and from the most valuable aspects of human community.[43] The middlebrow arts, for all their glib formulas, were inexpressive of life's emotional and spiritual complexities. McLuhan commented on a marketing campaign touting the historical romances of Thornton Wilder: "'Democratic' vanity has reached such proportions that it cannot accept as human anything above the level of cretinous confusion of mind."[44] Richard Chase concurred, calling, in 1958, for a restoration of higher cultural standards to reinvigorate the "moral imagination": "'Aristocratic' values are necessary, I don't mean social privilege, wealth, or snobbery. I mean the sense of obligation and amenity, the moral imagination which humanizes the raw economics of bourgeois money-grabbing and gives depth to our American notions of social responsibility."[45]

Something of the existentialist's lonely stand against conformity can be discerned in much highbrow criticism. Intellectuals repeatedly warned of mass media's power to encourage a false sense of group solidarity. The propaganda machines of Nazi Germany and the Soviet Union exemplified the cause for concern. Clement Greenberg wrote in 1939, "The encour-

agement of kitsch is merely another of the inexpensive ways in which totalitarian regimes seek to ingratiate themselves with their subjects."[46] Marshall McLuhan called *Time* magazine a formula "for clique control and indoctrination." Henry Luce, he wrote, treated his "goose-stepping" readers like "a crowd of enthusiastic kids lining the curbs as *Time* marches on. Power, glitter, and mass hypnosis."[47]

At its worst, these critics warned, middlebrow art encouraged a descent into violence. McLuhan described the contents of *Life* magazine as "heavy doses of pictorial violence, mayhem, and death plus equally heavy rations of strip tease (in ads and news alike), plus a wodge of pseudo-science." And, he continued, "this sado-masochistic mechanism of punch and get punched will be found everywhere from Winchell to the kids' comics."[48] Superman comics seemed to him to manifest "the strong-arm totalitarian methods of the immature and barbaric mind. . . . [T]oday the dreams of youths and adults alike seem to embody a mounting impatience with the laborious processes of civilized life and a restless eagerness to embrace violent solutions."[49]

The self-identified middlebrows met the moral indignation of the highbrows with satire. The portrait of the intellectual drawn in the mass media was one of a misanthrope alienated from human society, out of touch with social realities, and suspiciously European in outlook. A highbrow was, wrote Russell Lynes in *Harper's* magazine, "the kind of person who looks at a sausage and thinks of Picasso." In the middlebrow imagination, highbrows were ugly women and effete men, perhaps secretly sexual deviates. With critical minds devoid of true creativity, they busily policed the boundaries of their "little corner of intellectualism" and hated to have their authority questioned. Their vaunted taste merely reflected a defensive elitism prompted by status anxieties.[50]

The middlebrow understood the tiresome incomprehensibility of much highbrow art and literature as a facade of sophistication masking a dearth of content. Like the mythical emperor's new clothes, the mystique of highbrow discourse was maintained by an obscurity that enabled charlatans to confound the gullible. To Lynes, who seems to have considered himself an "upper-middlebrow," the highbrow was "a person educated beyond his intelligence." Lynes quipped: "There is a certain air of omniscience about the highbrow, though that air is in many cases the thin variety encountered on the tops of high mountains from which the view is extensive but the details are lost."[51]

Middlebrow writers appointed themselves as the defenders of popular taste against the authoritarian edicts of highbrow moral crusaders. Lynes accused highbrows of a totalitarian desire "to eliminate the middlebrows and devise a society that would approximate an intellectual feudal system."[52] Given the choice, some middlebrows might well have preferred a

real nobility rooted in wealth and privilege to the false and fusty elitism of the highbrows, whose cultural authority they jealously resented. But they also liked to imagine that their middlebrow ways constituted the main defense of American culture (including its naked highbrow emperors) against totalitarian barbarism.

The terms of this debate conditioned the critical reception of spontaneous art, sometimes fostering gross misunderstandings. Highbrow and middlebrow critics each condemned the culture of spontaneity as a particularly egregious manifestation of all that was wrong with the opposing camp. The vocabulary and tone of their criticisms followed the established lines of attack.

Highbrows condemned the culture of spontaneity as mercenary and arriviste. Writing in the journal *Social Problems*, Ernest van den Haag explained the success of Kerouac's *On the Road* by observing: "[O]ur society is dominated by an immensely powerful mass of consumers who will extravagantly reward whoever produces diversions—entertainment—that they can effortlessly digest. . . . The Hollywood technique of movie advertising has entered the novel from within." Van den Haag viewed the restlessness of Kerouac's characters as typically arriviste behavior: "[T]he mania for motion is a continuation of a characteristic mass culture attitude, stemming ultimately from traditionlessness and the attempt to get ahead fast." He concluded that though the beat writers might aspire to join the highbrows in the defense of humanistic values, ultimately they were intellectually inadequate to such an alliance: "The beat hipsters are too much part of the mass culture society they reject to conceive of various high culture alternatives. These would require a discipline and a tradition which they lack."[53]

Other highbrow critics similarly identified spontaneity with the attitudes of the middlebrow media. Norman Podhoretz, writing in *Partisan Review*, attributed Kerouac's popularity to the shallowness of "mass-circulation magazines" and to television programs that conditioned readers to prefer "restless, rebellious, confused youth living it up" over "thin, balding, buttoned-down instructors of English."[54] Robert Brustein in *Horizon* grouped bebop jazz, abstract expressionist painting, and beat writing with James Dean movies and rock-and-roll music as forms of mindless "self indulgence."[55]

Many highbrow critics felt that spontaneous art reflected the sensationalism and dulled sensibilities of the dominant culture. Norman Podhoretz wrote that beat literature exhibited a "pathetic poverty of feeling."[56] Van den Haag attributed the "stupidity" of *On the Road* to an advanced case of kitsch:

> Where actual feeling has been stunted entirely, the affected person, though longing for it, is unable to identify it. Hence, he is likely to con-

fuse it with sentimentality and, on the other hand, sensation (kicks). The "beat" hipster does the former in his vague pseudo-biological, psycho-philosophical theorizing and the latter in his practice.[57]

Highbrows like van den Haag were not inclined to take the intellectual heritage of the spontaneous aesthetic seriously.

Some wrote in existentialist terms about a flight from responsibility. Robert Brustein used a painting by Theodoros Stamos to illustrate his point that "[a]s far as these painters are concerned, the outside world might just as well not exist. . . . Having abdicated the traditional responsibilities of the avant-garde . . . they seem determined to slough off all responsibility whatsoever."[58] Frank Butler in the *American Scholar* sneered that "the beatnik is driven by nothing so much as a stark fear of life in all its challenging complexity and in all its infinite forms."[59] Ernest van den Haag concurred, offering the observation that the beat poet "who appears to be seeking and rediscovering the tension of existence is actually intolerant of it and drowns it and himself in meaningless brawls, jazz, drugs, and agitated travels."[60]

Such critics often conflated the spontaneous artist with the "hipster," a sensationalized image of the urban underworld. In the September 1948 issue of the *Partisan Review*, Anatole Broyard derided bebop as "expressing the hipster's pretensions" to intellectuality. According to him, the "shuffle of decapitated cadences" in bebop "corresponded to the hipster's social behavior as jester, jongleur, or prestidigitator."[61] Such comparisons led to the image of the nihilistic hipster-beatnik that was popularized in the late 1950s.

Even those intellectuals who advocated the spontaneous arts fell into similar misinterpretations.[62] Norman Mailer, who described himself as a "near-beat adventurer," overemphasized existentialism and the "hipster" stereotype in his 1957 essay, "The White Negro."[63] Mailer portrayed the postwar generation in the dramatic polarities characteristic of existentialist thought: "One is Hip or one is Square . . . one is a rebel or one conforms, one is a frontiersman in the Wild West of American night life, or else a Square cell, trapped in the totalitarian tissues of American society." Mailer's existential frame of reference, with its implicit dichotomy of individual will and social pressures, led him to interpret spontaneity as fundamentally antisocial; he wrote excitedly of the hipster's decision "to divorce oneself from society, to exist without roots":

> In short, whether the life is criminal or not, the decision is to encourage the psychopath in oneself, to explore that domain of experience where security is boredom and therefore sickness, and one exists in the present, in that enormous present which is without past or future, memory or planned intention, the life where a man must go until he is beat.[64]

This rootless, antisocial psychopath, living in the present without past or future, was a projection created by postwar intellectuals. The present that Paul Goodman celebrated in *Gestalt Therapy* was not without a past or a future. A creative tension between exploration and rootedness pervaded Kerouac's work as it governed his life. The social construction of the "authentic" self was a dominant theme in Ginsberg's poetry. The idea of a present without past had no meaning for these writers, as it had no meaning for the jazz musicians whose flights of improvisation could be achieved only after the painstaking accumulation of musical technique known as "woodshedding."

To his credit, Mailer was among the few intellectuals of the 1950s who recognized the importance of the energy-field model of human experience to the culture of spontaneity. Arguing that the hipster accurately perceived the individual as "a vector in a network of forces," he called for "a neo-Marxian calculus aimed at comprehending every circuit and process of society from ukase to kiss as the communication of human energy." The social dimensions of the energy-field model were identified by Mailer as the essence of "swinging," which he understood as an intersubjective event predicated on the successful intuition of another's energy: "To swing is to communicate, is to convey the rhythms of one's own being to a lover, a friend, or an audience, and—equally necessary—be able to feel the rhythms of their response. To swing with the rhythms of another is to enrich oneself."

Yet Mailer's idea of the libidinal economy emphasized the competitive nature of existence, defining energy transactions as a zero-sum exchange, with winners and losers, rather than as a synergy: "Life is a contest between people in which the victor generally recuperates quickly and the loser takes long to mend, a perpetual competition of colliding explorers in which one must grow or else pay more for remaining the same."[65] Mailer's existentialist I-against-the-world attitude and his conflation of the avant-garde with the hipster prompted distortions that contributed to his problematic glorification of the artist-as-psychopath. From this perspective, it was inevitable that he would misconstrue the beats' interest in African American culture: his "White Negro" essay created a stereotype of the American Negro as the quintessential existentialist and psychopath, living the ultimate nonconformist's life on the fringes of American society:

> Knowing in the cells of his existence that life was war, nothing but war, the Negro (all exceptions admitted) could rarely afford the sophisticated inhibitions of civilization, and so he kept for his survival the art of the primitive, he lived in the enormous present, he subsisted for his Saturday night kicks, relinquishing the pleasures of the mind for the more obligatory pleasures of the body.

Such misleading interpretations, however celebratory, did little to allay highbrows' fears that in spontaneous artists they faced their mortal enemies.

Less inclined than Mailer to celebrate "the obligatory pleasures of the body," most highbrow critics persisted in interpreting spontaneity as a sign of emotional immaturity. Ernest van den Haag compared the prosodic experiments of the beats to "the secret languages children invent." Like juvenile delinquents, he wrote, they "pretend[ed] to have found meaning in the mere act of rebelling."[66] Diana Trilling, writing in the *Partisan Review*, contrasted the "infantile camaraderie" of *On the Road* to the earnest fellowship of her own youth in the 1930s, and expressed her maternal concern for all the "panic-stricken kids in bluejeans."[67] In the *American Scholar*, Frank Butler more sternly condemned beat bohemianism as "one continuous adolescent indulgence."[68]

The highbrows attacked spontaneous artists, as they were wont to attack the middlebrows, for mindlessness and antiintellectualism. Brustein characterized them as "hostile to the mind, petulant toward tradition, and indifferent to order and coherence. . . . [Their] most characteristic sound is a stammer or a saxophone wail; [their] most characteristic symbol, a blotch and a glob of paint."[69] John Ciardi of Rutgers University, the president of the College English Association, gleefully referred to Kerouac as "a high school athlete who went from Lowell, Massachusetts to Skid Row, losing his eraser en route."[70] Frank Butler railed against "the pretense that the Beat Generation represents a movement of any artistic validity whatsoever." Its poetry, in his opinion, was "barely literate"; its prose, "sprawling and empty"; its painting, "without character or control." He concluded by describing the culture of spontaneity as "an anti-intellectual, anti-artistic gang of sentimental dabblers and semi-criminal nihilists, devoted to destruction, motivated by pettiness, and equipped with mediocrity."[71]

Highbrow critics were accustomed to accuse their middlebrow antagonists of conformity. Committed to upholding the burden of individuality, they were confounded by the beat tenet of intersubjectivity, which subverted the dichotomy opposing the individual to the ensemble. Ernest van den Haag wrote that "individuation, though an apparent goal" of the beats, was "implicitly rejected" in their practice. Their behavior, he felt, was even more conformist than that of the notorious executives in gray flannel suits, because the beats were clearly "more in need of each other."[72] In *Horizon*, Robert Brustein extended this accusation to other branches of what he called the "cult of unthink," characterizing all spontaneous artists in whatever medium as "conformists masquerading as rebels."[73]

Some even linked the spontaneous aesthetic to the commander-in-

chief of the middlebrows, President Dwight D. Eisenhower. Kerouac's writing reminded Brustein of "an Eisenhower press conference, stupefying in its unreadability."[74] Frank Getlein, writing in the *New Republic*, anticipated Serge Guilbaut's later criticism of abstract expressionism in declaring it "a splendid artistic equivalent of Eisenhower Republicanism in politics."[75] Norman Podhoretz went farther, accusing the beat generation of "an anti-intellectualism so bitter that it makes the ordinary American's hatred of eggheads seem positively benign."[76]

As with their response to mass culture, beneath the highbrows' most virulent attacks on spontaneity lay a fear of barbarism and physical violence. Brustein called Allen Ginsberg's "Howl," "a description of the worst degradations to which the human animal can descend." He compared the spontaneous artist to Marlon Brando's Stanley Kowalski in *A Streetcar Named Desire*:

> A man of much muscle and little mind, often surly and discontented, prepared to offer violence with little provocation. . . . Whatever intelligence he has is subordinated to his feelings. But even the emotions of this hero are blunted and brutalized. . . . Rejection of coherent speech for mumbles, grunts, and physical gyrations is a symptom of this anarchy.[77]

Such quotations betray the traditional intellectual's considerable investment in the ideology of a mind/body dichotomy and reveal a deep distrust of physicality. Norman Podhoretz waxed greatest in paranoia when he called the culture of spontaneity "a vicious assault on the only protections we have against political and cultural barbarism," perpetrated by "young men who can't think straight and hate anyone who can." In the pages of the *Partisan Review*, he insisted over the objections of LeRoi Jones that:

> The "populism" of Kerouac's work is enlisted into the service of a violent anti-intellectualism and . . . "bop prosody" and the passion for jazz are weapons in the same cause. . . .
> There is a suppressed cry in these books: kill the intellectuals who can talk coherently, kill the people who can sit still for five minutes at a time.[78]

Amidst all the negative furor with which beat writing was received by the intellectual press, a few middlebrow writers lauded it as a strike against highbrow pretensions.[79] The beats shared the middlebrow's distrust of the ivory tower. Carl Solomon, once Allen Ginsberg's fellow patient at the Columbia Psychiatric Institute, later worked for the publishers of Ace paperbacks. Solomon predicted: "Big, new-critic professors are going to be washed away by the flood of honest amateur writers on GI Bills in writing correspondence courses who, until now, have

been frightened away . . . by the likes of Allen Tate, Partisan Review, my penmanship teacher, and the whole apparatus of stinking old-time capitalists. . . ."[80]

Solomon's enthusiasm was matched by the populist celebration of American folk culture in Kerouac's work. Describing Dean Moriarty, the hero of *On the Road*, Kerouac contrasted him to the intellectuals he knew:

All my other current friends were "intellectuals"—Chad the Nietz-schean anthropologist, Carlo Marx and his nutty surrealist low-voiced serious talk, Old Bull Lee and his critical anti-everything drawl. . . . But Dean's intelligence was every bit as formal and shining and complete, without the tedious intellectualness. And his "criminality" was not something that sulked and sneered; it was a wild yea-saying overburst of American joy.[81]

It was in an unsophisticated "fellaheen" culture of the West that Kerouac placed his hopes for the future of a democratic American society.

But most middlebrow writers pounced on spontaneous art as a vulnerable new manifestation of objectionable high-culture attitudes. While highbrow critics found the beats conformists, *Life* magazine, in keeping with its negative portrayal of highbrows, conversely called the beats "individualistic and antisocial to the point of neuroticism."[82] The *Chicago Tribune* likewise described the beatnik as a "complicated neurotic" who "hates the thought of the forty hour working week, of suburbia and its television antennae, of supermarkets and bowling leagues, of commuter trains and dry cleaning, of conformity and respectability."[83] Caroline Bird, writing in 1957 in *Harper's Bazaar*, similarly linked modern jazz with an egotistical nonconformity: "[The hipster's] main goal is to keep out of a society which, he thinks, is trying to make everyone over in its own image. . . . He takes marijuana because it supplies him with experiences that can't be shared with 'squares.'"[84]

Middlebrow critics would never concede the possibility that spontaneity had an internal logic they had not fathomed that was not directed at antagonizing "the squares." Like the "consensus" model of American politics that predominated in the 1950s,[85] their mind-set assumed that corporate liberalism defined the monolithic American way of life; and so they defined all alternative value systems as simply "nonconformity" or "deviance." This attitude encouraged them to conflate the avant-garde with other "nonconformists," including juvenile delinquents and foreigners. In *Life*, Paul O'Neil pointed to Kerouac's enthusiasm for "cheap Mexican tarts" and commented that William Burroughs had "rubbed shoulders with the dregs of a half dozen races."[86] Herb Caen of the San Francisco *Chronicle* coined the term "beatnik," associating the beats by implication with a diminutive Soviet satellite.[87] Popular magazines and

television shows portrayed San Francisco's North Beach as a den of deviants. One television movie in July 1959 portrayed beatniks robbing, torturing, and killing average Americans; real North Beach bohemians who tried for roles as extras were rejected as not looking authentic enough.[88]

The beatniks were nonetheless also cast, like highbrows in the popular press, as petty dictators and elitists. O'Neil called them "demagogues," commenting: "People just like them distributed pamphlets for the Communists in the 1930s, . . . and then as now thirsted cunningly for the off-beat cause which could provide them with some sense of martyrdom and superiority." He gleefully recounted how a true aristocrat, Dame Edith Sitwell, had humiliated Allen Ginsberg in an interview. ("My you *do* smell bad, don't you. What was your name again? Are you one of the action poets?")[89]

The middlebrow media also suggested that, like other highbrows, the beats were deficient in masculinity. When *Time* magazine reviewed *On the Road*, it emphasized the fact that Kerouac still lived with his mother. In *Life*, O'Neil also observed that Philip Lamantia lived "in fleabag hotels on money doled out by his widowed mother" and concluded, "[W]ho ever heard of rebels so pitiful, so passive, so full of childish rages and nasty, masochistic cries?" The beatniks, O'Neil asserted, for all their talk about good sex, enjoyed very little of the real thing, since the "scrawny" men had trouble attracting the "hostile little females" of the species.[90]

Defying what they perceived as a highbrow penchant for incomprehensible art, the mass-circulation magazines and newspapers made it clear that they would not be taken in by charlatans posing as avant-garde artists. In August 1949, *Life* magazine noted that Clement Greenberg, described as "a formidably highbrow New York critic," had proclaimed Jackson Pollock to be America's greatest painter. To the *Life* writer, Pollock was only a "puzzled looking man," and his art "nothing more than interesting, if inexplicable, decorations"; still other viewers, *Life* wrote, might consider Pollock's art "degenerate . . . as unpalatable as yesterday's macaroni." The accompanying description of Pollock's painting method was intended to make it sound ridiculous: it quoted a statement on automatism to suggest that Pollock admitted not knowing what he was doing. "After days of brooding and doodling," the writer concluded, with implied winks and nudges, "Pollock decides the painting is finished, a deduction few others are equipped to make." The review's sarcastic tone was aimed not only at Pollock, but at Greenberg and at highbrows in general.[91]

In the late fifties, similar views were espoused by John Canaday in the *New York Times*. Though Canaday was willing to concede merit to the most famous abstract expressionists, he derided the "freaks, the charlatans and the misled who surround this handful of serious and talented artists." He compared abstract expressionism to the paintings of Betsy the

ape at the Baltimore zoo, whose artistic experiments had recently been televised. His barbs were again directed equally at the artists themselves and at their highbrow advocates: the fault, he wrote, lay "quite directly with professors, museum men, and critics," who were too ready to indulge in "a blind defense of any departure from convention, including pretentious novelties."[92]

Charges of charlatanism were even more common in middlebrow treatments of the beats. The religion writer for *Time* magazine called them "a bunch of fancy-talking young bums." Admitting his ignorance of Zen Buddhism, he nonetheless declared their profession of Zen to be mere affectation.[93] Stuart Mitchner, a senior at Indiana University, wrote in the *Chicago Tribune* that beatnik poetry consisted of "worthless literary dissonance" equivalent to children's poundings on the piano. In his opinion, the beat generation was "a handful of nothing . . . freaks, loafers, and zombies . . . without talent or ambition."[94] *Life*'s Paul O'Neil also indulged in veiled antihighbrow invective, calling the beatniks "talkers, loafers, passive little con men, lonely eccentrics, mom-haters, cop-haters, exhibitionists with abused smiles and second mortgages on a bongo drum—writers who cannot write, painters who cannot paint. . . ."[95]

In some ways, the beats were able to turn such middlebrow attacks to their advantage. Allen Ginsberg achieved national prominence as the author of *Howl and Other Poems* only after the second printing of the book was seized by the San Francisco postal authorities as obscene. The obscenity trials of *Howl* in 1957 and of *Big Table* in 1958 brought some highbrow support for the beats against those who were perceived as the mindless enforcers of conformity. John Ciardi wrote concerning *Big Table* that while he was no admirer of Kerouac's "assaults on near prose," he felt compelled to take a stand against the "excessive literal-mindedness" of those postal inspectors who took it upon themselves to act as literary critics.[96]

Ginsberg followed up on this public relations victory by lobbying hard to create a "united front" of poets devoted to "cultural revolution." Ginsberg and Corso had set the wheels in motion in the autumn of 1956, by convincing Lawrence Ferlinghetti to mail copies of *Howl* to Lionel Trilling, Mark Van Doren, and Malcolm Cowley. Ginsberg began buttonholing editors at parties in New York in order to press for a joint poetry anthology, with the result that Donald Allen's anthology of *The New American Poetry* was published by Grove Press in 1960.[97]

THE "BEAT GENERATION"

By 1959, there were over three thousand Americans in the bohemian enclaves of Venice West, North Beach, and Greenwich Village pursuing versions of the spontaneous lifestyle.[98] According to social psychologist

Francis Rigney, who studied the North Beach community, the average age of this "beat generation" that year was twenty-seven. Younger than Allen Ginsberg and Helen Frankenthaler, they were born in the early years of the Depression; during World War II, they were in their early teens; some fought in Korea. A disproportionately large number (about half of the total) hailed from Jewish or Catholic backgrounds.[99]

Whereas highbrow and middlebrow observers like Anatole Broyard, Norman Mailer, and Caroline Bird suggested that nonconformity was the essence of the beatnik-hipster's existence, the beat writers themselves emphasized the continuities between themselves and the "squares." Their strategy of disclosing the social neurosis was far from a simple instance of "self versus society." As Francis Rigney observed: "[These] bohemians' behavior in many ways represents an exaggerated and prolonged version of the dynamics common to everyone . . . [displaying] open sexual or angry material that threatens the stabilized attitude systems and defenses of those ordinarily hiding *their own such impulses.*"[100]

Outside observers who conflated avant-garde practices with juvenile delinquency doomed themselves to understanding the culture of spontaneity as a mere reaction against the status quo, rather than as a positive cultural program. Kerouac, though, insisted that *On the Road* was meant to articulate a social vision distinct from "all this overlaid mental garbage of 'existentialism' and 'hipsterism' and 'bourgeois decadence.'"[101] The culture of spontaneity self-consciously maintained a cultural agenda opposed to both academic and mass culture. Both forms of the dominant culture, Ginsberg later explained, were predicated on a managerial ideology that encouraged psychological splitting.[102] As he told an interviewer: "The desensitization had begun, the compartmentalization of mind and heart, the cutting off of the head from the rest of the body, the robotization of mentality that could lead . . . supposedly realistic, mature, ripeminded academics to pursue a 1984-style cybernetic warfare."[103] Spontaneity's cultural challenge to this Cold War culture was founded on the principles of body-mind holism and intersubjectivity.

Yet how well does a sense of the obstacles imposed by the dominant culture explain the gap between this idealistic vision and the biographies of spontaneity's leading figures? Can Charlie Parker, Jack Kerouac, and Jackson Pollock, with their huge failures in human relationships, really be understood as advocates of intersubjectivity? How can their self-destructive drug abuse and alcoholism be reconciled with the tenet of body-mind holism? Rigney's study points to some answers.

The practice of spontaneity aimed to reconfigure authority by altering the accustomed patterns by which the ego controlled both the mind and the body. But in defying the discipline inherited through ideological conditioning, spontaneous artists skirted the abyss of psychological disinte-

gration. As Rigney described the bohemians' struggle for productive creativity:

> It is true that these men have strong intellectual and esthetic *interests*
> . . . But their enthusiasm burns out quickly; their work habits are erratic, and their artistic output irregular. . . . The six writers work only
> in spurts, as do the three painters. . . . The spurts are followed by
> grinding self-doubts, tensions, and drinking bouts; all work ceases for
> some when their symptoms become too severe and they have to be
> hospitalized. Seven have gone to mental hospitals, three of these have
> had shock treatments.[104]

The quest for behavioral guidelines rooted in intersubjectivity was similarly fraught with hazards. How, in every interaction, could the constructions of reality expressed by others be best reconciled with the subjective reality of one's own feelings and priorities? A North Beach respondent perceived such conflicting demands in one of Rigney's Rorschachs; he saw "[A] Couple of men taking things away from each other and realizing they're killing themselves by doing it. Their souls are joined but their bodies are not. Their bodies are separate, separately fed, separately kept alive."[105]

The difficulties of an intersubjective existence were compounded by the radical stance of bohemian subjectivity in relation to the dominant culture. This situation posed a puzzling contradiction. An intersubjective metaphysics asserts that we know reality and truth only by checking our experiences and our interpretations of experience against those of others. But cultural radicalism is predicated on the conflicting idea that some of the most widely held beliefs of others are illusions. Radical intersubjectivity therefore demanded a multivariable calculus of skepticism and trust that must have complicated human relationships beyond imagination. Rigney observed that his subjects considered communication extremely important and therefore, also, extremely difficult and dangerous.[106]

Critics perceived spontaneity's calculated abandon as a flight from social responsibility. But they expected responsibility to manifest itself in recognizable forms—in breadwinning, scholarly activity, or political organizing. Spontaneity's cultural pioneers could boast only less tangible achievements. In *The Real Bohemia*, Rigney acknowledged this conflict of perspectives by including a poem written by a poet known only as "Joy," addressed to conventionally "responsible" apologists like himself and entitled "To Sociologists and Publicists of the Beat Generation":

> peripheral man
> you're like a native who's gone tourist . . .
> sorry to say you miss the point

> these things are lived
> not sociologized. . . .
> write for the square
> you think you'll turn him on?
> you think it's worth it? man,
> . . . these no-inside beings who grab
> and take for granted
> who want all given to them
> and make nothing of it. . . .[107]

The last four lines here rehearse a roster of faults attributed by many observers to the beat generation itself. But Joy's poem uses them to describe "the square," inverting such critics' claims to a monopoly on social responsibility. At this point in Rigney's book, as in Ginsberg's poem, "America," it becomes a matter of perspective as to who is speaking truths about whom.

Into the Sixties

> The brainwashing will continue, tho the work be
> found acceptable, and people will talk as emptily
> about the void, hipness, the drug high, tenderness,
> comradeship, spontaneous creativity . . . as they
> have been talking about man's "moral destiny"
> (usually meaning a good job & full stomach & no
> guts and the necessity of heartless conformity . . .).
>
> —Allen Ginsberg, 1961

By 1960, the culture of spontaneity was poised to have a powerful impact on American society. It embodied a cohesive set of values distinctly divergent from the culture of corporate liberalism. Its tenets and practices offered a template for expressions of social dissent.

The spontaneous aesthetic had developed during World War II, in direct reaction against the narrowing scope of artistic and political possibilities within the corporate-liberal nexus. Despite the patriotic sentiments generated by the war effort, radical cultural change had seemed more than ever necessary, for the war suggested a profound pathology of Western civilization. This attitude gained new adherents twenty years later, as the prolonged Cold War led eventually to American involvement in Vietnam. The dominant culture continued to preach the panaceas of consumerism and technological progress. But a growing number of dissenters demanded a reorientation of cultural attention and a redistribution of social energies.

Though informed by a substantial intellectual tradition, the values advanced by the culture of spontaneity were embodied in arts emphasizing action and interaction, rather than in conventional intellectual forms. The content of the critique required this. The "ideogram," the "plastic palimpsest," and "spontaneous bop prosody" challenged both the liberal definition of the rational individual and the omniscient cachet of science.

Emphasizing intersubjectivity and body-mind holism, these forms suggested alternatives to the social and psychological arrangements on which corporate liberalism was based.

As we have seen, the path of the avant-garde toward defining these values had been neither single nor straight. At first, Charles Olson, Jackson Pollock, Adolph Gottlieb, and others, influenced by surrealism and Jungian psychology, endeavored to recreate the "primitive" worldview of "participation mystique." At a time when most Americans prided themselves on their expansive drive to master nature, these artists sought recognition for a world of powerful irrational forces. In their way, they combated the pervasive ethnocentrism of white America, acknowledging the wisdom of American Indian, African, and Asian cultures. As the decade of the forties progressed, this tendency was distilled into a fascination with the ideogram: a form of signification that linked participation mystique to the communicative capacity of picture-symbols which retained a "spatial" or "plastic" quality.

Though the notion of plasticity hinted at the important theme of body-mind holism, it was not until late in the forties that the "energy field" model of human experience brought this idea to the foreground of avant-garde practice. The aesthetic of spontaneity reached maturity in the arts of "plastic dialogue," including gesture-field painting, collage, and projective verse. The concept of the human body-mind as an event in a field of energy propelled poetry and painting in the direction of the performing arts, leading to new explorations in modern dance and in the Zen art of clay pottery.

Bebop jazz musicians had pioneered this terrain of performance, developing the musical equivalent of plastic dialogue while reasserting the African American roots of their music. Bebop emphasized improvisational solos within a group dynamic, and explored new complexities of rhythm, phrasing, and tone in order to increase the expressiveness of those solos as utterances of pure prosody. The beat writers adapted these elements of bebop in their literary work. Their poetry readings, like bop jam sessions, relied on an "oral" bias of attention, underlining the social value of authentic, face-to-face contacts.

The authentic voices of the avant-garde, however, were persistently garbled by the way they were framed in highbrow and middlebrow discourse. Perhaps this was inevitable, since the work purposely defied explication. Dwight Macdonald, justifying the avant-garde program in his essay "The Root Is Man" of 1946, had acknowledged the law of the "inverse ratio" of truth to communicability: the more authentic the version of truth one tried to communicate, the less likely it was to be communicated intact.[1]

This law held true as the culture of spontaneity was transformed into

the sixties counterculture. In the sixties, the principles of intersubjectivity and body-mind holism informed diverse countercultural beliefs and practices, including tribalism, nudism, environmentalism, pacifism, drug use, and open sexuality. But the culture of spontaneity was significantly recast as it was popularized, politicized, and rebelled against in its turn.

FORMALISM AND IRONY

As late as 1950, abstract expressionism still defined an upstart faction among American modernist painters. In that year, eighteen abstract expressionists—including Jackson Pollock, Adolph Gottlieb, Willem de Kooning, Robert Motherwell, Richard Pousette-Dart, Bradley Walker Tomlin, Theodoros Stamos, Barnett Newman, and James Brooks—boycotted a juried national exhibition at the Metropolitan Museum of Art because of the presumed hostility of the judges to their work. Their open letter to the president of the museum earned them the nickname of "the Irascibles" from the *New York Herald Tribune*.[2]

But in the world of mass media, as abstract expressionists discovered, even bad reviews make good publicity. *Life* magazine's satirical articles on Jackson Pollock (1949) and the Irascibles (1950) contributed to a growing public curiosity about abstract expressionism. Museums and wealthy collectors took note. In 1951, the Eighth Street Club's Ninth Street Show in New York and the "School of New York" show organized by Robert Motherwell for the Perls Gallery in Beverly Hills were pivotal in creating the reputation of gesture painting as the "new American" style. The next year, Harold Rosenberg's essay "The American Action Painters" made an existentialist reading of abstract expressionism available to intellectuals, supplementing Clement Greenberg's perpetually supportive reviews in the *Nation*. By the mid-1950s, gesture-field painting had become accepted among the taste-makers to such an extent that it indeed began to seem like a new national style.[3]

Among a new generation of painters, however, gesture-field painting easily degenerated into a set of mere formal principles. Their use of the techniques explored during the 1940s did not necessarily imply a grasp of the logic that had brought painting to that point within a different historical context. Hans Hofmann's art classes, which were attended by most of the younger generation of the "New York school," helped to propagate a purely formal understanding of abstract expressionist techniques. Larry Rivers has written that he studied with Hofmann for years without gaining any real understanding of what "plasticity" meant.[4] Predictably, the increasing commercial success that accompanied the form's acceptance by the art establishment compounded the problem of imitativeness.

The formal triumph of gesture-field painting lay in its capacity to translate issues of broad social significance into problems internal to the act of painting. A radical conception of human subjectivity was embodied in the process of composition itself, enabling painters to produce works in which personal expression and cultural critique were condensed onto the single act of painting. As Jack Tworkov described this link between the formal and ethical dimensions of his painting: "Esthetic judgment concerns itself with one question: 'What is true, what is false?'"[5] Most painters of the first generation understood implicitly what was at stake, and were glad to be able to attach their pointedly nonverbal grasp of experience to a formal vocabulary that they could discuss without embarrassment and without reference to a bulky intellectual apparatus.[6]

But this triumph of closure was itself also a source of weakness. With metaphysical, psychological, and formal issues condensed one upon the other, there could be no certainty that the viewers—or even the creators—of this art were operating on all three levels. By 1958, the appropriation of the plastic palimpsest for a variety of uses, from Cold War cultural exchanges to advertising, had significantly altered the meanings that it carried. As gesture-field painting became more familiar to the American public in these contexts, it no longer generated the emotional impact that had accompanied its first appearances and that might have impelled an understanding of it on other, more radical grounds. Whether it could continue to function as a viable form of communication once control over its meaning had been lost in this way was a topic of intense debate among artists.[7]

In 1953, Jackson Pollock himself abandoned the gestural pouring technique that had come to epitomize the form. With his ambition to define the cutting edge of American art still unabated, Pollock was searching for a way out of the blind alley of self-repetition and even self-parody to which his style seemed to have condemned him. The frustrations and insecurities attendant upon his inability to develop a satisfactory new style led to his relapse into alcoholism, culminating in his early death in 1956.[8] Pollock was not the only one who felt this frustration, although he manifested it most dramatically. Jack Tworkov also commented: "By the end of the fifties I felt that the automatic aspect of abstract expressionist painting of the gestural variety . . . had reached a stage when its forms had become predictable and repetitive."[9]

Partly as a result of this formalization, many younger artists felt a need to rebel against the predominance of gesture-field painting in order to develop their own painterly visions. As a vehicle for expressing subjectivity, the form had ceased to be useful. As Grace Hartigan recalled of her own attitude during the 1950s: "I began to get guilty for walking in and freely taking their form . . . [without] having gone through their struggle for

content, or having any context except an understanding of formal quali-
ties. . . . I decided I had no right to the form—I hadn't found it myself."[10]
For Hartigan, Larry Rivers, and other painters who turned away from ab-
stract expressionism, a return to figurative representation in "gestural re-
alism" provided the means to a new artistic vocabulary.

The birth of gestural realism implied something more than a genera-
tional imperative to originality. It connoted a shift in the artists' concep-
tion of the social role of art. Gestural qualities attested to a continuing
belief in the primacy of subjective experience. But figurative subjects
evinced a turn away from metaphysics as the ground on which art was to
engage society. Gestural realism engaged society on the more topical level
of public myth. It was a return to history painting of a kind, with the em-
phasis now placed on questioning or undermining national myths rather
than on constructing them.[11] Its intent was to subvert the very process of
mythmaking—as epitomized in Larry Rivers's *Washington Crossing the
Delaware*, a reinscription of Emanuel Leutze's famous 1851 painting on
the same topic (fig. 11.1). In keeping with this attitude, gestural realists
greeted the abstract expressionists' own self-mythicizing with a similar
degree of irony. Gestural realism did not abandon the cultural project of
the postwar avant-garde, but redirected it toward more topical concerns
and did not reject the ironic mode.

Robert Rauschenberg's attack on the intersubjective claims of "plastic
dialogue" struck more directly at the heart of gesture-field painting. In
1957, Rauschenberg painted the series *Factum I* and *Factum II*. One was a
spontaneous gestural collage. The other was a careful reproduction of the
first. The two were virtually indistinguishable.

By the mid-fifties, Rauschenberg, schooled at Black Mountain College,
had come to suspect the emotionalism, philosophizing, and "projecting
of the unconscious onto canvas" that characterized the art of his men-
tors.[12] It was something of a scandal among insiders when Franz Kline,
under Willem de Kooning's tutelage, began using a Bell-Opticon projec-
tor to enlarge small, spontaneous sketches, which he painstakingly repro-
duced to create monumental "gestural" abstractions.[13] *Factum I* and
Factum II challenged gesture-field painting's premise that the subjective
experience and psychic energy of the artist were being communicated di-
rectly to the viewer through a plastic and sensual medium. If the domi-
nant culture's appropriations of abstract expressionism demonstrated the
fallacy of this premise from outside the movement, such re-presentations
as Kline's enlargements falsified it from within.

Through *Factum I* and *Factum II*, Rauschenberg unequivocally as-
serted the nonidentity of the artistic and aesthetic processes: either of
these two works viewed in isolation would presumably elicit nearly the
same aesthetic response, though the two resulted from radically different

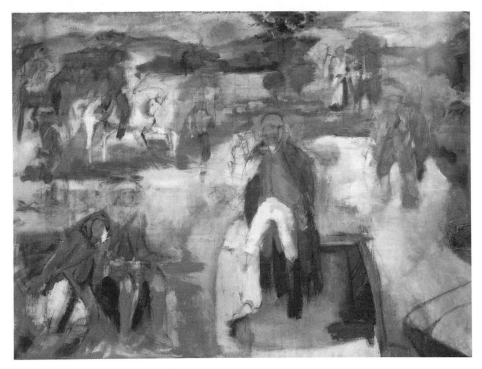

11.1. Larry Rivers, *Washington Crossing the Delaware*, 1953

acts of artistic creation. Into this gap between the artistic and the aesthetic flowed a sea of irony—irony that was no longer simply an option that could be chosen or rejected, but irony that had to be admitted as an unavoidable aspect of all communication.

Fortunately for the proponents of abstract expressionism, Rauschenberg's challenge did not amount to a total refutation. To demonstrate that the gesture-field form could be used in a deception was not the same as proving it incapable of telling the truth. It is significant that the first *Factum* preexisted its copy, as Kline's small drawings preexisted their larger incarnations. The spontaneous gesture remained, even in these works, the basis of artistic expression and the source of a potential for authentic communication. *Factum I* and *Factum II* did not yet deal in the mechanistic simulacra of pop art, in which the possibility for authentic communication was problematized beyond recovery.[14] Nevertheless, Rauschenberg's work made it clear that the painters of gestural palimpsests would have to relinquish all claims to working in a medium that was not susceptible to the same falsifications of experience to which print culture and the mass media were liable.

The growing sense that art's impact on the viewer or audience had little relation to the intentions of the artist lent strength to a late-fifties neo-dadaist movement against the communication of subjective experience through art. One of the main influences in this direction was John Cage, whose musical philosophy was heavily indebted to the Zen Buddhist teachings of Daisetz Suzuki. Cage used a variety of methods to circumvent any conscious or unconscious communication of his own subjectivity through his music.[15]

Cage had gathered a number of second-generation abstract expressionist painters to him when he taught at Black Mountain College in the early 1950s.[16] If half of Robert Rauschenberg's artistic sensibility followed the lead of gesture painters like Willem de Kooning and Franz Kline, the other half resonated to the music of John Cage.[17] Rauschenberg's blank *White Paintings*, from 1951, formed the painterly equivalent of John Cage's *4′33″*, a musical composition in which the pianist remained silent so that incidental noises from the audience and surroundings became, themselves, the "music." In both, the cachet of art was used simply as a framing device to entice viewers and audiences into an aesthetic awareness of their own everyday reality.

Within the culture of spontaneity, the imperative to communicate authentic human experience made subjective expression seem both important and difficult. By contrast, Cage asserted that nothing of importance could be communicated; art could at best stimulate the senses of the viewer or listener, and the less it delivered of an anticipated "communication," the better. "Composing's one thing, performing's another, listening's a third," he wrote; "What can they have to do with one another?"[18] Thus Cage made a principle of the ironic gap between artist, art, and audience that the culture of spontaneity had sought to foreclose. Summarizing his position for Julian Beck and Judith Malina, cofounders of the Living Theatre, Cage wrote in 1952:

$$
\begin{array}{ll}
& \text{instantaneous} \\
& \text{and unpredictable} \\
\end{array}
$$

nothing is accomplished by writing a piece of music $\left.\begin{array}{c} \\ \\ \\ \end{array}\right\}$ our ears are
" " " " hearing " " " " now
" " " " playing " " " " in excellent
condition[19]

The conviction that artistic and aesthetic experiences were not intrinsically matched affected avant-garde practices in every medium. The issue divided the beat writers when in September 1959, William Burroughs began slicing up old issues of *Time* and *Life* magazines, advocating this chance "cut-up" technique as a method of composition that eluded sub-

jectivity. Gregory Corso, who believed that the subjective imagination was the proper basis of poetry, became furious when Burroughs cut up some of his (Corso's) poems.[20] Kerouac reacted similarly, calling the cut-up "just an old Dada trick" and insisting in an interview for the *Paris Review* that the true role of art was the integration of conscious and unconscious levels of experience.[21] Nevertheless, LeRoi Jones wrote in 1961 to the editors of the *Evergreen Review*, in answer to Kerouac's "Essentials of Spontaneous Prose":

> [T]he pure ecstatic power of the creative climax can never be the reader's; even though he has traced and followed frantically the writer's steps, to that final "race to the wire of time." The *actual* experience of this "race" is experienced *only* by the writer, whose entire psyche is involved and from whence the work is extracted. . . . the reader is finished, stopped, but his mind still lingers, sometimes frantically, between the essential and the projected.[22]

By the early sixties, Jones had torturously concluded that it was useless to expect that a work of literature could fully communicate the author's emotional reality.

The "New York poets" of Jones's generation were more comfortable than he with this conclusion. In their taste for irony and aphorism, the New York poets, including Frank O'Hara, John Ashbery, James Schuyler, and Kenneth Koch, were closer in sensibility to the proponents of the New Criticism, although they did not burden their works with the restrictive forms and diction of academic poetry. It makes sense that the second generation of "New York school" painters, with their own heightened sense of irony, associated more with these New York poets than with their Black Mountain, San Francisco, or beat counterparts.

The New York poets defied the earnest tone of spontaneity with their cosmopolitan irony and wit. Frank O'Hara's "Personism" essay of 1959, for instance, was a mock manifesto in which he alluded disparagingly to the self-importance of poetic theorists like Charles Olson and Allen Ginsberg, writing, "I don't even like rhythm, assonance, all that stuff." Concerning the problem of artistic communication, O'Hara was equally glib: "How can you really care if anybody gets it, or gets what it means, or if it improves them. Improves them for what? . . . Too many poets act like a middle-aged mother trying to get her kids to eat too much cooked meat . . . I don't give a damn whether they eat or not." Regarding the avant-garde's self-appointed duty to expand Americans' consciousness, O'Hara remarked, "Nobody should experience anything they don't need to." A poem, he suggested, should have the immediacy and direct communicative power of—a telephone call.[23]

The whimsical, ironic tone of O'Hara's work is captured in such poems

as "A Pleasant Thought from Whitehead." The title itself, alluding to the speculative philosophy that influenced projective verse and abstract expressionist painting, is mocking in its refusal to take the entire theoretical apparatus more seriously than as the source of "a pleasant thought." The poem pokes fun at Whitehead's idea of communication as an intersection of events in space-time, and at the dreams of cultural transformation that the avant-garde located there:

> Ah!
> reader! you open the page
> my poems stare at you you
> stare back, do you not? my
> poems speak on the silver
> of your eyes your eyes repeat
> them to your lover's this
> very night. Over your naked
> shoulder the improving stars
> read my poems and flash
> them onward to a friend.
>
> The eyes the poems of the
> world are changed! . . .[24]

Like Robert Rauschenberg's *Factum* paintings, O'Hara's poems challenged avant-garde assumptions about the link between technique and content. The poetry of the New York School poets was spontaneous and subjective, but it lacked the radical impetus that these qualities were supposed to ensure. Instead, it focused lyrically on quotidian events in the poets' daily lives. As Philip Auslander has observed, "the Existentialist thrust of Action painting, the sense that the painting is of the same metaphysical substance as the artist's existence, is not present in New York School poetry."[25] It would be a short step from the neodadaism of Rauschenberg and the irony of O'Hara to the simulacra and "put ons" of Andy Warhol's pop art factory.[26]

Sixties Countercultures

While many avant-garde painters, musicians, and writers were distancing themselves from the ideas and practices that defined spontaneous art, elements of the spontaneous style were becoming definitive characteristics of a widespread youth movement. As Allen Ginsberg noted,

> The stylistic attributes were picked up by later generations—that is to say spontaneous speech, the use of . . . marijuana and psychedelics, the preoccupation with American Indians, the second religiousness

that Kerouac spoke of (the phrase being Spengler's), the interest in black music or the sense of a Fellaheen subterranean underground nonofficial existence.[27]

At the request of his publishers, Jack Kerouac had followed up on the success of *On the Road* with another popular novel, *The Dharma Bums*, which introduced his readers to the San Francisco poets and their lifestyle. Like *On the Road*, *The Dharma Bums* was a how-to book, this time filled with descriptions of *Kama Sutra* sex, haiku poetry, Zen-Buddhist backpacking, and the attitudes of San Francisco poet Gary Snyder (introduced as the character Japhy Ryder). In *The Dharma Bums*, Kerouac presented Zen Buddhism as a joyful alternative to the "suburban ideal . . . and general dreary gray censorship of all our real human values."[28] He predicted a mass movement against the cultural imperatives of corporate liberalism, calling for a generation who would transform American society by rejecting the cult of affluence:

> refusing to subscribe to the general demand that they consume production and therefore have to work for the privilege of consuming all that crap they didn't really want anyway. . . . I see a vision of a great rucksack revolution, thousands or even millions of young Americans wandering around with rucksacks. . . . all of 'em Zen lunatics who . . . by being kind and also by strange unexpected acts keep giving visions of eternal freedom to everybody.[29]

Here was an idealistic blueprint for the hippie counterculture, a literary precursor of Timothy Leary's "Turn on, tune in, and drop out."[30]

When the counterculture developed in the mid-1960s, its music was not the modern jazz that Kerouac loved, however; it was rock. "Rock" developed in the mid-sixties as a hybrid of folk music and rock-and-roll.[31] The latter was in a sense a musical half-brother to bebop, for it was rooted in the "jump" music that grew out of swing, blended with the lyrics and instrumentation of electric rhythm-and-blues. Rock brought rock-and-roll together with the post-1957 folk revival that had become the sound of the civil rights movement and antiwar activism.[32] The combination created a sound that was shared by musicians as diverse as Bob Dylan, the Lovin' Spoonful, the Byrds, Buffalo Springfield, the Fugs, and Jimi Hendrix.[33]

As a musical expression of countercultural tendencies, rock boasted three sources of popular appeal that bebop jazz had lacked. One was the power of identification provided by song lyrics.[34] Bebop musicians had mostly avoided lyrics in order to communicate with the immediacy of pure prosody. Rock combined lyrics with prosodic soloing, sacrificing much of bebop's conversational dynamic but gaining the opportunity to

deliver a verbal message. Second, rock was a music intended for dancing as well as for listening. In bebop, improvisational gestures of the body-mind were available almost exclusively to the musicians; but danceable rock music offered audiences the opportunity to get in on the act. Finally, electrical amplification and tighter formats made rock music more compatible with the production and marketing techniques of the mass-culture music industry.[35] This enabled rock to become the musical voice of a mass movement, although it also diffused much of its potential radicalism through commodification.

Although rock was not the music that had originally developed in conjunction with the culture of spontaneity, in many ways it partook of the spontaneous aesthetic. Rock lyrics were often written as spontaneous poetry, as with Bob Dylan's 1965 underground classic, "Subterranean Homesick Blues."[36] When people danced to rock, it was a form of group improvisation, if not exactly in the style of Merce Cunningham.[37] In the California "acid tests," the Grateful Dead developed a rock performance style emphasizing group improvisation. Spontaneous sound-and-light shows that were designed to be experienced while high on LSD, the acid tests were engineered by Ken Kesey and his Merry Pranksters—among whom was Neal Cassady, erstwhile hero of Kerouac's *On the Road*.[38] Rock was also an important element of "happenings" like the Gathering of the Tribes for the First Human Be-In. At this event in 1967, twenty thousand hippies gathered in San Francisco's Golden Gate Park to smoke marijuana, drop acid, and listen to (among others) Allen Ginsberg, Michael McClure, Gary Snyder, Jerry Rubin, the Jefferson Airplane, Country Joe and the Fish, the Grateful Dead, and Janis Joplin with Big Brother and the Holding Company.[39]

Historians have justifiably emphasized the differences between the hippie counterculture and the 1960s student Left. The Students for a Democratic Society (SDS) was inspired primarily by the civil rights movement in the South. Its leaders were committed to an organized engagement with specific social and political issues. Their methods were at odds with the hippies' rejection of the normal forms of discipline and authority. As Todd Gitlin has recounted, when Ken Kesey was invited by organizers to speak at the 1965 Vietnam Day teach-in on the campus of the University of California at Berkeley, he

> showed up in Day-Glo regalia, sized up the crowd and the bombastic speakers as some kind of ego-clamoring fascist rally, and announced that "you're not gonna stop this war with this rally, by marching. . . . That's what *they* do," marching was *their* game, whereupon he honked a chorus of "Home on the Range" with his harmonica, a back-woods American boy to the end, and told the fifteen thousand antiwarriors

the only thing that would do any good was to "look at the war, and turn your backs and say . . . Fuck it." This was not what the organizers wanted to hear on the verge of a march into fearsome Oakland to confront the army base.[40]

But the New Left had links to the postwar culture of spontaneity beyond the obvious existentialism of Martin Luther King, Jr.[41] Gitlin has acknowledged that many members of the movement smoked marijuana.[42] Tom Hayden, a founder of the New Left, read *On the Road* when he graduated from high school in 1957. Over the next three years, he emulated Kerouac's Sal Paradise, hitchhiking across the country and writing his own short story about a "journey into an emotional and intellectual wilderness" in search of social values beyond careerism.[43]

The common heritage that SDS shared with the counterculture was prominent in Hayden's "Port Huron Statement" of 1962, a definitive articulation of New Left values. Enumerating the "paradoxes" of modern American life, the statement called for a recovery of authentic human relations and for the establishment of a decentralized, participatory democracy of the sort precluded by the liberal establishment.[44] In a separate speech, Hayden demanded that American universities encourage

> a quality of mind that is not compulsively driven . . . nor one which represses threats to its habits, but one which has full, spontaneous access to present and past experience, one which easily unites the fragmented parts of personal history, one which openly faces problems which are troubling and unresolved. An intuitive alertness to that which is capable of occurring, to that which is not yet realized, and a passion for the continuous opening of human potential. These are the qualities—the weapons—that might unravel the heavy cape of impotence, the qualities that might restore the dominance of human over functional responsibilities and bring to men once more the will and the ability to exert real influence over events as citizens.[45]

At the same time, he called for a system of higher education founded on intersubjectivity rather than on objectivity:

> A really excellent university, I believe, would not be organized along corporate and authoritarian lines, but in a way that would truly activate the creative potential of students and faculty. . . . [A]s there can be no final unamendable Truth in a community of free inquiry, there can be no arbitrary authority structure for the relation of teacher and student.[46]

Like the culture of spontaneity, the New Left attempted to rehabilitate the physical body and its emotions as guides to social behavior. In "A Let-

ter to the New (Young) Left," Hayden called for a return of emotions to politics.[47] Mario Savio, as the spokesperson of the Berkeley Free Speech Movement, also condemned the "depersonalized" politics of the corporate-liberal bureaucracy.[48] Savio cast the cause of the New Left as a struggle of the body against the machine: "There is a time when the operation of the machine becomes so odious, makes you so sick at heart, that you can't take part; . . . you've got to put your bodies upon the gears and upon the wheels, upon the levers, upon all the apparatus and you've got to make it stop.[49]

Consonant with this emphasis on the role of the body, the New Left insisted, as spontaneous artists had, that ideas emerged from actions, not the other way around.[50] In 1967, the New Left united with the hippies for a march on the Pentagon that led Norman Mailer to describe New Left politics as a kind of spontaneous theater. Mailer wrote:

> If the march did more or less succeed, one knew it would be as a result of episodes one had never anticipated, and the results might lead you in directions altogether unforeseen. . . . One did not march on the Pentagon and look to get arrested as a link in a master scheme to take over the bastions of the Republic step by step, no, that sort of sound-as-brickwork-logic was left to the FBI. Rather, one marched on the Pentagon because . . . because . . . and here the reasons became so many and so curious and so vague, so political and so primitive, that there was no need, or perhaps no possibility to talk about it yet. . . . [P]olitics had again become mysterious. . . . belief was reserved for the revelatory mystery of the happening, where you did not know what was going to happen next; that was what was good about it.[51]

If the student radicals invested action with intellectual authority, however, they were less impressed with the "action painters" than with the revolutionary actions of Fidel Castro and Che Guevara.[52] Perhaps it was this preference for organized insurgency over dialogue that inscribed their movement's limitations, portending the eventual disintegration of the student Left into violent splinter groups like the Weathermen. In the sixties, though, even avant-garde artists felt the tidal pull of politics, as the broadening political spectrum held forth the promise of immediate social relevance.

As LeRoi Jones became disillusioned with the avant-garde dream of social change through art, he too began to seek a middle ground between cultural and political revolution. After a visit to Castro's Cuba in 1960, Jones wrote in two letters to Charles Olson:

> CUBA LIBRE! Just returned couple days ago from Havana & rest of green-land. Marvelous . . . everything there. What those people do

. . . are doing. Despite all bullshit of rotting colossus del norte.

. . . [N]ow my "work," the real part, is taking me somewhere, in my thinking, at least, that I've never been. Someplace that is, I think, violently positive for me. Some kind of break-OUT, at least.[53]

In the forties and fifties, as William Harris has argued, projective verse and beat jazz prosody had mapped out for Jones "a circuitous route back to blackness, back to self, back to a sense of individual and racial identity."[54] But by 1960, Jones was becoming aware of the limitations of the spontaneous aesthetic. In the coming years, he would reject the bohemian counterculture in favor of black nationalism and Black Power militancy.[55] As abstract expressionism gave way to pop art, rock overshadowed jazz, and a youth counterculture transformed beats into hippies, LeRoi Jones moved to Harlem and renamed himself Imamu Ameer Baraka.

N o t e s

INTRODUCTION

1. In writing of the culture of spontaneity, I am aware that the term "culture" has been defined in many ways. I use the term in a sense derived from anthropology, to refer to (1) a coherent set of practices, (2) the beliefs and values structuring those practices, and (3) the material artifacts of those practices. But the "culture of spontaneity" constituted a less self-sufficient system than anthropologists usually address: the creators, viewers, and audiences of spontaneous art were only partially outside the larger "American culture." The title of this book also plays on the word "culture" to suggest "cultivation," and the paradox that spontaneity is an art that improves with practice.

2. See Philip Gleason, "Americans All: World War II and the Shaping of American Identity," *Review of Politics* 43:3 (July 1981): 483–518.

3. The New Criticism in America was represented by the critical writings of, among others, Allen Tate, John Crowe Ransom, and Lionel Trilling. The contemporary poets these scholars championed included Robert Lowell, Karl Shapiro, Elizabeth Bishop, and Randall Jarrell. (See Mary Emma Harris, *The Arts at Black Mountain College* [Cambridge, MA: MIT Press, 1987], 196.) The academic voice of the New Critics predominated in the *Hudson, Sewanee,* and *Kenyon Reviews.* The "new literature" was described by Malcolm Cowley in *The Literary Situation* (New York: Viking, 1954). An excellent example of this type of writing is Flannery O'Connor's *Wise Blood* (New York: Farrar, Straus, and Giroux, 1949), in which wartime dislocation is re-encoded as spiritual test. See also Reinhold Niebuhr, *The Children of Light and the Children of Darkness* (New York: Scribner's, 1944).

4. I mean politics in the broadest sense, as working to influence the distribution of power and resources within society. The aesthetic of spontaneity was ideologically counterhegemonic.

My use of the concept of cultural hegemony derives from Antonio Gramsci, particularly through Stuart Hall's essay "Gramsci's Relevance for the Study of Race and Ethnicity," *Journal of Communication Inquiry* 10:2 (Summer 1986): 5–27. From Raymond Williams, I have taken the useful concept of the cultural formation, a group of people engaged in a common cultural enterprise and sharing a common social context shaping that enterprise. See Williams, *The Sociology of Culture* (New York: Schocken Books, 1981). I have also made extensive use of Fredric Jameson's concep-

tion of the dialectical interaction of social conditions and cultural forms, as set forth in *The Political Unconscious: Narrative as a Socially Symbolic Act* (Ithaca: Cornell University Press, 1981).

5. Ann Farber, quoted in Matthew Rohn, *Visual Dynamics in Jackson Pollock's Abstractions* (Ann Arbor: UMI Research Press, 1987), 118.

6. Ibid.

7. Paul Zumthor, *Oral Poetry: An Introduction*, Kathryn Murphy-Judy, trans. (Minneapolis: University of Minnesota Press, 1990), 131.

8. On the evolution of corporate liberalism, see James Weinstein, *The Corporate Ideal in the Liberal State: 1900–1918* (Boston: Beacon Press, 1968), especially p. xiv. Barnett Newman in 1962 used the term "state capitalism"; see David Craven, "Abstract Expressionism, Automatism, and the Age of Automation," *Art History* 13:1 (March 1990): 72. See also Warren Susman, "Toward a History of the Culture of Abundance," *Culture as History: The Transformation of American Society in the Twentieth Century* (New York: Pantheon, 1984), xix–xxx.

9. See Samuel Haber, *Efficiency and Uplift: Scientific Management in the Progressive Era* (Chicago: University of Chicago Press, 1964).

10. George Lipsitz, *Class and Culture in Cold War America: A Rainbow at Midnight* (South Hadley, MA: Bergin and Garvey, 1982), 5–8. See also Herbert Hoover, *American Individualism* (Garden City, NY: Doubleday, Page and Co., 1922).

11. See Alan Brinkley, *Voices of Protest* (New York: Vintage, 1982).

12. See Steve Fraser, "The 'Labor Question,'" and Nelson Lichtenstein, "From Corporatism to Collective Bargaining: Organized Labor and the Eclipse of Social Democracy in the Postwar Era," in Fraser and Gary Gerstle, eds., *The Rise and Fall of the New Deal Order, 1930–1980* (Princeton: Princeton University Press, 1989), 55–84 and 122–52. In my opinion, Alan Brinkley, in *The End of Reform: New Deal Liberalism in Recession and War* (New York: Knopf, 1995), misrepresents the triumph of corporate liberalism by framing it as "a process of adjustment and redefinition . . . the result of countless small adaptations to a broad range of experiences" (pp. 14 and 269), rather than as the political victory of its proponents over those advancing competing ideologies.

13. Lipsitz, *Class and Culture*, 3–4.

14. See C. Wright Mills, "The Structure of Power in American Society," in *Power, Politics, and People* (New York: Oxford University Press, 1963), 23–38.

15. See Richard Edwards, *Contested Terrain: The Transformation of the Workplace in the Twentieth Century* (New York: Basic Books, 1979), 130–62.

16. Henry Luce, *The American Century* (New York: Farrar and Rinehart, 1941), 30, 32–33, 37–38.

17. Marshall McLuhan, "The Psychopathology of *Time* and *Life*," *Neurotica* 5 (Autumn 1949): 5–16. All citations in this paragraph are from this source.

18. Ronald Sukenick, *Down and In: Life in the Underground* (New York: Beech Tree Books, 1987), 17.

19. Throughout this work, I use the term "avant-garde" only loosely, to refer to this cultural formation of artists and writers who collectively articulated the theory of spontaneity and embodied it in artistic forms. Many of the Americans who shared in this project took exception to the use of the term "avant-garde" to describe their work, deploring its European cachet and its implication of innovation for innova-

tion's sake. Yet among two generations of artists and writers born roughly between 1910 and 1925, there developed a discourse of spontaneity that has been of lasting significance to American culture. Their consuming interest in anthropology and in ideas of a "collective unconscious" was balanced on the cusp between a modernist exploration of individual consciousness and a postmodernist exploration of cultural conventions; and between a modernist quest for universal values and a postmodernist insistence on the contextuality of meaning.

A previous generation of avant-garde artists had developed in America during the first years of this century. Alfred Stieglitz, who was a patron of Gertrude Stein, founded the Little Galleries of the Photo-Secession, or "291" (for 291 Fifth Avenue, its address) in 1905. Poets of his generation, for whom the Armory Show of 1913 was something of a revelation, included Alfred Kreymborg, Wallace Stevens, William Carlos Williams, Mina Loy, and Max Bodenheim. See Bram Dijkstra, *The Hieroglyphics of a New Speech: Cubism, Stieglitz, and the Early Poetry of William Carlos Williams* (Princeton: Princeton University Press, 1969); and Dickran Tashjian, *Skyscraper Primitives: Dada and the American Avant-Garde, 1910–1925* (Middletown, CT: Wesleyan University Press, 1975).

20. I use "metaphysics" in the technical sense, to mean an ontological and epistemological theory.

21. For a longer discussion of these distinctions, see the entries "Enlightenment" and "Romanticism" in Paul Edwards, ed., *The Encyclopedia of Philosophy* (New York: Macmillan and the Free Press, 1967).

22. Throughout this work, I use the word "discourse" to mean a conversation or debate, conducted through a variety of media and texts, that develops into a body of "knowledge" and/or an attitude about the world.

23. For a related viewpoint, see Alice Walker, "In Search of Our Mothers' Gardens," in *In Search of Our Mothers' Gardens: Womanist Prose* (San Diego: Harcourt Brace Jovanovich, 1983).

24. See Russell Jacoby, *The Last Intellectuals: American Culture in the Age of Academe* (New York: Basic Books, 1987).

25. See the introduction to Christopher Lasch, *The New Radicalism in America: The Intellectual as a Social Type, 1889–1963* (New York: Alfred A. Knopf, 1966).

26. Despite the significance of the spontaneous aesthetic in postwar American life, treatments of this movement in current histories are far from adequate. W. T. Lhamon's *Deliberate Speed: The Origins of a Cultural Style in the American 1950s* (Washington: Smithsonian Institution Press, 1990) attempts a synthetic treatment of this material, but his work lacks a grasp of the cultural logic that made "sense" of the "style." As a result, the book is fated to become a hodgepodge, in which the "deliberate speed" of the Supreme Court's ruling in *Brown v. Board of Education* is loosely equated with the deliberate speeding of beat writers down the road and across the page. Other works, like John Patrick Diggins's *Proud Decades: America at War and Peace, 1941–1960* (New York: Norton, 1988); and William Graebner's *The Age of Doubt: American Thought and Culture in the 1940s* (Boston: Twayne, 1991), do not exhibit any grasp of the social vision that distinguished the art and literature of spontaneity from both the academic high culture and the popular mass culture of the period.

27. Ann Gibson, "Theory Undeclared: Avant-Garde Magazines as a Guide to Ab-

stract Expressionist Images and Ideas" (Ph.D. diss., University of Delaware, 1984). David Craven, "Abstract Automatism, Automatism and the Age of Automation," *Art History* 13:1 (March 1990): 72–103. Craven, "Abstract Expressionism and Third World Art: A Post-Colonial Approach to 'American' Art," *Oxford Art Journal* 14:1 (1991): 44–66. Michael Leja, *Reframing Abstract Expressionism: Subjectivity and Painting in the 1940s* (New Haven: Yale University Press, 1993). Also Stephen Polcari, *Abstract Expressionism and the Modern Experience* (New York: Cambridge University Press, 1991).

28. See T. J. Clark, "Clement Greenberg's Theory of Art"; and Michael Fried, "How Modernism Works: A Response to T. J. Clark," *Critical Inquiry* 9:2 (Sept. 1982).

29. T. J. Clark, "Jackson Pollock's Abstraction," in Serge Guilbaut, ed., *Reconstructing Modernism: Art in New York, Paris, and Montreal, 1945–1964* (Cambridge, MA: MIT Press, 1990), 180, quoted in Leja, *Reframing,* 9.

30. Clark, "Clement Greenberg's Theory of Art," 149, 151, 153–54. Serge Guilbaut, *How New York Stole the Idea of Modern Art: Abstract Expressionism, Freedom, and the Cold War,* Arthur Goldhammer, trans. (Chicago: University of Chicago Press, 1983).

31. Fried, "How Modernism Works," 223, 228.

32. See Hayden White, *Tropics of Discourse: Essays in Cultural Criticism* (Baltimore: Johns Hopkins University Press, 1978), 4–5.

33. See Kenneth Burke, "Literature as Equipment for Living," in *The Philosophy of Literary Form: Studies in Symbolic Action* (Baton Rouge: Louisiana State University Press, 1941), 293–304.

34. Guilbaut focuses on the use of abstract expressionism as Cold War propaganda. For my critique of his argument, see chapter 10.

35. Particularly, my emphatic divergence from the perspective offered by Michael Leja will be evident throughout this work. Although we treat some of the same themes, such as primitivism, myth, and subjectivity, he insists that abstract expressionism furthered, rather than challenged, the dominant postwar culture. While I distinguish "highbrow" culture, "middlebrow" or mass culture, and the culture of spontaneity as three cultural formations engaged in a struggle for hegemony, Leja employs a more Foucauldian paradigm in which all dissent is superficial and circumscribed. Leja identifies the cultural work of abstract expressionism as one with that of "middlebrow and highbrow constituencies taken broadly and together":

> a refurbishing of the culture's prevailing model of self as essentially autonomous, integral, rational and effectual. . . . Insofar as it participated in adjusting and resecuring the dominant ideology's model of subjectivity, New York School art engendered historical effects much less radical and progressive than its unconventional look and its stormy public reception might lead us at first to imagine. . . . [T]he relation between New York School art and the dominant culture was one of deep interdependence obscured by superficial antagonism. . . . Abstract Expressionism was a Trojan horse transporting a reconfigured older ideology into a new era. . . . Claims about primitive impulses and unconscious drives in man functioned to naturalize, psychologize, and individualize the violence and brutality of modern experience. They undermined collectivist theories and explanations by displacing responsibility

away from the political and economic orders and the nationalism, imperialism, and authoritarianism fostered by those orders . . . in the cause of rescuing a dominant ideology. . . . The new self was "friendly" to the dominant ideology insofar as it preserved a maximum of the latter's fundamental categories, tenets, and assumptions. . . . The works were vehicles by which [this] ideology permeated the very core and structure of the individual's sense of self. This colonization of subjectivity is the source of an hegemonic ideology's force, and the condition that gives it stability and momentum. (Leja, *Reframing Abstract Expressionism*, 4, 9–10, 16, and 330)

David Craven comes closer to my own analysis in describing abstract expressionism as "a profound form of romantic anticapitalism" (Craven, "Abstract Expressionism, Automatism, and the Age of Automation," 74). But he does not go far enough in identifying the cultural vision developed there, with the result that spontaneous art appears purely as a gesture of negation: antiindustrialism, anticapitalism, antiscientism, antimechanism, even anticommunication (Craven follows Meyer Schapiro in describing abstract expressionism as distinguished by "a high degree of non-communication" and as "a visual language 'in which communication seems to be deliberately prevented'" [ibid., 76]). This logic ultimately leads Craven to focus on the contradictions and compromises demanded by artists' conciliation to the status quo, rather than on the alternatives they postulated.

36. Richard Candida Smith's work, *Utopia & Dissent* (Berkeley: University of California Press, 1995), is similarly interdisciplinary, but focuses on the West Coast and is more narrative than analytical, organized into chapters by artist rather than by idea.

37. Leja links the two by finding common themes of fear, violence, masculine subjectivity, and "psychological distress." Leja, *Reframing Abstract Expressionism*, 110.

38. Susan Sontag, *Against Interpretation, and Other Essays* (New York: Farrar, Straus, and Giroux, 1966), 35, 14.

39. In this, I but share the orientation of the artists themselves, as Michael McClure stated in *Scratching the Beat Surface* concerning Charles Olson's poem, "The Kingfishers":

So. It is there. The poem stands in itself. Sherman Paul's gloss of the poem tells us much of what it means but I am more impressed with the poem than with what it means . . . I am more impressed with the huge black and white calligraphic paintings of Franz Kline and what they create in my physiomental skyfield, with their transmission of energy, than I am with what Kline specifically meant. . . . Each is a new construct in a storm of newly invented structures.

Michael McClure, *Scratching the Beat Surface* (San Francisco: North Point Press, 1982), 64–65.

Chapter One
THE EMERGENCE OF AN AVANT-GARDE

1. Depending on the allowances one is willing to make for changes in vocabulary, such ideas could be argued to have an even longer history, spanning back at least to

the rise of romanticism. The purpose of this study is not to trace this tradition to its origins, but to account for its role in the art and cultural politics of the post–World War II period.

2. Francis O'Connor, *Jackson Pollock* (New York: Museum of Modern Art, 1967), 17. Steven Naifeh and Gregory Smith, *Jackson Pollock: An American Saga* (New York: C. N. Potter, 1989), 190–91.

3. Before the 1940s, American artists found it impossible to get attention among the American art-buying public as world-class abstract artists. In 1943, Pollock became the first American painter to have a one-man show at Peggy Guggenheim's Art of This Century Gallery. What is more, she retained Pollock on a monthly stipend of $150—an unprecedented arrangement for an American artist, which encouraged others in the possibility of making a living by their art alone. After Pollock's success in 1943, much more became possible for American artists—both formally, on the canvas, and practically, on the market. See Naifeh and Smith, *Jackson Pollock*, 435–51.

4. See, for instance, T. J. Clark, "Jackson Pollock's Abstraction," in Serge Guilbaut, ed., *Reconstructing Modernism: Art in New York, Paris, and Montreal, 1945–1964* (Cambridge, MA: MIT Press, 1990).

5. See Warren Susman, "The Culture of the Thirties," in *Culture as History: The Transformation of American Society in the Twentieth Century* (New York: Pantheon, 1984), 179.

6. In the 1930s, the American Communist Party attempted to develop a more centrist political appeal under the rubric of the Popular Front. Progressive idealists swelled the ranks of the party from 12,000 in 1929 to 100,000 in 1939. See Serge Guilbaut, *How New York Stole the Idea of Modern Art: Abstract Expressionism, Freedom, and the Cold War*, Arthur Goldhammer, trans. (Chicago: University of Chicago Press, 1983), 18.

7. See Guilbaut, *How New York*, 18–23, 38–40. See also Gerald M. Monroe, "The American Artists' Congress and the Invasion of Finland," *Archives of American Art Journal* 15 (1975). "17 Members Bolt Artists' Congress," FMPS Papers, Archives of American Art; quoted in Guilbaut, *How New York*, 40.

8. Henry Miller, "Everyman: From *Obscenity and the Law of Reflection*," *Iconograph* 3 (Fall 1946): 5.

9. See Dore Ashton, *The New York School: A Cultural Reckoning* (New York: Penguin, 1972), 148. See also Cécile Whiting, *Antifascism in American Art* (New Haven: Yale University Press, 1989), 135–36 and 171–72.

10. See Marcel Jean, ed., *The Autobiography of Surrealism* (New York: Viking, 1980), 375–77. André Breton and Leon Trotsky, "Manifesto: Towards a Free Revolutionary Art," Dwight Macdonald, trans., *Partisan Review* 4:1 (Fall 1938), 49–53; reprinted in Herschel B. Chipp, ed., *Theories of Modern Art* (Los Angeles: University of California Press, 1968), 483–86. Trotsky's name was replaced in publication by that of Mexican muralist Diego Rivera, who was a neighbor and sympathizer of Trotsky's in Coyoacán. David and Cecile Shapiro, eds., *Abstract Expressionism: A Critical Record* (New York: Cambridge University Press, 1990), 16.

11. Max Ernst, quoted in Stephen Polcari, *Abstract Expressionism and the Modern Experience* (New York: Cambridge University Press, 1991), 22. See Helena Lewis, *Dada Turns Red: The Politics of Surrealism* (Edinburgh: Edinburgh University Press, 1990). See also Dickran Tashjian, *A Boatload of Madmen: Surrealism and the American Avant-Garde, 1920–1950* (New York: Thames and Hudson, 1995), 110–36.

12. Wolfgang Paalen, "The New Image," Robert Motherwell, trans., *Dyn* 1 (Spring 1942), 7.

13. Ibid., 9–12. *Dyn* was named from the Greek *dynaton*, meaning "the possible," and was available in New York City through Wittenborn-Schultz, booksellers and publishers. In 1945, Motherwell edited a collection of Paalen's essays from the magazine into a volume published by Wittenborn-Schultz entitled *Form and Sense*. See also Irving Sandler, *The Triumph of American Painting: A History of Abstract Expressionism* (New York: Harper and Row, 1970), 37.

14. See also Erika Doss, *Benton, Pollock, and the Politics of Modernism: From Regionalism to Abstract Expressionism* (Chicago: University of Chicago Press, 1991), 349–52.

15. See Sandler, *Triumph of American Painting*, 14–20.

16. Robert Motherwell, "The Modern Painter's World" *Dyn* 6 (Nov. 1944): 12–13. See also Adolph Gottlieb, Mark Rothko, and Barnett Newman, letter to E. Alden Jewell of the *New York Times*, June 13, 1943, quoted in Ellen H. Johnson, ed., *American Artists on Art, from 1940 to 1980* (New York: Harper and Row, 1982), 14: "There is no such thing as good painting about nothing. We assert that the subject is crucial."

17. For the significance of WPA to those painters who would today be classified as abstract expressionists, see Shapiro and Shapiro, eds., *Abstract Expressionism*, 14; and Sandler, *Triumph of American Painting*, 7.

18. George Lipsitz, *Class and Culture in Cold War America: A Rainbow at Midnight* (South Hadley, MA: Bergin and Garvey, 1982), 5. As Richard Edwards has written, bureaucratic control constituted the most advanced form of industrial discipline. Power was depersonalized as "company policy" and "built into job categories, work rules, promotion procedures, . . . definitions of responsibilities, and the like." Bureaucratic control rewarded workers who were "rule-oriented," dependable, and willing to "internalize the enterprise's goals and values." Richard Edwards, *Contested Terrain: The Transformation of the Workplace in the Twentieth Century* (New York: Basic Books, 1979), 130–52.

19. Allan M. Winkler, *The Politics of Propaganda: The Office of War Information, 1942–1945* (New Haven: Yale University Press, 1978), 8–13, 22–23.

20. MacLeish to Franklin D. Roosevelt, May 16, 1942, OFF folder, FDR Papers, FDR Library, Hyde Park, NY; quoted in Sydney Weinberg, "What to Tell America: The Writers' Quarrel in the Office of War Information," *Journal of American History* 55 (1968): 75. OFF Project Proposal, no. 3, box 37, MacLeish Papers, Manuscript Division, Library of Congress; quoted in Weinberg, "What to Tell America," 76, n. 14. See also Jerome S. Bruner, "OWI and the American Public," *Public Opinion Quarterly* 7 (Spring 1943): 128, 131.

21. See Lester G. Hawkins, Jr., and George S. Pettee, "OWI: Organization and Problems," *Public Opinion Quarterly* 7 (Spring 1943): 19–20.

22. John Morton Blum, *V Was for Victory: Politics and American Culture during World War II* (New York: Harcourt Brace Jovanovich, 1976), 32.

23. A. H. Feller, "OWI on the Home Front," *Public Opinion Quarterly* 7 (Spring 1943), 64. Weinberg, "What to Tell America," 82. For a more detailed explanation of the close connections between the radio industry and an advertising oligarchy, see Erik Barnouw, *History of Broadcasting in the United States*, vol. 2, *The Golden Web* (New York: Oxford University Press, 1985), 220–36. Radio owners and advertisers would

soon launch an offensive against government regulation favoring "quality programming" such as MacLeish's radio plays.

24. Archibald MacLeish, *Reflections* (Amherst: University of Massachusetts Press, 1986), 155.

25. Harold Gosnell, "Obstacles to Domestic Pamphleteering by OWI in World War II," *Journalism Quarterly* 23 (Dec. 1946): 360–61.

26. Feller, "OWI on the Home Front," 64.

27. Gosnell, "Obstacles to Domestic Pamphleteering," 361. Bernard de Voto to Elmer Davis, Aug. 23, 1943, Bernard de Voto Papers, Stanford University, quoted in Weinberg, "What to Tell America," 80.

28. Minutes of a meeting of Bureau of Graphics and Printing with William Lewis and Price Gilbert, quoted in Weinberg, "What to Tell America," 85.

29. Several versions of this story exist, none definitive. See Weinberg, "What to Tell America," 86; Blum, *V Was for Victory,* 39 and 345; John Charles Carlisle, "A Biographical Study of How the Artist Became a Humanitarian Activist: Ben Shahn, 1930–1946" (Ph.D. diss., University of Michigan, 1972), 172–74; and Selden Rodman, *Portrait of the Artist as an American: Ben Shahn* (New York: Harper and Brothers, 1951), 65–67.

30. Brennan to Davis, April 6, 1943, Pringle Papers, Manuscript division, Library of Congress, quoted in Weinberg, "What to Tell America," 86.

31. Malcolm Cowley, "The Trials of Elmer Davis," *New Republic*, May 3, 1943, 591–93.

32. Carlisle, *Ben Shahn*, 173. Weinberg, "What to Tell America," 83.

33. The elections of 1942 had seated an anti–New Deal majority in the House, composed of Republicans and Southern Democrats. When the OWI appropriations bill came to the floor of the House, it proved an opportunity for attacking leftism in the government. See the *Congressional Record*, 78th Cong., 1st sess., 1311, 6126 (Jan. 14, Feb. 25, June 18, 1943). Blum, *V Was For Victory*, 231.

34. Cowles was a personal friend of Wendell Willkie and had accompanied him on his One-World tour the previous year. Gosnell, "Obstacles to Domestic Pamphleteering," 364 and 369; Blum, *V Was for Victory*, 41; Weinberg, "What to Tell America," 89, n. 64; Winkler, *Politics of Propaganda*, 65.

35. "Two OWI Aides Resign," *New York Times*, May 19, 1944: 25.

36. Shahn, quoted in Carlisle, "Ben Shahn," 174.

37. Olson, quoted in Catherine Seelye, ed., *Charles Olson and Ezra Pound: An Encounter at St. Elizabeth's* (New York: Grossman, 1975), xx.

38. In an essay entitled "The Price of Free World Victory," Henry Wallace had challenged the ethos of imperialism that Henry Luce had set forth in "The American Century"—though Dwight Macdonald wrote a response to both essays asserting the similarity of their visions. See Henry Wallace, *Democracy Reborn* (New York: Da Capo Press, 1944), 190–96; and Dwight Macdonald, "The (American) People's Century," *Partisan Review* 9:3 (May-June, 1942): 294–310.

39. Charles Olson, "Songs of Maximus," in Donald Allen, ed., *The New American Poetry* (New York: Grove, 1960), 11–12.

40. Dwight Macdonald, "The Root Is Man (Part I)" *Politics* 3 (April 1946): 101. For a thorough description of Dwight Macdonald and *Politics* magazine, see Gregory Sumner, *Dwight Macdonald and the Politics Circle: The Challenge of Cosmopolitan*

Democracy (Ithaca: Cornell University Press, 1996). Sumner calls the radicalism of *Politics* "a communitarian alternative to both Marxian socialism and cold war liberalism that deserves much more careful consideration than it has received to date" (2).

41. Macdonald, "Root Is Man," 112.

42. Ibid., 102.

43. Ibid., 100, 104.

44. Reflecting this emphasis on the politics of personal interaction, Macdonald's Radical political platform included three planks: pacifism, which emphasized international fraternity as against the rampant nationalism of bureaucratic collectivism; greater freedom of the press and of opinion; and the "decentralization of industry until its scale becomes human." Ibid., 100, 104.

45. Macdonald, "Root Is Man (Part 2)," *Politics* 3 (June 1946): 212.

46. C. Wright Mills, "The Powerless People: The Role of the Intellectual in Society," *Politics* 1:4 (April 1944): 69–71.

47. Charles Olson, notebook, "Key West I (#9)," Jan. 1945, Charles Olson Papers, Prose Series, Archives and Special Collections Department, Thomas J. Dodd Research Center, University of Connecticut Libraries; used with permission.

48. He would later change this poem's title to "The K," in reference to the Maya glyph for the god Kulkulkan, the astronomer-king who embodied Olson's new aspirations for social influence through cultural channels. See Charles Olson, "Mayan Letter #5," in Olson, *Selected Writings*, Robert Creeley, ed. (New York: New Directions, 1966), 84–89.

49. Charles Olson, "Projective Verse," reprinted in Donald Allen, *The New American Poetry*, 386–99. Unless otherwise noted, all quotations related to this essay are to be found in this text and are not individually annotated.

50. William Carlos Williams, *Imaginations*, Webster Scott, ed. (New York: New Directions, 1970), 259.

51. William Carlos Williams, *The Autobiography of William Carlos Williams* ([1951] New York: New Directions, 1967), 341. Williams, "Against the Weather," in *Selected Essays* (New York: Random House, 1954), 196.

52. Williams, "The Poem as a Field of Action," *Selected Essays*, 286, 290.

53. On defamiliarization, see Viktor Shklovsky, "Art as Device" (1925), in *Theory of Prose*, Benjamin Sher, trans. (Elmwood Park, IL: Dalkey Archive Press, 1990), 6. (Sher prefers to translate the concept as "estrangement.")

54. In *Ideogram: History of a Poetic Method*, Laszlo Géfin lists the qualities valorized by the New Critics as complexity and coherence, wit and irony, aphorism, and logical composition. He refers to them as the "new traditionalists" and even the "new reactionaries." Géfin, *Ideogram: History of a Poetic Method* (Austin: University of Texas Press, 1982), 85.

55. See T. S. Eliot, "Tradition and the Individual Talent" and "Blake," in *The Sacred Wood: Essays on Poetry and Criticism* ([1920] New York: Barnes and Noble, 1928), 47–59 and 151–58.

56. William Carlos Williams, *Paterson* (New York: New Directions, 1963), 100 and 118–19.

57. Williams, "The Poem as a Field of Action," 285.

58. Williams, *Paterson*, 129–30. Excerpts from this book were published in the abstract expressionist art magazine *Tiger's Eye* in June 1949.

59. Pound decreed that a poem should constitute a revelatory "image" evoking "an emotional and intellectual complex." Ezra Pound, "Vorticism," reprinted in *Gaudier-Brzeska: A Memoir* ([1916] New York: New Directions, 1961), 92, quoted in Géfin, *Ideogram*, 4 and 9. See also the principles of the imagist manifesto as reprinted in Ezra Pound, "A Retrospect," in T. S. Eliot, ed., *Literary Essays of Ezra Pound* (London: Faber and Faber, 1954), 3. Williams and Pound had known each other since early in the century, when both were students at the University of Pennsylvania. See Williams, *Autobiography*, 56ff.

The subtitle of *Kora* alluded to a creative method described by French painter Vasily Kandinsky in his book *Concerning the Spiritual in Art*. Kandinsky there characterized an "improvisation" as an artwork rapidly transcribed from its origins in the artist's imagination. See *Kora in Hell: Improvisations* (Boston: Four Seas Co., 1920), 26. For Williams's indebtedness to Kandinsky, see Peter Schmidt, *William Carlos Williams, the Arts, and Literary Tradition* (Baton Rouge: Louisiana State University Press, 1988), 100; Bram Dijkstra, *The Hieroglyphics of a New Speech: Cubism, Stieglitz, and the Early Poetry of William Carlos Williams* (Princeton: Princeton University Press, 1969), 70; and William Marling, *William Carlos Williams and the Painters, 1909–1923* (Athens: Ohio University Press, 1982), 94. In 1947, Robert Motherwell oversaw the publication of Kandinsky's book in English translation by the New York publishers Wittenborn and Schultz.

60. William Carlos Williams, *Spring and All* (1923) in *Imaginations*, 116–7.

61. A special issue of *Poetry* magazine was devoted to the "Objectivists" in Feb. 1931, through Pound's patronage. See Géfin, *Ideogram*, 53.

62. Dijkstra, *Hieroglyphics of a New Speech*, 166. Williams, *Imaginations*, 101 and 138.

63. Ezra Pound, "In a Station of the Metro," *The Norton Anthology of American Literature*, 2d ed. (New York: W. W. Norton and Co., 1985), vol. 2, 1127.

64. For a history of Black Mountain College, see Martin Duberman, *Black Mountain: An Exploration in Community* (New York: E. P. Dutton, 1972). See also Mary Emma Harris, *The Arts at Black Mountain College* (Cambridge, MA: MIT Press, 1987).

65. Ferry had been the director of public relations for the CIO-Political Action Committee. Olson had been director of the Foreign Nationalities Division of the Democratic National Committee. "Charles Olson, letter to W. H. Ferry," *Olson: The Journal of the Charles Olson Archives* 2 (Fall 1974), 15n. Tom Clark, *Charles Olson: The Allegory of a Poet's Life* (New York: W. W. Norton and Co., 1991), 86–87.

66. Fund for the Republic, *Report, 1952–5* and *Report, 1952–6*. See also Frank Kelly, *Court of Reason: Robert Hutchins and the Fund for the Republic* (New York: Free Press, 1981), pp. 1–24; and Thomas Reeves, *Freedom and the Foundation: the Fund for the Republic in the Era of McCarthyism* (New York: Knopf, 1969).

67. "Charles Olson, letter to W. H. Ferry," 8.

68. Ibid., 11–13.

69. For a full explication of the significance of the "glyph" to the culture of spontaneity, see chapter 3.

70. Bernarda Bryson Shahn, *Ben Shahn* (New York: Abrams, 1972), 184.

71. Duberman, *Black Mountain*, 283–84.

72. Harris, *Arts at Black Mountain*, 182.

73. In the first "Manifesto of Surrealism," written in 1923, Breton had called for an art based on "pure psychic automatism." See Jean, ed., *The Autobiography of Surrealism*, 123.

74. See Paalen, "The New Image," 9. Dali had joined the surrealists in 1929. In 1930, he was honored with the responsibility of furnishing the frontispiece for the publication of Breton's "Second Surrealist Manifesto." Dawn Ades, *Dali and Surrealism* (New York: Harper and Row, 1982), 65–118.

75. Alfred Barr, director of the Museum of Modern Art, first brought surrealist painting, particularly in its more abstract manifestations, to the serious attention of American artists. In 1936, abstract surrealism was included in the Museum's "Cubism and Abstract Art" exhibition; the following year it was well represented in an exhibition of "Fantastic Art, Dada, and Surrealism." See Sandler, *Triumph of American Painting*, 33–38.

76. Paalen broke with the surrealists soon after arriving in Mexico because he felt that they did not champion the value of American Indian art strongly enough. See his "Farewell au Surréalisme," *Dyn* 1: 26.

77. Robert Motherwell, interviews with Paul Cummings, Nov. 24, 1971–May 1, 1974, typescript, 34–35, Robert Motherwell Papers, Archives of American Art, Smithsonian Institution.

John Graham, an emigré Russian intellectual, introduced a slightly different circle of New York artists, including Jackson Pollock, Adolph Gottlieb, Mark Rothko, Willem de Kooning, David Smith, and Arshile Gorky, to the surrealist method of automatism around 1937. See Polcari, *Abstract Expressionism*, 22; and Sandler, *Triumph of American Painting*, 23.

In 1940, English surrealist Gordon Onslow-Ford was lecturing in New York at the New School for Social Research. Onslow-Ford advocated these automatist experiments as the right direction for the revitalization of surrealism. See Gordon Onslow-Ford, "The Painter Looks within Himself" *London Bulletin* (June 1940), 31; quoted in Sandler, *Triumph of American Painting*, 43, n. 26.

78. Particularly in the context of the war, the Americans rejected the kind of whimsicality that characterized Breton's celebration of the unconscious. For an account of the activities of the European surrealists in America, see Naifeh and Smith, *Jackson Pollock*, 418–20.

79. Edward Renouf, "On Certain Functions of Modern Painting," *Dyn* 2 (July-Aug. 1942): 20.

80. See Isidore Lucien Ducasse, *Lautreamont's Maldoror*, Alexis Lykiard, trans. (London: Allison and Busby, 1970), 177; and Jean, ed., *The Autobiography of Surrealism*, 52.

81. Harold Rosenberg, "Life and Death of the Amorous Umbrella," *VVV* 1 (June 1942), 12–13. For a similar American reaction to the surrealists during the war years, see Henry Miller, *The Air-conditioned Nightmare* ([1945] New York: New Directions, 1970), 257. On *VVV*, see Tashjian, *Boatload of Madmen*, 210–14.

82. Motherwell, quoted in Sidney Janis, *Abstract and Surrealist Art in America* (New York: Reynal and Hitchcock, 1944), 65; see Polcari, *Abstract Expressionism*, 53.

83. Renouf, "Modern Painting," 25.

84. Art critic Clement Greenberg consistently emphasized the contributions of cubism to abstract expressionism. See Sandler, *Triumph of American Painting*, 80–85.

85. Sandler, *Triumph of American Painting*, 41; William C. Seitz, "Abstract Expressionist Painting in America" (Ph.D. diss., Princeton University, 1955), 110.

86. Letter to E. Alden Jewell, quoted in Sandler, *Triumph of American Painting*, 68.

87. See Mary Davis MacNaughton, "Adolph Gottlieb: His Life and Art," in *Adolph Gottlieb: A Retrospective* (New York: Arts Publisher, 1981), 36.

88. Adolph Gottlieb, interview with Martin Friedman, Aug. 1962, typescript, 3; Adolph and Esther Gottlieb Foundation, New York; used with permission.

89. Adolph Gottlieb, interview with Dorothy Seckler, Oct. 25, 1967, typescript, 17; Adolph and Esther Gottlieb Foundation; used with permission.

90. William Carlos Williams, *I Wanted to Write a Poem*, Edith Heal, ed. (Boston: Beacon Press, 1958), 30.

91. Williams, *Autobiography*, 341. See Olson, "Letter for Melville" (1951) in George F. Butterick, ed., *The Collected Poems of Charles Olson* (Berkeley: University of California Press, 1987), 233–41. Olson and Williams reacted against the university system as a force favoring the corporatization of American intellectual life. For a concurring view from a cultural historian, see Russell Jacoby, *The Last Intellectuals: American Culture in the Age of Academe* (New York: Basic Books, 1987).

92. T. J. Clark has suggested that abstract expressionist painting represents "the style of a certain petty bourgeoisie's aspiration to aristocracy." This formulation is true to a point, but ignores the dimension of ethnicity; it seems somehow more appropriate to the context of nineteenth-century French painting, on which Clark is an acknowledged expert.

93. Williams, *Autobiography*, 311.

94. Charles O. Hartman, *Jazz Text* (Princeton: Princeton University Press, 1991), 4.

95. LeRoi Jones, *Blues People: The Negro Experience in White America and the Music That Developed from It* (New York: William Morrow, 1963), 181. Ira Gitler, *Swing to Bop: An Oral History of the Transition in Jazz in the 1940s* (New York: Oxford University Press, 1985), 311. See also Amiri Baraka, *The Autobiography of LeRoi Jones* (New York: Freundlich Books, 1984), 57–62. For a full discussion of bebop jazz as part of the culture of spontaneity, see chapter 8.

96. Olson, notebook, "Key West 2 (#10)," Feb. 1945, Charles Olson Papers, Prose Series; used with permission.

97. Clark, *Charles Olson*, 73–74. Funded by the Carnegie Foundation, the CCAU had been conceived by Louis Adamic, an immigrant, writer, and early advocate of cultural pluralism, who edited its quarterly, *Common Ground*. Adamic spoke out in favor of ethnic diversity in his essay "30,000 New Americans," reprinted in *My America* (New York: Harper and Row, 1938).

98. In the Old Testament, Ishmael is disinherited and exiled by his father, Abraham. *Call Me Ishmael*, written as Olson's doctoral dissertation for Harvard's program in American Civilization, was funded by a Fulbright grant and published by Reynal and Hitchcock in 1947. But it was rejected by the faculty at Harvard, and Olson never received his degree.

99. Baraka, *Autobiography of LeRoi Jones*, 156. For his account of crying, interpreted as a confrontation with the personal and social dilemma of being a black, middle-class intellectual, see ibid., 118.

100. Allen Ginsberg, "An Exposition of William Carlos Williams' Poetic Practice," in *Composed on the Tongue* (Bolinas, CA: Grey Fox Press, 1980), 132.

101. Ginsberg, *Journals: Early Fifties–Early Sixties*, Gordon Ball, ed. (New York: Grove Press, 1977), 114.

102. Gerald Nicosia, *Memory Babe: A Critical Biography of Jack Kerouac* (New York: Penguin, 1983), 32 and 147. See, for instance, Jack Kerouac, *Dr. Sax* (New York: Grove-Wiedenfeld Press, 1959), 3, 61–63, 117–20, and 204–8; and Kerouac, *Visions of Cody* (New York: Penguin, 1972), 362–63.

103. Ashton, *New York School*, 8.

104. Hartman, *Jazz Text*, 38. See also Schmidt, *William Carlos Williams*, 109, n. 28. Schmidt provides a useful critique of Michael Riffaterre's "Semantic Incompatibilities in Automatic Writing" (in Mary Ann Caws, ed., *About French Poetry From Dada to Tel Quel* [Detroit, 1974], 223–41). I am arguing here against both Riffaterre, who wants to reduce the spontaneous artistic act to the representation or appearance of spontaneity, and T. J. Clark, who insists that abstract expressionist painting is "lyric" in that it preserves "the illusion in an artwork of a singular voice or viewpoint, uninterrupted, absolute, laying claim to a world of its own. . . . [The] lyric cannot be expunged by modernism, only repressed." T. J. Clark, "In Defense of Abstract Expressionism," *October* 69 (Summer 1994): 47–48.

105. See Michael Davidson, "Palimtexts: Postmodern Poetry and the Material Text," in Marjorie Perloff, ed., *Postmodern Genres* (Norman: University of Oklahoma Press, 1989), 75–95.

106. Hartman, *Jazz Text*, 47. The form of these works was ideally democratic. But its difficulty worked against this since only a very literate minority were likely to find the works accessible. This is a contradiction that continually plagued avant-garde art.

Chapter Two
THE AVANT-GARDE AND THE AMERICAN INDIAN

1. *Pre-Columbian Stone Sculpture*, Wakefield Gallery, May 16–June 5, 1944, exhibition catalogue; Barnett Newman Papers, microfilm reel 3481, Archives of American Art, Smithsonian Institution.

2. I apply the terms "Native American," "American Indian," and "Amerindian" interchangeably to refer to the inhabitants of the American continent (not just the United States) before the European conquest, and to their descendents in the twentieth century who maintained a cultural connection to these antecedents. Although members of the avant-garde were aware of the diversity of Native American traditions, they seldom distinguished among them.

3. Quoted in W. Jackson Rushing, "Ritual and Myth: Native American Culture and Abstract Expressionism," in Maurice Tuchman, ed., *The Spiritual in Art: Abstract Painting, 1890–1985* (New York: Abbeville Press, 1986), 277. See also Ann Eden Gibson, "*Iconograph* Magazine," in *The Indian Space Painters: Native American Sources for American Abstract Art*, exhibition catalogue (New York: Baruch College Gallery, 1991).

4. Jackson Pollock, interview, *Arts and Architecture* (Feb. 1944); reprinted in Ellen H. Johnson, ed., *American Artists on Art, from 1940 to 1980* (New York: Harper and Row, 1982), 2.

5. Charles Olson, *Selected Writings*, Robert Creeley, ed. (New York: New Directions, 1966), 86. Blake had written: "Contraries are positives. A negation is not a con-

trary." William Blake, "Milton," plate 30, title, from David V. Erdman, ed., *The Complete Poetry of William Blake* (Berkeley: University of California, 1982), 129.

6. See also David Craven on "cultural convergences" in "Abstract Expressionism and Third World Art: A Post-Colonial Approach to 'American' Art," *Oxford Art Journal* 14:1 (1991): 45.

7. Michael Taussig, *Mimesis and Alterity: A Particular History of the Senses* (New York: Routledge, 1993). For more on the politics of cultural mimesis, see also Richard White, *Middle Ground: Indians, Empires, and Republics in the Great Lakes Region, 1650–1815* (New York: Cambridge University Press, 1991), x and 50–53; and Homi Bhabha, "How Newness Enters the World: Postmodern Space, Postcolonial Times, and the Trials of Cultural Translation," in *The Location of Culture* (New York: Routledge, 1994), 224–28.

8. Ann Gibson, "Theory Undeclared: Avant-Garde Magazines as a Guide to Abstract Expressionist Images and Ideas" (Ph.D. diss., University of Delaware, 1984), 286.

9. See Steven Naifeh and Gregory Smith, *Jackson Pollock: An American Saga* (New York: C. N. Potter, 1989), 287–88.

10. See the exhibition catalogue, Museum of Modern Art, *Twenty Centuries of Mexican Art* (New York: Museum of Modern Art, 1940), especially p. 138.

11. See Robert Fay Schrader, *The Indian Arts and Crafts Board: An Aspect of New Deal Indian Policy* (Albuquerque: University of New Mexico Press, 1983). See also Kenneth Philp, *John Collier's Crusade for Indian Reform, 1920–1954* (Tucson: University of Arizona Press, 1977); and Robert Kuasnicka and Herman Viola, eds., *The Commissioners of Indian Affairs, 1824–1977* (Lincoln: University of Nebraska Press, 1979).

12. Collier had begun his administrative career as a Progressive in the settlement house movement in New York City. His rather romantic perception of Native American tribes as "cooperative commonwealths" had its basis in the writings of the Russian anarchist Peter Kropotkin, who had countered the paradigm of the social Darwinists with examples of primitive societies that functioned on the principle of mutual aid. Under Collier, the Indian Service more than doubled the percentage of its employees who were Native American, and succeeded in acquiring funds for American Indians from the New Deal relief agencies. But the fulfilment of Collier's vision lay in such unusual projects as the creation of tribal buffalo herds for the Sioux and the Crow. See Stephen J. Kunitz, "The Social Philosophy of John Collier," *Ethnohistory* 18:3 (Summer 1971): 215; and Philp, *John Collier's Crusade*, 7.

13. Some Native Americans resisted Collier's innovations. Many of these embraced the ethos of individualism and the opportunities for liberty and prosperity that it offered. They feared that Collier was initiating a "back to the teepee" campaign that would keep American Indians separate from and inferior to the American mainstream, with fewer opportunities for betterment. But many tribes voted to adopt constitutions or charters in order to be recognized according to the provisions of the Indian Reorganization Act. See Kuasnicka and Viola, eds., *The Commissioners*, 277–79.

14. See ibid., 284.

15. Schrader, *Indian Arts*, 143.

16. Ibid., 126–27. *René d'Harnoncourt: A Tribute* (New York: Museum of Modern Art, 1968), Museum of Modern Art Archives. After the war, as vice president of the

Museum of Modern Art, d'Harnoncourt helped to organize numerous art exchanges between the United States and Latin America. Finally, in 1949, he would replace Alfred Barr as the director of the museum, a position that he held until 1968.

17. For an account of the postwar shift in the "plot structure" of ethnohistories, see Edward Bruner, "Ethnography as Narrative," in Victor Turner and Edward Bruner, eds., *The Anthropology of Experience* (Urbana: University of Illinois Press, 1986).

18. René d'Harnoncourt, "North American Indian Arts," *Magazine of Art* (1939): 164. Oliver La Farge, "The Indian as Artist," *New York Times* magazine, Jan. 26, 1941: 8–9, 23. Schrader, *Indian Arts*, 165, 173, 185.

19. Frederick H. Douglas and René d'Harnoncourt, *Indian Art of the United States* (New York: Museum of Modern Art, 1941), 9–10, 12.

20. Quoted in Schrader, *Indian Arts*, 238.

21. For a good overview of the surrealists' interest in primitive art, see Evan Maurer, "Dada and Surrealism," in William Rubin, ed., *"Primitivism" in Twentieth-Century Art* (New York: Museum of Modern Art, 1984), vol. 2, 535–93. For an account of surrealist interest in American Indian culture particularly, see Elizabeth Cowling, "The Eskimos, the American Indians, and the Surrealists," *Art History* 1 (Dec. 1978): 484–99. In New York City, surrealists bought American Indian art from Julius Carlebach's bric-a-brac shop on Third Avenue, where it was sold as a curiosity at a time when it had not yet won the high-culture cachet of art. They also bought ceremonial masks from George Heye, head of the Museum of the American Indian in Brooklyn.

22. Wolfgang Paalen, "Totem Art," *Dyn* 4–5 (Dec. 1943): 17.

23. Similarities also exist between the Jungian paradigm and the Nietzschean idea of the "Dionysian" set forth in *The Birth of Tragedy from the Spirit of Music* (1871). For a discussion of the influence of Nietzschean ideas in abstract expressionism, see Ann Eden Gibson, "Theory Undeclared: Avant-Garde Magazines as a Guide to Abstract Expressionist Images and Ideas" (Ph.D. diss., University of Delaware, 1984), 239ff. Neitzsche wrote that "the mystical jubilation of Dionysos . . . breaks the spell of individuation and opens a path to the maternal womb of being." Friedrich Nietzsche, *"The Birth of Tragedy" and "The Genealogy of Morals,"* Francis Golffing, trans. (Garden City, NY: Doubleday, 1956), 97. See also ibid., 22–24, 46, 67.

24. Carl Jung, "Psychology and Literature," in *Modern Man in Search of a Soul*, W. S. Dell, trans. ([1933] New York: Harcourt and Brace, 1950), 165. Adolph Gottlieb and Mark Rothko, "Letter to the *New York Times*," in Johnson, ed., *American Artists on Art*, 13–14.

25. Irving Sandler, *The Triumph of American Painting: A History of Abstract Expressionism* (New York: Harper and Row, 1970), 33.

26. Robert Motherwell, "The Modern Painter's World," *Dyn* 6 (Nov. 1944): 12–13. Sigmund Freud, *New Introductory Lectures on Psychoanalysis*, James Strachey, trans. (New York: Norton and Co., 1965), 160; Freud, *Introductory Lectures on Psychoanalysis* (New York: Norton, 1966), 375–77; and Freud, *Civilization and Its Discontents*, James Strachey. trans. (New York: Norton: 1961), 28.

27. See Carl Jung, *The Psychology of the Unconscious: A Study of the Transformations and Symbolism of the Libido, A Contribution to the History of the Evolution of Thought*, Beatrice M. Hinkle, trans. ([1916] New York: Dodd, Mead, 1947), 139–44; see also Jung, *Psychology and Religion* (New Haven: Yale University Press, 1938), 16.

28. Carl Jung, *Civilization in Transition*, 2d ed., R. F. C. Hull, trans. (Princeton: Bollingen Foundation and Princeton University Press, 1970), 9–11.

29. Jung, *Psychology and Religion*, 41.

30. See Carl Jung, *The Integration of the Personality*, Stanley Dell, trans. (New York: Farrar and Rinehart, 1939).

31. Quoted in Ira Progoff, *Jung's Psychology and Its Social Meaning* (New York: Julian Press, 1953), 68.

32. Jung, *Psychology and Religion*, 49.

33. Jung, "Psychology and Literature," 171. The idea that particular forms of cultural organization encouraged the development of distinctive psychological "types" was widespread in the 1930s and 1940s. See, for example, Ruth Benedict's *Patterns of Culture* (Boston: Houghton Mifflin Co., 1934); and Erik Erikson's *Childhood and Society* ([1950] New York: Norton, 1963).

34. Jung, *Psychology and Religion*, 58.

35. Ibid., 18.

36. Ibid., 58 and 95.

37. Jung, "Archaic Man," in *Modern Man in Search of a Soul*, 140–41, 144. French anthropologist Lucien Levy-Bruhl coined the term "participation mystique" in *La Mentalité Primitive* (1922).

38. Wolfgang Paalen, "Paysage Totemique," *Dyn* 1 (Spring 1942): 48. Translation mine. Paalen, "Totem Art," 18–20.

39. Marx traced this alienation to the institution of private property. See Karl Marx, "Estranged Labor," in Dirk J. Struik, ed., Martin Milligan. trans., *Economic and Philosophic Manuscripts of 1844* (New York: International Publishers, 1969), 106–19. See also "Private Property and Communism," ibid., particularly pp. 138–43.

40. Paalen, "Totem Art," 17.

41. The following works by Jung were available in English in 1943: *Modern Man in Search of a Soul, Psychological Types, The Secret of the Golden Flower, Contributions to Analytical Psychology, Psychology of the Unconscious, Two Essays in Analytical Psychology, The Integration of the Personality,* and *Psychology and Religion*. See William McGuire, *Bollingen: An Adventure in Collecting the Past* (Princeton: Princeton University Press, Bollingen Series, 1982), 105.

42. From 1943 through 1965, Bollingen published many books on Jungian psychology and related topics, many of which would become literary references of the 1960s counterculture. Among the better known of these have been the *Collected Works* of Jung, published in several volumes beginning in 1953; the *I Ching*, or Chinese *Book of Changes*, with a foreword by Jung, which has sold over half a million copies since its first printing in 1950; Gladys Reichard's monumental study, *Navaho Religion;* Joseph Campbell's *Hero with a Thousand Faces;* E. H. Gombrich's *Art and Illusion;* and Daisetz Suzuki's *Zen and Japanese Culture*. See also Kenneth Rexroth, "The Bollingen Series," in *With Eye and Ear* (New York: Herder and Herder, 1970), 201–5.

43. A friend of Mary Mellon's from her days at the Becker gallery in the early 1930s, Oakes became the first Bollingen fellow in 1942. Her resulting work, *Where the Two Came to Their Father: A Navaho War Ceremonial*, recorded the blessing ceremony of Navajo men inducted into the U.S. Army during World War II. The text was accompanied by her painted copies of Navajo sandpaintings. Published in December 1943, the book was released in conjunction with an exhibition at the National

Gallery of Art (also a Mellon creation) featuring her paintings. Oakes received a second grant from Bollingen, and she left, in the winter of 1943–44, to study Maya culture in Guatemala. She was searching for archetypal symbols, and perhaps even for a connection between Maya and Egyptian cultures. In November 1945, she settled in the Maya village of Todos Santos, which was inaccessible by road and which had no resident Catholic priest. There she wrote two books for the general reader, *The Two Crosses of Todos Santos* and *Beyond the Windy Place*. She also convinced the Bollingen trustees to fund a translation of the *Popol Vuh*, the holy book of the Quiché-speaking Indians. This translation, however, was never completed. See McGuire, *Bollingen*, 64.

44. Quoted in Rushing, "Ritual and Myth, 283.

45. McGuire, *Bollingen*, 6.

46. John Graham, *System and Dialectics of Art*, Marcia Allentuck, ed. ([1937] Baltimore: Johns Hopkins University Press, 1971), 93–95. Graham, "Primitive Art and Picasso," *Magazine of Art* 30:4 (April 1937): 237–38.

47. Gottlieb and Rothko, "The Portrait and the Modern Artist," transcript of a radio broadcast; reprinted in Clifford Ross, ed., *Abstract Expressionism: Creators and Critics* (New York: Harry N. Abrams, 1990), 207–12.

48. Gail Levin, "Richard Pousette-Dart's Emergence as an Abstract Expressionist," *Arts* (March 1980), 125. Rushing, "Ritual and Myth," 293.

49. See Mary Davis MacNaughton, "Adolph Gottlieb: His Life and Art," in *Adolph Gottlieb: A Retrospective* (New York: Arts Publisher, 1981), 38–40.

50. Adolph Gottlieb, interview with Dorothy Seckler, typescript, 16, Adolph and Esther Gottlieb Foundation; used with permission.

51. Adolph Gottlieb, interview with Martin Friedman, Aug. 1962, typescript 1-A, 20, Adolph and Esther Gottlieb Foundation; used with permission.

52. Ibid., 1-A, 8.

53. Steven Polcari, *Abstract Expressionism and the Modern Experience* (New York: Cambridge University Press, 1991), 245.

54. See, for instance, Craven, "Abstract Expressionism and Third World Art." And Stephen Polcari, *Abstract Expressionism*, 237–50.

55. The Bureau of Ethnology was established under the auspices of the Smithsonian Institution in 1879, with John Wesley Powell as director. After 1894 it became the Bureau of American Ethnology.

56. Judith Wolfe, "Jackson Pollock's Jungian Imagery," *Artforum* 11 (Nov. 1972): 65–73.

57. Pollock, interview with Selden Rodman; reprinted in Ross, ed., *Abstract Expressionism*, 146.

58. See, for example, Elizabeth Langhorne, "Jackson Pollock's *The Moon Woman Cuts the Circle*," *Arts* (March 1979): 128–37; William Rubin, "Pollock as Jungian Illustrator: The Limits of Psychological Criticism," parts 1 and 2, *Art in America* (Nov. and Dec., 1979); Donald E. Gordon, "Pollock's 'Bird,' or How Jung Did Not Offer Much Help in Myth-Making," *Art in America* (Oct. 1980): 43–53; Irving Sandler, David Rubin, and Elizabeth Langhorne, "More on Rubin on Pollock," *Art in America* (Oct. 1980): 57–67.

59. Quoted in Naifeh and Smith, *Jackson Pollock*, 865n.

60. C. L. Wysuph, *Jackson Pollock: Psychoanalytic Drawings* (New York: Horizon

Press, 1970), 19. On Pollock's possible indebtedness to Harvey Fergusson's *Modern Man: His Belief and Behavior* (New York: Knopf, 1936), see Michael Leja, *Reframing Abstract Expressionism: Subjectivity and Painting in the 1940s* (New Haven: Yale University Press, 1993), 178–90.

61. Naifeh and Smith, *Jackson Pollock*, 333.

62. Polcari, *Abstract Expressionism*, 240.

63. See Dore Ashton, *The New York School: A Cultural Reckoning* (New York: Penguin, 1972), 152.

64. According to Pollock's Jungian therapist, Violet de Laszlo. Cited in Claude Cernuschi, *Jackson Pollock: Meaning and Significance* (New York: HarperCollins, 1992), 107.

65. Rushing, "Ritual and Myth," 294.

66. Paalen, "Totem Art," 20.

67. Judging from the writings of d'Harnoncourt, Paalen, and Graham, an economic analysis of the effects of colonialism on American Indian culture was common among avant-garde artists. John Graham wrote about U.S. influences in Mexico:

> The imperialist penetration (civilization) a) robs primitive people of their possessions, of their knowledge, of their customs b) brings to them only cheap destructive products c) creates an artificial need for these products d) introduces the speed-up methods and puts natives to work at slave-wages never to be able to catch up in their expenses with their effort . . . This creates a spirit of hopelessness, discouragement, indifference and therefore abandonment and squalor.

"Mexico," typescript, 4–5; John Graham Papers, microfilm reel 4043, Archives of American Art, Smithsonian Institution.

68. J. J. Brody, *Indian Painters and White Patrons* (Albuquerque: University of New Mexico Press, 1971). Dorothy Dunn, *American Indian Painting of the Southwest and Plains Areas* (Albuquerque: University of New Mexico Press, 1968). See also Craven, "Abstract Expressionism and Third World Art," 53–54.

69. Two other American Indian painters who responded to abstract expressionism were George Morrison and Yeffe Kimball. Unlike Herrera, both Morrison and Kimball left the reservations and joined the New York City art community. Morrison, who taught for many years at the Rhode Island School of Design, was not considered to paint in an "Indian" style. But his quasi-abstract, quasi-figurative compositions were derived from a minute attention to rock formations that suggests a version of "participation mystique." Terrance Talaswaima of the Artist Hopid (see below) created similar works. Yeffe Kimball served as a reviewer of American Indian art for *Art Digest* in the late 1940s. Although she was from Oklahoma, under the influence of abstract expressionism she began painting in a style akin to Northwest Coast Indian art. See, for instance, *Art Digest* 27 (Nov. 1, 1952): 17.

70. Quoted in Dorothy Dunn, "The Art of Joe Herrera," *El Palacio* 59:12 (Dec. 1952): 372. As Indian commissioner, John Collier had refused to rely, as was traditional, on the advice of Christian missionaries in matters of culture; instead he commissioned a series of studies from professional ethnologists. These were published throughout the 1940s, and included Alexander and Dorothea Leighton, *The Navaho*

Door (1944); Laura Thompson and Alice Joseph, *The Hopi Way* (1945); Gordon Mac-Gregor, *Warriors Without Weapons* (1946); Dorothea Leighton and Charles Kluck-hohn, *The Navaho* (1946) and *Children of the People* (1947); and Alice Joseph, *The Desert People* (1949). (See Kunitz, "The Social Philosophy of John Collier," 222.) It was to these studies that Herrera referred.

71. See Donald Fixico: *Termination and Relocation: Federal Indian Policy, 1945–1960* (Albuquerque: University of New Mexico Press, 1986).

72. Vine Deloria, Jr., *God Is Red* (New York: Grosset and Dunlap, 1973), 70–78, 89–103. In a following book, *The Metaphysics of Modern Existence* (New York: Harper and Row, 1979), Deloria also cited Alfred North Whitehead and Marshall McLuhan, thinkers I have linked to the culture of spontaneity. He specifically invoked participation mystique in *The Metaphysics of Modern Existence*, 22. This strategy of reclaiming the radical difference posited by primitivism operates along dynamics similar to Ishmael Reed's novel, *Mumbo Jumbo* (1972). For a useful analysis of the cultural politics embodied in Reed's text, see James Snead, "European Pedigrees/African Contagions: Nationality, Narrative, and Communality in Tutuola, Achee, and Reed," in Homi Bhabha, ed., *Nation and Narration* (New York: Routledge Press, 1990), especially pages 244–47.

73. Quoted in Patricia Janis Broder, *Hopi Painting: The World of the Hopis* (New York: Brandywine Press, 1979), 27. Michael Kabotie, a founder of the Artist Hopid, claimed the Maya as ancestors of the Hopi (Broder, 52). For Charles Olson's interest in the Maya, see below. Olson was also interested in Hopi culture, particularly in the fact that their language contains no tenses to distinguish past, present, and future time, but only modes to distinguish what is latent (the future, dreams, plans) from what is manifest (present or past experience). See Benjamin Lee Whorf, "An American Indian Model of the Universe," *International Journal of American Linguistics* 16:2 (1950): 67–72, cited by Olson in *A Special View of History* (Berkeley: Oyez, 1970), 24.

74. Quoted in *Art News* 91 (Feb. 1992): 89. Significantly, in the production of these works the surrealist automatism of abstract expressionism has been supplanted by conscious references to tribal art sources and prehistoric pictographs. But American Indian artists have found cubism, in its capacity to represent the simultaneity of disparate perspectives, extremely useful in articulating their experience of American Indian identity.

75. Olson, notebook "(#3), Winter 1939–40," Charles Olson Papers, Prose Series, Archives and Special Collections Department, Thomas J. Dodd Research Center, University of Connecticut Libraries.

76. Olson, *Selected Writings*, 84.

77. Ibid., 78–79.

78. Ibid., 86.

79. Carol Kyle, "The Meso-American Cultural Past and Charles Olson's 'The Kingfishers,'" *Alcheringa*, n.s. 1 (1975): 68–77. Olson's poem may have been inspired in part by "The Heights of Macchu Picchu," a poem by the revolutionary Chilean poet Pablo Neruda. "Alturas de Macchu Picchu" was first published in 1945, and later appeared in translation in *Tiger's Eye*, a magazine of abstract expressionist art.

80. All quotations from "The Kingfishers" are taken from Charles Olson, *The Col-*

lected Poems of Charles Olson, George F. Butterick, ed. (Berkeley: University of California Press, 1987), 86–93.

81. Guy Davenport, "The Symbol of the Archaic," *Georgia Review* 28 (1974): 644. Emphasis mine.

Chapter Three
I D E O G R A M

1. Robert Motherwell, "The Modern Painter's World," *Dyn* 6 (Nov. 1944): 13. See also Ann Gibson, "Abstract Expressionism's Evasion of Language," in David and Cecile Shapiro, eds., *Abstract Expressionism: A Critical Record* (New York: Cambridge University Press, 1990), 197–98.

2. Paalen, "Totem Art," *Dyn* 4–5 (Dec. 1943): 20.

3. Kenneth Beaudoin, "This Is the Spring of 1946," *Iconograph* 1 (Spring 1946): 3–4.

4. In 1942, Busa worked for the WPA along with Lee Krasner, Jackson Pollock, William Baziotes, and Jerry Kamrowski, who were among the last artists to be employed by the project. At that time, he admired Pollock's painting for what he termed "a natural access to his unconscious." Irving Sandler, *The Triumph of American Painting: A History of Abstract Expressionism* (New York: Harper and Row, 1970), 33. Peter Busa, interview with Dorothy Seckler, Sept. 5, 1965, Peter Busa Papers, Archives of American Art, Smithsonian Institution, 8. Ann Gibson, "Painting Outside the Paradigm: Indian Space," *Arts* 57 (Feb. 1983): 99–100.

5. Ann Gibson, "*Iconograph* magazine," in *The Indian Space Painters: Native American Sources for American Abstract Art*, exhibition catalogue (New York: Baruch College Gallery, 1991), 37, n. 8. See also Gibson, "Painting Outside the Paradigm."

6. Miró had asserted such ideas as early as 1936 in the influential French art magazine *Cahiers D'art*. Sidra Stich, *Joan Miró: Development of a Sign Language* (St. Louis, MO: Washington University Gallery of Art, 1980), 8, 10, and 60, n. 2.

7. James Dolan, "Typography," *Iconograph* 1 (Spring 1946), 9.

8. This point was also made by Chiang Yee in *Chinese Calligraphy: An Introduction to Its Aesthetic and Technique*, foreword by Herbert Read (London: Methuen and Co., 1938), which became available in New York during the war.

9. Olson, notebook "Washington (#12)," Spring 1945, Charles Olson Papers, Prose Series, Archives and Special Collections Department, Thomas J. Dodd Research Center, University of Connecticut Libraries; used with permission.

10. Ann Eden Gibson, "Theory Undeclared: Avant-Garde Magazines as a Guide to Abstract Expressionist Images and Ideas" (Ph.D. diss., University of Delaware, 1984), 38. As Kenneth Rexroth wrote in 1961:

> Jolas spent several years trying to shift the basis of Surrealism from Freud and Marx to Jung and St. John of the Cross, publishing in *transition* Joyce's *Finnegan's Wake* and imitating it in polylingual poems full of neologisms which nobody read. He and his friends launched "The Revolution of the Word," complete with manifesto (which he persuaded all sorts of French personages to sign), but nothing came of it and he went back to America. As an apologist for his own brand of Surrealism, he was, if anything, a more cogent and learned polemicist than Breton himself, and to his door can be laid the be-

ginning of the present popularity of Jungianism, with its chaos of undigested symbology and its antinomian mysticism. Out of him come the pseudo mahatmas of *On the Road*—but, alas, all devoid of his curious and amusing learning.

Kenneth Rexroth, "The Influence of French Poetry on American," in Bradford Morrow, ed., *The World Outside the Window: Selected Essays* (New York: New Directions, 1987), 162.

11. Abraham Lincoln Gillespie, Jr., "The Syntactic Revolution," *Iconograph* 5 (New Orleans, March 1942).

12. Laszlo Géfin, *Ideogram: History of a Poetic Method* (Austin: University of Texas Press, 1982), 14. Olson's extensive notes on Fenollosa's essay are preserved in the notebook "Washington, Spring 1945 (#12)," Charles Olson Papers.

13. Pound, "Vorticism," in *Gaudier-Brzeska: A Memoir* ([1916] New York: New Directions, 1961), 97, 102. Emphasis mine.

14. See Ernest Fenollosa, "The Chinese Written Character as a Medium for Poetry," Ezra Pound, ed.; reprinted in Pound, *Instigations* ([1920] Freeport, NY: Books for Libraries Press, 1967), 357–88. Unless otherwise noted, all subsequent citations are from this source.

15. Fenollosa maintained that phonetic conventions have only modified and supplemented this basic root of Chinese written vocabulary. This was a viewpoint corroborated by Chiang Yee in *Chinese Calligraphy* (1938). For a critique of the ideographic understanding of Chinese, see John DeFrancis, *The Chinese Language: Fact and Fantasy* (Honolulu: University of Hawaii, 1984).

16. Quoted in Géfin, *Ideogram*, 14.

17. Fenollosa [Pound, ed.], "The Chinese Written Character," 379.

18. See Warren I. Susman, "'Personality' and the Making of Twentieth-Century Culture," in *Culture as History* (New York: Pantheon, 1984), 271–86.

19. Dolan, "Typography," 10. Charles Olson, "Projective Verse," reprinted in Donald Allen, ed., *The New American Poetry* (New York: Grove Press, 1960), 386–99.

20. Géfin, *Ideogram*, 54.

21. William Carlos Williams, *Paterson* (New York: New Directions, 1963), 20.

22. Pound likewise described his poetry as "a form of super-position . . . one idea set on top of another." Pound, "Vorticism," 89.

23. Charles Olson, notebook "Key West I (#9)," Jan. 1945, typescript, 2, Charles Olson Papers. William Carlos Williams, "Against the Weather: A Study of the Artist" (1939) in *Selected Essays* (New York: Random House, 1954), 202.

24. Olson, "The Attack, Now, in Painting and Writing" (May 24, 1952), Charles Olson Papers, Prose folder 53; used with permission.

25. Charles Olson, *Selected Writings*, Robert Creeley, ed. (New York: New Directions, 1966), 105, 110–11.

26. Olson, "Project (1951): The Art of the Language of Mayan Glyphs," *Alcheringa* 5 (Spring-Summer, 1973): 95, 97.

27. Olson, *Selected Writings*, 113.

28. Ibid., 92–94.

29. Ibid., 113.

30. Olson's sense that the spatial and material qualities of Maya writing had important cultural implications has been echoed by Walter Ong's more recent theory on

the differences between oral and written cultures. The characteristics that Ong associates with oral cultures are similar to those that Olson ascribed to the Maya:

> In the absence of elaborate analytic categories that depend on writing to structure knowledge at a distance from lived experience, oral cultures must conceptualize and verbalize all their knowledge with more or less close reference to the human lifeworld. . . . A chirographic (writing) culture and even more a typographic (print) culture can distance and in a way denature even the human, itemizing such things as the names of leaders and political divisions in an abstract, neutral list entirely devoid of a human action context. . . .
> By keeping knowledge embedded in the human lifeworld, orality situates knowledge within a context of struggle.

Walter Ong, *Orality and Literacy: The Technologizing of the Word* (New York: Methuen, 1982), 43-44.

31. For a discussion of how literature uses a time dimension to resolve aesthetically those ideological impasses that cannot be resolved logically, see Frederic Jameson, "On Interpretation," in *The Political Unconscious: Narrative as a Socially Symbolic Act* (Ithaca: Cornell University Press, 1981), especially pp. 80–83. Olson's poem functions differently from the work Jameson describes, however, in that it seeks disclosure rather than closure; that is, it is unpacking the ideological basis of an event rather than using the portrayal of an event to obfuscate ideological contents.

32. The text of the poem is taken from Charles Olson, *A Nation of Nothing But Poetry*, George Butterick, ed. (Santa Rosa, CA: Black Sparrow Press, 1989), 84. See also editorial note, ibid., 191.

33. Robert Motherwell, interviews with Paul Cummings, Nov. 24, 1971–May 1, 1974, typescript, 59–60, Robert Motherwell Papers, Archives of American Art, Smithsonian Institution.

34. In 1950, Olson wrote in an essay entitled *Human Universe:* "Value is perishing from the earth because no one cares to fight down to it beneath the glowing surfaces so attractive to all . . . [Yet] Several of us go back to hieroglyphics or ideograms to right the balance . . . the hieroglyphs of the Maya disclose a placement of themselves toward nature of enormous contradiction to ourselves." Olson, *Selected Writings*, 54–63.

35. Barnett Newman, "The Ideographic Picture," exhibition catalogue (New York: Betty Parsons Gallery, 1947); reprinted in Ellen Johnson, ed., *American Artists on Art, from 1940 to 1980* (New York: Harper and Row, 1982), 15.

36. Wolfgang Paalen had suggested something similar in *Dyn* in 1942: "[T]he sign—which is an intermediate abstraction between the painted image and the letter—does not necessarily refer to *existing* objects. . . . Instead [signs] operate as visual symbols whose function is to bring about behaviour conducive to the material realization of the ideas which are so signified." Paalen, "Suggestion for an Objective Morality," *Dyn* 1 (April-May 1942): 17.

37. *Theodoros Stamos*, exhibition catalogue (New York: Marlborough Gallery, 1972).

38. Dore Ashton, *The New York School: A Cultural Reckoning* (New York: Penguin, 1972), 165. Stephen Polcari, *Abstract Expressionism and the Modern Experience* (New York: Cambridge University Press, 1991), 325.

39. "Indian Space" painter Will Barnet claimed that his art presented "the next step past Cubism" in "shapes whose positive and negative identities were ambiguous, or 'all positive.'" Quoted in Sandra Kraskin, "The Indian Space Painters," in *The Indian Space Painters* exhibition catalogue (see note 5 above), 8; and in Ann Gibson, "Painting Outside the Paradigm." On Kline's painting in relation to calligraphy, see: Lawrence Alloway, "Signs and Surfaces: Notes on Black and White Painting in New York," *Quadrum* 9 (1960): 49–62; Franz Kline, interview with Katharine Kuh, *The Artist's Voice* (New York: Harper and Row, 1962); Harry F. Gaugh, *Franz Kline: The Vital Gesture* (New York: Cincinnati Art Museum and Abbeville Press, 1985), 77–78 and 130.

40. Stephen Polcari, *Abstract Expressionism and the Modern Experience* (New York: Cambridge University Press, 1991), 334.

41. Adolph Gottlieb, lecture; reprinted in Clifford Ross, ed., *Abstract Expressionism: Creators and Critics* (New York: Harry N. Abrams, 1990), 54.

42. "Language Is a Primary Abstraction," *Tiger's Eye* 5 (Oct. 1948): 73.

43. Martin Eidelberg, ed., *What Modern Was: Design, 1935–1965* (New York: Harry N. Abrams, 1991), 245.

44. Quoted in Selden Rodman, *Portrait of the Artist as an American: Ben Shahn* (New York: Harper and Brothers, 1951), 31.

Chapter Four
SUBJECTIVITY, EXISTENTIALISM,
AND PLASTIC DIALOGUE

1. Donald Kuspit, "Abstract Expressionism: The Social Contract," *Arts* 54:2 (March 1980): 118. See Serge Guilbaut, *How New York Stole the Idea of Modern Art: Abstract Expressionism, Freedom, and the Cold War*, Arthur Goldhammer, trans. (Chicago: University of Chicago Press, 1983), 143. For a summary of Guilbaut's arguments, see Michael Leja, *Reframing Abstract Expressionism: Subjectivity and Painting in the 1940s* (New Haven: Yale University Press, 1993), 47. Harold Rosenberg, the Trotskyite art critic, anticipated the gist of Marxist critiques of abstract expressionism in his essay "The American Action Painters," *Art News* 51:8 (Dec. 1952). There he warned that, separated from an organic audience, the avant-garde artist's work becomes a tool or plaything of tastemakers and profiteers. Yet unlike Guilbaut, Rosenberg allowed that "the tiny circle of poets, musicians, theoreticians, [and] men of letters" who comprised an educated audience for this work might carry it further, to greater social effect:

2. See, for example, Dore Ashton, *The New York School: A Cultural Reckoning* (New York: Viking, 1972), 174–85; Douglas Tallack, *Twentieth-Century America: The Intellectual and Cultural Context* (New York: Longman, 1991), 99; and William Graebner, *The Age of Doubt: American Thought and Culture in the 1940s* (Boston: Twayne, 1991), 135.

3. William Barrett, *The Truants: Adventures among the Intellectuals* (Garden City, NY: Anchor/Doubleday, 1982), 133. See also Dore Ashton, *The Unknown Shore: A View of Contemporary Art* (Boston: Brown, Little, and Co., 1962), 33–35.

4. I do not include abstract expressionist "color-field" painting in this study because I believe that, properly understood, it signifies a divergent impulse in art. Significantly, when Barnett Newman and Mark Rothko began painting color fields

(Newman in 1948, Rothko in 1950), they discarded the technique of automatism or spontaneous composition. These paintings evoke a desire for transcendence that is alien to gesture painting. Significantly, Newman equated "sublimity" with the "pure idea" and Rothko wrote of "transcendental experiences." Their paintings take the viewer away from the complexity and rough-and-tumble nature of the quotidian world into a realm of harmonious simplicity. By contrast, gesture painting emphasized the subjective presence of the artist. (See Leja, *Reframing Abstract Expressionism*, 37–38.) It understood life's meaning to be immanent rather than transcendent. As Willem de Kooning stated in 1951, "Art never seems to make me peaceful or pure. I always seem to be wrapped in the melodrama of vulgarity." Quoted in Dore Ashton, *The New York School: A Cultural Reckoning* (New York: Penguin, 1972), 17.

5. See Irving Sandler, *The New York School: The Painters and Sculptors of the Fifties* (New York: Harper and Row, 1978), 2–3.

6. Fred Orton has rightfully recovered the Trotskyite roots of Rosenberg's approach to art, reading Rosenberg's essay "The American Action Painters" as a continuation of his "The Pathos of the Proletariat." See Orton, "Action, Revolution, and Painting," *Oxford Art Journal* 14:2 (1991): 3–17. But Orton is wrong to dismiss existentialist readings of Rosenberg's work as "lazy." Rosenberg's vocabulary is in places unmistakably existentialist.

7. For an account of the response of the New York art community to Rosenberg's essay, see Steven Naifeh and Gregory Smith, *Jackson Pollock: An American Saga* (New York: C. N. Potter, 1989), 706; and Deborah Solomon, *Jackson Pollock: A Biography* (New York: Simon and Schuster, 1987), 237.

8. Robert Motherwell, "The Modern Painter's World," *Dyn* 6 (Nov. 1944): 13. Following Motherwell, Rosenberg asserted that the new American painting no longer regarded the canvas "as a place where the mind records its contents"; instead, it was "itself the 'mind' through which the painter thinks." Rosenberg, "The American Action Painters," in *The Tradition of the New* (London: Thames and Hudson, 1960), 26. Subsequent quotations of the text are from this source (pp. 23–29) and are not individually cited.

9. "The American will is *easily satisfied* in its efforts to realize itself in knowing itself." Emphasis mine.

10. See Ashton, *New York School*, 182 and 184.

11. Hannah Arendt, "What Is *Existenz* Philosophy?" *Partisan Review* 13:1 (Winter 1946); Jean-Paul Sartre, "The Root of the Chestnut Tree" (Winter 1946); William Barrett, review of Sartre's *Being and Nothingness* (Spring 1946); Delmore Schwartz, review of the novels of Albert Camus (Spring 1946); Simone de Beauvoir, "Pyrrhus and Cyneas" (Summer 1946); William Barrett, "Dialogue on Anxiety" (March 1947); Barrett, review of Auden's *The Age of Anxiety* (Sept. 1947).

12. For William Carlos Williams's criticism of T. S. Eliot, see Williams, *I Wanted to Write a Poem*, Edith Heal, ed. (Boston: Beacon Press, 1958), 30.

13. W. H. Auden, *The Age of Anxiety* (New York: Random House, 1947).

14. Hannah Arendt, "What Is *Existenz* Philosophy," 37–38.

15. Ronald Aronson and Adrian van den Hoven have commented on Sartre's "choice . . . to live in total disregard of his own body: the for-itself in permanent opposition to the in-itself, the nonphysical sexual being. . . ." Aronson and van den Hoven, eds., *Sartre Alive* (Detroit: Wayne State University Press, 1991), 20.

16. Barrett, *Truants*, 120. See Arendt, "What Is *Existenz* Philosophy," 41, 54–55.

17. See Sartre, "The Root of the Chestnut Tree," *Partisan Review* 13:1 (Winter 1946): 27; Arendt, "What Is *Existenz* Philosophy?" 41, 43, 44, 49, 50; Barrett, *What Is Existentialism*, foreword to the 1964 edition ([1947] New York: Grove Press, 1964), 8. See also Alasdair MacIntyre, "Existentialism," in *Encyclopedia of Philosophy*, Paul Edwards, ed. (New York: Macmillan and the Free Press, 1967), vol. 3, 147–48.

18. Sartre, "The Root of the Chestnut Tree," 26, 31, 33.

19. See Ashton, *New York School*, 176–78.

20. Quoted in Harold Rosenberg, "De Kooning: On the Borders of the Act," in *The Anxious Object: Art Today and Its Audience* (New York: Horizon Press, 1964), 128. See also Sandler, *New York School*, 11.

21. Willem de Kooning, in Emile de Antonio, *Painters Painting: The New York Art Scene, 1940–1960*, Turin Film Corporation (Montauk, NY: Mystic Fire Video, 1972). I see T. J. Clark's effort to define abstract expressionism as the art of the "vulgar" as rooted in the same premises. See Clark, "In Defense of Abstract Expressionism," *October* 69 (Summer 1994): 22–48.

22. See Stephen Polcari, *Abstract Expressionism and the Modern Experience* (New York: Cambridge University Press, 1991), 283.

23. Rosenberg, "De Kooning: On the Borders of the Act," 124 and 127.

24. Willem de Kooning, talk at Subjects of the Artist school, 1949, published in Thomas B. Hess, *Willem de Kooning* (New York: Braziller, 1959), 15–16.

25. Willem de Kooning, "Content is a glimpse," *Location* (Spring 1963), excerpted in Ellen Johnson, ed., *American Artists on Art, from 1940 to 1980* (New York: Harper and Row, 1982), 21–22.

26. Quoted in Claude Cernuschi, *Jackson Pollock: Meaning and Significance* (New York: HarperCollins, 1992), 144.

27. Robert Saltonstall Mattison, *Robert Motherwell: The Formative Years* (Ann Arbor: UMI Research Press, 1987), 159.

28. Robert Motherwell, April 1979, quoted in Stephanie Terenzio, *Robert Motherwell & Black* (Storrs: University of Connecticut Press, 1980), 130.

29. In February 1947, Clement Greenberg proclaimed in the *Nation*: "Pollock has gone beyond the stage where he needs to make his poetry explicit in ideographs." Clement Greenberg, "Art," *Nation* 164:5 (Feb. 1, 1947): 139.

30. On the influential encouragement by Clement Greenberg, see Naifeh and Smith, *Jackson Pollock*, 523. Pollock is reported to have remarked after the completion of either *Shimmering Substance* (Deborah Solomon's account in *Jackson Pollock: A Biography*) or *Eyes in the Heat* (Naifeh and Smith), "That's for Clem!" Whether the influence was imparted from Greenberg to the Pollocks or vice versa is a matter of debate. Solomon contends that during that summer on Long Island, Lee Krasner taught Clement Greenberg everything she knew about art criticism; and Naifeh and Smith corroborate her influence on his thinking.

31. Jackson Pollock in *Possibilities* 1 (Winter 1947–48); reprinted in Francis V. O'Connor, *Jackson Pollock* (New York: Museum of Modern Art, 1967), 40. The editors of *Possibilities* included Robert Motherwell, Harold Rosenberg, and John Cage.

32. Even when he returned to figurative allusions in the *Black and White* series of 1950–51, he would preserve the compositional primacy of these interactive gestural

lines: whereas before the gestures had occluded the image, now the image emerged from the gestures. See, for instance, Pollock's *Frogman*, from 1951.

Michael Leja has discussed Pollock's similarly figurative "cut-outs" of 1948–50 in his *Reframing Abstract Expressionism*. But, like many critics, Leja overemphasizes the existentialist, individual-against-society quality of these works, abetted by his insistence on drawing parallels between abstract expressionism and film noir. For Leja, these cut-outs present "an image of bondage" through a "figure detached, alienated from the field, yet ensnared by it" (299–300). The most salient point about the human figures in these works, however, is that they, too, are fields. The cut boundary of the figure constitutes a permeable barrier separating two systems (figure and ground) differentiated only by their level of organization or degree of coherence.

33. Parker Tyler, "Jackson Pollock: The Infinite Labyrinth," *Magazine of Art* (March 1950): 93.

34. Lee Krasner, interview with Bruce Glaser, "Jackson Pollock," *Arts* 41 (April 1967): 38.

35. See, for example, the imaginary dialogue embedded in Barrett's *What Is Existentialism?;* Barrett's "A Dialogue on Anxiety," *Partisan Review* 14 (March-April 1947); and Auden's *Age of Anxiety.*

36. William Graebner, *Age of Doubt*, 141.

37. Tworkov in *Jack Tworkov: Paintings, 1928–1982* (Philadelphia: Pennsylvania Academy of Fine Arts, 1987), 128.

38. Harold Rosenberg, *De Kooning* (New York: Abrams, 1974), 36, quoted in Richard Schiff, "Water and Lipstick: De Kooning in Transition," in *Willem de Kooning Paintings* (Washington: National Gallery of Art, 1994), 58. Schiff provides a sensitive treatment of the link between de Kooning's art and politics.

39. Simone de Beauvoir wrote in her 1946 essay for the *Partisan Review:* "I have need of others for . . . my actions would recoil on themselves inert, useless, were they not carried by new projects towards a new future. . . . Lest our cries be lost in empty space I must have men near me who are ready to hear me." Beauvoir, "Pyrrhus and Cyneas," 333 and 335. See also Monika Langer, "Sartre and Marxist Existentialism," in Aronson and van den Hoven, eds., *Sartre Alive*, 166–67.

40. William James, *Principles of Psychology* ([1890] New York: Dover, 1950), vol. 1, 105.

41. Graebner, *Age of Doubt*, 135.

42. Matthew L. Rohn, *Visual Dynamics in Jackson Pollock's Abstractions* (Ann Arbor: UMI Research Press, 1987), 123.

43. George McNeil, "American Abstractionists Venerable at Twenty," *Art News* 55 (May 1956): 65.

44. Kuspit, "Abstract Expressionism," 117.

45. In *The Phenomenology of Perception* (1945), he argued that the capacity for choice and intention that Sartre reserved for the conscious mind must be ascribed to the body as well. Charles Olson found Merleau-Ponty's ideas much more to the point than Sartre's. See Frederick A. Olafson, "Maurice Merleau-Ponty," *Encyclopedia of Philosophy*, vol. 5, 280–81; and Charles Olson, *Muthologos: The Collected Lectures and Interviews*, vol. 2, George F. Butterick, ed. (Bolinas, CA: Four Seasons Foundation, 1979), 87.

46. This was the approach advocated by James Baldwin in *The Fire Next Time*

(New York: Vintage, 1963), 40–44. Some radical feminists have also asserted this position; see, for instance, Margaret Atwood, *Surfacing* (New York: Simon and Schuster, 1972). See also Karl Marx, *On the Jewish Question*, Helen Lederer, trans. (Cincinnati: Hebrew Union College, 1958).

47. There are as well painters whose oeuvre does not fit into either camp. The paintings of Mark Tobey and the post-Pictograph paintings of Adolph Gottlieb display important affinities with gesture-field painting. Yet despite gestural components in their work, their paintings retain a quality of representationality that is at odds with the "presentation" of plasticity that is the basis of gesture painting.

ꞌ The work of those at the heart of the postwar aesthetic of spontaneity partook more of a quality of indexical than of symbolic signification. (My reference is to Charles Peirce's semiotics: a "symbol" signifies metaphorically, as a word signifies its referent or as a photograph represents a landscape. "Indexical" signification is that by which a sign indicates an object to which it is "really and in its individual existence connected," as a word signifies its writer or as a photograph is indexical of the photographer whose point of view it represents. Charles S. Peirce, "Prolegomena to an Apology for Pragmaticism," in James Hoopes, ed., *Peirce on Signs: Writings on Semiotic* [Chapel Hill: University of North Carolina Press, 1991], 251.)

West Coast painter Mark Tobey began to produce his automatic "white writing" in the early 1930s. Although his interest in Eastern religions and calligraphy has parallels with the early abstract expressionist interest in ideographic painting, he cannot be counted within the cultural phenomenon of "plastic automatism" that developed among East Coast painters during World War II. As Tobey's term "white writing" suggests, the skeins of lines that compose his paintings were primarily symbolic rather than indexical.

Between 1947 and the mid-1950s, Adolph Gottlieb slowly gravitated from *Pictographs* toward a more integrated, allover composition. An early example of this shift is his *Pictograph—Heavy White Lines* (1947), in which the cubist scaffolding dividing the pictographic compartments asserts its presence as a compositional element in its own right. In the *Imaginary Landscapes* and *Burst* series that Gottlieb produced from the mid-1950s and on into the 1960s, areas of gestural density function as contained compositional elements within large canvases which balance the frenetic activity of these gestural strokes with large areas of blank canvas and quiet circles of color. Again, in these works the symbolic as opposed to the indexical content of the gestural strokes is emphasized. The gestural component in a painting like *Dialogue* is a *representation* of the complexity and imperfection of sublunary creation, rather than a *presentation* of the artist enmeshed in its materiality.

48. Sandler, *New York School*, 32–33. On Franz Kline and existentialism, see Ashton, *New York School*, 181.

49. Sandler, *New York School*, 90–139; Judith E. Bernstock, *Joan Mitchell* (New York: Hudson Hills Press, 1988), 21 and 33.

50. Richard Armstrong, "Jack Tworkov's Faith in Painting," in Tworkov, *Jack Tworkov*.

51. *Recent Paintings by Jack Tworkov*, exhibition catalogue (New Haven: Yale University Art Gallery, 1963).

52. Kenneth Baker, "Painting Without Pretext," in Tworkov, *Jack Tworkov*, 11–12.

53. Tworkov in *Jack Tworkov*, 133.

54. James Brooks, statement, *Twelve Americans* (New York: Museum of Modern Art, 1956).

55. James Brooks in Frank Popper, *Origins and Development of Kinetic Art*, Stephen Bann, trans. (Greenwich, CT: New York Graphic Society, 1968), 84.

56. Quoted in *James Brooks*, exhibition catalogue, Dallas Museum of Fine Arts, 1972.

57. Quoted in Carl Belz, *Frankenthaler: The 1950s* (Waltham, MA: Rose Art Museum, Brandeis University, 1981), 14.

58. Quoted in Karen Wilkin, *Frankenthaler: Works on Paper, 1949–1984* (New York: George Braziller, 1984), 36.

59. Quoted in Barbara Rose, *Helen Frankenthaler* (New York: Harry N. Abrams, 1970), 30–32, 36–38.

60. Harold Rosenberg, "Art and Words," in *The De-definition of Art* (New York: Horizon Press, 1972), 64.

61. On this point, I disagree with Michael Leja, who insists that "the subjectivity requisite for production of [abstract expressionist] art was male." Leja, *Reframing Abstract Expressionism*, 6 and 268.

62. Quoted in Rose, *Frankenthaler*, 48.

63. Belz, *Frankenthaler*, 13.

64. Frank O'Hara, *Art Chronicles, 1954–1966* (New York: George Braziller, 1975), 121.

65. Martin James, "Panel: All-Over Painting," *It Is* 2: 73.

66. Oscar Collier, *Iconograph Quarterly Supplement of Prejudice and Opinion*, 1946, n.p. See the Oscar Collier Papers, Archive of American Art, Smithsonian Institution.

Chapter Five
SUBJECTIVITY IN THE ENERGY FIELD: THE
INFLUENCE OF ALFRED NORTH WHITEHEAD

1. Paul Tipler, *Physics* (New York: Worth Publishers, 1976), 705–6.

2. Dorothy Emmet, "Alfred North Whitehead," in *The Encyclopedia of Philosophy* (New York: Macmillan and the Free Press, 1967), 290.

3. Nathaniel Lawrence, *Alfred North Whitehead: A Primer* (New York: Twayne Publishers, 1974), 20.

4. Barnett Newman, reply to Clement Greenberg, 1947; reprinted in Ellen H. Johnson, ed., *American Artists on Art, from 1940 to 1980* (New York: Harper and Row, 1982), 19.

5. Tworkov, *Jack Tworkov: Paintings, 1928–1982* (Philadelphia: Pennsylvania Academy of Fine Arts, 1987), 133.

6. Robert Motherwell, April 1979, quoted in Stephanie Terenzio, *Robert Motherwell & Black* (Storrs: University of Connecticut Press, 1980), 130.

7. Robert Saltonstall Mattison, *Robert Motherwell: The Formative Years* (Ann Arbor: UMI Research Press, 1987), 12–14.

8. Mattison, *Motherwell*, 10.

9. Ibid., 6. For more on abstract expressionist interest in Dewey's philosophy, see Stewart Buettner, *American Art Theory, 1945–1970* (Ann Arbor: UMI Research Press,

1981), 58–62. Also Buettner, "John Dewey and the Visual Arts in America," *Journal of Aesthetics and Art Criticism* 33:4 (Summer 1975): 383–91.

10. Motherwell, "Beyond the Aesthetic," *Design* (April 1946); reprinted in Frank O'Hara, *Robert Motherwell* (New York: Museum of Modern Art, 1965), 37.

11. William Carlos Williams, "The Poem as a Field of Action," in *Selected Essays* (New York: Random House, 1954), 282.

12. Charles Olson, "Projective Verse," reprinted in Donald Allen, ed., *The New American Poetry* (New York: Grove Press, 1960), 386–99. The capitalization was Olson's.

13. Ed Dorn, letter to Charles Olson, Feb. 6, 1960, Charles Olson Papers, Archives and Special Collections Department, Thomas J. Dodd Research Center, University of Connecticut Libraries; used with permission.

14. Robert Creeley in Donald Allen and Warren Tallman, eds., *Poetics of the New American Poetry* (New York: Grove, 1973), 266.

15. Robert Duncan (1956) in Allen and Tallman, eds., *Poetics of the New American Poetry*, 188. Emphases mine.

16. Charles Olson, *The Special View of History*, Ann Charters, ed. (Berkeley: Oyez, 1970), 16.

17. Alfred North Whitehead, *Adventures of Ideas* (New York: Macmillan and Co., 1933), 177.

18. Ibid., 209.

19. Ibid., 177–78.

20. Newman in Johnson, *American Artists on Art*, 19.

21. Motherwell, lecture at Hunter College, Feb. 1954, quoted in Mattison, *Motherwell*, 10.

22. Whitehead, *Adventures of Ideas*, 200–202.

23. Ibid., 237–38.

24. Ibid., 262, quoted in Emmet, "Whitehead," 293.

25. A. N. Whitehead, *Process and Reality: An Essay in Cosmology* ([1929] New York: Free Press, 1978), 184; Emmet, "Whitehead," 293; Whitehead, *Adventures of Ideas*, 228.

26. Whitehead, *Adventures of Ideas*, 243–44.

27. Jackson Pollock, quoted in Claude Cernuschi, *Jackson Pollock: Meaning and Significance* (New York: HarperCollins, 1992), 144.

28. For a neurophysiological critique of Hume's metaphysics from a clinical perspective, see Oliver Sachs, "The Possessed," in *The Man Who Mistook His Wife for a Hat and Other Clinical Tales* (New York: Harper and Row, 1987), 120–25.

29. Whitehead, *Adventures of Ideas*, 209–10.

30. Emmet, "Whitehead," 293.

31. Whitehead, *Modes of Thought* (New York: Macmillan, 1938), 232, quoted in Emmet, "Whitehead," 295. *Modes of Thought* is composed of the materials originally presented in the lectures at Wellesley that Robert Motherwell attended.

32. On immanence in postmodern or "field" poetry see Charles Altieri, "From Symbolist Thought to Immanence: The Ground of Postmodern American Poetics," *Boundary 2* 1:3 (Spring 1973): 605–37.

33. See Olson, *Selected Writings*, Robert Creeley, ed. (New York: New Directions, 1966), 160–61.

34. Tom Clark, *Charles Olson: The Allegory of a Poet's Life* (New York: W. W. Norton and Co., 1991), 113.

35. See Dwight Macdonald, "The Root Is Man," Politics 3:4 (April 1946): 97.

36. Charles Olson to Robert Creeley, "Mayan Letters" #13 (April 1, 1951) in Olson, *Selected Writings*, 112.

37. American Indian activist Vine Deloria, Jr., has also drawn this parallel, in *The Metaphysics of Modern Existence* (New York: Harper and Row, 1979).

38. Olson, "He / in the dark stall," *The Collected Poems of Charles Olson*, George F. Butterick, ed. (Berkeley: University of California Press, 1987), 266. Olson's disclaimer concerning the distance between his attitudes and older forms of primitivism was repeated in his "Letter to Elaine Feinstein," of 1959: "I am talking from a new 'double axis': the replacement of the Classical-representational by the *primitive-abstract*. I mean of course not at all primitive in that stupid use of it as opposed to civilized. One means it now as 'primary,' as how one finds anything, pick it up as one does new—fresh/first." *Selected Writings*, 28.

39. Donald Allen published a collection of Olson's speculative writings under the title *Proprioception* in 1965. Many of these writings had been published previously by LeRoi Jones. See Clark, *Charles Olson*, 278.

40. Olson, "Projective Verse," 395.

41. Walter Ong, *Orality and Literacy: The Technologizing of the Word* (New York: Methuen, 1982), 32–33.

42. See Charles Olson, "Letter to Elaine Feinstein," in *Selected Writings*, 28.

43. Olson, "Guggenheim Fellowship Proposal, 1948," in *Olson: The Journal of the Charles Olson Archives* 5 (Spring 1976): 32. See also George F. Butterick, *A Guide to the Maximus Poems of Charles Olson* (Berkeley: University of California Press, 1978), xxi.

44. This poem is included in Charles Olson, *Maximus Poems*, George F. Butterick, ed. (Berkeley: University of California Press, 1983), as "Maximus to Gloucester, Letter 27 [withheld]," 184–85 [II.14–II.15].

45. Whitehead, *Adventures of Ideas*, 240–44. Emphases mine, to identify Olson's sources.

46. Ibid., 243–44.

47. As he wrote in "Maximus to Gloucester, Letter 3": "As the people of the earth are now, Gloucester is heterogeneous, and so can know polis not as localism. . . ."

48. Ibid., I.10.

49. Olson, "The Story of an Olson, and Bad Thing," *Collected Poems*, 175–82.

50. See Christine Poggi, *In Defiance of Painting: Cubism, Futurism, and the Invention of Collage* (New Haven: Yale University Press, 1992), 4–5, 12, 17. Similarly, Jean Dubuffet's *art brut* was concerned primarily with the representational uses of collage as a means of undermining the beaux arts tradition.

51. It is easy to perceive in this a rewording of Lautreamont's "chance meeting upon a dissecting table of a sewing machine and an umbrella." See chapter 1.

52. Carlo Carrá, "Piani plastici come espansione sferica nello spazio," *Lacerba* (March 15, 1913), quoted in Poggi, *In Defiance of Painting*, 167.

53. Papini, "Il Cerchio si chiude," *Lacerba* (Feb. 15, 1914), quoted in Poggi, *In Defiance of Painting*, 185–86.

54. Motherwell, "Beyond the Aesthetic," quoted in E. A. Carmean, Jr., *The Collages of Robert Motherwell* (Houston: Museum of Fine Arts, 1972), 91.

55. See, for instance, Robert Motherwell, "The Modern Painter's World," *Dyn* 6 (Nov. 1944): 9.

56. Carmean, *Collages of Robert Motherwell*, 32.

57. "Robert Motherwell: A Conversation at Lunch," in *An Exhibition of the Work of Robert Motherwell* (Northampton, MA: Smith College, 1963), quoted in Carmean, *The Collages of Robert Motherwell*, 93.

58. Helen Hutton, *The Technique of Collage* (New York: Watson-Guptill, 1968), 9.

59. "Robert Motherwell: A Conversation at Lunch," quoted in Carmean, *Collages of Robert Motherwell*, 93.

60. See Charles O. Hartman, *Jazz Text* (Princeton: Princeton University Press, 1991), 38.

61. Robert Hobbs, *Lee Krasner* (New York: Abbeville Press, 1993), 57–61.

62. Barbara Rose, *Lee Krasner: A Retrospective* (New York: Museum of Modern Art, 1983), 13, 37, 43, 45, 50.

63. I use the term "collage" to describe poetry into which the poet has imported entire blocks of writing from other sources; not, as the term has sometimes been used, to describe any poetry with radical narrative discontinuities. See, for instance, Andrew Clearfield, *These Fragments I Have Shored: Collage and Montage in Early Modernist Poetry* (Ann Arbor, UMI Research Press, 1984), 9.

64. William Carlos Williams, *Paterson* (New York: New Directions, 1963), 212–13.

65. Olson, *Selected Writings*, 82–83.

66. Williams, *Paterson*, 44–45.

67. Ibid., 43.

68. Olson, "The Song and Dance Of," *Maximus Poems*, I.54–I.58.

69. Ezra Pound, "Cavalcanti," in *Make It New: Essays* (London: Faber and Faber, 1934), 348–49, quoted in Butterick, *A Guide to the Maximus Poems*, 89–90.

Chapter Six
GESTALT

1. Quoted in Martin Duberman, *Black Mountain: An Exploration in Community* (New York: E. P. Dutton, 1972), 377. For Goodman's reference to the literal nature of these metaphors, see Frederick Perls, Ralph Hefferline, and Paul Goodman, *Gestalt Therapy: Excitement and Growth in the Human Personality* (New York: Dell, 1951), 180.

2. Robert Motherwell, "Beyond the Aesthetic" (April 1946); reprinted in Motherwell, *The Collected Writings of Robert Motherwell*, Stephanie Terenzio, ed. (New York: Oxford University Press, 1992), 36.

3. See Paul Goodman, "Better Judgement and Public Conscience," *Partisan Review* (July-Aug. 1942), and the original version, published as "Volition and 'Public Conscience,'" in Goodman, *Drawing the Line: The Political Essays of Paul Goodman,* Taylor Stoehr, ed. (New York: Free Life Editions, 1977). Goodman wrote in the original: "Almost all prepared the war by their arduous corporate labor"(109).

4. There is as yet no comprehensive biography of Paul Goodman; one certainly ought to be written. This sketch of Goodman's career is taken from the chronology in Kingsley Widmer, *Paul Goodman* (Boston: Twayne, 1980), 13–15.

5. Reinhold Niebuhr, *The Children of Light and the Children of Darkness* (New

York: Charles Scribner's Sons, 1944). Louis Fischer and Richard Wright in *The God That Failed: Six Studies in Communism*, Richard Crossman, ed. (London: Hamish Hamilton, 1950). See John W. Coffey, *Political Realism in American Thought* (Cranbury, NJ: Associated University Presses, 1977), 77, 93, and 128; Joel Rosenthal, *Righteous Realists: Political Realism, Responsible Power, and American Culture in the Nuclear Age* (Baton Rouge: Louisiana State University Press, 1991), 8 and 123; William S. Graebner, *The Age of Doubt: American Thought and Culture in the 1940s* (Boston: Twayne, 1991), 48; and Victor Navasky, *Naming Names* (New York: Penguin, 1991), 52.

6. Tom Clark, *Charles Olson: The Allegory of a Poet's Life* (New York: Norton, 1991), 217–19.

7. Navasky, *Naming Names*, ix, 20–21, 44, 83–85. Richard Polenberg, *One Nation Divisible: Class, Race, and Ethnicity in the United States since 1938* (New York: Penguin, 1980), 91.

8. George Tindall and David Shi, *America: A Narrative History*, brief 2d ed. (New York: Norton, 1989), 823–24. Graebner, *Age of Doubt*, 61–62. Polenberg, *One Nation Divisible*, 146–49. William O'Neill, *American High: The Years of Confidence, 1945–1960* (New York: Free Press, 1986), 212–13. Will Herberg, *Protestant-Catholic-Jew: An Essay in American Religious Sociology* (Chicago: University of Chicago Press, 1955), 2–3, 12–14, 23, 31, 38–39, 48–50, 59–60, 82–83, 258.

9. Polenberg, *One Nation Divisible*, 99, 103–5. Graebner, *Age of Doubt*, 49–50. Daniel Bell, *The End of Ideology: On the Exhaustion of Political Ideas in the Fifties* (New York: Free Press, 1962), 402.

10. John Diggins, *The Proud Decades: America in War and Peace, 1941–1960* (New York: Norton, 1988), 73–74.

11. Edward Steichen, ed., *The Family of Man* (New York: Museum of Modern Art, 1955), especially 58–59, 64–66, 120–26. See also Roland Barthes, "The Great Family of Man," in *Mythologies*, Annette Lavers, trans. (New York: Farrar, Straus, and Giroux, 1972), 100–103.

12. John Blum, *V Was for Victory: Politics and American Culture during World War II* (New York: Harcourt Brace Jovanovich, 1976), 325–29. George Lipsitz, *Class and Culture in Cold War America: A Rainbow at Midnight* (South Hadley, MA: Bergin and Garvey, 1982), 2–8. See also Seymour Melman, *The Permanent War Economy* (New York: Simon and Schuster, 1974).

13. O'Neill, *American High*, 73. Kenneth Jackson, *Crabgrass Frontier: The Suburbanization of the United States* (New York: Oxford University Press, 1985), 191 and 232–34. Tindall and Shi, *America*, 816–20 and 862. Diggins, *Proud Decades*, 99. Graebner, *Age of Doubt*, 125. Lipsitz, *Class and Culture in Cold War America*, 112 and 129. Thomas Geoghegan, *Which Side Are You On?* (New York: Penguin, 1991), 52. Clyde Barrow, *Universities and the Capitalist State: Corporate Liberalism and the Reconstruction of American Higher Education* (Madison: University of Wisconsin Press, 1990), 4, 9, 251, 253, and 258.

14. C. Wright Mills, *White Collar: The American Middle Classes* (New York: Oxford University Press, 1951). Elaine Tyler May, *Homeward Bound: American Families in the Cold War Era* (New York: Basic Books, 1988), 14 and 208–11.

15. May, *Homeward Bound*, 16–19 and 94–96. Andrea Weiss and Greta Schiller, *Before Stonewall: The Making of a Gay and Lesbian Community* (New York: Naiad Press, 1988), 42.

16. Goodman, "A Touchstone for the Libertarian Program," reprinted in *Drawing the Line*, 17–20.

17. The influence of existentialism is evident here and is striking in other works by Fromm, such as *Escape from Freedom* (1941).

18. Paul Goodman, "The Political Meaning of Some Recent Revisions of Freud," *Politics* 2:7 (July 1945): 197–99.

19. See David Riesman, "Some Observations on Community Plans and Utopias," in *Individualism Reconsidered and Other Essays* (Garden City, NY: Doubleday Anchor, 1954), 70–98. Richard King, *The Party of Eros: Radical Social Thought and the Realm of Freedom* (Chapel Hill: University of North Carolina Press, 1972), 46.

20. Paul Goodman, "Political Meaning," 201, 198.

21. Perls et al., *Gestalt Therapy*, 307. Emphases mine.

22. Ibid., 77, 97, 337–39.

23. Ibid., 311, 303.

24. Ibid., 307, 242, and 311.

25. After 1933, Reich's thinking rapidly deteriorated into scientism and paranoia. But his thinking before that date remains of interest. Reich died in an American prison in 1957, where he was serving a sentence for mail fraud in relation to the distribution of "orgone accumulators." For a brief history of Reich's career see Janine Chassegut-Smirgel and Béla Brunberger, *Freud or Reich? Psychoanalysis and Illusion*, Claire Pajaczkowska, trans. (New Haven: Yale University Press, 1986), 102–8.

26. Wilhelm Reich, *The Sexual Revolution: Toward a Self-Governing Character Structure*, rev. ed., Theodore P. Wolfe, trans. (New York: Farrar, Strauss, and Giroux, 1969), 10 and 4. King, *Party of Eros*, 61.

27. Goodman, "Political Meanings," reprinted in Goodman, *Nature Heals: The Psychological Essays of Paul Goodman*, Taylor Stoehr, ed. (New York: Free Life Editions, 1977), 55.

28. Perls also numbered other important figures of the later counterculture among his circle, including improvisational dance artist Ann Halprin; Charlotte Selver, pioneer of "tactile" and "self-expressive" therapy; and Selver's companion, Alan Watts, a popularizer of Zen Buddhism. Martin Shepard, *Fritz* (New York: Saturday Review Press, E. P. Dutton and Co., 1954), 2–3, 56–61, 64.

29. Perls et al., *Gestalt Therapy*, 228, 25, and xii. Gestalt psychology also formed the basis of E. F. Gombrich's defense of modern art in *Art and Illusion*, published by the Bollingen Foundation in 1955.

30. Perls et al., *Gestalt Therapy*, 328. Widmer, *Paul Goodman*, 92. Paul Christensen, *Charles Olson: Call Him Ishmael* (Austin: University of Texas Press, 1979), 29.

31. Jay Stevens, *Storming Heaven: LSD and the American Dream* (New York: Harper and Row, 1987), 130–31. Widmer, *Paul Goodman*, 93. Timothy Leary, *High Priest* (New York: World Publishing Co., 1968), 13.

32. Shepard, *Fritz*, 61.

33. Perls et al., *Gestalt Therapy*, 10–11. Paul Goodman, *Five Years* (New York: Brussel and Brussel, 1966), 18.

34. Perls et al., *Gestalt Therapy*, ix.

35. American psychology since the 1920s had divorced "attitude" from its etymological roots linking it to body posture, so that it was generally held to refer to a purely mental phenomenon. Both Freudians and behaviorists had fostered this split-

ting, although John Dewey had combated it. In mid-twentieth-century America, the word "attitude" connoted a general mental perspective, more emotional and less articulate than an "opinion." Unlike an opinion, everyone had one. It remained for Gestalt therapy to reincorporate bodily attitude into this disembodied psychological notion. See Donald Fleming, "Attitude: The History of a Concept," *Perspectives in American History* 1 (1967): 287–365.

36. Perls et al., *Gestalt Therapy*, 180 and 162.

37. Ibid., 231. Goodman, *Five Years*, 19.

38. Perls et al., *Gestalt Therapy*, 75.

39. Goodman, "The Emperor of China," *Possibilities* 1 (1947–48): 7.

40. Ibid.

41. Ann Gibson, interview with Robert Motherwell, cited in Gibson, "Theory Undeclared: Avant-Garde Magazines as a Guide to Abstract Expressionist Images and Ideas" (Ph.D. diss., University of Delaware, 1984), 399, n. 6.

42. Perls et al., *Gestalt Therapy*, 95.

43. Ibid., 33.

44. Goodman, "Advance-Guard Writing in America: 1900–1950," *Kenyon Review* 13 (1951): 357; reprinted in Goodman, *Creator Spirit, Come! The Literary Essays of Paul Goodman*, Taylor Stoehr, ed. (New York: Free Life Editions, 1977), 153.

45. Goodman, *Five Years*, 22. Perls et al., *Gestalt Therapy*, 395.

46. Perls et al., *Gestalt Therapy*, 234.

47. Ibid., 395–96.

48. Ibid., 3.

49. Ibid., 78, 313, and 316. Goodman felt that only when words were detached from authentic contact could the self-abjuration and false consensus that characterized contemporary America occur (28). Similarly, he wrote, the Freudian technique of verbal free association allowed a patient to skirt issues verbally, whereas proprioceptive contact in conjunction with free association addressed specific resistances and encompassed all experiences, not just mental memories.

50. Perls et al., *Gestalt Therapy*, 320–21. Emphasis mine.

51. Ibid., 331.

52. Ibid., 323, 108, 321.

53. Ibid., 245.

54. Paul Goodman, "Excerpts from a Journal: The Legs of My Dog," *Instead* 3 (April 1948), n.p. The contents of *Instead* reflected surrealist and existentialist influences. Its editors were Matta Echaurren, Lionel Abel, and Harold Rosenberg. See Ann Gibson, "Theory Undeclared," 82–97.

Chapter Seven
THE BODY IN PLASTIC DIALOGUE:
DANCE AND CERAMICS

1. Charles Olson, letter to M. Wildenhain, March 8, 1952, published in *Olson: The Journal of the Charles Olson Archives* 8 (Fall 1977): 23.

2. Roger Copeland, "Merce Cunningham and the Politics of Perception," in Roger Copeland and Marshall Cohen, eds., *What Is Dance? Readings in Theory and Criticism* (New York: Oxford University Press, 1983), 307–24.

3. Stephen Polcari, *Abstract Expressionism and the Modern Experience* (New York: Cambridge University Press, 1991), 49–50.

4. Copeland, "Cunningham," 309.

5. See Joe Klein, *Woody Guthrie: A Life* (New York: Knopf, 1980), 147.

6. Don McDonagh, *The Rise and Fall and Rise of Modern Dance* (Chicago: a capella Press, 1990), 25–26.

7. Charles Olson, *Letters for Origin, 1950–56*, Albert Glover, ed. (London: Cape Goliard Press, 1969), 53.

8. Charles Olson, "Katherine Litz Dance Concert: A Review," *Olson: The Journal of the Charles Olson Archives* 8 (Fall 1977): 16–20.

9. Charles Olson, "Applause (for Nick Cernovich)," *The Collected Poems of Charles Olson*, George F. Butterick, ed. (Berkeley: University of California Press, 1987), 227.

10. Charles Olson, "Apollonius of Tyana," in Robert Creeley, ed., *Selected Writings* (New York: New Directions, 1966), 138–39.

11. Ibid., 148.

12. Olson, "Human Universe," *Selected Writings*, 60–61.

13. McDonagh, *Rise and Fall*, x.

14. Ibid., 36.

15. John Cage, quoted in Copeland, "Cunningham," 321–22. Compare Charles Olson in "The Story of an Olson, and Bad Thing," in *Collected Poems*, 179: "multiple observation at the same instant that others / make less multiple observations, is the difference" (see chapter 5). See also Lynn Garafola, "Toward an American Dance: Dance in the City," in Leonard Wallock, ed., *New York: Culture Capital of the World, 1940–1965* (New York: Rizzoli International Publications, 1988), 178.

16. Cunningham, quoted in McDonagh, *Rise and Fall*, 37.

17. Merce Cunningham, "Two Questions and Five Dances," *Dance Perspective* 34 (Summer 1968); reprinted in Selma Jeanne Cohen, ed., *Dance as a Theatre Art: Source Readings in Dance History* (New York: Harper and Row, 1974), 198–204.

18. McDonagh, *Rise and Fall*, 43.

19. Copeland, "Cunningham," 315. Emphasis his.

20. Cunningham in Stanley Rosner, ed., *The Creative Experience* (New York: Grossman Publishers, 1970), 182–83.

21. Willa Cooper Needler, "Improvisation and Group process," M.A. thesis, Wesleyan University, 1979. See also Cynthia Novack, *Sharing the Dance: Contact Improvisation and American Culture* (Madison: University of Wisconsin Press, 1990), 166–74.

22. Mary Lynn Kotz, *Rauschenberg: Art and Life* (New York: H. N. Abrams, 1990), 76.

23. Ibid., 78–79 and 115. See also James Leggio, "Robert Rauschenberg's *Bed* and the Symbolism of the Body," *Studies in Modern Art*, vol. 2, *Essays in Assemblage*, John Elderfield, ed. (New York: Museum of Modern Art, 1992).

24. Quoted in Michael Kirby, ed., *Happenings* (New York: E. P. Dutton, 1965), 44–45.

25. See Joseph Ruzicka, "Jim Dine and Performance," in *Studies in Modern Art*, vol. 1, *American Art of the 1960s* (New York: Museum of Modern Art, 1991), 97–121.

See also Russell Ferguson, ed., *Hand-Painted Pop: American Art in Transition, 1955–62* (Los Angeles: Museum of Contemporary Art, 1992).

26. Kotz, *Rauschenberg*, 118.

27. Ibid., 115.

28. Ibid., 116.

29. Quoted in Rose Slivka, *Peter Voulkos: A Dialogue with Clay* (Boston: New York Graphic Society, 1978), 52.

30. Quoted in Mary Emma Harris, *The Arts at Black Mountain College* (Cambridge, MA: MIT Press, 1987), 191.

31. See William Morris, *Selected Writings*, G. D. H. Cole, ed. (New York: Random House, 1934). Eileen Boris, *Art and Labor: Ruskin, Morris, and the Craftsman Ideal in America* (Philadelphia: Temple University Press, 1986). David Whisnant, *All That Is Native and Fine: The Politics of Culture in an American Region* (Chapel Hill: University of North Carolina Press, 1983). T. J. Jackson Lears, "The Figure of the Artisan: Arts and Crafts Ideology," in *No Place of Grace: Antimodernism and the Transformation of American Culture, 1880–1920* (New York: Pantheon, 1981), 59–96.

32. Warren Mackenzie described Leach's objective as "to produce sound handmade pots and to sell them at a price which would allow people of moderate means to use them in their daily lives." Mackenzie, introduction to *The Quiet Eye: Pottery of Shoji Hamada and Bernard Leach* (Monterey, CA: Monterey Peninsula Museum of Art, 1990), 21–22.

33. Ibid., 25.

34. See Soetsu Yanagi et al., "Mingei Revisited," *Studio Potter* 25:1 (Dec. 1996): 1–25.

35. Mackenzie, *Quiet Eye*, 1.

36. Thomas Hoover, in *Zen Culture* (London: Routledge, 1988), 186–98, summarizes these aesthetic principles in the three terms *shibui, wabi,* and *sabi. Shibui* means spare yet strong. *Wabi* translates as simple sincerity and naiveté, as of a peasant from a remote province. *Sabi* refers to a quality of asymmetry and imperfection, as of an object worn, cracked, and mellowed by use. In the spring of 1960, *It Is* magazine published an essay by Hoseki Shin'ichi Hisamatsu, Zen master and professor at the Kyoto College of Fine Art, listing seven characteristics of Zen art, which he translated as: asymmetry, simplicity, austerity, naturalness, subtle profundity, unworldliness, and quietness. See "Seven Characteristics of Zen Art by Hoseki Shin'ichi Hisamatsu," *It Is* 5 (Spring 1960): 62–64.

37. See Dore Ashton, *The Unknown Shore: A View of Contemporary Art* (Boston: Little, Brown, and Co., 1962), 104.

38. Sokei-An, *Cat's Yawn* ([1940–41] New York: First Zen Institute of America, 1947) 1:2 (Aug. 1940): 5. Zen Buddhism is a Japanese derivative of the Chinese Ch'an Buddhism, which is heavily influenced by Taoism and therefore differs greatly from the Buddhism of the Indian subcontinent in precept and ritual. The first Zen master to travel to the United States was Soyen Shaku, who was invited to attend the Parliament of Religions at the Columbian Exposition in Chicago, in 1893. At this time, he was treated as an exotic curiosity. Soyen Shaku charged his disciples, Daisetz Suzuki and Sokatsu Shaku, with bringing a true understanding of Zen to America. Sokatsu Shaku's disciple Sokei An founded the First Zen Institute of America in 1930 on West 70th Street in New York City. He published *Cat's Yawn* from 1940 to 1941,

ceasing to teach with the Japanese bombing of Pearl Harbor. See also: Rick Fields, *How the Swans Came to the Lake: A Narrative History of Buddhism in America*, 3d ed. (Boston: Shambhala, 1992).

39. Daisetz Suzuki, *Zen and Japanese Culture*, 2d ed. (New York: Pantheon Books, 1959), 14.

40. Ibid., 14–15. The Zen conception of the self as always already constituted through the unconscious body is dramatized in a famous Zen *koan* (parable or riddle): Buddha saw his wiser self (Monju) standing outside the gate and invited him in. Monju replied, "There is no way outside the gate. Why do you ask me in?" (Yoel Hoffmann, *Every End Exposed: The 100 Koans of Master Kido* [Brookline, MA: Autumn Press, 1977], 19.) This *koan* presents the subject/object dichotomy as a fiction of the conscious mind.

41. Sherman E. Lee, *Tea Taste in Japanese Art* (New York: Asia Society, 1963), 27–31.

42. Jackson Pollock, interview with William Wright, 1950, quoted in Ellen H. Johnson, ed., *American Artists on Art, from 1940 to 1980* (New York: Harper and Row, 1982), 8.

43. Lee, *Tea Taste*, 33. In 1905, American visitors to the temple of Sokatsu Shaku described the Zen master painting monumental calligraphy this way: "Seizing the great brush, big as a horse's tail, he flung like lightning four Chinese characters on the eight-foot length of silk canvas." Sokei-An, *Cat's Yawn* 1:3.

44. Daisetz Suzuki, *Essentials of Zen Buddhism* (New York: Dutton, 1962), xvii.

45. Hoover, *Zen Culture*, 197.

46. Yanagi, *The Unknown Craftsman: A Japanese Insight into Beauty*, adapted by Bernard Leach, foreword by Shoji Hamada (New York: Kodansha International, 1978), 98. Compare the Arts and Crafts aesthetic of John Ruskin in *The Stones of Venice*, vol. 2 (1853): "Imperfection is in some sort essential to all we know of life. It is the sign of life in a mortal body. . . . To banish imperfection is to destroy expression, to check exertion, to paralyze vitality." Quoted in Hoover, *Zen Culture*, 195.

47. Yanagi, *Unknown Craftsman*, 185.

48. See *The Sound of the One Hand: 281 Zen Koans with Answers*, Yoel Hoffmann, trans. (New York: Basic Books, 1975), 47.

49. M. C. Richards, *Centering: In Pottery, Poetry, and the Person* (Middletown, CT: Wesleyan University Press, 1964), 9.

50. Ibid., 15–16.

51. Ibid., 19.

52. Mackenzie, *Quiet Eye*, 27.

53. Martin Duberman, *Black Mountain: An Exploration in Community* (New York: E. P. Dutton, 1972), 343.

54. Slivka, *Voulkos*, 16.

55. Ibid., 32. Martin Eidelberg, ed., *What Modern Was: Design, 1935–1965* (New York: Harry N. Abrams, 1991), 291.

56. Quoted in Slivka, *Voulkos*, 34.

57. Quoted in ibid., 27.

58. Ibid., 27 and 40.

59. Slivka, "The New Ceramic Presence," *Craft Horizons* (July/Aug. 1961); reprinted in Slivka, *Voulkos*, 137.

60. Slivka, *Voulkos*, 18. Soetsu Yanagi, too, felt the bounds of his folk aesthetic stretched to their breaking point; he wrote in consternation of the "present craze for deliberate deformation" of pots (Yanagi, *Unknown Craftsman*, 121).

61. Eidelberg, ed., *What Modern Was*, 401.

62. Toshiko Takaezu, interview with the author, Aug. 10, 1993, in Quakertown, NJ. All following quotations of Takaezu also come from this interview.

Chapter Eight
BEBOP

1. Quoted in Grover Sales, *Jazz: America's Classical Music* (New York: Prentice-Hall, 1984), 117. See also Don Heckman, "Pres and Hawk: Saxophone Fountainheads," *Down Beat* (Jan. 3, 1963): 20–22; reprinted in Lewis Porter, ed., *Lester Young: A Reader* (Washington: Smithsonian Institution Press, 1991), 258.

2. Linguistically, prosody refers to those elements of a verbal utterance that are not contained in the symbolic sign that is the word, but communicated through other means: rhythm, accent, tone, timbre—the musical elements of speech made by the body and, as Paul Zumthor has written in his study of oral poetry, "otherwise untranslatable into language." Paul Zumthor, *Oral Poetry: An Introduction*, Kathryn Murphy-Judy, trans. (Minneapolis: University of Minnesota Press, 1990), 131, 138.

3. See LeRoi Jones, *Blues People: The Negro Experience in White America and the Music That Developed from It* (New York: William Morrow, 1963), 176. See also David Stowe, *Swing Changes: Big Band Jazz in New Deal America* (Cambridge, MA: Harvard University Press, 1994).

4. Jones, *Blues People*, 26–27 and 175–76.

5. Ira Gitler, *Swing to Bop: An Oral History of the Transition in Jazz in the 1940s* (New York: Oxford University Press, 1985), 4. See also Acklyn Lynch, "Black Culture in the Early Forties," in *Nightmare Overhanging Darkly: Essays on African American Culture and Resistance* (Chicago: Third World Press, 1993), 65.

6. See Thomas Kochman, "Fighting Words," in *Black and White Styles in Conflict* (Chicago: University of Chicago Press, 1981), 52–58; and Roger D. Abrahams, "Rapping and Capping: Black Talk as Art," in John F. Szwed, ed., *Black America* (New York: Basic Books, 1970), 134–35.

7. Gitler, *Swing to Bop*, 75, 80.

8. The Basie band was unusual among big bands for the creative license given to the players, for Count Basie used "head arrangements" (arrangements worked up together by the musicians during rehearsal and remembered) rather than the more standard written arrangements and charts. See Jones, *Blues People*, 182–84.

9. Gitler, *Swing to Bop*, 40.

10. Miles Davis, *Miles: The Autobiography* (New York: Simon and Schuster, 1989), 53–55. Lynch, "Black Culture in the Early Forties," 90–92.

11. Gitler, *Swing to Bop*, 5.

12. Ibid., 4–6.

13. Lynch, "Black Culture in the Early Forties," 57–64. See also Jones, *Blues People*, 177–82; and Amiri Baraka, *The Autobiography of LeRoi Jones* (New York: Freundlich Books, 1984), 57–62.

14. Quoted in Gitler, *Swing to Bop*, 311.

15. Ibid., 314.

16. Ibid., 225.

17. Davis, *Miles*, 77. See also Lynch, "Black Culture in the Early Forties," 88.

18. "How Deaf Can You Get?" *Time* 51:20 (May 17, 1948): 74.

19. Weldon Kees, "Muskrat Ramble: Popular and Unpopular Music," *Partisan Review* 15:5 (May 1948): 622.

20. In 1946, for instance, John Tasker Howard's 692-page third edition of *Our American Music* devoted only three and a half pages to jazz. Henry Pleasants, *Serious Music—and All That Jazz!* (New York: Simon and Schuster, 1969), 116. An essay in the *Partisan Review* in 1948 entitled "The State of American Music" mentioned only Aaron Copland, Charles Ives, and (in deprecating terms) John Cage. Kurt List, "Music Chronicle: The State of American Music," *Partisan Review* 15:1 (Jan. 1948): 85–90.

21. Gitler, *Swing to Bop*, 106–7.

22. Eric Salzman, *Twentieth-century Music* (Englewood Cliffs, NJ: Prentice-Hall, 1974), 29.

23. See "Consonance," *New Grove Dictionary of Music and Musicians*, vol. 4, 667–69. See also Charles O. Hartman, *Jazz Text* (Princeton: Princeton University Press, 1991), 71; and Ted Greene, *Jazz Guitar: Single Note Soloing* (Melville, NY: Dale Zdenek Publications, 1987), vol. 1, 82–83.

24. Hartman, *Jazz Text*, 16. For more published transcriptions of bebop solos in their harmonic contexts, see Porter, ed., *Lester Young Reader*, 217, 229.

25. Quoted in Gitler, *Swing to Bop*, 68.

26. Ibid., 86.

27. Quoted in Ted Gioia, *The Imperfect Art: Reflections on Jazz and Modern Culture* (New York: Oxford University Press, 1988), 118–19, from Gary Giddins, *Celebrating Bird* (New York: William Morrow, 1987), 66.

28. Sonny Criss, quoted in Gitler, *Swing to Bop*, 171.

29. Pleasants, *Serious Music*, 104.

30. See Lawrence Levine, *Highbrow/Lowbrow: The Emergence of Cultural Hierarchy in America* (Cambridge, MA: Harvard University Press, 1988), 59–60, 104–46, 178–82, and 188–93.

31. As John Szwed and Morton Marks have observed, "Everything we know about Afro-American musical performance style tells us that this music was played with greater flexibility and rhythmic subtlety than the notation of sheet music can suggest." John F. Szwed and Morton Marks, "The Afro-American Transformation of European Set Dances and Dance Suites," *Dance Research Journal* 20:1 (Summer 1988): 31–32. The term "bebop" itself is said to have originated from Gillespie's practice of scat singing his musical ideas to his sidemen because all the sixteenth and thirty-secondth notes made them too difficult to write down and to read. Gitler, *Swing to Bop*, 119.

32. I am applying to musical genres the method of cultural morphology explicated by Fredric Jameson in his essay "On Interpretation," in *The Political Unconscious: Narrative as a Socially Symbolic Act* (Ithaca: Cornell University Press, 1981), 35, 57, 63, and 81. Social conditions precipitate psychological and cultural responses, which register as modifications in existing discursive forms.

33. The song was by Ray Nobel. Barnet's rendition can be found on RCA Victor, *Great Dance Bands of the Thirties and Forties* (LPM-2081); and on RCA Victor, *Golden Anniversary Album* (PR-111).

34. "KoKo," recorded Nov. 26, 1945, Charlie Parker, alto sax; Dizzy Gillespie, trumpet, piano; Curley Russell, bass; Max Roach, drums; included in *The Smithsonian Collection of Classic Jazz* R033/P7-19477 (CBS, 1987).

35. See Barney Kessel, quoted in Gitler, *Swing to Bop*, 158.

36. Quoted in ibid., 170.

37. See George Simon, *The Big Bands* (New York: Macmillan, 1971), 40–69.

38. Pleasants, *Serious Music*, 134.

39. Quoted in Ronald Sukenick, *Down and In: Life in the Underground* (New York: Beech Tree Books, 1987), 11–12.

40. Miles Templar, Reply to Anatole Broyard, *Partisan Review* 15:9 (Sept. 1948): 1054.

41. Quoted in Gitler, *Swing to Bop*, 52.

42. Templar, Reply to Anatole Broyard, 1054. For the original criticism, see Anatole Broyard, "A Portrait of the Hipster," *Partisan Review* 15:6 (June 1948): 721–27.

43. Davis, *Miles*, 221–22. Without give-and-take among the soloists, the bebop sound would not come out right. In 1949, Miles Davis played with Oscar Pettiford's band, and later lamented: "That band wasn't into playing as a group. Everybody was playing these long solos and shit, trying to outdo the next guy. It was all fucked up and it was a shame, because it could have been something else." Davis, *Miles*, 125.

44. Archie Shepp, foreword to John Clellon Holmes, *The Horn* ([1958] New York: Thunder's Mouth Press, 1987), iii.

45. Davis, *Miles*, 89.

46. Quoted in Gitler, *Swing to Bop*, 302.

47. Templar, Reply to Anatole Broyard, 1054.

48. Davis, *Miles*, 70.

49. Ibid., 9.

50. Pleasants, *Serious Music*, 145.

51. Kenny Clarke, quoted in Gitler, *Swing to Bop*, 55.

52. Quoted in ibid., 52–54.

53. Ibid., 101, 106.

54. Among the most famous scat singers of the bebop era were Sarah Vaughan, Ella Fitzgerald, Betty Carter, Leo Watson, Mel Torme, Slim Gaillard, Babs Gonzales, Jackie Cain, Roy Kral, Dave Lambert, and Buddy Stewart. See Gitler, *Swing to Bop*, 232–33. See also Roy Carr, Brian Case, and Fred Dellar, *The Hip: Hipsters, Jazz, and the Beat Generation* (Boston: Faber and Faber, 1986), 22–25.

55. George Lipsitz has observed that the exclusion of African Americans from full participation in white society has meant that their subculture is not completely permeated by the values of the dominant culture. Lipsitz points out the ways in which black music (particularly rock and roll) has remained outside the particular discipline imposed by corporate industrialism, which valorizes predictability, reproducibility, impersonality, and delayed gratification. (George Lipsitz, "Dialogic Aspects of Rock and Roll," *Time Passages: Collective Memory and American Popular Culture* [Minneapolis: University of Minnesota Press, 1990], 111.) It seems necessary to add to Lipsitz's analysis that African American culture has preserved alternative values not only as the passive result of white exclusion. Historically, blacks have asserted grounds for rejecting assimilation to the dominant culture even when it seemed available as an option. See, for instance, James Baldwin, *The Fire Next Time*

(New York: Vintage, 1963), 40–44. African American culture is not defined by the absence of the dominant culture, but by the transplantation and hybridization of African cultures in America. See, for instance, William A. Stewart, "Understanding Black Language," in Szwed, ed., *Black America*, 123–26.

56. Jones, *Blues People*, 1, 6, and 142.

57. Thomas Kochman has traced this intersubjective dynamic through several aspects of African American secular and religious culture. See Thomas Kochman, "The Force Field," in *Black and White Styles in Conflict*, 109–10.

58. John Szwed, "Josef Skvorecky and the Tradition of Jazz Literature," *World Literature Today* 54:4 (Autumn 1980): 588.

59. See John Shepherd, *Music as Social Text* (Cambridge: Polity Press, 1991), 20. See also Thomas Kochman, "Information as Property," in *Black and White Styles in Conflict*, 97–98.

60. As Thomas Kochman has written, "about the only *incorrect* thing you can do is not to respond at all." Kochman, "Force Field," 111.

61. Rollo May and I. Yalom, "Existential Psychotherapy," in Raymond J. Corsini, ed., *Current Psychotherapies*, 3d ed. (Itasca, IL: F. E. Peacock, 1984), 358. See also Michael O'Malley, *Keeping Watch: A History of American Time* (New York: Viking, 1990).

62. Alan Trachtenberg, *The Incorporation of America* (New York: Hill and Wang, 1982), 60. Van English, "Daylight Savings Time," in *Encyclopedia Americana*, International ed. (Danbury, CT: Grolier, 1996), vol. 8, 548.

63. Lipsitz, *Time Passages*, 112.

64. Davis, *Miles*, 101.

65. Charles Keil, "Motion and Feeling in Music," *Journal of Aesthetics and Art Criticism* 24:3 (1966): 345. Cited in Kochman, "Force Field," 111.

66. LeRoi Jones to Charles Olson, Dec. 9, 1958, Olson Papers, Archives and Special Collections Department, Thomas J. Dodd Research Center, University of Connecticut Libraries; used with permission. Olson himself had written in 1951: "All that TIME IS, is RHYTHM (and there is no way of knowing any rhythym OTHER THAN YOUR OWN, than BY your own." Olson, *Letters for Origin, 1950–1956*, Albert Glover, ed. (London: Cape Goliard Press, 1969), 83.

67. "[T]ime the physical event (or spiritual, emotional, psychological, psychical &c. for that matter) but time the phenomenon." Jones to Olson, Dec. 9, 1958.

68. Davis, *Miles*, 100.

69. Zumthor, *Oral Poetry*, 24. See also Walter Ong, *The Presence of the Word* (New Haven: Yale University Press, 1967); and Ong, *Orality and Literacy: The Technologizing of the Word* (New York: Methuen, 1982), 11 and 36–57.

The distinction between oral and literate cultures is not dichotomous. The exact extent to which cultures can be characterized along a continuum from orality to literacy has been hotly debated by scholars.

Those thinkers supporting a distinction between the worldviews of cultures on the basis of literacy versus orality include Walter Ong, Jack Goody, Paul Zumthor, Franz Bauml, Brian Stock, Paul Saenger, Marshall McLuhan, and Albert Lord. See Lord, *The Singer of Tales* ([1960] Cambridge, MA: Harvard University Press, 1964); Goody, *The Domestication of the Savage Mind* (New York: Cambridge University Press, 1977); and Edmund Carpenter and Marshall McLuhan, "Acoustic Space," in Car-

penter and McLuhan, eds., *Explorations in Communication: An Anthology* (Boston: Beacon Press, 1960), 68. Eric Havelock's *Preface to Plato* (Cambridge, MA: Belknap Press, 1963), argued that it was the development of phonetics in particular that constituted a revolution in culture.

Negative responses to this distinction arose on the grounds that the characterization of "oral" cultures relied too heavily on primitivist discourses. See the critique by Ruth Finnegan, "Literacy versus Non-Literacy: The Great Divide?" in Robin Horton and Ruth Finnegan, eds., *Modes of Thought: Essays on Thinking in Western and Non-Western Societies* (London: Faber, 1973). Finnegan argued that so-called oral cultures must not be thought of as incapable of self-awareness, individualism, irony, or fictionality. See also Deborah Tannen, "The Myth of Orality and Literacy," in William Frawley, ed., *Linguistics and Literacy* (New York: Plenum Press, 1982).

A mutually satisfactory understanding seems possible. See Goody, *The Logic of Writing and the Organization of Society* (New York: Cambridge University Press, 1986), xv; and Finnegan, *Literacy and Orality: Studies in the Technology of Communication* (New York: Blackwell, 1988), 146 and 160. As the cultural determinism of Goody's earlier studies of oral culture has been tempered by a neo-Marxist argument that recognizes economic and cultural interpenetration, Finnegan has conceded that the distinction between literacy and orality does identify cultural orientations facilitating different forms of cognitive development.

70. Shepherd, *Music as Social Text*, 79.

71. Jones, *Blues People*, 28, 142, and 6.

72. Ibid., 26. For more on African languages having a class of words called "ideophones," or sound ideas, see Zumthor, *Oral Poetry*, 102.

73. Jack Kerouac, *On the Road* (New York: Viking Penguin, 1957), 146.

74. Richard White, *The Middle Ground: Indians, Empires, and Republics in the Great Lakes Region, 1650–1815* (New York: Cambridge University Press, 1991), x, 50–53. Paul Zumthor has written: "In other parts of the world, [our technological] civilization—being spread over terrain less suited to its rapid implantation—lets us perceive a reality that it condemns in the long run but with which it now colludes. African societies offer the perfect example of this." Zumthor, *Oral Poetry*, 46.

75. For a fictional treatment of this theme, see James Baldwin, "Sonny's Blues," reprinted in Marcela Breton, ed., *Hot and Cool: Jazz Short Stories* (New York: Penguin, 1990), 92–130. Baldwin offers an excellent description of the intersubjectivity of bebop as an alternative to alienation.

76. David Rosenthal, *Hard Bop: Jazz and Black Music, 1955–1965* (New York: Oxford University Press, 1992), 37–40 and 48. The late forties had witnessed an infusion of Afro-Cuban music into bebop. In 1948 and 1949, Charlie Parker recorded with Machito's Afro-Cuban orchestra. Cuban conga-drum player Chano Pozo brought Dizzy Gillespie's big band its distinctive Afro-Cuban rhythms, the basis of recordings like "Cubana Be, Cubana Bop." See Gitler, *Swing to Bop*, 292.

77. Rosenthal, *Hard Bop*, 21–22.

78. Other pioneers of free jazz in the 1950s included Cecil Taylor and Albert Ayler.

79. Rosenthal, *Hard Bop*, 75. David Amram, *Vibrations* (New York: Viking Press, 1968), 261–62. Larry Rivers, *What Did I Do? The Unauthorized Autobiography of Larry Rivers* (New York: HarperCollins, 1992). Rose Slivka, *Peter Voulkos: A Dialogue with*

Clay (Boston: New York Graphic Society, 1978), 40. Lee Krasner, quoted in B. H. Friedman, *Jackson Pollock: Energy Made Visible* (New York: McGraw Hill, 1972), 88–89.

Chapter Nine
THE BEATS

1. See Ann Charters, *Kerouac: A Biography* (San Francisco: Straight Arrow Books, 1973), 12. For a critical but sympathetic account of the beat generation from a contemporary social psychologist, see Francis J. Rigney, *The Real Bohemia: A Sociological and Psychological Study of the "Beats"* (New York: Basic Books, 1961). Michael Schumacher, *Dharma Lion: A Critical Biography of Allen Ginsberg* (New York: St. Martin's Press, 1992), 479–80.

2. Allen Ginsberg, "Dedication," *Howl and Other Poems* (San Francisco: City Lights Books, 1956). Ginsberg, "Improvised Poetics," interview, Nov. 26, 1968; reprinted in Ginsberg, *Composed on the Tongue,* Donald Allen, ed. (Bolinas, CA: Grey Fox Press, 1980), 43. Ginsberg, quoted in David H. Rosenthal, *Hard Bop: Jazz and Black Music, 1955–1965* (New York: Oxford University Press, 1992), 77.

3. Among the faculty of Columbia University, Raymond Weaver was the one from whom Kerouac and Ginsberg learned most. Weaver had written a book on Herman Melville, had studied Jungian psychology, and had traveled in Japan, where he gained knowledge of Zen Buddhism. Weaver gave Kerouac a reading list including Zen classics, Melville's *Pierre,* and the works of the Egyptian gnostics. Gerald Nicosia, *Memory Babe: A Critical Biography of Jack Kerouac* (New York: Penguin, 1983), 139. See also Ginsberg, "The New Consciousness" (1972) in *Composed on the Tongue,* 69; and Schumacher, *Dharma Lion,* 24.

4. Ginsberg, "The New Consciousness," *Composed on the Tongue,* 74.

5. Ginsberg, quoted in Carolyn Cassady, *Off the Road: My Years with Cassady, Kerouac, and Ginsberg* (New York: William Morrow, 1990), 108.

6. Huncke was a morphine addict. See Herbert Huncke, *Guilty of Everything: The Autobiography of Herbert Huncke* (New York: Paragon Books, 1990). Cassady had grown up with an alcoholic hobo father. See his autobiography, *The First Third* (San Francisco: City Lights Books, 1971).

7. Ginsberg, "A Conversation [between Paul Geneson and Allen Ginsberg]," Aug. 8, 1974, *Composed on the Tongue,* 98.

8. In asserting their religious/ethnic identities, however, the beats were far from allying themselves with the established voices that claimed to represent these constituencies in American political life. In fact, their alternative constructions of the religious traditions they had inherited constituted a direct challenge to the hegemony of those voices. See James T. Fisher, "Jack Kerouac and Thomas Merton: The Last Catholic Romantics," in *The Catholic Counterculture in America* (Chapel Hill: University of North Carolina Press, 1989), 225–29. Ginsberg, "Notes for *Howl and Other Poems,*" in Donald Allen and Warren Tallman, eds., *Poetics of the New American Poetry* (New York: Grove Press, 1973), 318. See also Ginsberg, "When the Mode of the Music Changes the Walls of the City Shake," in Allen and Tallman., 327. And Schumacher, *Dharma Lion,* 12.

9. Charters, *Kerouac,* 123. Ginsberg, "Howl," in *Collected Poems, 1947–1980* (New York: Harper and Row, 1984), 131. Kerouac, "The Art of Fiction XLI: Jack Ker-

ouac," *Paris Review* 43 (Summer 1968), quoted in Kerouac, *Safe in Heaven Dead: Interviews with Jack Kerouac*, Michael White, ed. (New York: Harriman Books, 1990), 61.

10. Ibid., 50–51. Ginsberg, "The New Consciousness," *Composed on the Tongue*, 71.

11. LeRoi Jones, "How You Sound??" in Donald Allen, ed., *The New American Poetry* (New York: Grove Press, 1960), 425.

12. Allen Ginsberg, "Improvised Poetics" (1968) in *Composed on the Tongue*, 40–41.

13. Ginsberg, "The New Consciousness," *Composed on the Tongue*, 93.

14. Ginsberg, *Journals: Early Fifties–Early Sixties*, Gordon Ball, ed. (New York: Grove Press, 1977), 4.

15. Ginsberg to Olson, Nov. 1958, Charles Olson Papers, Archives and Special Collections Department, Thomas J. Dodd Research Center, University of Connecticut Libraries. It was not until considerably later that Ginsberg finally met Ezra Pound. According to Ginsberg's account of their meeting in Italy in 1967, in the course of their discussion Pound repudiated both intentionality ("The intention was bad—that's the trouble—anything I've done has been an accident") and anti-Semitism ("my worst mistake was the stupid suburban prejudice of anti-Semitism, all along"). In this way Ginsberg managed to eliminate the stumbling blocks that had made Pound a problematic antecedent figure for him. Allen Ginsberg, "Encounters with Ezra Pound," in *Composed on the Tongue*, 8.

16. Schumacher, *Dharma Lion*, 183–84.

17. Glen Wallach, "The C.O. Link: Conscientious Objection to World War II and the San Francisco Renaissance" (Senior essay, American Studies, Yale University, 1981). See also Michael Davidson, *The San Francisco Renaissance: Poetics and Community at Mid-century* (New York: Cambridge University Press, 1989), 39; and Linda Hamalian, "The Genesis of the San Francisco Renaissance: Literary and Political Currents, 1945–1955," in *Literary Review: An International Journal of Contemporary Writing* 32:1 (Fall 1988): 5–41.

18. See Charles Olson, "Against Wisdom as Such," *Black Mountain Review* 1. Tom Clark, *Charles Olson: The Allegory of a Poet's Life* (New York: W. W. Norton and Co., 1991), 248.

19. See Martin Duberman, *Black Mountain: An Exploration in Community* (New York: E. P. Dutton, 1972), 386–93.

20. Ginsberg, "Improvised Poetics," *Composed on the Tongue*, 42.

21. Ed Dorn to Charles Olson, May 7, 1956; Olson to Dorn, undated; Charles Olson Papers; used with permission.

22. Charles Olson, "Notes for a University at Venice, California," *Olson: The Journal of the Charles Olson Archives* 2 (Fall 1974): 65–68.

23. Clark, *Olson*, 276–78.

24. For an account of Jones's indebtedness to Olson's poetics, see William J. Harris, *The Poetry and Poetics of Amiri Baraka: The Jazz Aesthetic* (Columbia: University of Missouri Press, 1985), 34, 37, and 102.

25. See Olson, *Proprioception* (Bolinas, CA: Four Seasons Foundation, 1965), a collection of Olson's writings first published by LeRoi Jones.

26. Ginsberg, "First Thought, Best Thought" (1974), *Composed on the Tongue*, 106.

27. Allen Ginsberg to Charles Olson, c. Nov. 19, 1958, Charles Olson Papers; used with permission.

28. Ginsberg, "Improvised Poetics," *Composed on the Tongue*, 26 and 55–56.

29. See Kerouac, "Essentials of Spontaneous Prose," in Ann Charters, ed., *The Portable Beat Reader* (New York: Viking, 1992), 57.

30. Kerouac, *The Subterraneans* (New York: Grove-Wiedenfeld, 1958), 29. Emphasis mine.

31. Jay Stevens, *Storming Heaven: LSD and the American Dream* (New York: Harper and Row, 1987), 136–48. Schumacher, *Dharma Lion*, 342–47. Clark, *Olson*, 292. See also Olson, "Under the Mushroom," *Muthologos: The Collected Lectures and Interviews*, vol. 1, George F. Butterick, ed. (Bolinas, CA: Four Seasons Foundation, 1978), 20–62.

32. Clark, *Olson*, 294. Robert Creeley also wrote that LSD heightened the feeling that he was an event in a field of forces. Robert Creeley, *Contexts of Poetry* (Bolinas, CA: Four Seasons Foundation, 1973), 131.

33. Clark Coolidge, "Notes taken in Classes Conducted by Charles Olson at the University of British Columbia, Vancouver, August, 1963," *Olson: The Journal of the Charles Olson Archives* 4 (Fall 1975): 48.

34. Michael McClure, *Scratching the Beat Surface* (San Francisco: North Point Press, 1982), 53. McClure, "Note in a depression early '58," in Allen, ed., *The New American Poetry*, 422–23. McClure, "Peyote Poem," *Scratching the Beat Surface*, 7. McClure, "Hymn to St. Geryon, I," ibid., 338. See also McClure's letter to Olson concerning peyote, ibid., 97.

35. McClure, "The Shape of Energy," *Scratching the Beat Surface*, 44–45.

36. Ginsberg, "Improvised Poetics," *Composed on the Tongue*, 33–34, 36.

37. Olson, "Notes on Language," Charles Olson Papers, Prose folder 41; used with permission.

38. Kerouac, *Paris Review* interview, in *Safe in Heaven Dead*, 81–82.

39. John Clellon Holmes, "The Great Rememberer," in *Nothing More to Declare* (New York: E. P. Dutton and Co., 1967), 78.

40. Quoted in Charters, *Kerouac*, 79. For examples of Cassady's epistolary style, see Charters, ed., *Portable Beat Reader*, 190–92 and 196.

41. Charters, *Kerouac*, 132–33.

42. Kerouac, quoted in Holmes, *Nothing More to Declare*, 78.

43. Kerouac, "Essentials of Spontaneous Prose," in Charters, ed., *Portable Beat Reader*, 57.

44. Kerouac, *Paris Review* interview, in *Safe in Heaven Dead*, 81–82.

45. Kerouac, quoted in Charters, *Kerouac*, 147.

46. Kerouac, "Essentials of Spontaneous Prose," in Charters, ed., *Portable Beat Reader*, 57.

47. Charters, *Kerouac*, 155, 163.

48. Kerouac, *Doctor Sax* (New York: Grove-Wiedenfeld, 1959), 3.

49. Holmes to Ginsberg, June 14, 1949, published in "An Early Exchange on Poetics: John Clellon Holmes and Allen Ginsberg," in Arthur Knight and Kit Knight, eds., *Unspeakable Visions of the Individual*, vol. 10 (California, PA: A. W. Knight, 1980), 103. Michel Foucault, *The History of Sexuality*, trans. Robert Hurley (New York: Vintage, 1978), 58–62. Jack Kerouac, *Visions of Cody* (New York: Penguin, 1972), 351.

50. Ginsberg, "First Thought, Best Thought" (1974), *Composed on the Tongue*, 110. Kerouac, "Essentials of Spontaneous Prose," in Charters, ed., *Portable Beat Reader*, 58.

51. Ginsberg to Olson, Nov. 26, 1958, Charles Olson Papers.

52. Ginsberg, "When the Mode of the Music Changes," in Allen and Tallman, eds., *Poetics of the New American Poetry*, 324–25.

53. Kerouac, *Subterraneans*, 20.

54. Ibid., 14–15.

55. Kerouac, *Visions of Cody*, 261–62.

56. Ibid., 307.

57. Kerouac, *Subterraneans*, 3. Emphasis mine.

58. Kerouac, *On the Road* (New York: Viking Penguin, 1957), 37; see also 41–42.

59. Kerouac, "Essentials of Spontaneous Prose," in Charters, ed., *Portable Beat Reader*, 57. Emphasis in original.

60. Kerouac, "From October in the Railroad Earth," *Black Mountain Review* 7 (1957): 35.

61. Kerouac, *Visions of Cody*, 98.

62. Kerouac, *Subterraneans*, 19.

63.. These have been supplemented more recently by such works as Carolyn Cassady's *Off the Road*, making an intertextual discourse, though not a direct conversation.

64. Kerouac, *Mexico City Blues* (New York: Grove Press, 1959), 239. Emphases mine. Nicosia, *Memory Babe*, 65–67 and 124–25. Jim Christy, "Jack and Jazz: Woodsmoke and Trains," in John Montgomery, ed., *The Kerouac We Knew: Unposed Portraits* (Kentfield, CA: Fels and Firn Press, 1982), 43.

64. Holmes, *The Horn* ([1958] New York: Thunder's Mouth Press, 1988), 155.

66. Kerouac, *Visions of Cody*, 38–39.

67. Kerouac, "The Beginning of Bop," in *Kerouac's Last Word: Jack Kerouac in Escapade*, Tom Clark, ed. (Sudbury, MA: Water Row Press, 1986), 33–34.

68. Holmes, *Horn*, 8–10.

69. Kerouac, *Visions of Cody*, 351.

70. Holmes, *Horn*, 36.

71. Ibid., 64.

72. Other members of the combo were Eugene D'Hellemmes, bass; and Tommy Benford, drums. Because of the influence of the French musicians (who learned "le jazz hot" from the New Orleans masters) and the relatively early date (preceding the full-fledged evolution of bebop), this "Crazy Rhythm" has more of a "hot" than a "modern" sound. This explains why Cassady, in the dialogue as transcribed in the book, insists that it is a recording from the 1920s. But Kerouac was also right to be dubious of Cassady's date: in its complex phrasings, Hawkins's solo is clearly of a later period. In 1937, Hawkins had been traveling across Europe with a swing band, but at the border into Nazi Germany had been denied entry as an undesirable alien of "mongrel race." The white members of the band continued on into Germany; Hawkins turned aside to Paris, where his friend Benny Carter was living as an expatriate. The recording was originally issued as *Coleman Hawkins and His All-Star Jam Band* for Hughes Panassie and Charles Delauney's Swing label, and was later reissued in the Prestige Historical Series as Prestige 7633: *Django Reinhardt and the American Jazz Giants*.

73. Kerouac, *Visions of Cody*, 142–43. Other jazz musicians cited in this work include Gene Krupa ("Leave Us Leap"), Billie Holiday ("Them There Eyes" and "Good Morning Heartaches"), Charlie Parker ("Lover Man"), and Flip Phillips.

74. Kerouac, *Subterraneans*, 34–35.

75. Holmes, *Horn*, 154–55.

76. Carolyn Cassady, *Off the Road*, 168, 197.

77. Holmes, *Go* ([1952] Mamaroneck, NY: Paul P. Appel, 1977), 117.

78. Kerouac, *Visions of Cody*, 296.

79. Kerouac, *Mexico City Blues*, title page.

80. Kerouac, *Subterraneans*, 42.

81. Kerouac, "The Railroad Earth," *Lonesome Traveller* (New York: Grove-Wiedenfeld, 1960), 37–38. Ted Joans, an African American beat poet, similarly used syncopation and asymmetrical phrasing in his poems. See, for example, Joans, "Jazz Is My Religion," in Sascha Feinstein and Yusef Komunyakaa, eds., *The Jazz Poetry Anthology* (Bloomington: Indiana University Press, 1991), 104.

82. Ginsberg, "Notes for *Howl and Other Poems*," in Allen and Tallman, eds., *Poetics of the New American Poetry*, 318.

83. Ginsberg, "How *Kaddish* Happened," in Allen, and Tallman, eds., *Poetics of the New American Poetry*, 346.

84. Miles Davis, *Miles: The Autobiography* (New York: Simon and Schuster, 1989), 99.

85. Ginsberg, "Improvised Poetics," *Composed on the Tongue*, 33. Ginsberg linked tone, as the beats used it, to Ezra Pound's notion of "melopoeia." Pound had written: "[W]ords are charged, over and above their plain meaning, with some musical property, which directs the bearing or trend of that meaning . . . It is poetry on the borders of music, and music is perhaps the bridge between consciousness and the unthinking sentient and unsentient universe." Ezra Pound, "How to Read," *Polite Essays* (London: Faber and Faber, 1937), 170, 172.

86. Kerouac, "The Beginning of Bop," *Kerouac's Last Word*, 32.

87. Kerouac, "Old Angel Midnight," excerpted in Richard Kostelanetz, ed., *Text-Sound Texts* (New York: William Morrow, 1980), 133.

88. Kerouac, *Mexico City Blues*, 13. See James T. Jones, *A Map of Mexico City Blues: Jack Kerouac as Poet* (Carbondale: Southern Illinois University Press, 1992), 93–101.

89. Kerouac, *Mexico City Blues*, 107.

90. Ginsberg, "Notes for *Howl and Other Poems*," 318. Ginsberg, "Improvised Poetics," *Composed on the Tongue*, 46.

91. See chapter 3. See also Laszlo Géfin, *Ideogram: History of a Poetic Method* (Austin: University of Texas Press, 1982), 54.

92. Kerouac, *Mexico City Blues*, 75. See Jones, *A Map of Mexico City Blues*, 16, 41.

93. Robert Creeley to Charles Olson, May 24, 1950, in Charles Olson and Robert Creeley, *The Complete Correspondence*, George F. Butterick, ed. (Santa Barbara: Black Sparrow Press, 1980), vol. 1, 39.

94. Creeley, *Contexts of Poetry*, 48, 31–32.

95. David Amram, *Vibrations* (New York: Viking Press, 1968), 294.

96. The closest approach to group improvisation in jazz-poetry available on record is Kerouac's session with Zoot Sims and Al Cohn, done for Hanover Records in 1959, and released as *Blues and Haikus* (Hanover 5006). Kerouac's texts were later

published in Kerouac, *Scattered Poems* (San Francisco: City Lights Books, 1971). Some outtakes of the recording sessions are now available in *The Jack Kerouac Collection* boxed set, Rhino/Word Beat R-70939. In these recordings, Cohn and Sims can be heard improvising on the rhythms of Kerouac's haikus. This was more likely to be the case than that the poet would improvise words. As Ginsberg described the dynamic: "Kerouac would pronounce a little haiku like 'The bottom of my shoes are wet, from walking in the rain' and Al Cohn or Zoot Sims would take the rhythmic thing [Ginsberg sings] 'ta ba da ba ta ta, ta ta, ta da da ta ta ta,' a little haiku of music, then Kerouac would go, 'In my medicine cabinet, the winter fly has died of old age,' then Al Cohn would go 'Ta Ra ta ta da ta ta, ta ra ta ta, ta ra da da da.' So they would make rhythmic structures mirroring each other." Ginsberg, "The New Consciousness," *Composed on the Tongue*, 66–67.

97. Olson, "Notes on Language," Charles Olson Papers.

98. Paul Zumthor, *Oral Poetry: An Introduction*, Kathryn Murphy-Judy, trans. (Minneapolis: University of Minnesota Press, 1990), 119. Emphases mine.

99. Ginsberg, *Journals*, 109.

100. For the story of the *Chicago Review* and *Big Table*, see Edward de Grazia, *Girls Lean Back Everywhere: The Law of Obscenity and the Assault on Genius* (New York: Random House, 1992), 343–60. Other little magazines of the postwar decades included the *Evergreen Review*, Gil Sorrentino's *Neon*, LeRoi Jones's *yugen*, Ron Padsgett's *White Dove Review*, Dick Emerson's and Frederick Eckman's *Golden Goose*, Alexander Trocchi's *Merlin* (in Paris), *Fragmente* (published in Germany by Rainer Gerhardt), Cid Corman's *Origin*, Kenneth Patchen's *Ark*, and *Imagi*.

101. Ginsberg, "A Conversation [between Paul Geneson and Allen Ginsberg]," *Composed on the Tongue*, 95.

102. On the significance of reproducibility to the epistemology of the scientific method, see John Shepherd, *Music as Social Text* (Cambridge: Polity Press, 1991), 38–40.

103. Zumthor, *Oral Poetry*, 181.

104. Ginsberg, "Improvised Poetics," *Composed on the Tongue*, 20.

105. Zumthor, *Oral Poetry*, 117–18, 103, and 21.

106. See, for instance, Nicosia, *Memory Babe*, 492; and Barry Miles, *Ginsberg: A Biography* (New York: Viking, 1990), 196.

107. See Schumacher, *Dharma Lion*, 241–42; and Miles, *Ginsberg*, 215–16.

108. For an idiosyncratic approach to this idea, but one related to that of the beat and Black Mountain poets, see Marshall McLuhan, "Media Hot and Cold," in *Understanding Media* (New York: Mentor, 1964), 36–38.

109. Zumthor, *Oral Poetry*, 127.

Chapter Ten
BATTLING THE SOCIAL NEUROSIS

1. Serge Guilbaut, *How New York Stole the Idea of Modern Art: Abstract Expressionism, Freedom, and the Cold War*, Arthur Goldhammer, trans. (Chicago: University of Chicago Press, 1983), 189.

2. René d'Harnoncourt, "Challenge and Promise: Modern Art and Modern Society," *Magazine of Art* 41 (Nov. 1948): 251–52.

3. Frank C. Pierson, *Unions in Postwar America: An Economic Assessment* (New York: Random House, 1967), 48. Walter Galenson, *The American Labor Movement, 1955–1995* (Westport, CT: Greenwood Press, 1996), 16.

4. Union membership as a fraction of the total American workforce declined more than 10 percent between 1955 and 1961. Galenson, *American Labor*, ix, 1–2, 7, and 12–13. Archer Robinson, *George Meany and His Times* (New York: Simon and Schuster, 1981), 123.

5. Thomas Hine, *Populuxe* (New York: Alfred A. Knopf, 1986), 128–30.

6. John Diggins, *The Proud Decades: America in War and Peace, 1941–1960* (New York: W. W. Norton and Co., 1988), 187.

7. Diggins, *The Proud Decades*, 195. Charlie Gillett, *The Sound of the City: The Rise of Rock and Roll* (New York: Pantheon, 1983), xii.

8. Robert A. Divine, *Blowing on the Wind: The Nuclear Test Ban Debate, 1954–1960* (New York: Oxford University Press, 1978), 18, 16, and 157. For a more detailed treatment of this material, see Daniel Belgrad, "SANE and Beyond Sane: Poets and the Hydrogen Bomb, 1958–1960," in Chris Geist and Alison Scott, eds., *The Writing on the Cloud: American Culture Confronts the Atomic Bomb* (Lanham, MD: University Press of America, 1997).

9. See Lawrence S. Wittner, *Rebels Against War: The American Peace Movement, 1941–1960* (New York: Columbia University Press, 1969), chapter 9.

10. Pauling was a founding member of Everybody's Committee to Outlaw War. He won the Nobel Prize for chemistry in 1954, and the Nobel Peace Prize in 1962. See Anthony Serafini, *Linus Pauling: A Man and His Science* (New York: Paragon, 1989), 164–66, 177, 185.

11. Linus Pauling, *No More War!* (New York: Dodd, Mead, 1958), 209, 201. See also Serafini, *Pauling*, 193.

12. Winston Churchill, quoted in Allan Winkler, *Life under a Cloud* (New York: Oxford University Press, 1993), 59. SANE was concerned with maintaining its anti-Communist credentials. See Milton Katz, *Ban the Bomb: A History of SANE, the Committee for a Sane Nuclear Policy, 1957–1985* (New York: Greenwood Press, 1986), xii–xiii.

13. After Sputnik, the Eisenhower administration began to sponsor the test ban SANE had called for—as a way of justifying a hiatus on bomb development while it concentrated on a rocket delivery program. Willard Libby in the *New York Times*, April 26 and 28, 1957, quoted in Divine, *Blowing on the Wind*, 122. Libby, "The Nature of Radioactive Fallout and Its Effect on Man," *Hearings* before the Special Subcommittee on Radiation of the Joint Committee on Atomic Energy, 85th Cong., 1st sess., 691 (Washington, 1957), quoted in Divine, *Blowing on the Wind*, 136. Memorandum by the Commanding General, Manhattan Engineer District (Leslie Groves), Jan. 2, 1946, *Foreign Relations of the United States: 1946*, vol. 1, *General; The United Nations* (Washington, D.C.: U.S. Government Printing Office, 1972), 1203, quoted in Winkler, *Life under a Cloud*, 60. See Divine, *Blowing on the Wind*, 158, 169, and 182.

14. Ed Dorn to Charles Olson, Sept. 3, 1959, Charles Olson Papers, Archives and Special Collections Department, Thomas J. Dodd Research Center, University of Connecticut Libraries. See Belgrad, "SANE and Beyond Sane," 84.

15. Wittner, *Rebels Against War*, 243. Erich Fromm, *The Sane Society* (New York:

Henry Holt and Co., 1955), 12–17. Fromm, letter to Clarence Rickett, July 18, 1957, SANE Papers, series B, Swarthmore College Peace Collection, Swarthmore, PA, quoted in Divine, *Blowing on the Wind*, 166.

16. Gregory Corso, "Bomb," *Mindfield* (New York: Thunder's Mouth Press, 1989), 65–69.

17. John Clellon Holmes, *Go* ([1952] Mamaroneck, NY: Paul P. Appel, 1977), 32.

18. Michael Schumacher, *Dharma Lion: A Critical Biography of Allen Ginsberg* (New York: St. Martin's Press, 1992), 59.

19. Kerouac, *The Town and the City* (New York: Harcourt Brace, 1950), 369–70.

20. Allen Ginsberg, "The New Consciousness," (1972) in *Composed on the Tongue: Literary Conversations, 1967–1977* (Bolinas: Grey Fox Press, 1980), 70.

21. Ann Charters, *Kerouac: A Biography* (San Francisco: Straight Arrow Books, 1973), 38–39. Gerald Nicosia, *Memory Babe: A Critical Biography of Jack Kerouac* (New York: Penguin, 1983), 104–5. See also Kerouac's fictionalized account of the episode in *The Town and the City*, 319–29: "You've got to admit that the absolute relationship between officers and enlisted men is a fascistic set-up. No one can deny *that* any more than you can deny that it's precisely such a system we're supposed to be wiping out."

22. Schumacher, *Dharma Lion*, 54–55. Though war propaganda emphasized the evils of Nazi racist ideology, racism was far from dead in America, and Lionel Trilling's controversial appointment to the faculty at Columbia emphasized the perseverance of institutional anti-Semitism.

23. Ginsberg, "Howl," *Collected Poems, 1947–1980* (New York: Harper and Row, 1984), 126.

24. Sheldon and Eleanor Glueck, quoted in Norman Mailer, "The White Negro," in *Advertisements for Myself* (New York: Putnam, 1959), 306.

25. Allen Ginsberg to Charles Olson, Nov. 26, 1958, Charles Olson Papers; used with permission. For a description of the persecution of homosexuality during the Cold War period, see Andrea Weiss and Greta Schiller, *Before Stonewall: The Making of a Gay and Lesbian Community* (New York: Naiad Press, 1988), 42–55.

In the mid-twentieth century, psychiatric diagnosis was developing into an increasingly sophisticated instrument for describing normative personalities and effecting social adaptation. (Cultural historian Warren Susman called the 1950s the "age of Erik Erikson." See Susman, *Culture as History: The Transformation of American Society in the Twentieth Century* [New York: Pantheon, 1984], 284.) The definition of sanity therefore became a specific site of ideological contestation. Beat writers and bebop jazz musicians alike at times found themselves athwart the classificatory trends separating "healthy" from "unhealthy" behavior. Allen Ginsberg spent six months at the Columbia Psychiatric Institute in Rockland. Charlie Parker was kept at Camarillo State Hospital for seven months in 1946, where he was given electroshock treatments. Bebop pianist Bud Powell received electroshock therapy in 1946; afterward he could never play as creatively as he had before. See Miles Davis, *Miles: The Autobiography* (New York: Simon and Schuster, 1989), 93 and 112.

26. Kerouac, *On the Road* (New York: Viking Penguin, 1957), 9.

27. Ginsberg, "Encounters with Ezra Pound," *Composed on the Tongue*, 9.

28. Kerouac, *On the Road*, 89–90.

29. Ginsberg, "Howl," *Collected Poems*, 133.

30. Ginsberg, "America," *Collected Poems*, 146–47.

31. John Clellon Holmes, introduction to *Neurotica: The Authentic Voice of the Beat Generation, 1948–1951* (London: Jay Landesman, 1981), 9.

32. Jay Landesman, *Rebel Without Applause* (London: Bloomsbury Publishing, 1987), 142.

33. "Editorial Gesture," *Neurotica* 5 (Autumn 1949): 3.

34. Fredric Wertham, *Seduction of the Innocent* (New York: Rinehart and Co., 1954), 2–3.

35. Gershon Legman, *Love and Death: A Study in Censorship* (New York: Quick Lithographers, 1949), 47. See also Legman, "The Psychopathology of the Comics," *Neurotica* 3 (Autumn 1948): 3–30.

36. William H. Miernyk, *Trade Unions in the Age of Affluence* (New York: Random House, 1962), 7–9.

37. Russell Lynes, "Highbrow, Lowbrow, Middlebrow," *Harper's* (Feb. 1949): 19. See also Richard Chase, *Democratic Vista: A Dialogue on Life and Letters in Contemporary America* ([1958] Westport, CT: Greenwood Press, 1973), 49–51. Only the highbrows and middlebrows engaged in this battle; the "lowbrow" was by definition uninterested in matters of taste and culture.

38. See Chase, *Democratic Vista*, 57. See also Fromm, *Sane Society*, 5. For an example of the preoccupation with antiintellectualism among postwar intellectuals, see Richard Hofstadter, *Anti-intellectualism in American Life* (New York: Knopf, 1963).

39. Clement Greenberg, "Avant-Garde and Kitsch," reprinted in *Clement Greenberg: The Collected Essays and Criticism* (Chicago: University of Chicago Press, 1986), vol. 1, 11–12.

40. Chase, *Democratic Vista*, 4.

41. Greenberg, "Avant-Garde and Kitsch," 12.

42. Marshall McLuhan, "The Ballet Luce," in *The Mechanical Bride: Folklore of Industrial Man* (New York: Vanguard, 1951), 11.

43. Erich Fromm wrote in *The Sane Society*, "The alienated person is out of touch with himself, as he is out of touch with any other person. . . . With the senses and with common sense, but at the same time *without* being related to oneself and to the world outside productively" (120–21).

44. McLuhan, "Roast Duck with Jefferson," *Mechanical Bride*, 27.

45. Chase, *Democratic Vista*, 130.

46. Greenberg, "Avant-garde and Kitsch," 20.

47. McLuhan, "Ballet Luce," 10.

48. Ibid., 10–11.

49. McLuhan, "Superman," *Mechanical Bride*, 102.

50. Lynes, "Highbrow, Lowbrow, Middlebrow," 20 and 22.

51. Ibid., 20. See also Chase, *Democratic Vista*, 49.

52. Lynes, "Highbrow, Lowbrow, Middlebrow," 28.

53. Ernest van den Haag, "Kerouac Was Here," *Social Problems* 6:1 (Summer 1958): 22–27.

54. Norman Podhoretz, "The Know-Nothing Bohemians," *Partisan Review* 25:2 (Spring 1958); reprinted in Podhoretz, *Doings and Undoings* (New York: Farrar, Straus, and Co., 1964), 144.

55. Robert Brustein, "The Cult of Unthink," *Horizon* 1:1 (Sept. 1958): 44.

56. Podhoretz, "Know-Nothing Bohemians," 152 and 154–55.

57. Van den Haag, "Kerouac Was Here," 26.

58. Robert Brustein, "The Cult of Unthink," 44 and 135.

59. Frank Butler, "On the Beat Nature of Beat," *American Scholar* 30:1 (1960–61): 87.

60. Van den Haag, "Kerouac Was Here," 25.

61. Anatole Broyard, "A Portrait of the Hipster," *Partisan Review* 15:6 (June 1948), 724–26.

62. See John Clellon Holmes, "Introduction to *Go*" (1976); reprinted in Holmes, *Passionate Opinions: The Cultural Essays* (Fayetteville: University of Arkansas Press, 1988), 263–64.

63. Norman Mailer, *Advertisements for Myself*, 298. Mailer, "The White Negro (Superficial Reflections on the Hipster)," *Dissent* 4:3 (Summer 1957): 276–93.

64. Mailer, "White Negro," *Advertisements for Myself*, 301.

65. Ibid., 310–11, 319.

66. Van den Haag, "Kerouac Was Here," 24–25.

67. Diana Trilling, "The Other Night at Columbia: A Report" (1958); reprinted in Trilling, *Claremont Essays* (New York: Harcourt, Brace, and World, 1964), 161.

68. Butler, "On the Beat Nature of Beat," 83.

69. Brustein, "Cult of Unthink," 41 and 38.

70. John Ciardi, "Epitaph for the Dead Beats," *Saturday Review* (Feb. 6, 1960): 13.

71. Butler, "On the Beat Nature of Beat," 79, 81, and 91.

72. Van den Haag, "Kerouac Was Here," 25. See also Butler, "On the Beat Nature of Beat," 81.

73. Brustein, "Cult of Unthink," 38.

74. Ibid., 41.

75. Frank Getlein, "Schmeerkunst and Politics," *New Republic* 140:6 (Feb. 9, 1959): 271.

76. Podhoretz, "Know-Nothing Bohemians," 152.

77. Brustein, "Cult of Unthink," 40, 38, and 43.

78. Norman Podhoretz, "Correspondence," *Partisan Review* 25:3 (Summer 1958): 477 and 479. Podhoretz, "Know-Nothing Bohemians," 156–57.

79. Gilbert Millstein's favorable review of *On the Road* in the *New York Times* helped to launch it to popular success as a self-help, how-to book of cultural rebellion. In 1959, the *New York Post* ran a favorable twelve-part series on the beats, written by Al Aronowitz. Gilbert Millstein, "Books of the Times," *New York Times*, Sept. 5, 1957: 27. Al Aronowitz, "The Beat Generation," *New York Post*, March 1959. See Barry Miles, *Ginsberg: A Biography* (New York: Viking, 1990), 307.

80. Carl Solomon, letter to Neal Cassady, quoted in Charters, *Kerouac*, 154.

81. Kerouac, *On the Road*, 10–11.

82. Paul O'Neil, "The Only Rebellion Around," *Life*, Nov. 30, 1959: 119.

83. William Leonard, "In Chicago We're Mostly Unbeat," *Chicago Tribune*, Nov. 9, 1958: magazine, 8.

84. Caroline Bird, "Born in 1930—The Unlost Generation," *Harper's Bazaar* (Feb. 1957).

85. See, for example, Louis Hartz, *The Liberal Tradition in America* (New York:

HBJ Press, 1955) and Richard Hofstadter, *The American Political Tradition* (New York: Vintage, 1948), viii.

86. O'Neil, "Only Rebellion Around," 120 and 124.

87. Charters, *Kerouac*, 295.

88. Francis Rigney and L. Douglas Smith, *The Real Bohemia: A Sociological and Psychological Study of the "Beats"* (New York: Basic Books, 1961), 156.

89. O'Neil, "Only Rebellion Around," 126, 119, and 123.

90. Ibid., 123, 130, 119 and 129.

91. "Jackson Pollock: Is He the Greatest Living Painter in the United States?" *Life*, Aug. 8, 1949: 44–45. *Time* also scoffed at Greenberg's praise of abstract expressionism; see "The Best?" *Time*, Dec. 1, 1947: 55.

92. John Canaday, "Art," *New York Times*, Sept. 6, 1959: sect. 2, p. 16. Canaday's repeated attacks evoked a letter of objection signed by artists and intellectuals including Barnett Newman, Theodoros Stamos, William Barrett, James Brooks, John Cage, Adolph Gottlieb, Hans Hofmann, Willem de Kooning, Robert Motherwell, Harold Rosenberg, and several others. See Clifford Ross, ed., *Abstract Expressionism: Creators and Critics* (New York: Harry N. Abrams, 1990), 273.

93. "Beat Mystics," *Time* 71:5 (Feb. 3, 1958): 56.

94. Stuart Mitchner, "Those Phony Beatniks," *Chicago Tribune*, Nov. 8, 1959: magazine, 47.

95. O'Neil, "Only Rebellion Around," 119.

96. John Ciardi, "The Book Burners and Sweet Sixteen," *Saturday Review*, June 27, 1959: 22 and 30.

97. Charters, *Kerouac*, 270 and 278.

98. O'Neil, "Only Rebellion Around," 129. See also John Arthur Maynard, *Venice West: The Beat Generation in Southern California* (New Brunswick, NJ: Rutgers University Press, 1991).

99. See Rigney and Smith, *Real Bohemia*, 75, 35, and 78.

100. Ibid., 180 and 182. Emphasis in original.

101. Quoted in Charters, *Kerouac*, 63.

102. For one of the earliest articulations of this managerial philosophy, see Frederick Winslow Taylor, *The Principles of Scientific Management* (New York: Harper and Brothers, 1911). The book was reprinted in 1939 and again in 1947. Taylor's sadomasochistic disciplining of his own body is recounted in Samuel Haber, *Efficiency and Uplift: Scientific Management in the Progressive Era* (Chicago: University of Chicago Press, 1964), 4–7.

103. Ginsberg, "The New Consciousness," 70.

104. Rigney and Smith, *Real Bohemia*, 70–71 and 78.

105. Ibid., 72.

106. Ibid., 80.

107. Ibid., 142–43.

Conclusion
INTO THE SIXTIES

1. Dwight Macdonald, "The Root Is Man (Part 2)," *Politics* 3 (June 1946): 212.

2. Irving Sandler, *The Triumph of American Painting: A History of Abstract Expressionism* (New York: Harper and Row, 1970), 213, frontispiece, xv, and 259.

3. Serge Guilbaut, *How New York Stole the Idea of Modern Art: Abstract Expressionism, Freedom, and the Cold War*, Arthur Goldhammer, trans. (Chicago: University of Chicago Press, 1983), 242–43 and 204. Sandler, *Triumph of American Painting*, 269.

4. Larry Rivers, *What Did I Do? The Unauthorized Autobiography of Larry Rivers* (New York: HarperCollins, 1992), 78–80.

5. Jack Tworkov, *Jack Tworkov: Paintings, 1928–1982* (Philadelphia: Pennsylvania Academy of Fine Arts, 1987), 133.

6. James Brooks asserted in 1955: "An engrossment in the process of changing formal relations is the artist's method of relieving his self-consciousness as he approaches the mystery he hopes for." James Brooks, statement, *The New Decade: Thirty-Five American Painters and Sculptors* (New York: Whitney Museum of American Art, 1955). Recalling the visits made by Jackson Pollock and Lee Krasner to his studio in Montauk, Long Island, during the summer of 1949, Brooks said of Pollock: "It was good to talk about your work with him because he attacked it in a structural way—not bringing in other meaning that a painting has that you can't talk about too much." Quoted in Elayne Varian, *James Brooks, Paintings 1952–1975* (New York: Martha Jackson Gallery, 1975).

7. See Sandler, *The New York School: The Painters and Sculptors of the Fifties* (New York: Harper and Row, 1978), 278–79, 282.

8. See Sandler, *Triumph of American Painting*, 117–18.

9. Jack Tworkov, *Jack Tworkov: Winter Term Artist-in-Residence* (Dartmouth, NH: Dartmouth College, 1973), n.p.

10. Quoted in Sandler, *New York School*, 113. See also Stephen Polcari, *Abstract Expressionism and the Modern Experience* (New York: Cambridge University Press, 1991), 349.

11. Larry Rivers professed a will to change "the concept of the artist-as-hero into one of the hero-as-clown." Quoted in W[illiam] W[ilson], "Larry Rivers," *Artforum* (Oct. 1965): 11, cited in Sandler, *New York School,* 106. In this vein, there is a continuity between gestural realism and the pop art of Jasper Johns and Andy Warhol.

12. Quoted in Mary Lynn Kotz, *Rauschenberg: Art and Life* (New York: H. N. Abrams, 1990), 90.

13. David Deitcher, "Unsentimental Education: The Professionalization of the American Artist," in *Hand-Painted Pop: American Art in Transition, 1955–62*, exhibition catalogue, Russell Ferguson, ed. (Los Angeles: Museum of Contemporary Art, 1992), 106–7.

14. By 1962, pop art was a prevailing influence on the American art scene. A simulacrum is a copy for which there is no original—such as a silk-screen print, or a Marilyn Monroe. Pop demonstrated that when the "found objects" constituting subjective experience include the images and commodities of mass culture, the result is postmodern pastiche. See Ronald Tavel, "Theatre of the Ridiculous," *TriQuarterly* 9 (Spring 1966): 96.

15. Of course, Cage's subjectivity, as for instance his interest in Zen Buddhism, was still present in the very conception of such works. Ironically, the repudiation of subjectivity is itself a characteristic that marks Cage's works as uniquely his own. See Martin Duberman, *Black Mountain: An Exploration in Community* (New York: E. P. Dutton, 1972), 350–51.

16. See Sandler, *New York School*, 163–64, 33–35.

17. Ibid., 174–77. Especially pertinent here is Rauschenberg's *Erased de Kooning Drawing*, of 1953.

18. John Cage, *Silence* (Cambridge, MA: MIT Press, 1967), 14.

19. Ibid., xii.

20. Barry Miles, *Ginsberg: A Biography* (New York: Viking, 1989), 285.

21. Jack Kerouac, "The Art of Fiction XLI: Jack Kerouac," *Paris Review* 43 (Summer 1968), quoted in Kerouac, *Safe in Heaven Dead: Interviews with Jack Kerouac*, Michael White, ed. (New York: Harriman Books, 1990), 50–51.

22. LeRoi Jones, "Letter to the *Evergreen Review* about Kerouac's Spontaneous Prose" (1961); reprinted in Ann Charters, ed., *The Portable Beat Reader* (New York: Viking, 1992), 352–53.

23. Frank O'Hara, "Personism: A Manifesto," in Donald Allen and Warren Tallman, eds., *Poetics of the New American Poetry* (New York: Grove Press, 1973), 352–53.

24. Frank O'Hara, *The Selected Poems of Frank O'Hara* (New York: Vintage Books, 1974), 9–10.

25. Philip Auslander, *The New York School Poets as Playwrights* (New York: Peter Lang, 1989), 16–17.

26. See Donna De Salvo, "'Subjects of the Artists': Towards a Painting without Ideals," in *Hand-Painted Pop*, 88–89.

27. Allen Ginsberg, "The New Consciousness" (1972), in *Composed on the Tongue* (Bolinas, CA: Grey Fox Press, 1980), 65. See also Theodore Roszak, *The Making of a Counter Culture: Reflections on the Technocratic Society and Its Youthful Opposition* (Garden City, NY: Anchor Books, 1969).

28. Kerouac, *The Dharma Bums* (New York: Viking, 1958), 31.

29. Ibid., 87–88.

30. See Allen J. Matusow, *The Unraveling of America: A History of Liberalism in the 1960s* (New York: Harper and Row, 1984), 275.

31. Charlie Gillett, *The Sound of the City: The Rise of Rock and Roll*, rev. ed. (New York: Pantheon, 1983), x.

32. Important folk revival musicians included Harry Belafonte; Odetta; Pete Seeger; Peter, Paul, and Mary; Joan Baez; and the Rooftop Singers. Seeger, who had traveled with Woody Guthrie as a member of the Weavers, copyrighted many of the anthems of movement, including "If I Had a Hammer," "Where Have All the Flowers Gone," "Turn Turn Turn," and "We Shall Overcome." Gillett, *Sound of the City*, 291–92 and 295–96.

33. See ibid., 303–4, 338, 343, 322, and 315.

34. See ibid., 344–45. See also Todd Gitlin, *The Sixties: Years of Hope, Days of Rage* (New York: Bantam, 1987), 201.

35. See Gillett, *Sound of the City*, 13 and 40–41.

36. Ibid., 298–300.

37. The popularity of "contact improvisation" did not develop until the mid-1970s. See Cynthia J. Novack, *Sharing the Dance: Contact Improvisation and American Culture* (Madison: University of Wisconsin Press, 1990), 35–38 and 69–70. See also Jay Stevens, *Storming Heaven: LSD and the American Dream* (New York: Harper and Row, 1987), 306.

38. See Stevens, *Storming Heaven*, 248–49.

39. Gillett, *Sound of the City*, 353 and 356. See Stevens, *Storming Heaven*, 329–31.

40. Gitlin, *The Sixties*, 209. See also Gitlin's account of the Diggers' disruption of an SDS meeting in 1967: ibid., 226–30.

41. In his "Letter from the Birmingham Jail," King cited Martin Buber and Paul Tillich to ask: "Is not segregation an existential expression of man's tragic separation, his awful estrangement, his terrible sinfulness?" See Martin Luther King, Jr., "Selection from 'Letter from the Birmingham Jail,'" in David Hollinger, ed., *The American Intellectual Tradition* (New York: Oxford University Press, 1989), vol. 2, 327.

42. Gitlin, *The Sixties*, 201–2.

43. Tom Hayden, *Reunion: A Memoir* (New York: Random House, 1988), 19 and 75.

44. Ibid., 93. See "The Port Huron Statement," reprinted in Paul Jacobs and Saul Landau, eds., *The New Radicals: A Report with Documents* (New York: Random House, 1966), 150–62.

45. Hayden, "Student Social Action: From Liberation to Community," in Mitchell Cohen and Dennis Hale, eds., *The New Student Left: An Anthology* (Boston: Beacon Press, 1967), 283.

46. Ibid., 285.

47. Hayden, "A Letter to the New (Young) Left," in Cohen and Hale, eds., *The New Student Left*, 4 and 7. See also "The Radicalism of Disclosure," *Studies on the Left* 1 (Fall 1959); reprinted in Jacobs and Landau, *The New Radicals*, 91–93.

48. Mario Savio, "An End to History," in Cohen and Hale, eds., *The New Student Left*, 249. For the New Left's use of the term "corporate liberalism," see Carl Oglesby, "Let Us Shape the Future," ibid., 312–21.

49. Quoted in Matusow, *Unraveling of America*, 318.

50. See Hayden, "Letter to the New (Young) Left," 3.

51. Norman Mailer, *Armies of the Night: History as a Novel, the Novel as History* (New York: Signet, 1968), 102–3.

52. Matusow, *Unraveling of America*, 311. See also Mailer, *Armies of the Night*, 104.

53. LeRoi Jones to Charles Olson, Sept. 11, 1960, Charles Olson Papers, Archives and Special Collections Department, Thomas J. Dodd Research Center, University of Connecticut Libraries. LeRoi Jones to Charles Olson, c. Nov. 1960, Charles Olson Papers; used with permission.

54. William J. Harris, *The Poetry and Poetics of Amiri Baraka: The Jazz Aesthetic* (Columbia: University of Missouri Press, 1985), 53, 58.

55. See Amiri Baraka, *The Autobiography of LeRoi Jones* (New York: Freundlich Books, 1984), 192–93, 201, and 254–55.

Selected Bibliography

ARCHIVAL AND UNPUBLISHED SOURCES

Peter Busa Papers, Archives of American Art, Smithsonian Institution, New York and Washington, DC.

Carlisle, John Charles, "A Biographical Study of How the Artist Became a Humanitarian Activist: Ben Shahn, 1930–1946" (Ph.D. diss., University of Michigan, 1972).

Gibson, Ann Eden, "Theory Undeclared: Avant-Garde Magazines as a Guide to Abstract Expressionist Images and Ideas" (Ph.D. diss., University of Delaware, 1984).

Adolph Gottlieb Papers, Archives of American Art, Smithsonian Institution.

Adolph and Esther Gottlieb Foundation, New York.

Gottlieb, Adolph, interviews with Martin Friedman, Aug. 1962.

Gottlieb, Adolph, interviews with Dorothy Seckler, Oct. 25, 1967.

John Graham Papers, Archives of American Art, Smithsonian Institution.

Robert Motherwell Papers, Archives of American Art, Smithsonian Institution.

Archives of the Museum of Modern Art, New York.

Needler, Willa Cooper, "Improvisation and Group Process" (M.A. thesis, Wesleyan University, 1979).

Barnett Newman Papers, Archives of American Art, Smithsonian Institution.

Charles Olson Papers, Archives and Special Collections Department, Thomas J. Dodd Research Center, University of Connecticut Libraries, Storrs, CT.

Seitz, William C., "Abstract Expressionist Painting in America" (Ph.D. diss., Princeton University, 1955).

Takaezu, Toshiko, interview with the author, Quakertown, NJ, Aug. 1993.

PUBLICLY RELEASED FILMS AND RECORDINGS

De Antonio, Emile, *Painters Painting: The New York Art Scene, 1940–1960*, Turin Film Corporation (Montauk, NY: Mystic Fire Video, 1972).

Django Reinhardt and the American Jazz Giants. Prestige Historical Series 7633.

Great Dance Bands of the Thirties and Forties, RCA Victor LPM-2081.

Kerouac, Jack, Zoot Sims, and Al Cohn, *Blues and Haikus*. Hanover 5006. Recorded 1958, released Oct. 1959.

The Jack Kerouac Collection, boxed record set, Rhino/Word Beat R-70939.

Namuth, Hans, *Jackson Pollock* (1952).

The Smithsonian Collection of Classic Jazz R033/P7-19477 (CBS, 1987).

PUBLISHED SOURCES

Abel, Lionel, *The Intellectual Follies: A Memoir of the Literary Venture in New York and Paris* (New York: W. W. Norton and Co., 1984).

———, "It Is Time to Pick the Iron Rose," *VVV* 1 (June 1942): 1–2.

Ades, Dawn, *Dali and Surrealism* (New York: Harper and Row, 1982).

Allen, Donald, ed., *The New American Poetry* (New York: Grove Press, 1960).

Allen, Donald, and Warren Tallman, eds., *Poetics of the New American Poetry* (New York: Grove Press, 1973).

Alloway, Lawrence, "Signs and Surfaces: Notes on Black and White Painting in New York," *Quadrum* 9 (1960): 49–62.

Altieri, Charles, "From Symbolist Thought to Immanence: The Ground of Postmodern American Poetics," *Boundary 2* 1:3 (Spring 1973): 605–37.

Amram, David, *Vibrations* (New York: Viking Press, 1968).

Arendt, Hannah, "What Is *Existenz* Philosophy?" *Partisan Review* 13:1 (Winter 1946).

Aronson, Ronald, and Adrian van den Hoven, eds., *Sartre Alive* (Detroit: Wayne State University Press, 1991).

Ashton, Dore, *The New York School: A Cultural Reckoning* (New York: Penguin, 1972).

Auden, W. H., *The Age of Anxiety* (New York: Random House, 1947).

Auping, Michael, ed., *Abstract Expressionism: The Critical Developments* (New York: Harry N. Abrams, 1987).

Auslander, Philip, *The New York School Poets as Playwrights* (New York: Peter Lang, 1989).

Baldwin, James, "Sonny's Blues," in Marcela Breton, ed., *Hot and Cool: Jazz Short Stories* (New York: Penguin, 1990).

Baldwin, James, *The Fire Next Time* (New York: Vintage, 1963).

Baraka, Amiri [LeRoi Jones], *The Autobiography of LeRoi Jones* (New York: Freundlich Books, 1984).

Barrett, William, *The Truants: Adventures among the Intellectuals* (Garden City, NY: Anchor/Doubleday, 1982).

———, *What Is Existentialism?* ([1947] New York: Grove Press, 1964).

Beaudoin, Kenneth, "This Is the Spring of 1946," *Iconograph* 1 (Spring 1946).

Beauvoir, Simone de, "Pyrrhus and Cyneas," *Partisan Review* 13:3 (Summer 1946).

Belz, Carl, *Frankenthaler: The 1950s* (Waltham, MA: Rose Art Museum, Brandeis University, 1981).

Bernstock, Judith E., *Joan Mitchell* (New York: Hudson Hills Press, 1988).

Bhabha, Homi, ed., *Nation and Narration* (New York: Routledge Press, 1990).

Biskind, Peter, *Seeing Is Believing: How Hollywood Taught Us to Stop Worrying and Love the Fifties* (New York: Pantheon, 1983).

Bloom, Harold, *A Map of Misreading* (New York: Oxford University Press, 1975).

Blum, John Morton, *V Was for Victory: Politics and American Culture during World War II* (New York: Harcourt Brace Jovanovich, 1976).

Bourdieu, Pierre, *Distinction: A Social Critique of the Judgment of Taste*, Richard Nice, trans. (Cambridge: Harvard University Press, 1984).

Broder, Patricia Janis, *Hopi Painting: The World of the Hopis* (New York: Brandywine Press, 1979).

Brody, J. J., *Indian Painters and White Patrons* (Albuquerque: University of New Mexico Press, 1971).

Brustein, Robert, "The Cult of Unthink," *Horizon* 1:1 (Sept. 1958).

Buettner, Stewart, *American Art Theory, 1945–1970* (Ann Arbor: UMI Research Press, 1981).

———, "John Dewey and the Visual Arts in America," *Journal of Aesthetics and Art Criticism* 33:4 (Summer 1975): 383–91.

Butler, Frank, "On the Beat Nature of Beat," *American Scholar* 30:1 (1960–61).

Butterick, George, *A Guide to the Maximus Poems of Charles Olson* (Berkeley: University of California Press, 1978).

Cage, John, *Silence* (Cambridge, MA: MIT Press, 1967).

Carmean, E. A., Jr., *The Collages of Robert Motherwell* (Houston: Museum of Fine Arts, 1972).

Carr, Roy, Brian Case, and Fred Dellar, *The Hip: Hipsters, Jazz, and the Beat Generation* (Boston: Faber and Faber, 1986).

Cassady, Carolyn, *Off the Road: My Years with Cassady, Kerouac, and Ginsberg* (New York: William Morrow, 1990).

Cassady, Neal, *The First Third* (San Francisco: City Lights Books, 1971).

Cernuschi, Claude, *Jackson Pollock: Meaning and Significance* (New York: Harper-Collins, 1992).

Charters, Ann, *Kerouac: A Biography* (San Francisco: Straight Arrow Books, 1973).

———, *Olson/Melville: A Study in Affinity* (Berkeley: Oyez Press, 1968).

———, ed., *The Portable Beat Reader* (New York: Viking, 1992).

Chassman, Neil, ed., *Poets of the Cities of New York and San Francisco* (New York: Dutton, 1974).

Chipp, Herschel B., ed., *Theories of Modern Art* (Los Angeles: University of California Press, 1968).

Clark, T. J., "In Defense of Abstract Expressionism," *October* 69 (Summer 1994): 47–48.

Clark, Tom, *Charles Olson: The Allegory of a Poet's Life* (New York: W. W. Norton and Co., 1991).

Clifford, James, and George Marcus, eds., *Writing Culture: the Poetics and Politics of Ethnography* (Berkeley: University of California Press, 1986).

Cohen, Mitchell, and Dennis Hale, eds., *The New Student Left: An Anthology* (Boston: Beacon Press, 1967).

Cohen, Selma Jeanne, ed., *Dance as a Theatre Art: Source Readings in Dance History* (New York: Harper and Row, 1974).

Copeland, Roger, and Marshall Cohen, eds., *What Is Dance? Readings in Theory and Criticism* (New York: Oxford University Press, 1983).

Corsini, Raymond J., ed., *Current Psychotherapies*, 3d ed. (Itasca, IL: F. E. Peacock, 1984).

Corso, Gregory, *Mindfield* (New York: Thunder's Mouth Press, 1989).

Cowley, Malcolm, *The Literary Situation* (New York: Viking, 1954).

———, "The Trials of Elmer Davis," *New Republic,* May 3, 1943.

Cowling, Elizabeth, "The Eskimos, the American Indians, and the Surrealists," *Art History* 1 (Dec. 1978): 484–99.

Craven, David, "Abstract Expressionism, Automatism, and the Age of Automation," *Art History* 13:1 (March 1990).

———, "Abstract Expressionism and Third World Art: A Post-Colonial Approach to 'American' Art," *Oxford Art Journal* 14:1 (1991).

Creeley, Robert, *Contexts of Poetry* (Bolinas, CA: Four Seasons Foundation, 1973).

Darnton, Robert, *The Great Cat Massacre and Other Episodes in French Cultural History* (New York: Basic Books, 1984).

Davenport, Guy, "The Symbol of the Archaic," *Georgia Review* 28 (1974).

Davidson, Michael, "Palimtexts: Postmodern Poetry and the Material Text," in Marjorie Perloff, ed., *Postmodern Genres* (Norman: University of Oklahoma Press, 1989).

Davis, Mike, "The Barren Marriage of American Labor and the Democratic Party," *New Left Review* 124 (Nov.-Dec. 1980).

Davis, Miles, *Miles: The Autobiography* (New York: Simon and Schuster, 1989).

De Grazia, Edward, *Girls Lean Back Everywhere: The Law of Obscenity and the Assault on Genius* (New York: Random House, 1992).

Deloria, Vine, Jr., *God Is Red* (New York: Grosset and Dunlap, 1973).

———, *The Metaphysics of Modern Existence* (New York: Harper and Row, 1979).

d'Harnoncourt, René, "North American Indian Arts," *Magazine of Art* (1939).

Dijkstra, Bram, *The Hieroglyphics of a New Speech: Cubism, Stieglitz, and the Early Poetry of William Carlos Williams* (Princeton: Princeton University Press, 1969).

Divine, Robert A., *Blowing on the Wind: The Nuclear Test Ban Debate, 1954–1960* (New York: Oxford University Press, 1978).

Dolan, James, "Typography," *Iconograph* 1 (Spring 1946).

Doss, Erika, *Benton, Pollock, and the Politics of Modernism: From Regionalism to Abstract Expressionism* (Chicago: University of Chicago Press, 1991).

Douglas, Frederick H., and René d'Harnoncourt, *Indian Art of the United States* (New York: Museum of Modern Art, 1941).

Duberman, Martin, *Black Mountain: An Exploration in Community* (New York: E. P. Dutton, 1972).

Dunn, Dorothy, *American Indian Painting of the Southwest and Plains Areas* (Albuquerque: University of New Mexico Press, 1968).

———, "The Art of Joe Herrera," *El Palacio* 59:12 (Dec. 1952).

Edwards, Paul, ed., *Encyclopedia of Philosophy* (New York: Macmillian and the Free Press, 1967).

Edwards, Richard, *Contested Terrain: The Transformation of the Workplace in the Twentieth Century* (New York: Basic Books, 1979).

Ehrenreich, *The Hearts of Men: American Dreams and the Flight from Commitment* (New York: Anchor, 1983).

Eidelberg, Martin, ed., *What Modern Was: Design, 1935–1965* (New York: Harry N. Abrams, 1991).

Eliot, T. S., *The Sacred Wood: Essays on Poetry and Criticism* ([1920] New York: Barnes and Noble, 1928).

Feinstein, Sascha, and Yusef Komunyakaa, eds., *The Jazz Poetry Anthology* (Bloomington: Indiana University Press, 1991).

Feller, A. H., "OWI on the Home Front," *Public Opinion Quarterly* 7 (Spring 1943).

Fenollosa, Ernest, "The Chinese Written Character as a Medium for Poetry," Ezra

Pound, ed., in Pound, *Instigations* ([1920] Freeport, NY: Books for Libraries Press, 1967).

Ferguson, Russell, ed., *Hand-Painted Pop: American Art in Transition, 1955–62* (Los Angeles: Museum of Contemporary Art, 1992).

Field, Ruth, "Modern Poetry: The Flat Landscape," *Trans/formation* 1 (1952): 152–53.

Fields, Rick, *How the Swans Came to the Lake: A Narrative History of Buddhism in America*, 3d ed. (Boston: Shambhala, 1992).

Fisher, James T., *The Catholic Counterculture in America* (Chapel Hill: University of North Carolina Press, 1989).

Fixico, Donald, *Termination and Relocation: Federal Indian Policy, 1945–1960* (Albuquerque: University of New Mexico Press, 1986).

Fleming, Donald, "Attitude: The History of a Concept," *Perspectives in American History* 1 (1967): 287–365.

Foucault, Michel, *The History of Sexuality*, vol. 1, *An Introduction*, Robert Hurley, trans. (New York: Vintage, 1978).

Freud, Sigmund, *New Introductory Lectures on Psychoanalysis*, James Strachey, trans. (New York: Norton and Co., 1965).

Friedman, B. H., *Jackson Pollock: Energy Made Visible* (New York: McGraw Hill, 1972).

Fromm, Erich, *The Sane Society* (New York: Henry Holt and Co., 1955).

Gaugh, Harry, *Franz Kline: The Vital Gesture* (New York: Cincinnati Art Museum and Abbeville Press, 1985).

Géfin, Laszlo, *Ideogram: History of a Poetic Method* (Austin: University of Texas Press, 1982).

Gibson, Ann Eden, "*Iconograph* Magazine," in *The Indian Space Painters: Native American Sources for American Abstract Art*, exhibition catalogue (New York: Baruch College Gallery, 1991).

———, "Painting Outside the Paradigm: Indian Space," *Arts* 57 (Feb. 1983): 98–104.

Gillett, Charlie, *The Sound of the City: The Rise of Rock and Roll* (New York: Pantheon, 1983).

Ginsberg, Allen, *Collected Poems, 1947–1980* (New York: Harper and Row, 1984).

———, *Composed on the Tongue* (Bolinas, CA: Grey Fox Press, 1980).

———, *Howl and Other Poems* (San Francisco: City Lights Books, 1956).

———, *Journals: Early Fifties–Early Sixties*, Gordon Ball, ed. (New York: Grove Press, 1977).

Gioia, Ted, *The Imperfect Art: Reflections on Jazz and Modern Culture* (New York: Oxford University Press, 1988).

Gitler, Ira, *Swing to Bop: An Oral History of the Transition in Jazz in the 1940s* (New York: Oxford University Press, 1985).

Gitlin, Todd, *The Sixties: Years of Hope, Days of Rage* (New York: Bantam, 1987).

Gleason, Philip, "Americans All: World War II and the Shaping of American Identity," *Review of Politics* 43:3 (July 1981): 483–518.

Goodman, Paul, *Creator Spirit, Come! The Literary Essays of Paul Goodman*, Taylor Stoehr, ed. (New York: Free Life Editions, 1977).

———, *Drawing the Line: The Political Essays of Paul Goodman*, Taylor Stoehr, ed. (New York: Free Life Editions, 1977).

———, "The Emperor of China," *Possibilities* 1: (1947–48).

_____, *Five Years* (New York: Brussel and Brussel, 1966).

_____, *Nature Heals: The Psychological Essays of Paul Goodman*, Taylor Stoehr, ed. (New York: Free Life Editions, 1977).

_____, "The Political Meaning of Some Recent Revisions of Freud," *Politics* 2:7 (July 1945).

Gosnell, Harold, "Obstacles to Domestic Pamphleteering by OWI in World War II," *Journalism Quarterly* 23 (Dec. 1946).

Graebner, William S., *The Age of Doubt: American Thought and Culture in the 1940s* (Boston: Twayne, 1991).

Graham, John, "Primitive Art and Picasso," *Magazine of Art* 30:4 (April 1937).

_____, *System and Dialectics of Art*, Marcia Allentuck, ed. ([1937] Baltimore: Johns Hopkins University Press, 1971).

Greenberg, Clement, "'American-Type' Painting," *Partisan Review* 22:2 (Spring 1955): 189–94.

Guilbaut, Serge, *How New York Stole the Idea of Modern Art: Abstract Expressionism, Freedom, and the Cold War*, Arthur Goldhammer, trans. (Chicago: University of Chicago Press, 1983).

Hall, Stuart, "Gramsci's Relevance for the Study of Race and Ethnicity," *Journal of Communication Inquiry* 10:2 (Summer 1986): 5–27.

Harris, Mary Emma, *The Arts at Black Mountain College* (Cambridge, MA: MIT Press, 1987).

Harris, William J., *The Poetry and Poetics of Amiri Baraka: The Jazz Aesthetic* (Columbia: University of Missouri Press, 1985).

Hartman, Charles O., *Jazz Text* (Princeton: Princeton University Press, 1991).

Hess, Thomas B., *Willem de Kooning* (New York: George Braziller, 1959).

Hobbs, Robert, *Lee Krasner* (New York: Abbeville Press, 1993).

Hoffmann, Yoel, *Every End Exposed: The 100 Koans of Master Kido* (Brookline, MA: Autumn Press, 1977).

Holmes, John Clellon, *Go* ([1952] Mamaroneck, NY: Paul P. Appel, 1977).

_____, *The Horn* ([1958] New York: Thunder's Mouth Press, 1988).

_____, *Nothing More to Declare* (New York: E. P. Dutton and Co., 1967).

_____, *Passionate Opinions: The Cultural Essays* (Fayetteville: University of Arkansas Press, 1988).

Hoover, Thomas, *Zen Culture* (London: Routledge, 1988).

It Is: A Magazine for Abstract Art (New York), 1958–65.

Jacoby, Russell, *The Last Intellectuals: American Culture in the Age of Academe* (New York: Basic Books, 1987).

James, William, *Principles of Psychology* ([1890] New York: Dover, 1950).

Jameson, Fredric, *The Political Unconscious: Narrative as a Socially Symbolic Act* (Ithaca: Cornell University Press, 1981).

_____, "Reification and Utopia in Mass Culture," *Social Text* 1:1 (1979).

Jean, Marcel, ed., *The Autobiography of Surrealism* (New York: Viking, 1980).

Johnson, Ellen H., ed., *American Artists on Art, from 1940 to 1980* (New York: Harper and Row, 1982).

Johnson, Joyce, *Minor Characters* (New York: Washington Square Press, 1983).

Jones, Hettie, *How I Became Hettie Jones* (New York: Penguin, 1990).

Jones, James T., *A Map of Mexico City Blues: Jack Kerouac as Poet* (Carbondale: Southern Illinois University Press, 1992).

Jones, LeRoi, *Blues People: The Negro Experience in White America and the Music That Developed from It* (New York: William Morrow, 1963).

_____, "Hymn for Lanie Poo," *Preface to a Twenty-Volume Suicide Note* (New York: Totem, 1961).

Jung, Carl G., *Civilization in Transition*, 2d ed., R. F. C. Hull, trans. (Princeton: Bollingen Foundation and Princeton University Press, 1970).

_____, *The Integration of the Personality*, Stanley Dell, trans. (New York: Farrar and Rinehart, 1939).

_____, *Modern Man in Search of a Soul*, W. S. Dell, trans. ([1933] New York: Harcourt and Brace, 1950).

_____, *Psychology and Religion* (New Haven: Yale University Press, 1938).

_____, *The Psychology of the Unconscious: A Study of the Transformations and Symbolism of the Libido, A Contribution to the History of the Evolution of Thought*, Beatrice M. Hinkle, trans. ([1916] New York: Dodd, Mead, 1947).

Katz, Milton S., *Ban the Bomb: A History of SANE, the Committee for a Sane Nuclear Policy, 1957–1985* (New York: Greenwood Press, 1986).

Kees, Weldon, "Muskrat Ramble: Popular and Unpopular Music," *Partisan Review* 15:5 (May 1948).

Kelly, Frank, *Court of Reason: Robert Hutchins and the Fund for the Republic* (New York: Free Press, 1981).

Kerouac, Jack, *The Dharma Bums* (New York: Viking, 1958).

_____, *Doctor Sax* (New York: Grove-Wiedenfeld, 1959).

_____, *Kerouac's Last Word: Jack Kerouac in Escapade*, Tom Clark, ed. (Sudbury, MA: Water Row Press, 1986).

_____, *Lonesome Traveller* (New York: Grove-Weidenfeld, 1960).

_____, *Mexico City Blues* (New York: Grove Press, 1959).

_____, *On the Road* (New York: Viking Penguin, 1957).

_____, *Safe in Heaven Dead: Interviews with Jack Kerouac*, Michael White, ed. (New York: Harriman Books, 1990).

_____, *The Subterraneans* (New York: Grove-Wiedenfeld, 1958).

_____, *The Town and the City* (New York: Harcourt Brace, 1950).

_____, *Visions of Cody* (New York: Penguin, 1972).

King, Richard, *The Party of Eros: Radical Social Thought and the Realm of Freedom* (Chapel Hill: University of North Carolina Press, 1972).

Kirby, Michael, ed., *Happenings* (New York: E. P. Dutton, 1965).

Kochman, Thomas, *Black and White Styles in Conflict* (Chicago: University of Chicago Press, 1981).

Kostelanetz, Richard, ed., *Text-Sound Texts* (New York: William Morrow, 1980).

Kotz, Mary Lynn, *Rauschenberg: Art and Life* (New York: H. N. Abrams, 1990).

Kuh, Katharine, *The Artist's Voice* (New York: Harper and Row, 1962).

Kunitz, Stephen J., "The Social Philosophy of John Collier," *Ethnohistory* 18:3 (Summer 1971).

Kuspit, Donald, "Abstract Expressionism: The Social Contract," *Arts* 54:2 (March 1980).

Kyle, Carol, "The Meso-American Cultural Past and Charles Olson's 'The Kingfishers,'" *Alcheringa,* n.s. 1 (1975): 68–77.

Langhorne, Elizabeth, "Jackson Pollock's *The Moon Woman Cuts the Circle*," *Arts* (March 1979): 128–37.

Lasch, Christopher, *The New Radicalism in America: The Intellectual as a Social Type* (New York: Alfred A. Knopf, 1966).

Lawrence, Nathaniel, *Alfred North Whitehead: A Primer* (New York: Twayne Publishers, 1974).

———, *Whitehead's Philosophical Development: A Critical History of the Background of Process and Reality* (Berkeley: University of California Press, 1956).

Lee, Sherman E., *Tea Taste in Japanese Art* (New York: Asia Society, 1963).

Leggio, James, "Robert Rauschenberg's *Bed* and the Symbolism of the Body," *Studies in Modern Art,* vol. 2, *Essays in Assemblage,* John Elderfield, ed. (New York: Museum of Modern Art, 1992).

Legman, Gershon, *Love and Death: A Study in Censorship* (New York: Quick Lithographers, 1949).

Leja, Michael, *Reframing Abstract Expressionism: Subjectivity and Painting in the 1940s* (New Haven: Yale University Press, 1993).

Lewis, Helena, *Dada Turns Red: The Politics of Surrealism* (Edinburgh: Edinburgh University Press, 1990).

Lhamon, W. T., Jr., *Deliberate Speed: The Origins of a Cultural Style in the American 1950s* (Washington: Smithsonian Institution Press, 1990).

Lipsitz, George, *Class and Culture in Cold War America: A Rainbow at Midnight* (South Hadley, MA: Bergin and Garvey, 1982).

———, *Time Passages: Collective Memory and American Popular Culture* (Minneapolis: University of Minnesota Press, 1990).

Luce, Henry, *The American Century* (New York: Farrar and Rinehart, 1941).

Lynes, Russell, "Highbrow, Lowbrow, Middlebrow," *Harper's* (Feb. 1949).

McClure, Michael, *Scratching the Beat Surface* (San Francisco: North Point Press, 1982).

McDonagh, Don, *The Rise and Fall and Rise of Modern Dance* (Chicago: a capella Press, 1990).

Macdonald, Dwight, "The Root Is Man (Parts 1 and 2)," *Politics* 3 (April and June, 1946).

———, "What Is the Fascist State," *New International* 7:2 (Feb. 1941).

McGuire, William, *Bollingen: An Adventure in Collecting the Past* (Princeton: Princeton University Press, Bollingen Series, 1982).

Mackenzie, Warren, introduction to *The Quiet Eye: Pottery of Shoji Hamada and Bernard Leach* (Monterey, CA: Monterey Peninsula Museum of Art, 1990).

MacLeish, Archibald, *Reflections* (Amherst: University of Massachussetts Press, 1986).

McLuhan, Marshall, *The Mechanical Bride: Folklore of Industrial Man* (New York: Vanguard, 1951).

———, "The Psychopathology of *Time* and *Life*," *Neurotica* 5 (Autumn 1949).

MacNaughton, Mary Davis, "Adolph Gottlieb: His Life and Art," in *Adolph Gottlieb: A Retrospective* (New York: Arts Publisher, 1981).

MacNeil, George, "American Abstractionists Venerable at Twenty," *Art News* 55 (May 1956).

Mailer, Norman, *Advertisements for Myself* (New York: Putnam, 1959).

——, *Armies of the Night: History as a Novel, the Novel as History* (New York: Signet, 1968).

——, "The White Negro (Superficial Reflections on the Hipster)," *Dissent* 4:3 (Summer 1957).

Marx, Karl, *Economic and Philosophical Manuscripts of 1844*, Dirk Struik, ed., Martin Milligan, trans. (New York: International Publishers, 1969).

Mattison, Robert Saltonstall, *Robert Motherwell: The Formative Years* (Ann Arbor: UMI Research Press, 1987).

Matusow, Allen J., *The Unraveling of America: A History of Liberalism in the 1960s* (New York: Harper and Row, 1984).

Miles, Barry, *Ginsberg: A Biography* (New York: Viking, 1989).

Miller, Henry, "Everyman: From *Obscenity and the Law of Reflection*," *Iconograph* 3 (Fall 1946).

Mills, C. Wright, "The Powerless People: The Role of the Intellectual in Society," *Politics* 1:4 (April 1944).

Motherwell, Robert, *The Collected Writings of Robert Motherwell*, Stephanie Terenzio, ed. (New York: Oxford University Press, 1992).

——, "The Modern Painter's World," *Dyn* 6 (Nov. 1944).

Museum of Modern Art, *Twenty Centuries of Mexican Art* (New York: Museum of Modern Art, 1940).

Naifeh, Steven, and Gregory Smith, *Jackson Pollock: An American Saga* (New York: C. N. Potter, 1989).

Neurotica: The Authentic Voice of the Beat Generation, 1948–1951, introduction by John Clellon Holmes (London: Jay Landesman, 1981).

Newman, Barnett, "The First Man Was an Artist," *Tiger's Eye* 1 (Oct. 1947).

Nicosia, Gerald, *Memory Babe: A Critical Biography of Jack Kerouac* (New York: Penguin, 1983).

Novack, Cynthia, *Sharing the Dance: Contact Improvisation and American Culture* (Madison: University of Wisconsin, 1990).

O'Connor, Francis, *Jackson Pollock* (New York: Museum of Modern Art, 1967).

O'Hara, Frank, *Robert Motherwell* (New York: Museum of Modern Art, 1965).

——, *The Selected Poems of Frank O'Hara* (New York: Vintage Books, 1974).

Olson, Charles, *Additional Prose of Charles Olson*, George F. Butterick, ed. (Bolinas: Four Seasons, 1974).

——, *Call Me Ishmael* (New York: Reynal and Hitchcock, 1947).

——, *The Collected Poems of Charles Olson*, George F. Butterick, ed. (Berkeley: University of California Press, 1987).

——, "Katherine Litz Dance Concert: A Review," *Olson: The Journal of the Charles Olson Archives* 8 (Fall 1977).

——, "Letter to W. H. Ferry," in *Olson: The Journal of the Charles Olson Archives* 2 (Fall 1974).

——, *Letters for* Origin, *1950–56*, Albert Glover, ed. (London: Cape Goliard Press, 1969).

_____, *Maximus Poems*, George F. Butterick, ed. (Berkeley: University of California Press, 1983).

_____, *Muthologos: The Collected Lectures and Interviews,* 2 vols., George F. Butterick, ed. (Bolinas, CA: Four Seasons Foundation, 1978 and 1979).

_____, *A Nation of Nothing but Poetry*, George F. Butterick, ed. (Santa Rosa, CA: Black Sparrow Press, 1989).

_____, "Project (1951): The Art of the Language of Mayan Glyphs," *Alcheringa* 5 (Spring-Summer, 1973).

_____, *Selected Writings*, Robert Creeley, ed. (New York: New Directions, 1966).

_____, *The Special View of History*, Ann Charters, ed. (Berkeley: Oyez, 1970).

Olson, Charles, and Robert Creeley, *The Complete Correspondence*, George F. Butterick, ed., vol. 1 (Santa Barbara: Black Sparrow Press, 1980).

O'Neil, Paul, "The Only Rebellion Around," *Life*, Nov. 30, 1959.

Ong, Walter, *Orality and Literacy: The Technologizing of the Word* (New York: Methuen, 1982).

Paalen, Wolfgang, "The New Image," Robert Motherwell, trans., *Dyn* 1 (Spring 1942).

_____, "Paysage Totemique," *Dyn* 1 (Spring 1942).

_____, "Totem Art," *Dyn* 4–5 (Dec. 1943).

Peirce, Charles, "Prolegomena to an Apology for Pragmatism," in *Peirce on Signs: Writings on Semiotic*, James Hoopes, ed. (Chapel Hill: University of North Carolina Press, 1991).

Perls, Frederick, Ralph E. Hefferline, and Paul Goodman, *Gestalt Therapy: Excitement and Growth in the Human Personality* (New York: Dell, 1951).

Philp, Kenneth, *John Collier's Crusade for Indian Reform, 1920–1954* (Tucson: University of Arizona Press, 1977).

Pleasants, Henry, *Serious Music—and All That Jazz!* (New York: Simon and Schuster, 1969).

Podhoretz, Norman, "The Know-Nothing Bohemians" (1958), in *Doings and Undoings* (New York: Farrar, Straus, and Co., 1964).

Poggi, Christine, *In Defiance of Painting: Cubism, Futurism, and the Invention of Collage* (New Haven: Yale University Press, 1992).

Pohl, Frances K., *Ben Shahn: New Deal Artist in a Cold War Climate, 1947–1954* (Austin: University of Texas Press, 1989).

Polcari, Stephen, *Abstract Expressionism and the Modern Experience* (New York: Cambridge University Press, 1991).

Popper, Frank, *Origins and Development of Kinetic Art*, Stephen Bann, trans. (Greenwich, CT: NY Graphic Society, 1968).

Porter, Lewis, ed., *Lester Young: A Reader* (Washington: Smithsonian Institution Press, 1991).

Pound, Ezra, "How to Read," *Polite Essays* (London: Faber and Faber, 1937).

_____, *Literary Essays*, T.S. Eliot, ed. (London: Faber and Faber, 1954).

_____, "Vorticism," in *Gaudier-Brzeska: A Memoir* ([1916] New York: New Directions, 1961).

Progoff, Ira, *Jung's Psychology and Its Social Meaning* (New York: Julian Press, 1953).

Reich, Wilhelm, *The Sexual Revolution: Toward a Self-Governing Character Structure*, rev. ed., Theodore P. Wolfe, trans. (New York: Farrar, Strauss, and Giroux, 1969).

Renouf, Edward, "On Certain Functions of Modern Painting," *Dyn* 2 (July-Aug. 1942).

Rexroth, Kenneth, *With Eye and Ear* (New York: Herder and Herder, 1970).

———, *The World Outside the Window: Selected Essays*, Bradford Morrow, ed. (New York: New Directions, 1987).

Rigney, Francis J., *The Real Bohemia: A Sociological and Psychological Study of the "Beats"* (New York: Basic Books, 1961).

Rivers, Larry, *What Did I Do? The Unauthorized Autobiography of Larry Rivers* (New York: HarperCollins, 1992).

Robinson, Paul, *The Freudian Left: Wilhelm Reich, Geza Roheim, Herbert Marcuse* (New York: Harper and Row, 1969).

Rodman, Selden, *Portrait of the Artist as an American: Ben Shahn* (New York: Harper and Brothers, 1951).

Rohn, Matthew L., *Visual Dynamics in Jackson Pollock's Abstractions* (Ann Arbor: UMI Research Press, 1987).

Rose, Barbara, *Helen Frankenthaler* (New York: Harry N. Abrams, 1970).

———, *Lee Krasner: A Retrospective* (New York: Museum of Modern Art, 1983).

Rosenberg, Harold, "The American Action Painters," *Art News* 51:8 (Dec. 1952).

———, "De Kooning: On the Borders of the Act," in *The Anxious Object: Art Today and Its Audience* (New York: Horizon Press, 1964).

———, "Life and Death of the Amorous Umbrella," *VVV* 1 (June 1942).

———, *The Tradition of the New* (London: Thames and Hudson, 1962).

Rosenthal, David H., *Hard Bop: Jazz and Black Music, 1955–1965* (New York: Oxford University Press, 1992).

Rosner, Stanley, ed., *The Creative Experience* (New York: Grossman Publishers, 1970).

Ross, Clifford, ed., *Abstract Expressionism: Creators and Critics* (New York: Harry N. Abrams, 1990).

Roszak, Theodore, *The Making of a Counter Culture: Reflections on the Technocratic Society and Its Youthful Opposition* (Garden City, NY: Anchor Books, 1969).

Rubin, William, ed., *"Primitivism" in Twentieth-Century Art*, vol. 2 (New York: Museum of Modern Art, 1984).

Rushing, W. Jackson, "Ritual and Myth: Native American Culture and Abstract Expressionism," in Maurice Tuchman, ed., *The Spiritual in Art: Abstract Painting, 1890–1985* (New York: Abbeville Press, 1986).

Ruzicka, Joseph, "Jim Dine and Performance," in *Studies in Modern Art*, vol. 1, *American Art of the 1960s* (New York: Museum of Modern Art, 1991).

Sales, Grover, *Jazz: America's Classical Music* (New York: Prentice-Hall, 1984).

Salzman, Eric, *Twentieth-century Music* (Englewood Cliffs, NJ: Prentice-Hall, 1974).

Sandler, Irving, *The New York School: The Painters and Sculptors of the Fifties* (New York: Harper and Row, 1978).

———, *The Triumph of American Painting: A History of Abstract Expressionism* (New York: Harper and Row, 1970).

Sartre, Jean-Paul, "The Root of the Chestnut Tree," *Partisan Review* 13:1 (Winter 1946).

Schiff, Richard, "Water and Lipstick: De Kooning in Transition," in *Willem de Kooning Paintings* (Washington: National Gallery of Art, 1994).

Schmidt, Peter, *William Carlos Williams, the Arts, and Literary Tradition* (Baton Rouge: Louisiana State University Press, 1988).

Schrader, Robert Fay, *The Indian Arts and Crafts Board: An Aspect of New Deal Indian Policy* (Albuquerque: University of New Mexico Press, 1983).

Schumacher, Michael, *Dharma Lion: A Critical Biography of Allen Ginsberg* (New York: St. Martin's Press, 1992).

Seelye, Catherine, ed., *Charles Olson and Ezra Pound: An Encounter at St. Elizabeth's* (New York: Grossman, 1975).

Shahn, Bernarda Bryson, *Ben Shahn* (New York: Abrams, 1972).

Shapiro, David and Cecile, eds., *Abstract Expressionism: A Critical Record* (New York: Cambridge University Press, 1990).

Shepard, Martin, *Fritz* (New York: Saturday Review Press, E. P. Dutton and Co., 1954).

Shepherd, John, *Music as Social Text* (Cambridge: Polity Press, 1991).

Shklovsky, Viktor, "Art as Device" (1925) in *Theory of Prose*, Benjamin Sher, trans. (Elmwood Park, IL: Dalkey Archive Press, 1990).

Simon, George, *The Big Bands* (New York: Macmillan, 1971).

Slivka, Rose, *Peter Voulkos: A Dialogue with Clay* (Boston: New York Graphic Society, 1978).

Sokei-An, *Cat's Yawn* ([1940–41] New York: First Zen Institute of America, 1947).

Solomon, Deborah, *Jackson Pollock: A Biography* (New York: Simon and Schuster, 1987).

Stevens, Jay, *Storming Heaven: LSD and the American Dream* (New York: Harper and Row, 1987).

Stich, Sidra, *Joan Miró: Development of a Sign Language* (St. Louis, MO: Washington University Gallery of Art, 1980).

Still, Clyfford, "Statement," in *Fifteen Americans*, Dorothy Miller, ed. (New York: Museum of Modern Art, 1952).

Stott, William, *Documentary Expression and Thirties America* (New York: Oxford University Press, 1973).

Sukenick, Ronald, *Down and In: Life in the Underground* (New York: Beech Tree Books, 1987).

Susman, Warren, *Culture as History: The Transformation of American Society in the Twentieth Century* (New York: Pantheon, 1984).

Suzuki, Daisetz, *Essentials of Zen Buddhism* (New York: Dutton, 1962).

––––––, *Zen and Japanese Culture*, 2d ed. (New York: Pantheon Books, 1959).

Szwed, John, "Joseph Skvorecky and the Tradition of Jazz Literature," *World Literature Today* 54:4 (Autumn 1980).

Tallack, Douglas, *Twentieth-Century America: The Intellectual and Cultural Context* (New York: Longman, 1991).

Tashjian, Dickran, *A Boatload of Madmen: Surrealism and the American Avant-Garde, 1920–1950* (New York: Thames and Hudson, 1995).

Templar, Miles, Reply to Anatole Broyard, *Partisan Review* 15:9 (Sept. 1948): 1054.

Terenzio, Stephanie, *Robert Motherwell & Black* (Storrs: University of Connecticut Press, 1980).

Turner, Victor, and Edward Bruner, eds., *The Anthropology of Experience* (Urbana: University of Illinois Press, 1986).

Tworkov, Jack, *Jack Tworkov: Paintings, 1928–1982* (Philadelphia: Pennsylvania Academy of Fine Arts, 1987).

Tyler, Parker, "Jackson Pollock: The Infinite Labyrinth," *Magazine of Art* 43:3 (March 1950).

Van den Haag, Ernest, "Kerouac Was Here," *Social Problems* 6:1 (Summer 1958).

Weinberg, Sydney, "What to Tell America: The Writer's Quarrel in the Office of War Information," *Journal of American History* 55 (1968).

Weiss, Andrea, and Greta Schiller, *Before Stonewall: The Making of a Gay and Lesbian Community* (New York: Naiad Press, 1988).

White, Richard, *Middle Ground: Indians, Empires, and Republics in the Great Lakes Region, 1650–1815* (New York: Cambridge Unversity Press, 1991).

Whitehead, Alfred North, *Adventures of Ideas* (New York: Macmillan and Co., 1933).

———, *Modes of Thought* (New York: Macmillan, 1938).

———, *Process and Reality: An Essay in Cosmology* ([1929] New York: Free Press, 1978).

Widmer, Kingsley, *Paul Goodman* (Boston: Twayne, 1980).

Wilkin, Karen, *Frankenthaler: Works on Paper, 1949–1984* (New York: George Braziller, 1984).

Williams, Raymond, *The Sociology of Culture* (New York: Schocken Books, 1981).

Williams, William Carlos, *The Autobiography of William Carlos Williams* ([1951] New York: New Directions, 1967).

———, *I Wanted to Write a Poem*, Edith Heal, ed. (Boston: Beacon Press, 1958).

———, *Imaginations*, Webster Scott, ed. (New York: New Directions, 1970).

———, *Kora in Hell: Improvisations* (Boston: Four Seas Co., 1920).

———, *Paterson* (New York: New Directions, 1963).

———, *Selected Essays* (New York: Random House, 1954).

Wilson, Edmund, *Axel's Castle: A Study in the Imaginative Literature of 1870 to 1930* (New York: Scribner's, 1931).

Winkler, Allan M., *The Politics of Propaganda: The Office of War Information, 1942–1945* (New Haven: Yale University Press, 1978).

Wolfe, Judith, "Jackson Pollock's Jungian Imagery," *Artforum* 11 (Nov. 1972).

Wysuph, C. L., *Jackson Pollock: Psychoanalytic Drawings* (New York: Horizon Press, 1970).

Yanagi, Muneyoshi [Soetsu], *Folk Crafts in Japan* ([1936] Tokyo: Society for International Cultural Relations, 1949).

———, *The Unknown Craftsman: A Japanese Insight into Beauty*, adapted by Bernard Leach, foreword by Shoji Hamada (New York: Kodansha International, 1978).

Yee, Chiang, *Chinese Calligraphy: An Introduction to Its Aesthetic and Technique*, foreword by Herbert Read (London: Methuen and Co., 1938).

Zumthor, Paul, *Oral Poetry: An Introduction*, Kathryn Murphy-Judy, trans. (Minneapolis: University of Minnesota Press, 1990).

PLATES

1. Howard Daum, *untitled #264*, c. 1946, oil on canvas, 24″ × 20″. Courtesy of Snyder Fine Art, New York.

2. Willem de Kooning, *Woman V*, 1952–53, oil on canvas, 154.5 × 114.5 cm. Reproduced courtesy of the Willem de Kooning Revocable Trust/Artist Rights Society, New York, and by permission of the National Gallery of Australia, Canberra.

3. Jackson Pollack, *Sounds in the Grass: Shimmering Substance*, 1946, oil on canvas, 30 1/8″ × 24 1/4″ (76.3 × 61.6 cm). The Museum of Modern Art, New York. Mr. and Mrs. Albert Lewin and Mrs. Sam A. Lewisohn Funds. Photograph ©1977 The Museum of Modern Art, New York.

4. Jackson Pollack, *Scent*, c. 1955, oil and enamel on canvas, 78″ × 57 1/2″. Courtesy of the Collection of David Geffen, Los Angeles.

5. James Brooks, *A-1953*. Collection of Charlotte Park Brooks.

6. Helen Frankenthaler, *Holocaust*, 1955, enamel, tube oil pigment, and turpentine on canvas, 68″ × 54″. Courtesy of the Museum of Art, Rhode Island School of Design. The Albert Pilavin Collection of Twentieth Century American Art. © Helen Frankenthaler, 1998.

7. Robert Motherwell, *Yellow Envelope*, 1958, collage of oil and paper on board, 22″ × 18″ (55.9 × 45.7 cm). Courtesy of funds given by the Shoenberg Foundation, Inc., and gift of the Dedalus Foundation, 189:1995, The Saint Louis Art Museum (Modern Art). © 1997 Dedalus Foundation Inc./Licensed by VAGA, New York.

8. Lee Krasner, *Blue Level*, 1955, oil and collage on canvas, 82 1/4″ × 58″ (208.9 × 147.3 cm). © Estate of Lee Krasner. Courtesy Robert Miller Gallery, New York.

FIGURES

1.1 Thomas Hart Benton, *Steel*, from *America Today,* 1930. Distemper and egg tempera on gessoed linen with oil glaze. 92″ × 117″. Courtesy of the Collection, the Equitable Life Assurance Society of the U.S. © The Equitable Life Assurance Society of the U.S.

1.2 Jackson Pollock, *Mural*, 1943, oil on canvas, 8′ 1 1/2″ 19′ 10″. Reproduced by permission of the University of Iowa Museum of Art, Gift of Peggy Guggenheim 1959.6.

1.3 Ben Shahn, *Nicholas C.*, 1951, tempera, 92 1/2″ × 22 1/2″.

1.4 Adolph Gottlieb, *Eyes of Oedipus*, 1941, oil on canvas, 32 1/4" × 25". © 1979 Adolph and Esther Gottlieb Foundation, Inc., New York.

2.1 Jackson Pollock, *The Magic Mirror*, 1941 (84-48 DJ), oil and granular filler on canvas, 46" × 32". Courtesy of the Menil Collection, Houston.

2.2 Chumash cave paintings. Reprinted from Campbell Grant, *The Rock Paintings of the Chumash: A Study of a California Indian Culture* (Berkeley, University of California Press, 1965). Courtesy Clara Louise Grant.

2.3 Richard Pousette-Dart, *Desert*, 1940, oil on canvas, 43" × 6' (109 × 182.8 cm). The Museum of Modern Art, New York. Given anonymously. Photograph © 1997 The Museum of Modern Art, New York.

2.4 Reproduction of the Anasazi mural at Awatovi, from the "Indian Art of the United States" exhibit, 50" × 120". © Denver Art Museum.

2.5 Reproduction of the basketmaker mural from Barrier Canyon, Utah, 13 1/2' × 60'. Installation view of the exhibition "Indian Art of the United States," Museum of Modern Art, New York, January 22–April 27, 1941. Photograph © 1997 The Museum of Modern Art, New York.

2.6 Chilkat blanket from the "Indian Art of the United States" exhibit, 32" × 40".

2.7 Adolph Gottlieb, *Pictograph*, 1942, oil on canvas, 48" × 36". © 1979 Adolph and Esther Gottlieb Foundation, Inc., New York.

2.8 (p. 69) Beatien Yazz, *Lady Silversmith*, 1948, 13 3/8" × 18 7/8". Courtesy of the Museum of Northern Arizona.

2.9 (p. 70) Joe Herrera, *Petroglyph Turtle*, 1952, 23" × 20". Courtesy of the Museum of Northern Arizona.

2.10 Terrance Talaswaima [Honvantewa], *Petroglyph Turtle*, 1974, acrylic, 19" × 14". Courtesy of the Hopi Arts and Crafts Guild.

3.1 Jackson Pollock, *Guardians of the Secret*, 1943, oil on canvas, 48 3/8" × 75 3/8" (122.87 × 191.45 cm). courtesy of the San Francisco Museum of Modern Art, Albert M. Bender Collection, Albert M. Bender Bequest Fund Purchase.

3.2 Chinese ideogram, *guang*, "to ramble"

3.3 Ben Shahn, *A Glyph for Charles*, 1951, tempera on paper, 37" × 25".

3.4 Maya glyphs. Figure 30 from Ian Graham, *The Art of Maya Hieroglyphic Writing*, Peabody Museum Press. Copyright 1971 by the President and Fellows of Harvard College and the Center for Inter-American Relations, Inc., New York. Photograph by Ian Graham taken courtesy of the University Museum, Philadelphia.

3.5 Bradley Walker Tomlin, *#3*, 1948, oil on canvas, 40" × 50 1/8" (101.3 × 127.2 cm). The Museum of Modern Art, New York. Gift of John E. Hutchins in memory of Frances E. Marder Hutchins. Photograph © 1997 The Museum of Modern Art, New York.

3.6 Lee Krasner, *Composition*, 1949, oil on canvas, 38 1/16" × 27 13/16". Courtesy of the Philadelphia Museum of art. Given by Aaron E. Norman Fund, Inc.

3.7 Willem de Kooning, *Orestes*, 1947, enamel on paper and wool, 61 cm × 92 cm. Willem de Kooning Revocable Trust/Artist Rights Society, New York.

3.8 Adolph Gottlieb, *Letter to a Friend*, 1948, oil, tempera, and gouache on canvas, 47 7/8" × 36 1/4". © 1979 Adolph and Esther Gottlieb Foundation, Inc., New York.

4.1 Franz Kline, *Wanamaker Block*, 1955, oil on canvas, 78 3/4" × 71 1/4". Courtesy of the Yale University Art Gallery, Gift of Richard Brown Baker, B.A. 1935.

7.1 Robert Rauschenberg, *Bed*, 1955. Combine painting: oil and pencil on pillow, quilt, and sheet on wood supports, 6' 3 1/4" × 31" × 8" (191.1 × 80 × 20.3 cm). The Museum of Modern Art, New York. Gift of Leo Castelli in honor of Alfred H. Barr, Jr. Photograph © 1997 The Museum of Modern Art, New York.

7.2 Shoji Hamada, plate, 1962, glazed stoneware.

7.3 Peter Voulkos, plate, 1959, stoneware with natural, beige, and blue glazes. Collection of the Oakland Museum of California, Gift of the Art Guild, Oakland Museum Association.

7.4 Toshiko Takaezu, *Mask*, 1960, glazed stoneware.

11.1 Larry Rivers, *Washington Crossing the Delaware*, 1953, oil, graphite, and charcoal on linen, 6' 11 5/8" × 9' 3 5/8" (212.4 × 283.5 cm)]. The Museum of Modern Art, New York. Photograph © 1997 The Museum of Modern Art, New York, given anonymously.

TEXTS

Quotations from unpublished letters of Ed Dorn to Charles Olson, Charles Olson Papers, Archives and Special collections, Thomas J. Dodd Research Center, University of Connecticut Libraries. Used with permission.

Quotations from the 1962 interview with Martin Friedman are used with the permission of the Adolph and Esther Gottlieb Foundation, New York.

Quotations from unpublished letters of Allen Ginsberg to Charles Olson, Charles Olson Papers, Archives and Special collections, Thomas J. Dodd Research Center, University of Connecticut Libraries. Used with permission. Courtesy Allen Ginsberg estate.

Quotations from the John Graham Papers courtesy of Archives of American Art.

Quotations from unpublished letters of LeRoi Jones to Charles Olson, Charles Olson Papers, Archives and Special collections, Thomas J. Dodd Research Center, University of Connecticut Libraries. Used with permission. Reprinted by permission of Sterling Lord Literistic, Inc., © 1958, 1960 by Amiri Baraka.

Quotations from the Robert Motherwell Papers courtesy of Archives of American Art.

Quotations from unpublished letters of Charles Olson, Charles Olson Papers, Archives and Special collections. Thomas J. Dodd Research Center, University of Connecticut Libraries. Used with permission.

Charles Olson's poem "Glyphs" © 1989 by the Estate of Charles Olson and the University of Connecticut. Reprinted from *A Nation of Nothing But Poetry* with the permission of Black Sparrow Press.

Ezra Pound's poem "In a Station of the Metro," from *Personae*, © 1926 by Ezra Pound. Reprinted by permission of New Directions Publishing and Faber & Faber, Ltd.

Quotations from the 1967 interview with Dorothy Seckler are used with the permission of the Adolph and Esther Gottlieb Foundation, New York.

William Carlos William's poem "The Red Wheelbarrow," from *Collected Poems, 1909–1939*, vol. 1. © 1938 by New Directions Publishing Corp. Reprinted by permission of New Directions.

Index